The Image Multiplied

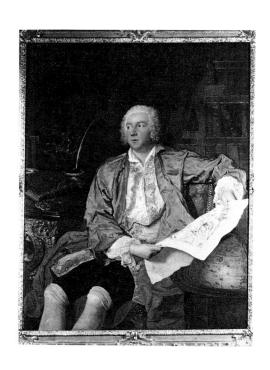

THE IMAGE MULTIPLIED

Five centuries of printed reproductions

of paintings and drawings

SUSAN LAMBERT

TREFOIL PUBLICATIONS, LONDON

Published by Trefoil Publications Ltd
7 Royal Parade, Dawes Road, London SW6

First published 1987

ISBN 0 86294 096 6

Designed by Elizabeth van Amerongen
Typeset by Wandsworth Typesetting Ltd.
Printed by BAS Printers Ltd.

Contents

An original is a creation
motivated by desire.
Any reproduction of an original
is motivated by necessity.
The original is the result of
an automatic mental process,
the reproduction, of a mechanical
process. In other words:
Inspiration then information,
each validates the other.
All other considerations are
beyond the scope of these
statements.
It is marvellous that we are
the only species that creates
gratuitous forms.
To create is divine, to reproduce
is human.

Man Ray

Foreword

Ad gloriam non est satis unius opinio
The opinion of one is not enough for glory.

The story of *The Image Multiplied* begins in the Renaissance and culminates in the Age of Mechanical Reproduction. It is interesting that this five hundred year history seems to exist as it were in tension between two opposing narrative streams. One is an extroverted narrative of progress, of technological change led by artists and craftsmen who were, in their cultural milieu, the leaders of scientific and technical expertise. Their interest, as members of a growingly self-conscious elite, was to spread their own fame, glory and prospects of employment through the 'civilised' world. The other narrative is that of Art History, itself an invention of the Renaissance, which distinguishes the artist as a genius and the work of art as a record of conjunction between human mind and amenable material. As a historical study it looks backward in time, and as a manifestation of humanistic culture, it looks inward for the necessary conditions of human creativity. Its value system depends on concepts such as authenticity, which guarantees the personal responsibility for an object, and originality, which attests the reliability of the object as evidence. To distinguish these values the opinion of the multitude is irrelevant: the praise of a single scholar is sufficient for glory, and glory itself is a moment of *éclaircissement* for the privileged citizen, either at home or in the dedicated surroundings of the Art Gallery.

When Walter Benjamin wrote his classic essay of 1936 'The Work of Art in the Age of Mechanical Reproduction', he acknowledged that he wrote, like Marx, prognostically, looking to a future in which the conditions under which works of art were made must eventually lead to the dissolution or transformation of Art itself. Quoting Marinetti's eulogy of war as beauty, he foresaw what became three years later catastrophe and holocaust. Such massive realities loom large, and for us it is a privilege dearly bought that we can sit and question whether indeed the Age of Mechanical Reproduction has changed 'the reaction of the masses towards Art'. Rather than remove what Benjamin called the *aura* of art, does not mechanical reproduction in fact intensify it? National galleries only confirm the status of their canonical treasures by selling framed reproductions; the most highly priced painting sold at auction recently was one version of an image made wearisome by reproduction; the practice of art history, even when it is a training in connoisseurship and attribution science, has come to depend almost entirely on reproductive photography, on slides and on illustrations in books. Distancing ourselves even further than Benjamin could from the fascistic visions of Marinetti, we may imply doubt

7

about another Modernist myth and question whether mechanised reproduction has meant for our century a genuinely critical phase of historical development. The narrative set out in these pages seems to identify at least several equivalent technological changes. One might say that the use of acid to produce the actual printing line represented a kind of alienation on a continuum with the alienation supposedly produced by photography. But Susan Lambert shows how the fact of alienation has itself intensified the cult of personal involvement and has become central to the aura of some *original* art works.

It is probably as hard to identify critical moments of change in the evolution of cultures as it is in the evolution of species, but at least the record is fuller. One of the problems that the historian has to face as she works through five hundred years of printed reproduction is the sheer quantity of evidence, relatively little of it processed already by scholarship, for of course print studies have until recently tended to concentrate on the fine qualities of the print rather than on any reproductive function it may have. Nevertheless the pages that follow show the extent to which the writing of history is a cumulative process, and it would be as a fresh approach to the field, not as a final survey, that we would wish this volume to be understood.

John Murdoch
Keeper of the Department of Designs, Prints and Drawings
at the Victoria and Albert Museum.

Acknowledgements

A great many people have helped with this work and the exhibition it accompanies which, since it covers 500 years of Western European cultural history, inevitably draws predominantly on the researches of others. The bibliography stands as an indication of the enormous debt which I owe to all those who have written on the subject as well as, I hope, a useful guide to further reading. There is, indeed, a growing literature on the subject which while inspiring me left me with the uncomfortable feeling that books about reproductions in which the 'originals' were always and inevitably reproductions themselves, left an obvious opening for us. The print collections at the Victoria and Albert Museum are enormous and have some spectacular treasures but are distinguished chiefly by their breadth of coverage rather than the fineness of individual impressions. From our own resources, therefore, we could put Volpato's print after Correggio's *Agony in the Garden* or Hollyer's after Landseer's *The Old Shepherd's Chief Mourner* beside the original paintings.

But that said, the exhibition as it has taken shape has depended increasingly on loans to fulfil that wish we had to show reproductions and the images they purported to translate side by side. Without the gracious support of Her Majesty The Queen, the exhibition would have been impossible. In terms of sheer numbers of objects lent, the contribution of the British Museum has shown that the support and enthusiasm of the nation's premier collection of graphic arts was vital. Their loan includes some of their finest drawings. The National Gallery, The Tate Gallery, Kenwood, The Courtauld Institute Galleries, The Fitzwilliam Museum, The Scottish National Portrait Gallery, The John Rylands University Library of Manchester and the Science Museum are among other British institutions which have made major contributions. Foreign institutions which have generously participated include the National Gallery of Ireland, the Bibliothèque Nationale and the Musée du Petit Palais in Paris, the Szépmüvészeti Muzeum in Budapest, the Kunst Museum Basel, the Amsterdams Historisch Museum in Amsterdam and the Staatliche Schlosser und Garten, Berlin. I also thank most warmly the private lenders many of whom have generously denuded their walls for the show.

More personally I would like to thank John Rowlands, Antony Griffiths, Frances Carey, Jane Roberts, Julia Baxter, Theresa-Mary Morton, Michael Kauffmann, Dennis Farr, John Sunderland, Peter Thornton, Margaret Richardson, Craig Hartley, Maureen Atrill, Sophie de Bussierre and Maxime Préaud. Without the advice and generous assistance of the leading scholars and experts in the field: David Alexander, Iain Bain, John Christian, Tim Clayton, Rob Dixon, Tanya Harrod, Charles Howell, Sarah Hyde, Christopher Lennox-Boyd, Julian Hartnoll, David McLean, Marianne Roland Michel, Marcia Pointon, David Rosand and Guy Shaw,

the project would have been impossible. Through Harley Preston I have enjoyed a sense of access to the profounder levels of international print connoisseurship. Like Harley, David Alexander read the entire text and made many helpful comments. I would also like to thank Iain Bain of the Tate Gallery, the staff of the Medici Society, and Stephen Johnston and John Ward, both of the Science Museum, who read chapters on aspects on which they were able to be especially helpful. Needless to say the errors and distortions remaining are mine.

Judith Bronkhurst tracked down many of the originals, often incorrectly attributed on the prints, and was helped by Frances Dunkels, Christopher Kingzett, Annette Lloyd Morgan, Jennifer Montagu and Julian Treuherz.

Many colleagues in the Museum have contributed. I would particularly like to thank Michael Archer, Marian Campbell, Clive Wainwright, Frances Collard, Nicholas Pearce, Malcolm Green, Merryl Huxtable, Elizabeth Martin, Gwyn Miles, John Wagstaff, Pauline Webber and Peter Young. Philip Spruyt de Bay took the many excellent photographs from the Museum's collections. Everyone in the Department of Designs, Prints and Drawings has played a valuable part but I would like to thank in particular Gill Saunders, who has done much more than administer the provision of the photographs, Elizabeth Miller and Kevin Edge, both of whom have worked closely with me, Anne Buddle, Stephen Calloway, Howard Coutts, Lionel Lambourne, Rosemary Miles, Charles Newton, Frances Rankine, Christopher Titterington, and Ron Parkinson all of whom have contributed knowledge and ideas. I would like to thank also especially Michael Snodin for some particularly imaginative suggestions and John Murdoch for considerable practical and scholarly help.

Many colleagues in the Museum have contributed. I would particularly like to thank Michael Archer, Marian Campbell, Clive Wainwright, Frances Collard, Nicholas Pearce, Malcolm Green, Merryl Huxtable, Elizabeth Martin, Gwyn Miles, John Wagstaff, Andrew Derbyshire, Pauline Webber and Peter Young. Philip Spruyt de Bay and Ian Jones took the many excellent photographs from the Museum's collections. Everyone in the Department of Designs, Prints and Drawings has played a valuable part but I would like to thank in particular Gill Saunders, who has done much more than administer the provision of the photographs, Elizabeth Miller and Kevin Edge, both of whom have worked closely with me, Anne Buddle, Stephen Calloway, Howard Coutts, Lionel Lambourne, Rosemary Miles, Charles Newton, Frances Rankine, Christopher Titterington, and Ron Parkinson all of whom have contributed knowledge and ideas. I would like to thank also especially Michael Snodin for some particularly imaginative suggestions and John Murdoch for considerable practical and scholarly help.

I am also most grateful to Conway Lloyd Morgan for making the publication happen, Lizzie van Amerongen for her sympathetic approach to the design and Caroline Bugler for editorial advice and for seeing it through the press.

Susan Lambert

The prints reproduce their originals in the same sense unless stated otherwise. Measurements refer to the painted or drawn surfaces of the 'original' works and to platemarks of the prints unless stated otherwise. Bibliographies are not provided for the original works, for they are not the subject of the text, but they are provided for drawings which relate to the reproductive process. The bibliographies given for the 'reproductions' are limited to the fullest or the most recent references. Details of the publications are found in the Select Bibliography under the name of the engraver of the image unless stated otherwise.

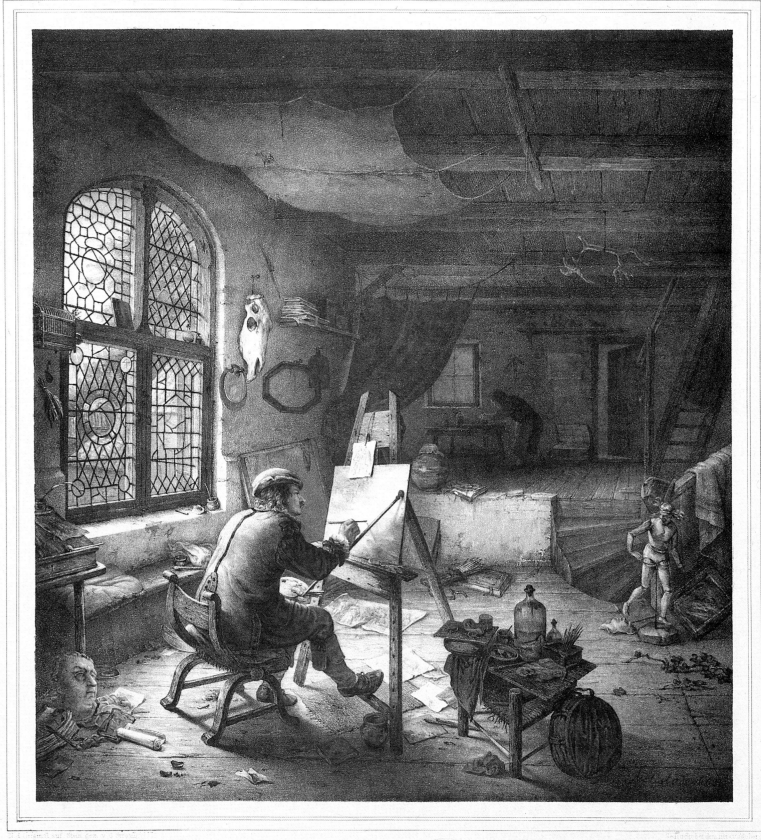

Nach dem Original auf Stein gez. v. J. Strobl. Gedruckt bei dem K. lith. Institut.

Adrian van Ostade in seiner Werkstatt, von ihm selbst.

Das Original ist von derselben Grösse.

Chapter 1
The Status of the Reproduction

CARL STRAUB (1805-P.1851) AFTER ADRIAEN VAN OSTADE

The Artist in his Studio

Lettered *N.d. Original auf Stein gez. v. C Straub. Gedruckt bei dem Herausgeber Adrian van Ostade in seiner Werkstätt von ihm selbst Das Original ist von derselben Grösse. Königl. Gemälde-Galerie in Dresden. Herausgegeben v. Franz Hanfstaengl.* Blind stamped with the combined mark of the publisher and the owner of the original painting.
Lithograph on India paper. 44 x 36.6
VAM E.268-1976

The print is virtually the same size as the original painting and aims at great verisimilitude. Compared with Ekeman-Alleson's version such details as the headdress of the lay figure and the bits and pieces on the window sill are faithfully rendered. But the lithographer's desire to leave out nothing has led to clutter, only suggested in the painting.

1B

LORENZ EKEMAN-ALLESON (1791-1828) AFTER ADRIAEN VAN OSTADE

The Artist in his Studio

Lettered *Adrian van Ostade pinx. L.Ekeman-Allesson lithogr. Das Original befindet sich in der Königl. Sächsischen Gemälde Gallerie in Dresden. Lithographirt und gedruckt bei J.G.Zeller in München.*
Lithograph printed in black and ochre. 46 x 36
VAM E.267-1976

In many ways this reproduction is less accurate than Straub's; the artist works on a virtually bare canvas and the sheets of paper at his feet, different in number, are more or less blank. The ochre tint, however, gives it an antique feel which provides some equivalent to the bygone atmosphere of the original.

ORIGINAL OR REPRODUCTION?

Today everything is 'original' from the junk shop's bygones to the local butcher's sausages. The word is frequently used in place of 'genuine', a living reflection of the value our culture attaches to the idea of the original. In this light, it is ironical to reflect that works of art achieve the status of original only through reproduction. Equally, the idea of the reproduction is most easily defined as the opposite of some kind of 'original'. Yet the cachet attached to the concept of originality is a relatively recent phenomenon. What we now consider as the most characteristic works of the great masters were usually preceded by full-size cartoons and painted *modelli*, which might bear more of the master's own hand than the 'finished' works. These were followed by copies or variations, painted sometimes by the artist himself and often, as it were, under licence within his milieu (figs.2,6). In such a sequence of collective effort the idea of a single 'original' is hardly relevant, and even if we decide to privilege a particular part of it, the relationship between the original and the 'reproduction' is far from as simple or mechanical as Man Ray proposed. The mechanism of creativity is itself complex, continuous and collaborative, and the significance we attach to it is a variable qualified by its every manifestation and 'reproduction'.

The radical change in the attitude to originality which has taken place during the centuries covered by this study has greatly influenced the respect in which reproductive prints are held. In 1480, the artist whether painter or engraver saw his job as one of furthering a tradition. His aim was to develop and refine treatments of subjects handed down to him and to pass them on in an improved form to posterity rather than to create new ways of seeing. There was little premium attached to inventiveness and pictures were not meant to be an expression of the artist's personality; any image was likely to reflect an earlier composition and to provide a basis for a later one. Reproductive prints took their place in this chain; they were, like all works of art, more or less close to their sources and not, therefore, basically different in the way they were conceived from the majority of paintings.

Cristofano Robetta (fig.5), the son of a Florentine hosier who came to engraving through work as a goldsmith relatively late in his development, approached the problem of composition in a way that was typical of artists of ordinary talent at the turn of the 15th and 16th centuries. The overall arrangement of the figures was often derived more or less closely from a known masterpiece but the background was supplied from another source or from the artist's imagination. The extent to which the work deviates from its source largely determines our perception of it as an

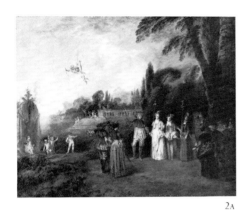

2A

JEAN-ANTOINE WATTEAU (1684-1721)

L'Ile de Cythère

Oil on canvas. 43.1 x 53.3
Städelsches Kunstinstitut, Frankfurt am Main

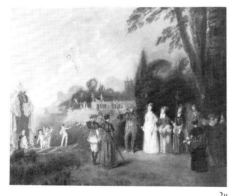

2B SEE FIG.101.

ANONYMOUS FRENCH PAINTER AFTER WATTEAU

L'Ile de Cythère. c.1720

Oil on canvas. 46 x 55.5
François Heugel, Paris

interpretation; only the respectability conferred by time stops us describing it as plagiaristic, or as a reproduction.

Many subjects had rigidly established conventions for their depiction. This was so for the *Annunciation*. The angel was shown as having entered from the left, kneeling in such a way as to provide a dynamic diagonal suggestive of recent movement. The Virgin, more or less static, was normally placed to the right, the point of culmination of the image. The action had the narrative movement of a frieze, and was arranged on a narrow stage, parallel to the onlooker, as in Filippo Lippi's altarpiece for the church of San Lorenzo in Florence (fig.3) which shows, nevertheless, an advanced understanding of the recently discovered principles of perspective. But these Lippi shows off in the background to the scene rather than by re-designing the whole representation of the subject on a deep stage. That the anonymous engraver used Lippi's painting as his model is clear not so much because of the similarity of composition but rather because of the faithfulness with which such details as the form of the lectern are followed (fig.3b & c).

In certain genres it was accepted that an image should be adapted in reproduction to accord with the accepted pattern for that kind of print. This was true of portraiture in the 17th century when the fashion for 'heads' engraved in the form of a bust looking out through a border led, on occasion, to the presentation of three-quarter and even full-length portrait 'originals' in this format. The borders, usually specifically designed for the engraved version, gave the reproductive engraver great scope for formal invention (fig.9) and for additions to the iconography often of the greatest importance, far beyond anything conceived of by the 'original' painter. Thus the engravers who promoted the image of the English monarchy in the early 17th century endowed James I with the attributes of Solomon or Augustus Caesar, and even the simplest classical ornament applied as a border to a bust portrait endowed its subject with a similar air of authority. The iconographic language of the engraved border was adopted back into the practice of painters late in the 17th and 18th centuries, so that painted images by artists from Lely to Gainsborough seem to allow a priority to the portrait engraving. Indeed the border became a feature of such splendid elaboration that it was taken up by some portrait painters themselves as decoration for their original compositions.[1]

Even reproductions which acknowledge the source of the image through inscription often show unexpected changes when compared with the so-called original. Wenceslaus Hollar came to England in the retinue of the Earl of Arundel in 1637 and must have been involved with any plans that the Earl had on the lines recorded by Vertue 'to make a large volume of prints of all his pictures, drawings and other rarities'[2]. However when his circumstances changed and Hollar found himself exiled to Antwerp without a patron and in need of money, the etchings he published of the Leonardo drawings from the Arundel collection show the heads grouped in combinations of his own invention. A particularly fine head (fig.7a), for example, is presented as a single study (fig.7b) whereas three slighter sketches (figs.7c & d) are merged into one composition (fig.7e).

As late as the 18th century the artist's creation was not sacrosanct. J.G. Huquier, better known as the publisher of sets of ornamental patterns, acquired the plates for Watteau's *Figures de Différents Caractères* between 1739 and 1745, some fifteen years after their original issue by Jean de Jullienne. Accustomed to providing images as patterns for craftsmen, he valued these plates only as reproductions of the unique conceptions of a master so far as this enhanced their value as useful types which could be adapted to many uses. To help them appeal to the current decorative taste he added backgrounds which elaborated the mood of the figures and replaced their distinguished isolation with an up-to-date prettiness. Although printed from the same plates as Jullienne's 'original' reproductions they no longer reproduce Watteau's drawings. The embellishments affect the images so that they have little more in common with Watteau's conception than his own figures had with the genre of single figures he had inherited from the previous generation[3] (fig.8).

Additional work to the plate can, when the painter and engraver is the same person, transform what starts as a reproduction into the artist's latest statement on the subject making it, in a sense, the prime version. Hogarth's paintings are on the one hand independent works of art yet at the same time carefully worked preparatory studies for the engravings. Equally the engravings, which in their early states reproduce the paintings closely, have an independent life. Never obsessed with reproducing the painting exactly — he did not work from a mirror image and his prints are therefore usually in reverse of the paintings — once work on the copper had begun Hogarth worked from pulls from the plate as much as from the painting. As time passed radical changes could occur clarifying or adding to the message. About twelve years intervened between the initial publication of *A Rake's Progress* and the reworking of its fourth plate (fig.10). The earlier version shows the Rake on the point of arrest for debt with his forsaken mistress, whom in an earlier plate he had been shown buying off, offering to bail him out. The later version introduces the idea of gambling as the source of his ruin: the sign of White's, a notorious gambling house, makes its appearance on one side of the street and on the other, a group of boys gamble with cards at the Rake's feet.

The interpretative nature of the hand-formed reproduction at least cannot be denied. Even where reproductions seem intended to present the image faithfully it is surprising how much can be put in or left out. The success of the image in its new form depends unexpectedly on its handling by its conveyor. A comparison between two lithographic reproductions of Ostade's *Artist's Studio* made in the same country at approximately the same date and likely, therefore, to be prone to the same influences, shows how much one individual's version of an original can differ from another's (figs.1a,b). Forms which are suggested rather than delineated in the tonality and texture of paint are drawn out with considerable variety and discrepancy. In Sir Hubert Herkomer's words 'To interpret other men's work - to render a coloured work in black and white - is a difficult art. To find the black and white that, as it were, underlies the colour, needs a fine sensitive eye.... The interpretation of pictures is an art in itself and should be judged and valued accordingly.'[4]

2c 2c

NICOLAS IV DE LARMESSIN (1684-1753) AFTER WATTEAU

LIle de Cythère c.1730

Lettered in French and Latin with title and *Gravée d'Après le Tableau original peint par Watteau, de la même grandeur de lestempe* and *du Cabinet de Mr de Jullienne à Paris chez la Veuve de F.Cheron graveur du Roy rue St. Jacques aux deux pilliers d'Or. Avec Privilege du Roy. A Watteau pinxit Larmessin Sculp.*
Etching and engraving. 33.3 x 44.1
VAM

An 'original' is not always easy to identify. The painting now attributed to an anonymous French painter was, until the rediscovery of the painting subsequently acquired by the Städelsches Kunstinstitut, almost unanimously believed to be the original. If either of them is indeed the original, Jullienne's probity is put in question for he claimed that Larmessin's print reproduced the painting, which was in his cabinet, actual size. Perhaps this discrepancy and the formal differences between the print and both paintings, like the position of the staff held by the central male figure, are an indication that the true original has yet to come to light.
Lit: Dacier & Vuaflart (Watteau) 155; M.Stuffmann and alia (Watteau) A2; Roland Michel, (Watteau), p.275.

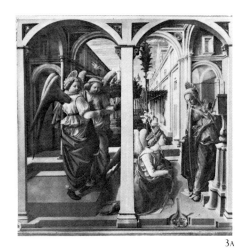

3A

FILIPPO LIPPI (C.1406-1469)

The Annunciation. c.1438

Oil on panel. 175 x 183
Church of Saint Lorenzo, Florence

The nature of reproduction is not however as simply imitative as Herkomer's praise for it suggests. However well or badly a reproduction captures the character of the original, it contributes to our reading of the original. The process of reproduction has the effect of removing the image from its 'original' context, usually reducing its size, and providing it with unforeseen juxtapositions (fig.4). The result for the onlooker is not only a different experience from that undergone in the presence of the original but an irreversibly changed relationship with the original. This factor shows up most clearly when considered in relation to large decorative schemes like the Sistine Ceiling (figs.87,88). Once a composition on a scale that calls for panning the eye, perhaps even also craning the neck, has been comprehended as an image that can be held in the hand or as part of a series of framed pictures on a wall, the struggle to grasp the composition in its larger and less accessible form takes on a different character. Response to the original is tempered by considerations, perhaps only in the subconscious, of how the image lives up to our vision of it in reproduction. The place of discovery is taken by a search for the anticipated.[5]

3B & C

ANONYMOUS, AFTER FILIPPO LIPPI

The Annunciation, from a set of 15 prints of *The Life of the Virgin and of Christ*. Both second state. c.1470-90

Engraving, 3C mounted on wood and coloured by hand within an illuminated border. The plate 22.4 x 16.4; with border 27 x 18.7
The Trustees of the British Museum

The engraver has followed the arrangement of Filippo Lippi's figures in the right half of the altar-piece closely. He has also retained the idea of the partioned composition by placing the column between the Angel of the Annunciation and the Virgin rather than between this scene and that of the attendant angels. The adventurous background recession has been truncated but is nevertheless derived from the same source. The feature of the columnar tree, in particular, has been taken up and repeated. The hand-colouring provides yet another modification of the composition returning it to a tonal rendering and introducing certain features like the brick wall below the arched light.

The re-interpretation of a composition such as this, which combined a reassuring familiarity with an up-to-date approach to the depiction of forms in space, must have helped to ensure demand for the print. The engraver used the images of others to help the sale of his own wares rather than with the intention of reproducing Lippi's 'original' but the end product was nevertheless, in a sense, a reproduction.
Lit: Hind (General) 1, p.121, 1.

3B

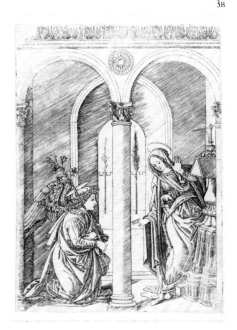

3C

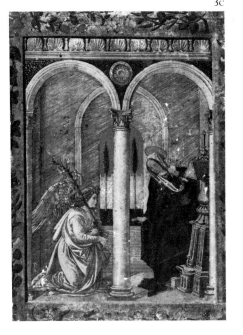

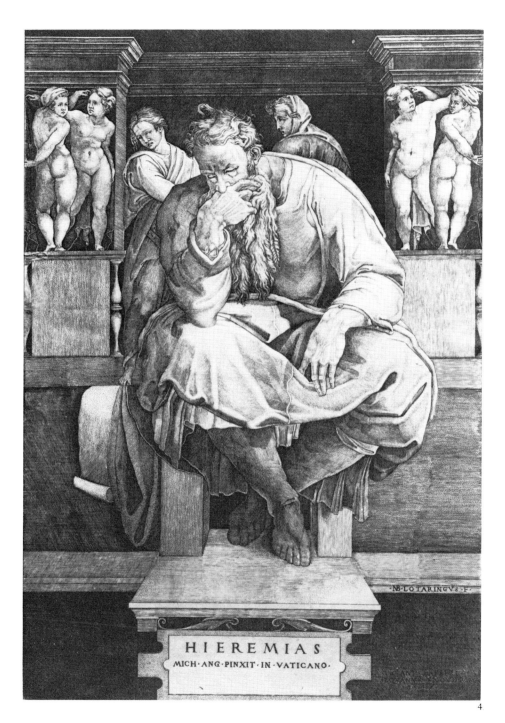

HIEREMIAS
MICH·ANG·PINXIT·IN·VATICANO·

4

NICOLAS BEATRIZET (C.1515-1560) AFTER
MICHELANGELO

**The Prophet Jeremiah. From the Sistine
Ceiling**

Lettered *.NB. Lotaringus .F.Ant. Lafreri. Sequanus.
Excud. Roma 1.5.4.7. Hieremias Mich. Ang. Pinxit. in.
Vaticano.*
Engraving. 42.2 x 29.5
VAM Dyce 1170

The singling out in reproduction of details from large
compositions gives them an independent existence
in our minds, which influences our perception of
their relationship with the whole when in the pres-
ence of the original.

4

17

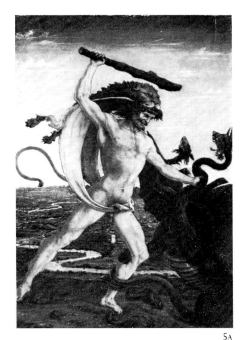

5A

ANTONIO POLLAIUOLO (1431/2-1498)

Hercules slaying the Hydra. c.1460

Oil on panel. 17 x 12
Uffizi, Florence

This little panel and its companion *Hercules slaying Antaeus* are closely related to large compositions painted for Lorenzo de' Medici in 1460, which are now lost. The inter-relationship between these works highlights the problem of defining the 'original'. Comparison with engravings linked to the compositions suggests that the panels differed from the lost paintings in some significant details and that they were conceived as independent variants on the same theme rather than as studies for or miniature copies of them.

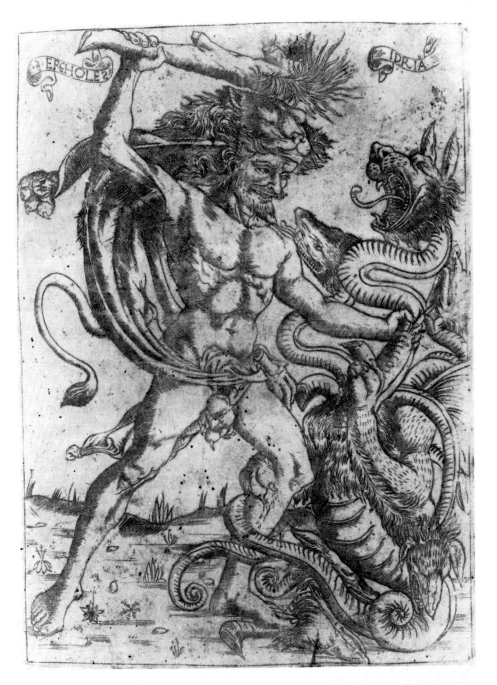

5B

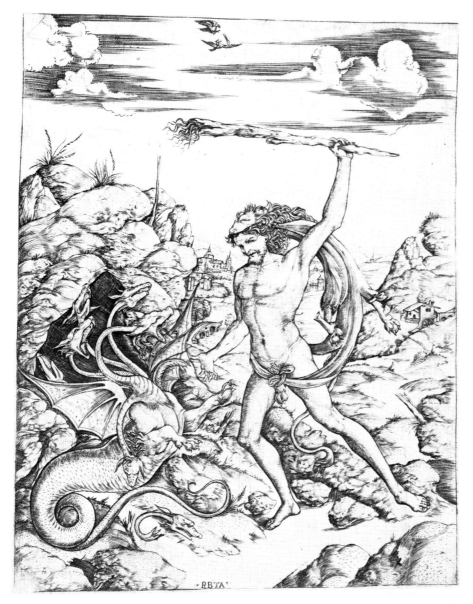

5B

ANONYMOUS, AFTER POLLAIUOLO

Hercules and the Hydra. c.1460

Engraving. 27 x 19
Topkapi Palace Museum, Istanbul

The engraving is in the same sense as the panel painting and follows the stance of Hercules and the Hydra fairly closely except that Hercules' club is flaming. The existence of a drawing in the British Museum with this feature, which also appears in Robetta's version, suggests that it may have been present in the lost painting. The entangled group is however given far more prominence and the greatly simplified background does no more than supply a plausible space for the action.
Lit: Hind (General) 1, p.194, 3.

5C

CRISTOFANO ROBETTA (1462–P.1534) AFTER POLLAIUOLO

Hercules and the Hydra. Second state

Signed .*RBTA.*
Engraving. 23.6 x 18.9
The Trustees of the British Museum

The figure of Hercules is very close, in reverse, to the painted figure. The main difference is the presence of the flaming torch which suggests that either Robetta's print was based on the earlier engraving or that they share a common source, most probably the lost canvas. The background is completely different. The winding Arno is replaced by a more northerly landscape inspired, but not in this case copied from the engravings of Schöngauer and Dürer. The clouds and the predatory hawk are an elaboration introduced in the second state.
Lit: Hind, (General) 1 p.207, 34; Levenson, Oberhuber, Sheehan, (General), pp.289-305.

5C

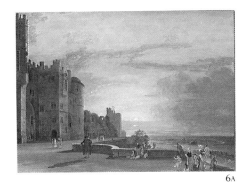

6A

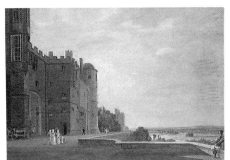

6B

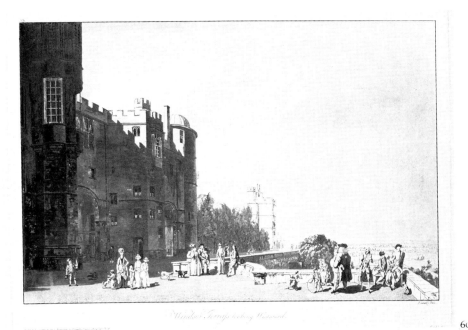

6C

6A, B, C
PAUL SANDBY (1730-1809)

Windsor Castle: the North Terrace looking west, at sunset. c.1770

Bodycolour on primed mahogany panel. 46.4 x 61.5
VAM P.7-1945

Windsor Castle: the North Terrace looking west, at sunset

Signed and dated in ink *P Sandby 1800*.
Bodycolour. 38 x 53
VAM D.1832-1904

Sandby painted at least seven versions of this composition, the dates of execution spanning almost his entire career.

Windsor Terrass looking Westward. 1776

Lettered with title and *P.Sandby Fecit. Publish'd according to Act of Parliament by P.Sandby St. Georges Row Sepr. 1st. 1776.* Numbered *No.3*.
Aquatint, printed in brown. 34 x 47.5
VAM E.55-1891

In one sense the print does reproduce an original. Sandby, however, pioneered the use of aquatint in Britain and invented a process which allowed the printmaker to paint the image onto the plate. It is, therefore, probably more in the spirit of the print's creation to see it as a version in a medium which engrossed the artist as much as paint.

7A
LEONARDO DA VINCI (1452-1519)

Pair of grotesque heads

Pen and ink. 16.2 x 14.3
Windsor Castle, Royal Library (C) Her Majesty
The Queen

7B
WENCESLAUS HOLLAR (1607-1677) AFTER LEONARDO

Grotesque head

Inscribed *Leonardo da Vinci inu W Hollar fecit*.
Etching. 11 x 7.8
VAM E.2496-1920

The head is in reverse of the original and the vigour of its depiction has been refined.
Lit: Pennington 1577.

7C & D
LEONARDO DA VINCI (1452-1519)

Studies (2) of grotesque heads, one single, one double

Pen and ink. 6.3 x 6.8; 6.2 x 6.4
Windsor Castle, Royal Library (C) Her Majesty
The Queen

7E
WENCESLAUS HOLLAR (1607-1677) AFTER LEONARDO

Five grotesque heads

Inscribed *Leonardo da Vinci inu W Hollar fec*.
Etching. 5.2 x 9.5
VAM E.2508-1920

All the heads are again reversed. Their re-grouping has resulted in the obscuring of parts of the originals. These images are not to our eyes among the most attractive of Leonardo's conceptions but they were the first of his drawings to be reproduced in any number. Hollar's publication was reprinted in 1648 and 1666, and in 1786 *Characaturas by Leonardo da Vinci from drawings by Wenceslaus Hollar out of the Portland Museum* was issued in crude imitation of Hollar's work.
Lit: Pennington 1608.

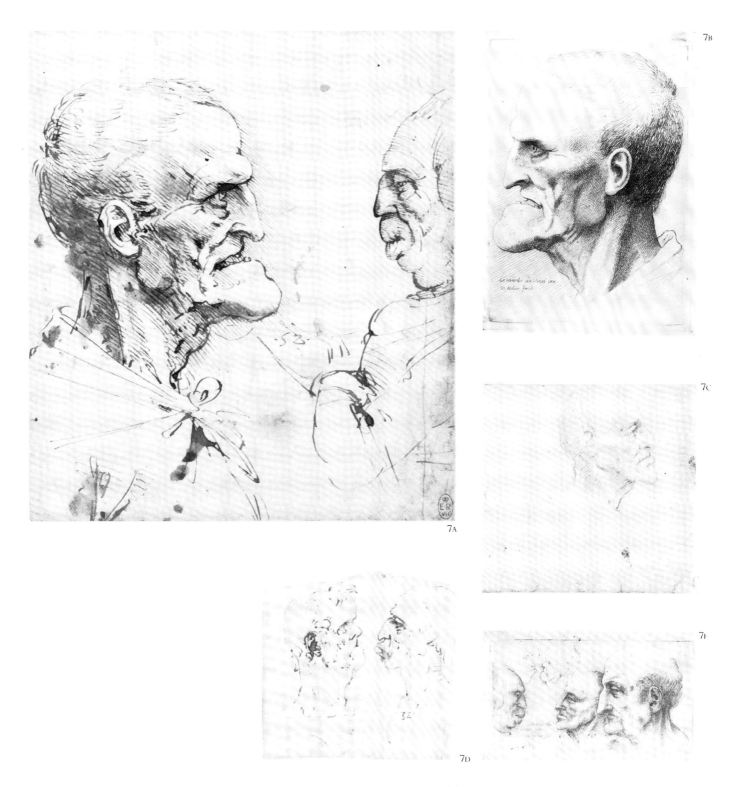

7A

7B

7C

7D

7I

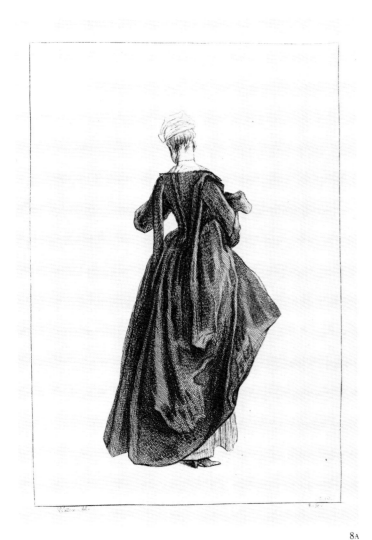

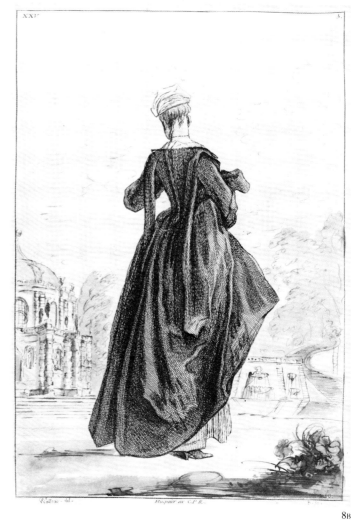

8A

8B

8A

FRANÇOIS BOUCHER (1703-1770) AFTER WATTEAU

Plate 250 from *Figures de différents caractères, de Paysages, et d'Études dessinées d'après nature par Antoine Watteau Peintre du Roy en Son Académie Royale de Peinture et Sculpture gravées a l'Eau forte par des plus Habiles Peintres et graveurs du Temps tirées de plus beaux cabinets de Paris,* **vol. 2, 1728**

Inscribed *Watteau. del. B. Sc.* Numbered *250*
Etching. 32.2 x 21.2
VAM
Lit: Jean-Richard 117.

8B

The same print with a background drawn in by Jean-Baptiste Lallemand (c.1710-1803/5)

Numbered *XXV* and *3.*
Etching with pen and wash. 29.5 x 20.7
Marianne Roland Michel
Lit: Roland Michel (Watteau) pp.258-259.

8C

The same print with the addition of the background as published by Jacques Gabriel Huquier in a surround drawn by Jacques de Lajoüe (1687-1761). c.1735

Signed *Lajoüe.*
Etching with pen and wash. 50.5 x 40.5
Musée des Beaux-Arts, Dijon

This group demonstrates the process of accretion which was a traditional part of image production. The hands of five artists are involved in the creation of the final image.
Lit: Roland Michel, *Lajoüe et l'Art Rocaille,* Neuilly-sur-Seine, 1984, D.142.

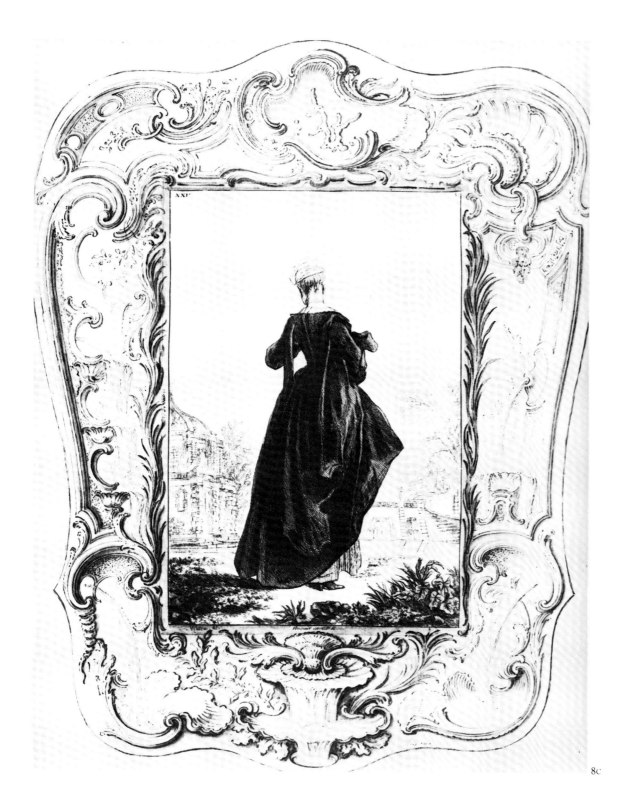

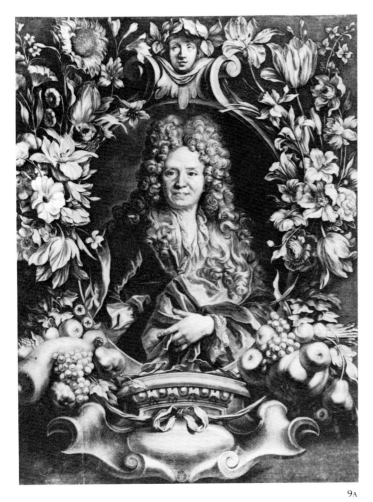

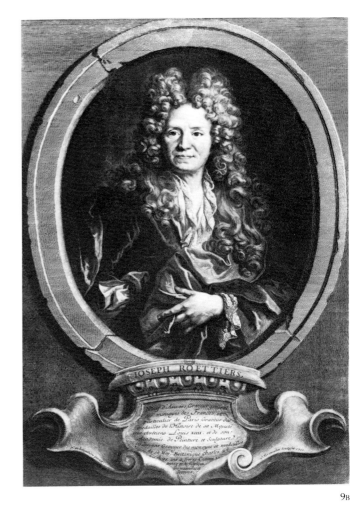

9A

CORNELIS MARTINUS VERMEULEN (C.1644–1708/9)
AFTER LARGILLIERRE

Joseph Roettiers. Portrait, half-length, within a border of flowers. First state

Lettered with scratched letters with name of sitter and a brief biography and *N de Largilliere pinxit C.Vermeulen sculpsit 1700.*
Engraving. Cut to 53 x 41.8
Musée du Petit Palais, Paris

9B

CORNELIS MARTINUS VERMEULEN (C.1644–1708/9)
AFTER LARGILLIERRE

Joseph Roettiers. Portrait, half-length, within an oval frame of masonry. Third state

Lettered with name of sitter etc. and *N. de Largillere pinxit C.Vermeulen sculpsit 1700.*
Engraving. 47.6 x 33.6
VAM E.3675-1960

This engraving differs considerably from Largillierre's painting of the same sitter in the Fogg Art Museum, USA, and must be based on a different, now lost, original. The floral frame presents a tour de force of engraving which could have been felt to present too much competition for the head. The final selection of a more sobre border is likely to reflect the image the sitter wished to present.
Lit: Firmin-Didot 2399; Rosenfeld pp.33, 378.

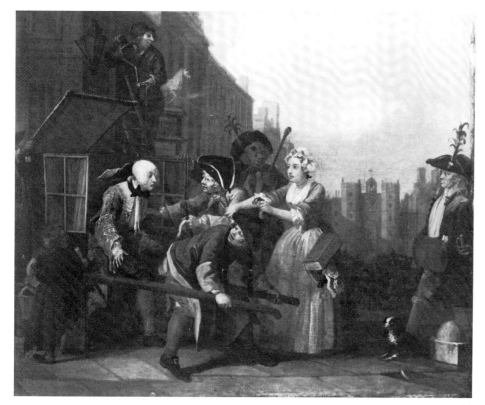

10A

WILLIAM HOGARTH (1697-1764)

A Rake's Progress. The Arrest. 1733-4

Oil on canvas. 62.5 x 75
Sir John Soane's Museum, London

10B & C

WILLIAM HOGARTH (1697-1764)

**A Rake's Progress. Plate 4. First and Third
States. In reverse of the painting**

Lettered *Invented Painted & Engrav'd by Wm Hogarth &
Publish'd June ye 24. 1735 According to Act of Parliament.*
Etching and engraving. 35.2 x 40.8
Rob Dixon; VAM F118(30)

A Rake's Progress consisted of eight compositions
which charted the downfall of a wealthy bourgeois
who aped the ways of his aristocratic counterpart.
Obviously such a work needed mass-producing if it
were to have the salutary influence intended. Further-
ermore the bravura of Hogarth's brushwork and the
lightness of his palette gives the paintings an attract-
iveness which distracts from their message. Thus, in
a sense, the functional black lines of the prints could
be said to provide the prime version.
Lit: Paulson 135.

10A

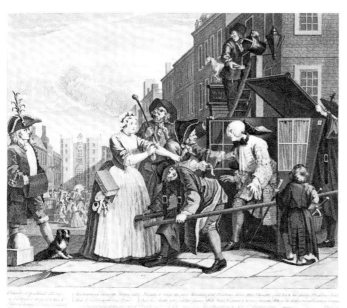

10B

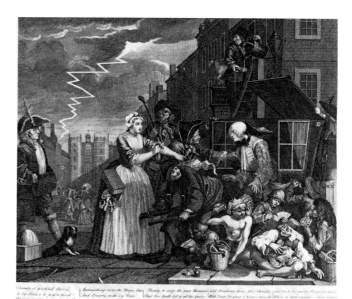

10C

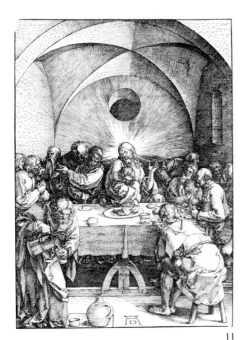

11

ALBRECHT DÜRER (1471-1528)

The Last Supper. No.2 of the set of 12 cuts illustrating the Passion of Jesus Christ, known as 'The Greater Passion', published in book form in 1511, with Latin text

Signed with monogram *AD* and dated *1510.*
Woodcut. 39.7 x 28.5
VAM E.703-1940

Executed after Dürer's Venetian journey of 1505-6, the woodcut shows in its centralised composition and its placing of the figures in space the impact of Renaissance vision. The tonal treatment of form calls into service the vocabulary of hatchings, flick and dots more frequently found in prints taken from metal plates which are more easily worked in this fashion for they have no directional grain.
Lit: Bartsch (General) 205.

The definition of a reproduction as an image made in emulation of an original is further complicated by the fact that many originals owe their very existence to the demands of the reproductive trade and are, therefore, designs which have a reproduction as their end product.

It is not customary to discuss such images of high status as Dürer's woodcuts in a context of reproduction. Critical attention, however, concentrated on his engravings in the later 16th and 17th centuries, by which time woodcut was often regarded as a utilitarian technique, lacking a direct relationship between the cutter's action and the printed mark. Rather than creating the surface that holds the ink, the cutter creates the voids; the block is pared away on either side of the desired line in such a way as to reproduce it as faithfully as possible. Hans Sachs's verse, which accompanies Jost Amman's illustration of a woodcutter in the *Ständebuch*, described a woodcutter's simple ambitions at the time of its publication in 1568:

> I am a wood-cutter good,
> And all designs on blocks of wood
> I with my graver cut so neat,
> That when they're printed on a sheet
> Of paper white, you'll plainly view
> The very forms the artist drew:
> His drawing, whether coarse or fine
> Is truly copied line for line.[6]

Woodcuts were, as this jingle suggests, most often cut by professional cutters rather than by the originator of a design. Whether Dürer cut at least some of his earlier blocks himself has been much discussed but any cutters he employed would have operated so closely to his instructions, probably following lines drawn by him actually on the wood, as to make any distinction between hands at least marginal. Examination of the cutter's work in Dürer's woodcuts shows, however, the technique developing from a predominantly linear to a basically tonal one. The encasing outlines of the early prints easily rendered in relief on wood, give way increasingly to the vocabulary of hatchings, flicks and dots executed more easily on metal plates worked in intaglio with a burin (fig.11)[7]. Had Dürer selected woodcutting as the technique most in sympathy with the graphic idea he wished to realise, rather than as the most practical technique in which to mass-produce the desired 'picture' at a price the market would afford, would he have pushed an inherently crude technique to such limits of subtlety?

At least in their genesis Dürer's woodcuts should not seem so different from, for example, the lithographs of Thomas Shotter Boys whose plates in *Picturesque Architecture in Paris, Ghent, Antwerp, Rouen, etc.* are acknowledged in the introduction as 'Pictures drawn on stone, and re-produced by printing with colours' (fig.12). The text makes it clear that the medium of lithography was selected not for any distinct-

ive quality it would bestow on the image but precisely for its capacity to simulate a greater variety of 'original' techniques. We are told that 'The view of the Abbaye St.Amand, Rouen, is intended to present the appearance of a crayon sketch heightened with colour; that of Ste. Chapelle, Paris, a sepia drawing, with touches of colour; the Fish-Market, Antwerp, a slight sketch in water-colours; St.Laurent, a finished water-colour drawing; the Cour of the Hôtel Cluny, an oil-painting[8] and so on. While the differences are not so apparent to our eyes, the stated intention leaves us in no doubt that the artist was providing what are in essence, if not quite literally, reproductions of his work in unique media for the wider market.

This market was well-established at least by the middle of the 16th century and a very large number of the prints that we now think of as reproductive were made not after independent masterpieces but from drawings made especially for the purpose. Much of Goltzius's work was of this kind. Beginning as the engraver of ornamental frames for the prints of his master, Dirck Volckertsz·Coornhert, he quickly became established independently, acting as his own publisher by 1582 and in time publishing the work of others. His early prints consist largely of reproductions of drawings by contemporaries and although, after a trip to Italy, he turned to the ancient and modern classics as subjects for his own burin, he also provided large numbers of drawings of his own invention for his assistants to engrave. That his drawing of *Lot and his Daughters* was made with reproduction in mind is suggested not only by the existence of a print by Jan Saenredam dated the same year but also because the protagonists in the drawing are all shown as left-handed. With the reversal of the image, which the process of engraving naturally produced, this anomaly was corrected (fig.13).

Oil paintings were also made for the engraving trade. In England, John Boydell, an engraver turned print publisher who became Lord Mayor of London in 1790, even claimed an attempt to create a British school of painting through the commissioning of paintings specifically for reproduction. He argued that the failure of history painting, the most highly regarded form of art at the time, to flourish in Britain was due to a lack of patronage rather than to a lack of native talent and conceived a business venture to remedy the situation[9]. Shakespeare was chosen as a source of suitably patriotic and dramatic subject matter and paintings were commissioned for an ambitious new edition illustrated with engravings (fig.14a). Profits from the sale of the edition and from large engravings sold separately from the text were intended to finance the painters' fees and the reproduction costs. To start with the venture was a success. Gillray, bitter that his services as an engraver had been turned down, was able with a ring of truth to pillory Boydell as a sorcerer who sacrificed Shakespeare for gain (fig.14b). But fluctuations of commerce were such that Boydell's bankruptcy was avoided eventually only through disposal of the project's assets through a lottery.

Most of the paintings designed for the reproductive trade were not as elevated in subject matter as those that formed the Shakespeare Gallery. More typical were Wheatley's *Cries of London*, a subject well-known in the history of engraving. Four-

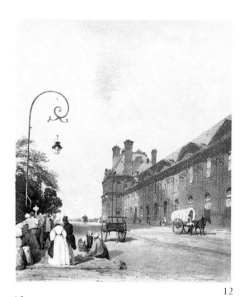

12 12

THOMAS SHOTTER BOYS (1803-1874)

Pavillon de Flore, Tuileries. Plate from *Picturesque Architecture in Paris, Ghent, Antwerp, Rouen etc. drawn from nature on stone by Thomas Shotter Boys.* **Printed by C.Hullmandel. Published by Thomas Boys, London, 1839**

Lettered with title.
Colour lithograph. 34 x 29
VAM E.5858-1903

These lithographs were based on water-colours and drawings made on the Continent from 1823 to 1837. Two water-colours close to this design are known, one in the Victoria and Albert Museum and the other in the Fitzwilliam Museum. There is also a study of the architecture in a private collection in the USA. Boys worked out the compositions for the new medium in chalk on tracing paper, taking the architectural details from previous studies but improvising the figures.
Lit. Roundell, pp.45-52, repr. frontispiece, pls.53-55.

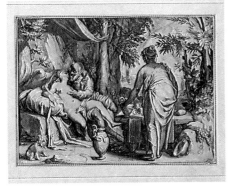

13A

13A

HENDRIK GOLTZIUS (1558-1617)

Lot and his daughters

Signed and dated (the two capital letters as monogram) *HGoltzius A 1597.*
Pen and ink and wash with carmine and white. 19.4 x 26.2
VAM Dyce 392

Drawings such as this are amongst the most admired of Goltzius's works and have in spite of their reproductive purpose been avidly collected. This example passed from the renowned collection of Sir Thomas Lawrence, P.R.A. to that of William Esdaile before entering the collection of the Rev. Alexander Dyce.

13B

JAN SAENREDAM (C.1565-1607) AFTER GOLTZIUS

Lot and his daughters. In reverse of the drawing

Lettered *H Goltzius Inuent. JSaenredam Sculpsit. Ao.1597. Cum privil. Sa Ca. M.* and with four lines of Latin verse.
Engraving. Cut to 20.2 x 26
VAM 13701

Jan Saenredam was an assistant in Goltzius's studio from about 1593 and engraved a considerable number of his drawings. This print follows the composition of the original closely, which, with its simple graduated washes and its use of white heightening, seems almost to provide a schema for the engraver to follow. The accompanying verse is by Cornelis Schonaeus, rector of the Haarlem Latin School, who frequently supplied verses for Goltzius's images.
Lit: Bartsch (General) 41.

teen of the paintings were exhibited at the Royal Academy between 1792 and 1795 but before the exhibition of any of them a newspaper 'puff' anounced that they were 'intended for the engraver and Schiavonetti, a very ingenious Italian artist, has already began upon those which are finished in a very promising style'[10]. The prints were published by Colnaghi but whether they initiated the project or Wheatley painted them as a speculation to be sold to a print publisher is not clear. Only two of the paintings survive, one a subject that was not engraved until this century and the other a variant on the design engraved as *Gingerbread* (fig.82). But the stretcher of the latter bears the address of Colnaghi's[11], suggesting that they were involved at least with that version when it was a blank canvas.

The second half of the 18th century saw the rise of a large group of artists who made their living by providing designs for the reproductive market. The resulting prints are indubitably what we think of as reproductions but what they reproduce is of little consequence in terms of Art. The images were desired as something outside the realm of art or as little luxuries for their own sake rather than as a reproduction of a great 'original' (figs.16,17). In our own century Margaret Tarrant's name is familiar as an artist not because her paintings can be seen in our public art galleries but because reproductions of her fairy-filled fantasies have decorated the bedrooms of small children and her images of blessedness have been used as prizes for Sunday School classes for over fifty years (fig.15).

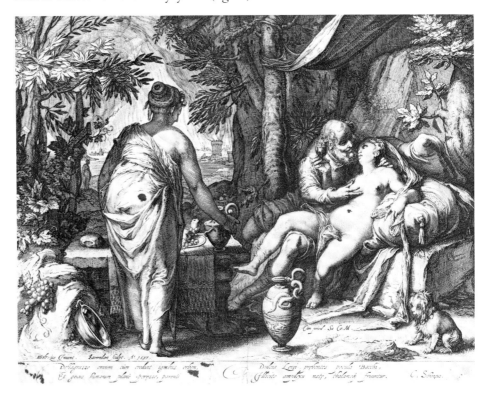

13B

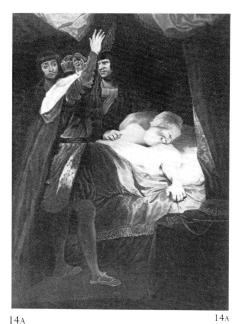

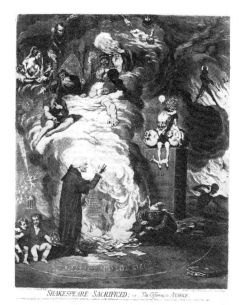

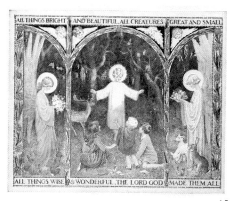

14A 14A

14B 14B

15

CAROLINE WATSON (1760/61-1814) AFTER REYNOLDS

The Death of Cardinal Beaufort. Second state

Lettered *Shakspeare Second Part of King Henry VI, Act III, Scene III Painted by Sir Joshua Reynolds Engrav'd by Caroe. Watson. Publish'd Augt. 1 1792 by John & Josiah Boydell, at the Shakespeare Gallery Pall Mall & No.90 Cheapside London.*
Etching and engraving. 56.9 x 40.5
VAM Theatre Museum

The collaboration of the President of the Royal Academy was essential if the Shakespeare Gallery was to have the prestige at which Boydell aimed. He was alleged to have overcome Reynolds's initial uneasiness at having such close contact with the reproductive trade by leaving an advance of £500. *Cardinal Beaufort* was on show in the Gallery by the Summer of 1789 and became the butt of considerable adverse criticism. The literal representation of 'the busy medling fiend' above the Cardinal's pillow as shown in Gillray's satire came in for particular ridicule and was subsequently removed from both the painting and the print. The painting, now much deteriorated, is at Petworth.
Lit: Penny ed. (Reynolds) 148.

JAMES GILLRAY (1757-1815)

Shakespeare-Sacrificed; or the Offering to Avarice

Lettered with title and *James Gillray, design et fecit. Pubd. June 20th. 1789. by Humphrey. No. 18. Old Bond Street. Soon as possible will be published, price One Guinea. N.1. of SHAKESPEARE ILLUSTRATED, with the Text, annotations, & c. complete; the Engravings to be carried on, in imitation of the Alderman's liberal plan...further particulars will shortly be given in all the public papers...*
Etching and aquatint, coloured by hand. 46.6 x 36.9
VAM Theatre Museum

Alderman Boydell is shown casting a spell over a bonfire of the plays of Shakespeare, the smoke from which weaves itself into satiric 'clips' from the paintings he had commissioned for the Shakespeare Gallery. In front of him sits Avarice, perched on a volume containing the list of subscribers upended like a tomb stone and clutching bulging bags of money. Behind him a boy with a palette and brushes prevents another boy with engraving tools from entering the charmed circle which is lettered in Greek with the motto of the Royal Academy's Great Exhibition Room 'Let no stranger to the Muses enter', a topical comment on the Royal Academy's refusal to allow engravers full membership. To the right a portfolio of engravings after the ancient masters is also outside the circle, neglected.
Lit: Penny ed. (Reynolds) 180.

THE MEDICI SOCIETY AFTER MARGARET TARRANT (1888-1959)

All Things Wise and Wonderful. First published 1925

Lettered with title and *Margaret W.Tarrant Ref. M.A.S.507 (c) The Medici Society Ltd, London, 1986.*
Colour Letterpress. 24.2 x 29.8
The Medici Society Ltd

This picture illustrates the first verse of Mrs Alexander's much loved hymn 'All Things Bright and Beautiful'. First published in 1925, it is still available at Medici Society shops and has proved to be the most popular of Margaret Tarrant's images. Tradition has it that framed copies of the print helped 'art dealers' remain solvent during the depression in the 'thirties. The majority of Medici prints reproduce independent works but exceptionally Tarrant worked for the firm on commission and was sent in 1936 at their expense to Palestine in order to experience the Holy Land at first hand.
Lit: J.Gurney, *Margaret Tarrant & her pictures,* 1982, p.8.

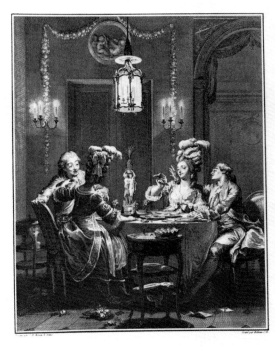

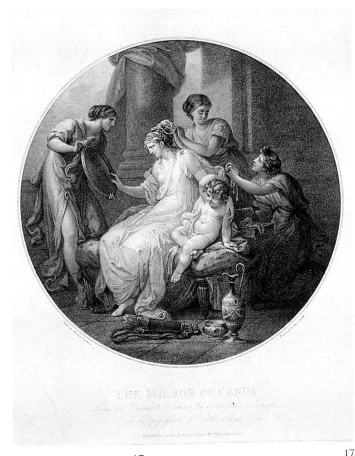

Le Souper fin

A P D R

16

16

ISIDORE STANISLAS HELMAN (1743-1806) AFTER JEAN
MICHEL MOREAU, CALLED LE JEUNE

Le Souper fin

Lettered with title and *Dessiné par J.M.Moreau le Jeune.
Gravé par Helman 1781. A.P.D.R.* Numbered 35.
Engraving and etching. 40 x 31
VAM E.484-1972

This print is one of a set of twelve after Moreau Le
Jeune, which pictures the life of a young aristocrat. A
different engraver worked on each plate after det-
ailed drawings supplied by Moreau Le Jeune for the
purpose. It was with this kind of print that French
salons were decorated. The series was a great success
and was re-issued, combined with an earlier series
based on the life of a young wife also after drawings
by Moreau Le Jeune, under the title *Le Monument du
Costume* in 1789.
Lit: H.W.Lawrence and B.Dighton, *French Line En-
gravings of the Late XVIII Century*, 1910, 241.

17

17

THOMAS TROTTER (C.1750 -1803) AFTER ANGELICA
KAUFFMANN

The Mirror of Venus. 1787

Lettered with title and *Painted by Angelica Kauffman.
Engraved by Thos. Trotter. From an Original picture by
Angelica Kauffman in the possession of Robt. Sayer Esqr
Published 10 October 1787, by Robert Sayer, 53 Fleet
Street, London.*
Stipple engraving, printed in brown. 40.8 x 35.8
VAM 27873

The original picture belonged to the publisher,
Robert Sayer, who may have commissioned it es-
pecially to have it reproduced and would certainly
have acquired it with reproduction in mind. It is a
playful, pseudo-erudite subject intended for the
boudoir, which aimed to flatter the inhabitant's
beauty by association and her intellect by its classical
reference.

Artists have made what we now consider to be 'original' prints almost since the invention of printmaking but the concept did not gain currency until the 19th century and was not defined until the present century. At a time when printmaking from blocks, plates and stones worked by hand was the only means available to mass-produce a visual image, prints with any relationship with the 'fine' arts were greatly in the minority for the same means were used to fulfil a multitude of utilitarian functions in the day-to-day life of civilisation. Printmaking as a technique contributed to the economy in a manner analogous to other techniques of manufacture.

The development of photography in the middle of the 19th century had a subversive effect on the engraving trade for it became split into two distinctive and somewhat hostile camps, one 'fine' art and the other 'commercial'. The engravers who aspired to the status of artist had long-standing reasons for wishing to dissociate themselves from reproductive work. Their relatively low standing had been highlighted in England by the attitude of the Royal Academy, which on its foundation in 1768 admitted no engravers as such, Francesco Bartolozzi being described as a painter. Shortly afterwards six engravers were elected as associates but without the right to vote or to teach engraving in the Academy Schools. When in 1812 a committee was set up to investigate the inferior position held by engravers in the Academy, it reported that engraving was wholly devoid of 'those intellectual qualities of invention and composition which painting, sculpture and architecture so eminently possess ... its greatest praise consisting in translating with as little loss as possible the original arts of design'. The committee concluded 'that with such an important difference in their intellectual pretensions as artists, it appeared to the framers of the Society that to admit engravers into the first class of their members would be incompatible with justice and due regard to the dignity of the Academy'[12]. The growth of photomechanical processes gave engravers an opportunity to distinguish not only the subject matter of their work from that of the more commercial end of the trade but the technique also, a development which must have contributed to the Academy's eventual acceptance of engravers on an equal basis as painters and sculptors in 1928.

A pamphlet by Seymour Haden, president of the British Society of Painter-Etchers and Engravers[13] on *The Relative Claims of Etching and Engraving to Rank as Fine Arts*, issued in 1883, shows the ideas with which this kind of printmaker became preoccupied. In it he put forward the biased but prevailing opinion that etching (which among printmaking techniques had been the preferred medium of painters in the past), 'depending on brain impulse is personal' and thus ranks as fine art whereas engraving, tainted by its earlier use as primarily a reproductive medium, is 'without personality and all the attributes which attend the exercise of the creative faculty' and is, therefore, merely a craft[14]. Societies founded to infuse 'creative' printmaking with vitality stressed how the prints they promoted differed from images that used the new technology. For example Théophile Gautier, the critic,

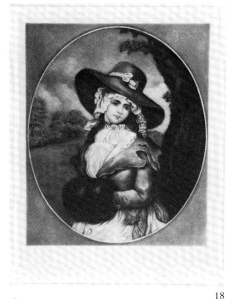

18 18

ANTOINE GAYMARD (WORKED FIRST QUARTER OF 20TH CENTURY) IN THE STYLE OF WILLIAM WARD

Fair Brunette. c.1920

Signed in pencil *A Gaymard* and blind stamped *Artists Proof*.
Mezzotint, printed in colours from a single plate on india paper. 25 x 19
Private Collection

Gaymard's pastiche borrows kudos from its association with William Ward, a leading 18th century exponent of mezzotint, a technique which in spite of its reproductive origins was particularly fashionable by the 'twenties. The india paper support and the 'Artists Proof' stamp add to the sense of the print's specialness, although the latter, a term correctly used to describe impressions outside the main edition reserved for the artist, is here mass-produced to give each impression an aura of closeness to the act of creation. That the print convinced its public is shown by the fact that, as the label on the back of the frame records, it was awarded as a prize for drawing and painting at a girls' school in the north of England in 1924.

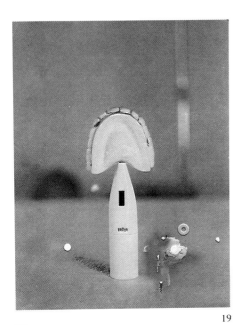

19

RICHARD HAMILTON (BORN 1922)

The Critic Laughs. 1968

Signed and dated in pencil *Richard Hamilton AP June 1968.*
Offset lithograph, laminated, and retouched with enamel paint, and screenprint. 59.5 x 46.5
VAM E.1075-1980

This soft-focus parody of Braun domestic appliance presentation was also a sophisticated dig at the establishment's obsession with technique, which was current when it was produced. The print was made from a photograph, reproduced by photo-offset-litho and laminated with plastic film to heighten its photographic impact. The margins were screenprinted with a matt white which simulated the effect of a photograph mounted on a matt board. Thick paint was applied to the photographic print prior to reproduction and more was added to each print after lamination as well as a little piece of collage. The print is a dialogue between reproduced and original effects with the result that every impression has 'original' work by the artist's hand and every impression is different.
Lit: Davison Art Center, Wesleyan University, Middletown, *The Prints of Richard Hamilton*, 1973, 22.

appealed to the public in the first portfolio issued by the influential *Société des Aquafortistes* founded in Paris in 1861 thus: 'In these times, when photography fascinates the vulgar by the mechanical fidelity of its reproductions, it is necessary to assert an artistic tendency in favour of free fancy and picturesque mood' and subscribers were assured that each impression of the prints sold was an original work of art.[15] A fetish was made out of the variety of effect achieved by different inking of the plate or the use of papers of different absorbency, denying the basic multiple nature of the print. These prints were often issued in an artificial number of states with a large number of proof impressions, first creating the market for something rarified and precious, and then pandering to the collector who saw himself as possessing a particular kind of aesthetic sensitivity in his appreciation of them (fig.18).

Formal definitions of the 'original' print were not promulgated until the 1960s and then ostensibly to help tax inspectors and customs and trading standards officers to distinguish original work from reproductions so that the former could receive privileged treatment and to protect the public from reproductive work which masqueraded as original[16]. But the importance that the regulations attached to a particular kind of manual involvement with the making of the printing surface on the part of the artist makes it appear in retrospect that they were framed also as a counter-movement by the old guard against a new generation of artists who were finding a powerful and personal means of expression in the photomechanical techniques of popular visual communication, shunned by artists since their invention.

The definition agreed at the Third International Congress of Artists in Vienna in 1960 formed the basis of the definitions adopted in many countries. It focussed largely on technique, stipulating that only prints 'for which the artist made the original plate, cut the wood block, worked on the stone or any other material' could be considered 'originals'. Any loophole of interpretation that this wording provided was tightened up in national definitions. Thus the United Kingdom National Committee of the International Association of Painters, Sculptors and Engravers in 1963 stressed that a print must be pulled from a surface 'predominantly executed by the hand of the artist, either from his own design or interpreting the work of another artist or as a result of collaboration'.[17] This implied that the choice of technique was more important even than the originality of the image which could, if the 'hand' of the printmaker was evident enough, be inherently reproductive (figs.22-24). The definition issued by the French National Committee of Engraving in 1965 was even stricter for it excluded 'any and all mechanical or photomechanical processes'[18]. The debate captured the attention of a wide range of artists and became itself a subject for their art (figs.19,20).

The definitions also concentrated on such peripheral matters as far as the essential character of any image is concerned, as the size of the edition and the obligatory presence of the artist's signature. Yet as early as the 18th century publishers of reproductive prints had used the exclusivity of the limited edition to fuel the demand that rarity creates. In France Jean de Jullienne, for example, limited the edition of his 1735 edition of the collected volumes after Watteau to one hundred

copies[19] to try to stimulate a market which was already glutted. In England the very real fragility of the mezzotint plate provided a pretext for the sale of 'proof' impressions (fig.21). It was indeed the reproductive trade which began to rationalise the practice. The Printsellers' Association, founded in 1847 to control the quality of reproductions, issued a *A few words on Art which are also words of advice and warning*[20] in the 1880s and distinguished four categories of impression: artist's proofs, proofs before letters, lettered proofs and prints. The artist's proofs were defined not as the term is usually used to-day as proofs of 'original' prints outside the main edition reserved for the artist but as a first run of prints from the plate before any letters. The proofs before letters were described as proofs lettered with the names of the painter and engraver but without the title. Each impression of both sorts of proofs from an edition approved by the Association were marked with a unique combination of letters, the former on the lower right and the latter on the lower left corner. All the proofs were to be issued in limited editions although curiously the artist's proofs, which were to be the first to be run off, were often printed in the largest quantity.

In spite of these connections with the reproductive trade the limited edition has become closely associated with the original end of the market. But many editions of reproductive prints continue to be limited and many prints original in concept are now, like reproductions, printed in photomechanical techniques capable of printing any number of equally good impressions.

Both reproductive and original prints have been signed in order to convey approval of a particular impression. The presence of the signature of anyone involved in the production of a print inevitably contributes to a sense of it being the product of an individual rather than of a machine. The presence of the artist's signature suggests the artist's immediate involvement. But since Whistler, who charged double for individually signed impressions of his prints, the print trade has capitalised on the artist's signature to increase the value of the product. The cheaper end of the reproductive trade may append a facsimile signature and even a genuine signature only proves that the artist actually touched the sheet for a moment (fig.25).

Only in the last decade has the freedom been extended to printmakers that was won for painters and sculptors early this century by such statements as Duchamp's presentation of standard sanitary fittings and department store wineracks as gallery exhibits. Duchamp aimed to 'reduce the aesthetic consideration to the choice of the mind, not to the ability or cleverness of the hand'[21]. The 'original' print still has its adherents, but the concept is outmoded. As in the past, original prints and reproductions have the same technology at their disposal. A print is what is claimed for it. How successful it is in relation to its pretensions, is a different issue.

20 *See colour plate VIII*
·MARCEL BROODTHAERS (1924-1976)

La Soupe de Daguerre. 1975

Colour photographs and screenprint. 46.5 x 61.3
VAM E.1132-1979

The print, apparently an image of luscious looking vegetables, is an elaborate pun on actuality, representation and reproduction. The ingredients of the soup are represented by stuck-on photographs while the title, with its reference to the inventor of the Daguerreotype, simulating a stick-on label, is in fact executed with a fine piece of trompe l'oeil screenprinting.
Lit: Newton (General) p.49.

21

WILLIAM WARD (1766-1826) AFTER J.R.SMITH

Detail from the mezzotint by William Ward (1766-1826) after J.R. Smith of *Portrait of John Horne Tooke*

VAM 22068

The rich textures of the mezzotint are dependent on the delicate curls of metal which are thrown up as the rocker pits the plate as well as on the hollows themselves, and these quickly wear. For this reason Valentine Green declared in the conditions of sale of his 'Dusseldorf Gallery' that proofs of the mezzotints would be limited to fifty impressions and sold at double the price[1]. Ward took this approach a step further with his declaration that the impression was one of the first fifty to be printed from the plate.
Lit: J.Frankau, *William Ward A.R.A., and James Ward, R.A.*, 1904, 297.

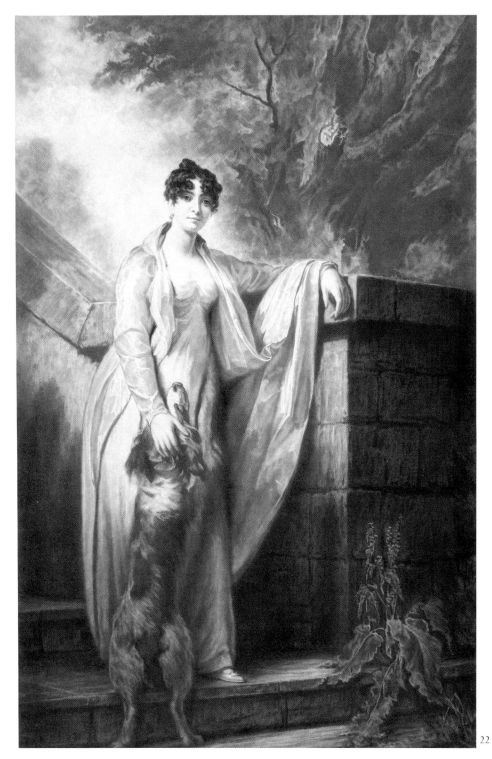

22

HENRY MACBETH-RAEBURN (1860-1947) AFTER
RAEBURN

Portrait of Mrs Finlay. c.1920

Signed in pencil *H.Macbeth-Raeburn Sct.* and inscribed
proof in progress.
Mezzotint, printed in colours from a single plate.
66.3 x 40.2
VAM E.3590-1932

Macbeth-Raeburn was a member of the Royal Ac-
ademy and of the Royal Society of Painter-Etchers
and Engravers although most of his prints reprodu-
ced paintings by 18th century artists. Once photo-
mechanical techniques became the norm for repro-
ductions the use of a manual technique was itself
enough to give a print the status of an original and
the fact that it reproduced a painting in the same
technique as it would have been reproduced when it
was painted no doubt added to a sense of its auth-
enticty and brilliance. That the engraver's creative
process was considered of more interest than the
faithfulness of the reproduction to its original is
suggested by the fact that he chose to give this stage
proof to the Victoria and Albert Museum and that
the Museum was happy to acquire it. The painting is
now in the Scottish National Gallery, Edinburgh.

23

JACQUES VILLON (PSEUDONYM OF GASTON DUCHAMP)
(1875-1963) AFTER PICASSO

Saltimbanques au chien

Signed and dated in facsimile *Picasso 1905.* Lettered
Gravé par Jacques Villon 1922.
Etching, aquatint and mezzotint, printed in colour
from at least three plates. 60 x 43
VAM E.51-1937

Reproductive printmaking in techniques which had
come to be associated with original prints was much
practised in France. Between 1922 and 1930 Villon
made thirty-eight interpretative prints for the Gal-
lery Bernheim-Jeune after artists such as Manet,
Cézanne, Renoir, Léger, Modigliani and Utrillo.
These prints have always been much sought after by
collectors and an impression of this example fetched
£4950 at the London branch of Christie, Manson and
Wood's sale of Important and Contemporary Prints
on 2 July 1987. It was published in an edition of 200.
Lit: C.de Ginestet and C.Pouillon, *Jacques Villon; les
estampes et les illustrations. Catalogue raisonné,* Paris,
1979, E634.

22

24

EMILE SULPIS (1856-1934) AFTER BURNE-JONES

The Mill

Signed in pencil *Emil Sulpis*. Lettered *Copyright 1899 by Messrs. Arthur Tooth and Sons Publishers 5 & 6 Haymarket, London, 41 Boulevard des Capucines, Paris 299, Fifth Avenue New York & Messrs. Stiefbold & Co. Berlin: Printed by Messrs. A. Salmon & Ardail, A. Porcabeuf succr. Paris.* With the stamp of the Printsellers' Association *F X.*
Etching on simulated vellum. Cut to 24.4 x 52.5
VAM E.994-1971

The oil painting on which this image is based is in the Victoria and Albert Museum. The use of etching, the technique most widely used by artists for original expression before the distinction between original and reproductive work was an issue, co-opts this image to the status of an 'original' although it follows Burne-Jones's composition faithfully. The fact that the edition was limited to 250 so-called artist's proofs and 25 presentation impressions also emphasised the preciousness of the product. Every impression was printed on simulated vellum which added prestige both through its association with drawings of the Renaissance and exceptional im-

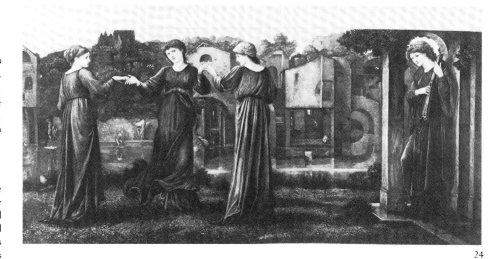

24

pressions of master prints, and through the more recent limitation of its use to documents of special significance. The letters in the Printsellers' Association stamp on the lefthand side are in a unique combination and provide proof of its status in the manner laid down in the Association's rules.

25

THE MEDICI SOCIETY AFTER L.S.LOWRY (1887-1976)

Berwick-upon-Tweed. Published in an edition of 650. 1973

Signed in pencil *L.S. Lowry*. Signed and dated in facsimile *L.S.Lowry 1938.* With the stamp of The Fine Art Trade Guild.
Colour collotype. 53.3 x 43.2
David McLean

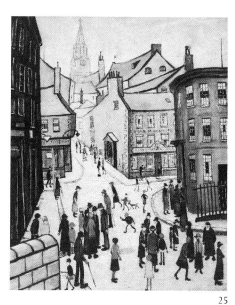

25

In 1910 The Fine Art Trade Guild, with which this reproduction was registered, was founded as an off-shoot of the Printsellers' Association and is today in its own words 'accepted... worldwide as the non-profit making body which authenticates Limited Editions of reproductions signed by the artist's own hand'[11]. The word 'authenticate', linked in the modern art lover's mind with the genuine or original, cleverly suggests rather more than it can do, referring as it does to reproductions. But what a Guild Stamp accompanied by a unique combination of letters guarantees is that no other edition of that particular image has had the approval of the Guild

and that the edition does not exceed 850. As the Approval Committee may at their discretion ask to see the original for comparison with the reproduction it is likely also to guarantee a level of faithfulness which, given that they also control the quality of paper on which the reproduction is printed and the steadfastness of the inks used, is unlikely to suffer too badly the deterioration the passage of time can produce. This factor is of particular significance for this popular subject as the original is lost, being stolen from the Crane Kalman Gallery in 1975.
Lit: H.Donn, *The Illustrated Limited Editions of L.S.Lowry*, p.28.

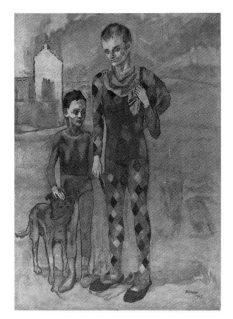

23

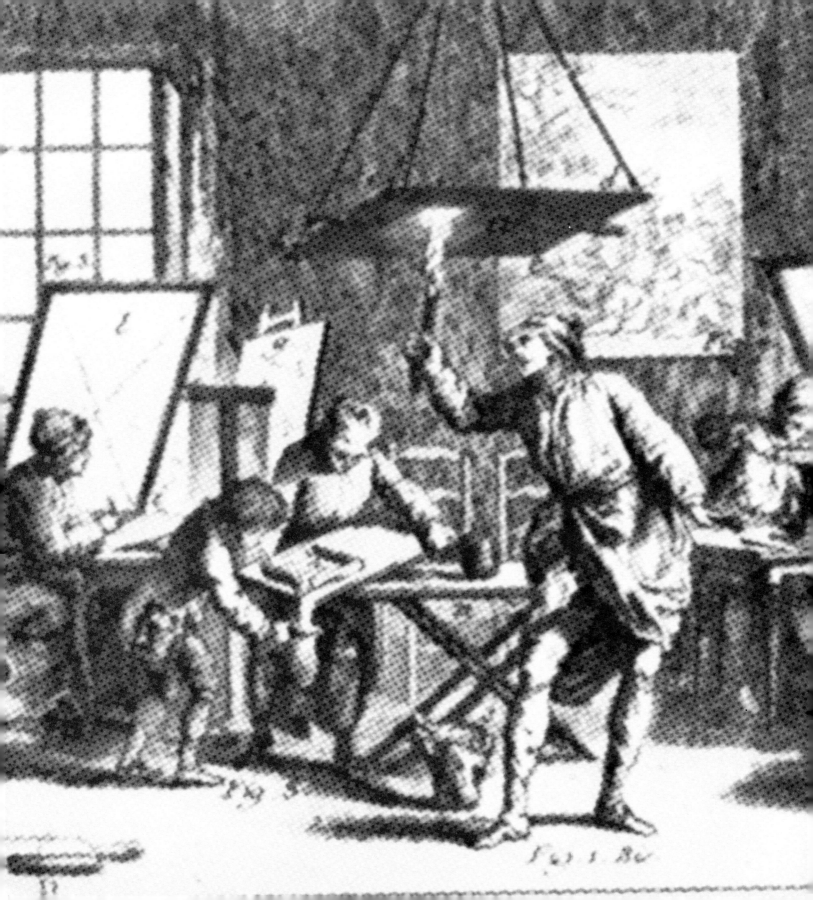

Chapter 2
Stages Involved in
Reproductive Printmaking

THE PRACTICAL ROLE OF THE ORIGINAL IMAGE AND THE USE OF SURROGATES

The first essential of a reproduction is a design to start from. This may or may not be the 'original'. There is evidence that engravers often had the actual original before them in the studio. Some engravers, like John Smith[1] (fig.31b), worked on occasion in the household of the artist whose paintings they reproduced and there is considerable correspondence, at least from the 18th century onwards, which indicates that engravers expected to refer to an original. Reynolds, for example, wrote to Countess Fitzwilliam asking for permission to have a print made after his portrait of her daughter, Lady Charlotte, explaining that the print could be 'finish'd while the picture is drying, so that it will not be detain'd on that account'[2] and Walpole wrote in a fit of pique against the mezzotinter of his portrait demanding the retrieval of the 'picture', the plate and all the impressions[3]. The introduction to the *Cabinet de Crozat* (fig.168) even claimed that engraved reproductions were superior to painted copies because the latter were usually mediocre, themselves frequently made from copies, whereas engravings were always made from the originals.[4] Some reproductions, like for example the *Recueil Jullienne* in its 1734 propectus, were advertised as engraved directly from the original[5] and Jullienne offered to authenticate each copy with his signature to certify the fact. Such claims may prove nothing about specific instances but they do show what was considered desirable.

It was not, however, always practicable for engravings to be made from the originals. In fact engravers frequently worked from other engravings (figs.27,28). Indeed a run-of-the-mill account of the *Art of Engraving* published in England in 1747 chose a print as the subject in the explanation of how to transfer the image to the plate[6]. If, however, an engraver wished to have the kudos of working from originals, painted copies made especially for the project were usually deemed to provide close enough contact with the original. When, for example, the English engraver Valentine Green, was granted exclusive rights to the reproduction of the paintings assembled at Dusseldorf by generations of the Electors Palatine, his first step was to despatch artists to make copies of the originals and he was sufficiently proud of the results to exhibit them in the Great Rooms at Spring Gardens, the venue of the

26

26

An Engraver's workshop. Detail from illustration by Robert Bénard to 'Gravure' from volume 9 of the plates to Diderot's *Encyclopédie, ou Dictionnaire raisonné des sciences, des arts, et des métiers,* **1771**

VAM, National Art Library

The image shows an engraver's studio in which the various activities involved in producing a print are being enacted. The three basic groups show different stages in the process. That on the right shows the plate itself in preparation. That in the centre shows the etching process with in its midst, the etcher, his needle poised, glancing across at the original on the easel. The single figure to the left, also seated before an easel uses a burin to put the finishing touches to another plate. The translucent frames diffuse the light from the windows evenly over the work areas.

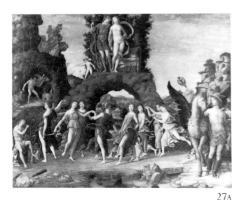

27A

27A
ANDREA MANTEGNA (1431-1506)

Parnassus. c.1497

Tempera on canvas. 150 x 192
Musée du Louvre, Paris

Society of Artists' exhibitions, in 1793 along with fourteen of the mezzotints engraved from them. Some paintings could not be moved. By the early 19th century the palazzi and churches of Italy must have been overflowing with droves of copyists busily supplying images for the worthy French, English and German publications on Italian art which abounded. The fact that before the availability of photography all reproduction required of necessity the manual copying of the image on to the printing surface meant that, while the use of copies as the source for the image introduced more opportunity for inaccuracies to creep in, it did not disrupt the continuity of process from first realisation to the last.

Photography, by contrast, changes the basic nature of the image as the product of someone's hand. Now when a reproduction is disappointing the reason is often that the photographs or colour transparencies, which frequently provide platemakers and printers with their working master of the image, are inadequate. The camera is not as sensitive to tonal nuance as the eye and is likely to have taken in some of the hues reflected into the original's surface by its setting. The transparency manufacturers' emulsions also have inherent limitations which respond to certain hues very inaccurately. Even the best colour transparencies deteriorate as time passes but they are, nevertheless, used again and again.

COPIES AS AN AID TO REPRODUCTION

In addition to copies made to supply the image, copies were made also to assist the engraving process. Most reproductions are considerably smaller than their originals. The creation of a copy scaled down to the size of the plate to be engraved separated the difficult task of reduction from the process of engraving. Moreover, the translation of the pictorial value of colour into differing tonal values in monochrome at this stage left the engraver freer to concentrate on achieving those shades by the disposition of the marks dictated by his chosen technique. Such copies were usually made by specially commissioned draughtsmen, frequently credited in the lettering on the prints, or by someone in the engraver's or painter's studio, perhaps the engraver himself. In rare instances they show too the participation of the original artist (figs.29-33). In the early years of colour photography, the copy still had its place: painted copies provided printers at home, who never saw the original, with a proxy against which to check and modify the colour modelling of the monotone separations made by the camera from the original (fig.30c).

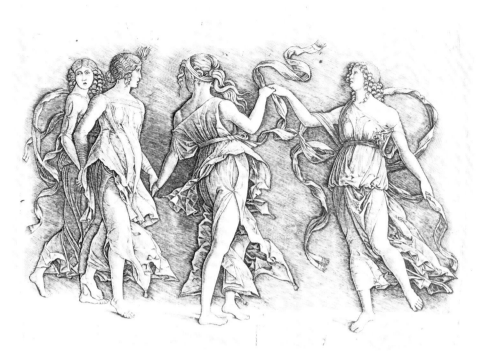

ATTRIBUTED TO ZOAN ANDREA (ACTIVE BY 1475-P.1518) AFTER MANTEGNA

Four women dancing. c.1497

Engraving. 25 x 34
Fitzwilliam Museum, Cambridge

This print reproduces in reverse four of the dancing nymphs from Mantegna's painting of the *Parnassus*. The figures have been removed from their background and show variations in pose which suggest that the engraver worked from a preparatory drawing which presented the composition at an earlier stage of development rather than from the completed painting. Certainly the use as a model of monochrome drawings on paper, which employed a similar formal language to line engraving, would have presented the engraver fewer problems of translation than a large painting employing a wide range of tones and colours.

Lit: Hind (General) 1 p.27, 21; Levenson, Oberhuber, Sheehan (General) 85; Levenson (General) p.69.

27B

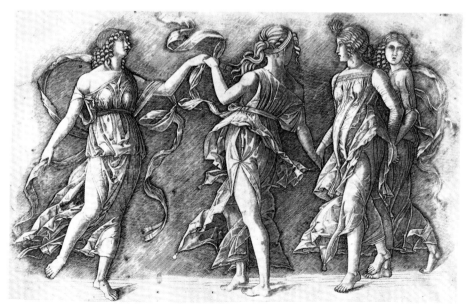

27C

ATTRIBUTED TO GIOVANNI ANTONIO DA BRESCIA (ACTIVE C.1490-P.1525) AFTER MANTEGNA

Four women dancing

Engraving. 21.7 x 33.9
The Trustees of the British Museum

Giovanni Antonio da Brescia is thought to have spent his early years in the circle of Mantegna and there is evidence that there was personal contact between them. Nevertheless the bulk of his Mantegnesque prints appear to be based on other engravings. That this is the case with this example is suggested by its resemblance to Zoan Andrea's engraving not only in design but even in the background hatchings: copied in the same sense on to the plate, they are printed in reverse.

Lit: Hind (General) 1 p.27,21a.

27C

28A

NICOLAS POUSSIN (1594-1665)

Ordination. From the first series of
Sacraments. **Before 1642, probably c.1636-7**

Oil on canvas. 95.5. x 121
The Duke of Rutland

28B

NICOLAS POUSSIN (1594-1665)

Ordination. From the second series of
Sacraments. **1647**

Oil on canvas. 117 x 178
The Duke of Sutherland Collection, on loan to Nat-
ional Gallery of Scotland

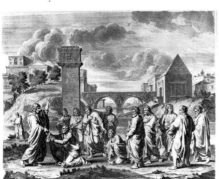

28D

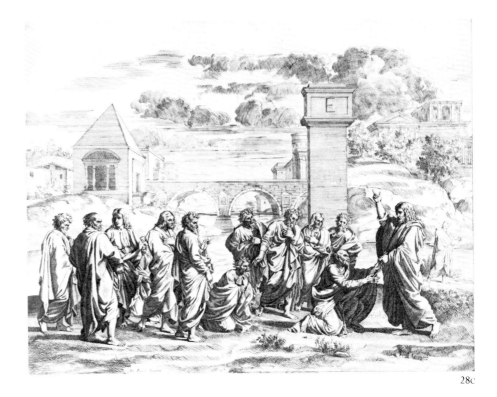

28C

28C

JEAN DUGHET (1619-1679) AFTER POUSSIN

Ordination. Plate 6 from a set of 7 after the
Sacraments , **c.1657-1666**

Lettered *Nic. Poussin Inuentor.*
Engraving and etching. Cut to 51.7 x 66.1
The Trustees of the British Museum

This image combines the foreground of the subject
from the first series with the background from the
second, both in reverse of the original paintings.
Poussin did not encourage the production of prints
after his work. Whether exceptionally he took the
opportunity of this set of reproductions, engraved by
his brother-in-law[1], to try out a conflation of the two
images is not known. What is clear, however, is that
engravings which show this version were not based
directly on either of the original paintings.
Lit: Andresen (Poussin) 251; Wildenstein (Poussin)
95.

28D

LOUIS DE CHÂTILLON (1639-1734) AFTER POUSSIN

Sacramentis Ordinis

Lettered with title and *N.Poussin In. Sacramentum Ord-
inis L. de Chastillon. Scul. N. de Poilly ex. cum. pri. Regis.*

Etching 151.8 x 66.6
The Witt Library, London

Lit: Andresen (Poussin) 258.

28E

CHARLES PIERRE JOSEPH NORMAND (1756-1840)
AFTER POUSSIN

L'Ordre.

Lettered *Poussin pinxit. Normand fils sc.*
Etching. Image 11.1 x 15.7
The Witt Library, London

Two examples of prints of this composition which
apparently reproduce a painting by Poussin but, in
fact, reproduce a composition which only exists in
printed form.

40

29A

ANDREA MANTEGNA (1431-1506)

Saint Sebastian

Signed in Greek letters: *To ergon tou Andreou.*
Oil on panel. 68 x 30
Kunsthistorisches Museum, Vienna

29B

DAVID TENIERS THE YOUNGER (1610-1690) AFTER
MANTEGNA

Saint Sebastian

Oil on panel. 22.9 x 16.7
The Courtauld Institute Galleries, London (Princes
Gate Collection)

David Teniers, custodian of the collection of Arch-
duke Leopold Wilhelm of Austria, Governor of the
Netherlands from 1647-56, made small copies of the
Italian paintings in his care as the first step to their
publication as engravings. They reduced the image
to the desired size and provided the engravers with
easily transported models. Inaccuracies inevitably
occurred. In this case the copy is less elongated than
the original and omits the horse and rider in the
cloud in the sky.
Lit: Courtauld Institute Galleries, *The Princes Gate
Collection,* 1981, 94.

29C

JAN VAN TROYEN (WORKED 1650-1660)) AFTER
TENIERS AFTER MANTEGNA

**Saint Sebastian. Plate from *Le Théâtre des
Peintures de David Teniers, natif d'Anvers, peintre,
et ayde de chambre des serenissimes Princes
Leopolde Guil.Archduc, & Don Jean d'Autriche:
Auqel sont representez les desseins tracés de sa
main, & gravés en cuivre par ses soins, sur les
Originaux Italiens, que le serme. Archiduc à
assemblé en son cabinet de la cour de Brusselles,
Brussels, privately printed and sold in
Antwerp by Henry Aertssens, 1660***

Lettered *A.Montani p. 5 Alta. 3 Lata. I.Troyen S.*
Etching. 22.9 x 16.3
VAM, National Art Library

The print, like all those in the *Théâtre*, is in reverse of
its original. It follows Teniers's copy in all its reduced
detail and inaccuracy suggesting that the engraver, in
spite of appending the dimensions of the original
painting, did not work from it.
Lit: Lloyd and Ledger (General) 27.

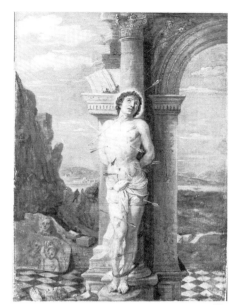

29B

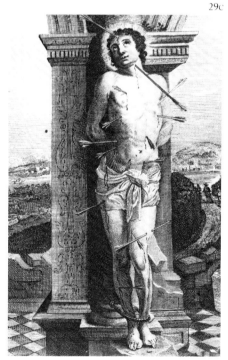

29C

29A

28E

41

30A

30A

CESARI MARIANNECCI AFTER ANDREA DEL SARTO

Madonna del Sacco, SS.Annunziata, Florence. Copied 1861

Watercolour and bodycolour. 31.2 x 61.5
VAM 4591

30B

CESARI MARIANNECCI AFTER ANDREA DEL SARTO

Madonna del Sacco. Published by the Arundel Society, 1862

With a label on the back lettered with title and *From the fresco by Andrea del Sarto, in the Cloister of the Annunziata at Florence. Chromolitho by Storch & Kramer under the direction of Professor L.Gruner Arundel Society.*
Colour lithograph. 31.3 x 63.4
VAM 19534

Mariannecci's copy provided the lithographers with a model which was in its turn copied on to the lithographer's key stone, from which areas for printing in each colour were selected out and again copied on to different stones, a separate stone for each colour. Inevitably the interpretation became modified; the faces bear subtly different expressions and the proportions of the Christ Child's legs are altered. But given the number of times the image was copied and transferred from surface to surface it is perhaps more remarkable that the lithograph did not differ more radically from its model.
Lit: Maynard (Arundel Society) p.24; Johnson (Arundel Society) p.36.

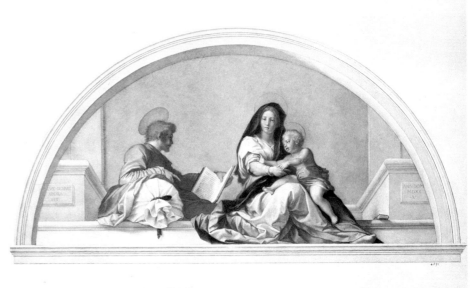

30B

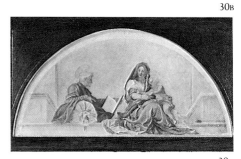

30C

30D

30C

ANONYMOUS COPYIST AFTER ANDREA DEL SARTO

Madonna del Sacco

Oil on canvas. 52 x 64.8
The Medici Society Ltd

Photography did not render the copyists redundant. The painted copy provided the reproduction studio at home with a coloured pattern against which actually to retouch the separation negatives before the making of the printing plates. It is interesting to note how differently this copyist transcribed the colours compared with the artist of the Arundel copy, executed some fifty years earlier.

30D

THE MEDICI SOCIETY AFTER ANDREA DEL SARTO

Madonna del Sacco. Published as no. 93 in the Italian Series, 1915. In a Medici frame

With the mark of the Medici Society
Colour collotype. Sight size 31.2 x 65
Private Collection

The crack splitting off to the right from the vertical crack running down from the top of the image was a 'special mark ' (see fig.148) added by the Medici Society to enable it to identify the reproduction of its reproductions without authority.

31A

GODFREY KNELLER (1646 OR 49-1723)

Grinling Gibbons (1648-1720). c.1690

Oil on canvas. 122 x 99
The Hermitage Museum, Leningrad

31B

ATTRIBUTED TO JOHN SMITH (C.1652-1742) AFTER
KNELLER

Engraver's model for *Grinling Gibbons*

Inscribed in ink by a later hand *Grinling Gibbons. Arch-
itect. Drawing By Kneller.*
Grey wash. 27.3 x 23
VAM E.166-1937

31C

JOHN SMITH (C.1652-1742) AFTER SIR GODFREY
KNELLER

Grinling Gibbons. First state. c.1690

Lettered *G.Kneller pinx Mr Grinlin Gibbons I smith fe: &
exc:.*
Mezzotint. 34.5 x 26.1
VAM 21867

The drawing translates Kneller's painting into shades
of grey and reduces it to the size of the copper plate.
There is, however, far greater detail in the mezzotint
like in the tresses of the sculpted head, which cor-
responds to that in the painting, showing that Smith
must have referred to the original also as he worked.
The mezzotint is in reverse of the original, somewhat
surprisingly in this case, for the result is that the
carver holds his compasses in his left hand.
Lit: Chaloner Smith (General) 105.

31A

31B

31C

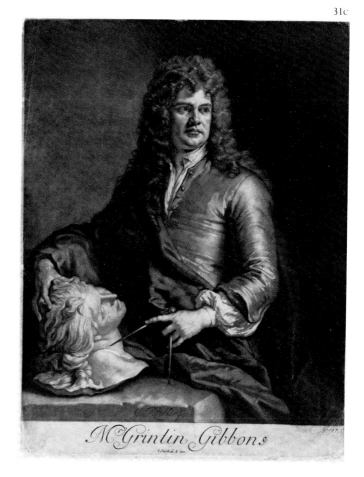

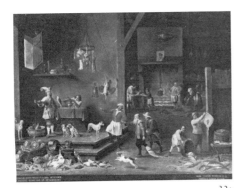

32A

DAVID TENIERS THE YOUNGER (1610-1690)

The Kitchen. 1646

Oil on canvas. 310 x 424
The Hermitage, Leningrad

32B

PROBABLY BY JOSEPH FARINGTON (1747-1821) AFTER
TENIERS

Engraver's model for *Teniers's Kitchen*

Wash, heightened with white. 22 x 42.5
VAM E.1052-1966

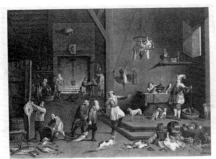

32C

33A

PETER PAUL RUBENS (1577-1640)

**The *Coup de Lance*. Painted for the high-altar
of the Church of the Récollets, Antwerp.
Installed 1620**

Oil on panel. 424 x 310
The Royal Museum, Antwerp

32C

JEAN BAPTISTE MICHEL (1748-1804) AFTER TENIERS

Teniers's Kitchen

Lettered with title and *In the Common Parlour at
Houghton. Size of the Picture f 5 I 6 3/4 by F 7 I 3/4 in
length Published July 1st 1777 by John Boydell Engraver in
Cheapside London. Teniers Pinxit. J.Farington delint.
J.B.Michel Sculpsit. John Boydell excudit 1777.* and with
the Walpole arms.
Etching and engraving. Cut to 47.8 x 61
VAM 21309

The print reproduces the original in reverse. The
poor state of the drawing reflects its working role in
the studio. It is one of a series of intermediary
drawings which Farington supplied for Boydell's
Gallery at Houghton Hall. Again the concentration on
the tonality of the original at the expense of its detail
suggests that the engraver was able to refer also to
the original, which was acquired like so many
Houghton pictures by Catherine II, Empress of
Russia, in 1779.

33B

PETER PAUL RUBENS (1577-1640)

**A preparatory *modello* for the *Coup de Lance*,
c.1619**

Oil on panel. 64.8 x 49.9
VAM, on permanent loan to the National Gallery,
London

Rubens oversaw the production of prints after his
paintings and sometimes seems to have used the
making of a print as an opportunity to reconsider
ideas tried out in sketch but rejected in the final
painting. The treatment of Christ's loincloth flap-
ping free and the representation of the figure on the
ladder, bare-headed rather than helmeted, differ
from the finished painting but re-appear in the print
after it.

33C

STUDIO OF PETER PAUL RUBENS (1577-1640)

Engraver's model for the *Coup de Lance*

Black chalk, grey and brown washes and grey body-
colour. The outlines indented for transfer. 60.3 x
43.2
The Trustees of the British Museum

The mechanical work of copying was done by an
assistant but the heightening in bodycolour was app-
lied by Rubens himself. As well as clarifying details,
Rubens paid particular attention to providing the

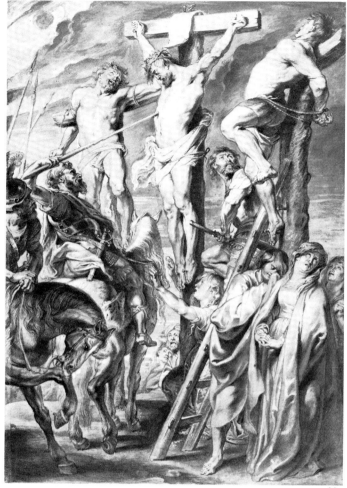

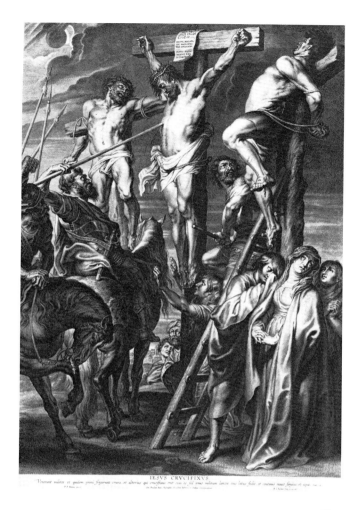

33C

33D

correct balance of light and shade. The drawing includes the differences noted between the completed altar-piece and the *modello* and introduces two other substantial alterations: the mounted soldier now thrusts the spear into Christ rather than throwing it with an easy under-arm action and the soldier on the ladder, in the act of breaking the legs of the thief, strikes with his left rather than his right arm. An additional spear has also been added on the left. Rubens's work on the copy suggests that these alterations met with his approval. Of a drawing serving a similar purpose Mariette commented 'It was done in black chalk by one of Rubens' disciples, and the great master contented himself with adding a few lines with pen and ink in the heads. This would have been a priceless piece if he had continued the same kind of

work across the whole design, for he was going in great style'[1]. This example graced the distinguished collections of both Pierre Crozat and Sir Thomas Lawrence.

Lit: Rowlands (Rubens) 162.

33D

BOETIUS A BOLSWERT (C.1580-1633) AFTER RUBENS

The Coup de Lance. State before the addition of the date 1631[1]

Lettered *Iesus Crucifixus. Venerunt milites: et quidem primi fregerunt crura, et alterius qui crucifixus erat cum eo. Sed unus militum lancea eius latus fodit, et continuo exiuit sanguis et aqua. Ioan.19. P.P.Rubens pinxit. Cum Privilegiis*

Regis Chrissianissimi, Serenissima Infantis, et Ordinum Confederatorum. B.à Bolswert Sculp. et excudit.
Engraving. 60.5 x 42.8
VAM Dyce 2214

The engraving, in the same sense as the original, follows the composition and the tonality of the drawn guide closely. The composition in this guise has had much currency. A later impression was used in the royal *Recueil d'estampes, d'après les plus beaux tableaux de Pierre Paul Rubens, Antoine van Dyck, Jacques Jourdaens et autres...*, published in 1759 and the painting was represented by a photographically based reproduction of the print in such a relatively recent work as Rooses' five volume catalogue of Rubens's paintings and drawings, issued from 1886 to '92.

Lit: Schneevoogt (Rubens) 48.

45

34A

A squaring frame. Detail from an illustration by Robert Bénard to 'Dessein' from volume 8 of the plates to Diderot's *Encyclopédie, ou Dictionnaire raisonné des sciences, des arts, et des métiers*, 1771

VAM, National Art Library

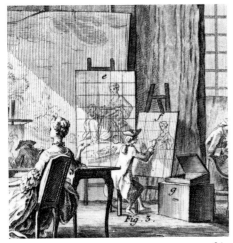

34B

An artist painting a reduced copy using the squaring method of reduction to guide him. Detail from an illustration by Robert Bénard to 'Peinture' from volume 8 of the plates to Diderot's *Encyclopédie, ou Dictionnaire raisonné des sciences, des arts, et des métiers*, 1771

VAM, National Art Library

A number of methods have been advocated to aid the reduction process and in particular to ensure that the image retains its correct internal proportions. Among the most used appears to have been the procedure of squaring (fig. 34), by which areas of the original composition could be identified and copied in a different size and in a proper relation to the whole. T.H. Fielding described a number of permutations of the process in *The Art of Engraving* published in 1841: 'When the picture is larger than the plate on which you intend to copy it, take a pair of compasses and divide the top and bottom into an equal number of parts, marking each part on the edge of the picture with a pencil or chalk; then with the compasses in the same position measure off along the sides of the picture, beginning at the bottom, as many parts as the side will contain, so that the remainder or fraction of a square, if any, may be at the top; for it seldom happens that the same measure, which equally divides the top and bottom of a picture, will also divide the sides, and it is better that the picture be marked out into perfect squares, leaving only a line of imperfect squares along the top, than is usually recommended, by dividing the sides equally as well as the top and bottom, cut the picture into a set of long squares. You can now, if an oil painting, draw lines with a black water colour, which is easily cleaned off afterwards by a spunge, if the picture be light, or white water colours, if dark: or if the subject be a painting in water colours, wrap round it threads from top to bottom, and from side to side; take a piece of smooth writing paper the size of the intended subject (which must always be much less than the plate, as to leave at least an inch or more of margin all round) and divide it with a pen and a pale tint of lake or vermilion into exactly the same number of squares as the picture; then with an F, HB or B pencil, copy whatever is in each square of the picture into the corresponding square on your paper, and to prevent mistakes number the squares both on the painting and the paper.'[7]

In addition, there were, as C.N. Cochin reported in his 1745 edition of Bosse's *De la Manière de Graver à l'Eau Forte et au Burin…*, many inventions which allowed the mechanical copying of a design on the same or a reduced or enlarged scale. Proportional compasses, which give a guide to the scaled dimensions, have a long history. Examples with fixed ratio were even found at Pompeii. The first instrument actually to help with the drawing, however, was the pantograph (fig. 35) known in its early years as a parallelogram. Apparently discovered early in the 17th century by a painter called Georgius, who claimed it had been disclosed to him 'by no human effort, but rather by some celestial genius'[8], the invention was published by Christoph Scheiner in *Pantographice, Seu Ars Delineandi re quaslibet per parallelogrammum lineare seu cavum mechanicum mobile libellis duobus explicata…* in Rome in 1631. It was to a development of this instrument, nicknamed 'le singe' because of its ability to draw out all sorts of paintings and drawings, which Cochin cites specifically with the claim that it was used with success by those who knew nothing of drawing[9]. The eidograph invented in 1821 worked on similar principles as the pantograph except that the intro-

duction of a central pivot in place of the sets of small wheels gave it greater freedom of movement with the result that it was easier to use and liable to give more accurate results. The instrument could also be used to transfer an image directly to the plate without an intermediate paper stage. William Wallace, professor of mathematics in the University of Edinburgh, announced in a paper read in 1831 'The instrument is applicable to the copying and reducing of very nice works of design; for example, the lineaments of a portrait. Indeed, it has actually been applied to the tracing reductions of a subject, of various sizes, on an etching ground on copper, and the process afterwards completed by an acid in the usual way, and impressions printed from the plate.'[10] Wallace claimed to have been assured by an engraver that it reduced by three-quarters the time used by methods employed to do the same job before its invention. But these devices were the invention of mathematicians and how much they were really used by engravers is questionable. Cochin's reference, made two years after the publication of improvements to the pantograph,[11] may have had as much symbolic as practical value. For the association of engraving with a mathematical instrument linked in theory if not in practice to the exactness and certainty of geometry allowed engraving to be perceived as progressive and increasingly precise.[12]

The invention of Dr Wollaston's Camera Lucida (fig.36) in 1806 provided the market with an instrument based on a new principle which used the refraction of light through a prism to cast an image on the sheet. The camera lucida was a development of the camera obscura. The latter, used since the Middle Ages, consisted originally of a dark room in which an image of the world outside was allowed to enter through a tiny hole in one wall and fall upon a surface, so that it could be copied or traced. A portable version consisting of a box with a lens, mirror (the image in a camera obscura is normally inverted) and ground-glass screen, from which the image could be drawn, was invented in the 17th century. The feature of the camera lucida which made it of particular use to copyists was that it is much more portable and can even be clamped to the drawing board. The user looks through the prism to find the reduced image on the paper below in such a way that he can follow the outlines of the image with his pencil. This invention was advocated particularly as an aid to the rendering of perpsective but the prospectus for one model advertised among its achievements that 'Paintings, prints, maps, the patterns used in various trades, &c. may be copied, reduced or enlarged with the greatest ease and accuracy,'[13] showing that some manufacturers looked for a wider market. Cornelis Varley's Graphic Telescope patented in 1811 was a somewhat similar invention which provided not only a transparent image on the sheet, the size of which could be altered by the use of eye-pieces and objectives of different magnification or reduction, but, by the omission of a mirror within the telescope, a reversed one.

The reducing function was, according to William Henry Fox Talbot, one of the important advantages which photography offered to the printmaker. The commentary on a 'Copy of a lithographic print' in the *Pencil of Nature*, published in 1844, stated 'All kinds of engravings may be copied by photographic means; and this app-

35A

Dessein, Pantographe. Illustration by Robert Bénard from volume 8 of the plates to Diderot's *Encyclopédie, ou Dictionnaire raisonné des sciences, des arts, et des métiers,* **1771**

VAM, National Art Library

The instrument can be reset with the fixed point (in this example on the left) between the drawing and tracing points so that a reversed as well as reduced image is achieved.

35B

Diagram from the instructions accompanying a Camera Lucida

Iain Bain

36

WILLIAM SHARP (1749-1824) AFTER FUSELI

The Three Witches. Scene from _Macbeth_

Inscribed _Fuseli Macbeth_ and with numbers round
each squared-up edge.
Pencil on tracing paper. 29.1 x 22.9
The Trustees of the British Museum

lication of the art is a very important one, not only as producing in general nearly fac-simile copies, but because it enables us at pleasure to alter the scale, and to make copies as much larger or smaller than the originals as we may desire. The old method of altering the size of a design by means of a pantograph or some similar contrivance, was very tedious, and must have required the instrument to be well constructed and kept in very excellent order: whereas the photographic copies become larger or smaller, merely by placing the originals nearer to or farther from the Camera.' In contemporary reproduction the place of the camera in this task is increasingly supplanted by the scanner.

TRANSFER AND REVERSAL TECHNIQUES

The transfer of the image to the plate could equally be done by the squaring method. If the drawn copy was the same size as the plate there were however other more labour-saving methods available. Bosse, Cochin and Fielding[15] all run through the same options, indicating little change in procedure over two hundred years. A drawn copy of the correct dimensions or, if the reproduction was to be the same size as the original, a tracing of it, could be dampened on its back, placed face downwards on a suitably prepared plate and run through the press as if taking a counter proof. If a plate is worked in the same sense as an original, the result is a printed image in reverse. This procedure had the advantage that it reversed the image for the engraver so that it would print the same way round as the original. Other methods involved rubbing the back of the drawing or a tracing of it or an intermediate sheet with 'vermilion, chrome yellow, white lead, or any other light colour in impalpable powder till well covered.'[16] The prepared surface was then placed in such a relation to the plate that it would act as a carbon when the lines of the design were re-traced, sometimes leaving evidence of indentation along the outlines. Tracing paper, when it was used, could be placed either way round depending on whether it was desired to reverse the image.

As well as manipulating the transfer technique to reverse the image on the plate, engravers worked with mirrors (figs. 37,38). According to Cochin 'To engrave with a mirror ... the painting or drawing should be placed in front of the mirror, between you and the mirror so that its back is turned to you and it faces the mirror, then you will see it in the same sense as it is worked on the copper.'[17] The decision whether or not to reverse the image seems often to have been a fairly arbitrary one, guided more by a desire for the image to look right in its new form than any theoretical stance about the value of representing the original as accurately as possible. Cochin pointed out the need for figures to be presented right-handed and it was on that kind of correctness that a 1734 advertisement for two subjects from the _Recueil Jullienne_ in the _Mercure de France_ concentrated, boasting 'They are engraved in the same size as the original, and with the mirror, so that all the actions are the right way round as in the pictures'[18]. Nowadays the image is easily reversed by the camera or it can be offset, a process which transfers it from one cylinder to another, thereby reversing it in the printing process.

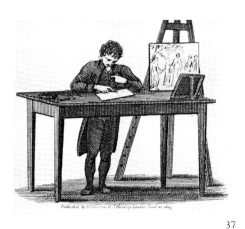

37

The Engraver. Illustration to *Jack of All Trades*, 1805

VAM, National Art Library

The engraver is shown engraving a reproduction of the picture placed on an easel beside him. He works from a reflection in the mirror, which corresponds in size to his plate.

38 38A

Lithographer's desk. Plate 1 from G.Engelmann, *Manuel du Dessinateur Lithographe*, Paris, 1822

VAM, National Art Library

This fold-out plate shows the 'original', a drawing of a right-handed swordsman, reflected in a mirror in the lid of the desk and drawn on the stone left-handed. The stone rests on a turn-table.

39A

GIOVANNI BATTISTA CIPRIANI (1727-1785)

Venus and Cupid. Design for a benefit ticket

Signed *J.B.Cipriani. del.*
Pen and ink and watercolour. 11 x 11
VAM 97-1892

39B

FRANCESCO BARTOLOZZI (1725-1815) AFTER G.B. CIPRIANI

For the Benefit of Mr Giardini

Lettered with title and *G B Cipriani inv. F.Bartolozzi sculp.*
Etching with stipple. Cut to 11.5 x 11.5
VAM 97a-1892

39C

GIOVANNI BATTISTA CIPRIANI (1727-1785)

Apollo, Mercury and a Muse. Design for a benefit ticket

Pen and ink and watercolour. Circular, diameter 11
VAM 97b-1892

39D

FRANCESCO BARTOLOZZI (1725-1815) AFTER G.B.CIPRIANI

Benefit of Mr Giardini

Lettered with title and *G.B.Cipriani inv F.Bartolozzi Sculp.*
Etching with stipple. Circular, cut to diameter 11
VAM 28964b

The reversal of the first but not of the second of these images highlights how arbitary was the attitude to direction.

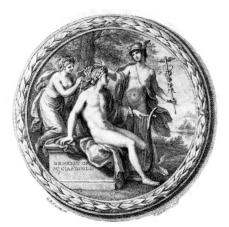

39C

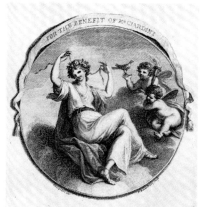

39D

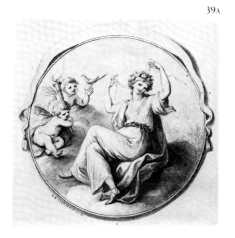

39A

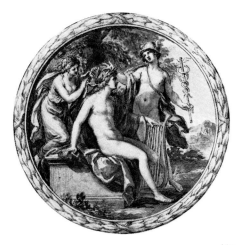

39B

40A

NICOLAS DE LARGILLIERRE (1656-1746)

Bardo Bardi Magalotti, Leiutenant-General and Governor of Valenciennes

Oil on canvas. 82 x 66
National Museum, Warsaw

Several replicas of this picture are known including one in the Bibliothèque Municipale, Valenciennes.

40B

There are three basic types of printing surfaces which have been commonly used for reproductive work: raised, sunken and flat. In the first category the ink is applied to raised surfaces, in the second it is held in grooves and hollows, and in the third, the surfaces are treated with grease and water so that the printer's ink is attracted to the greasy image and repelled by the water on the non-printing areas.

Whatever kind of surface or material was used, the image was always, before the introduction of photography, wrought by hand. The woodcutter cut away the unwanted wood from the block; the engraver pushed his burin through the metal plate or wood block; the mezzotinter scraped away the burr manually raised over the plate's surface; the etcher drew his needle through the wax ground laying bare the metal to the acid and the lithographer drew his design in grease on the stone or metal. If the image were to be printed in colour using separate printing surfaces, each one had to be made by hand and its shape had to be worked out by the human eye and brain to use to the maximum advantage the overprinting of a few coloured inks.

The invention of photography made it possible for much of this time-consuming work to be done quickly by chemical means although the layman might be surprised by how much artistry is still involved. The working image, either the original work of art or a black and white photograph or colour transparency of it, is photographed by the process camera to create a continuous tone negative. If the image is to be printed in colour, filters are successively applied to the lens to separate out the desired colours automatically, most often the three primaries, producing in such an example three continuous tone negatives. A blue filter produces the yellow tone, a red the blue, and green the red. In theory, colour reproduction should be successful with the use only of the three primaries but in practice a fourth printing in black is needed to render the shadows and the blacks of the original adequately, and to heighten the definition of the image. Different colours may be selected to reproduce an original of restricted colour range and additional colours can be required to achieve special effects; very strong or fluorescent colours are particularly difficult to convey through the three primaries. Whether negatives or positives, both made by printing the negatives on to sensitised film, are used to transfer the image photographically to the printing surface depends on which of the three categories of surface are required. Usually a screen, the fineness of which governs the size of the printed dots in the completed reproduction, is interposed either as the positive is made, or it is transferred in a separate operation directly onto the printing surface.

Since the late 1950s colour separation by electronic scanner has been developed. The light reflected off or projected through the working original, is split into the primary colours and converted into electrical impulses. White on the original produces a lot of impulses, and black, very few. The quality of the potential image at this stage is dependent on how densely the original is scanned. The impulses can be stored on a thin magnetically coated plastic disc and translated into a picture by

computer on demand. They can also be immediately and automatically processed to produce screened negatives or positives of the appropriate size, or they can be passed on to an electronically controlled engraving head capable of fashioning, in response to the impulses, the various types of conventional printing surface.

RETOUCHING

It can be argued that the traditional engraver retouched the plate as he altered it from state to state but the term has been given currency in connection with work related to photo-based printing plates and describes the process of making alterations to the negatives, positives and sometimes to the plates themselves by hand in response to personal judgements. Retouching is usually involved both before and after the plates have been made and is highly skilled work. Both the negatives and the positives are checked before going forward to the plate-maker. The dots on the positives can be reduced by the application of specially prepared acids if they seem too strong or strengthened by giving the negative the same treatment and making a new, corrected positive from it. If dense areas of flat colour are required, the relevant areas may be painted over with opaque paint. Before the surface is finally imposed, a print of the assembled positives or negatives can be made on sensitised paper for final checking and manual correction. Depending on the technique, the plates themselves may also be worked on by hand, to adjust contrast, to bring out detail and to remove imperfections. Scanners lessen the handwork necessary for they are fitted with tone and colour monitoring devices which check the signals against pre-set data at each stage. Controls enable the settings to be adjusted on demand. If work is required on some areas and not on others the positives and negatives produced by the scanner can also be worked on by hand, although their physical properties are such that they are less amenable to manual retouching than positives and negatives produced by the camera.

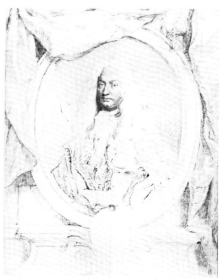

40c

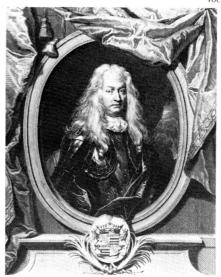

40D

40B

CORNELIS MARTINUS VERMEULEN (C.1644-1708/9) AFTER LARGILLIERRE

Bardo Bardi Magalotti (1630-1705). Unrecorded state

Inscribed in ink *M' de magaloti Vermeulen Sc.* Dry-point and engraving. Cut to 31.5 x 24 Musée du Petit Palais, Paris

This early proof shows the engravers' habit of sketching the design in with dry-point. The burr, clearly visible here, quickly wore away leaving little evidence of the practice in standard impressions.

40c

CORNELIS MARTINUS VERMEULEN (C.1644-1708/9) AFTER LARGILLIERRE

Bardo Bardi Magalotti (1630-1705)

Counter proof from early state with black chalk. Cut to 45.8 x 34.7 Musée du Petit Palais, Paris

The border, designed especially for the engraving of the portrait, is worked out in chalk on a counterproof of an early state of the print. This procedure provided the engraver with a pattern which corresponded in direction to the image as he engraved the copper but in reverse of the print.

40D

CORNELIS MARTINUS VERMEULEN (C.1644-1708/9) AFTER LARGILLIERRE

Bardo Bardi Magalotti (1630-1705). Second state

Lettered with name of sitter etc and *De Largillierre pinxit C.Vermeulen sculpsit et ex. 1693.* Engraving. Cut to 47.6 x 35 VAM E.3683-1960

The completed print, in reverse of the oil painting. Lit: Didot 2393; Rosenfeld p.33.

51

41A

41A
EDWIN HENRY LANDSEER (1802–1873)

The Highland Drovers: Scene in the Grampians

Oil on canvas.125.7 x 191.1
VAM FA 88

41B
JAMES HENRY WATT (1799–1867) AFTER LANDSEER

The Highland Drovers: Scene in the Grampians

Lettered with title and *Etched by J.H.Watt Jany. 1838. E.Landseer R.A. London Published May 5 1838 by H Graves, printseller by Special Appointment to her Majesty 6 Pall Mall.*
Etching and engraving. 66 x 89
VAM 18567
Lit: Beck (General) 21; Dyson (Landseer) pp. 39-40.

41B

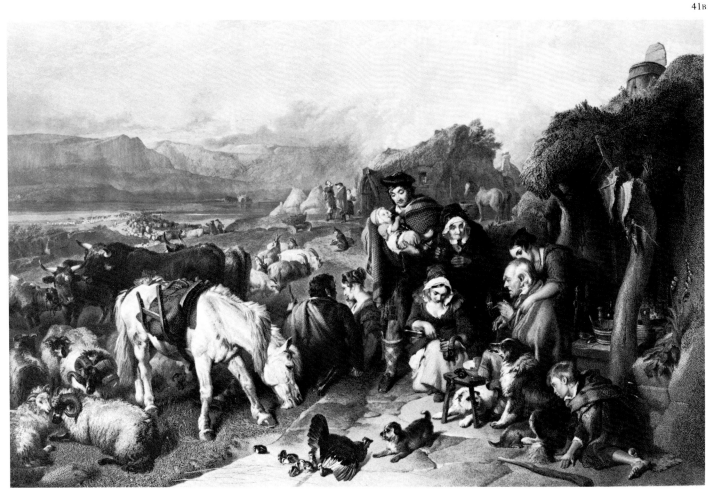

52

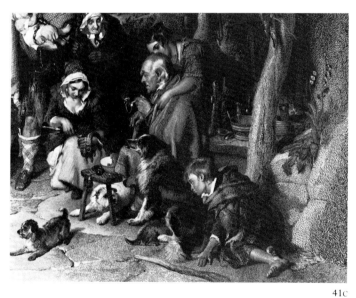

41C

41D *See colour plate II*

41C

The same detail from four trial proofs of different states of the print showing how the image was built up

VAM 18562,3,5,7

Colour separations from *The Highland Drovers: Scene in the Grampians* after Landseer

These illustrations show the four continuous tone separations into which modern four colour printing methods break down a painting before it is reassembled, with the four images printed one on top of the other, into a full-colour reproduction. Plates are proofed on presses which print a single, or sometimes two colours at a time, and each proof is inspected before the next colour or combination of colours is printed to see if corrections to subsequent plates are required. The colours are proofed in order of the quantity of ink being deposited on the sheet, the heaviest first, which usually results in the yellow plate being printed first, then the blue, then the red and finally the black. The tackiness of the ink in four colour press work means that better results are achieved if the order is reversed, the colour involving the least ink being printed first and that involving the most, last.

42

EDWARD GOODALL (1795-1870) AFTER TURNER

Prudoe Castle, Northumberland. Plate 2 of part 4 of *Picturesque views in England and Wales*, published by Robert Jennings, 1828

Inscribed in pencil by Turner *This part of sky wants clearness and this The whole of sky too much an etching [two illegible words] Would not some drypoint clear it and render it more quiet.* Lettered *Drawn by J M W Turner RA Etched by E.Goodall.*
Etching on India paper, with considerable pencil retouching. 25.7 x 30.2
VAM E.3014-1946

Although the elaborate drawings that Turner made for *Picturesque views in England and Wales* were based on existing sketches, they were made in the form from which the engraver worked especially for the reproductions. There are three more touched proofs in the British Museum. Together they illustrate how closely Turner supervised the engraving of his compositions. Indeed according to one who knew his circle it was frequently Turner who saw the way forward: 'When the plate gets well into progress, then comes the question of colour — a bit of bright orange, or scarlet, or blue; how shall it be rendered in black, or white, or gray? Turner knows; but the engraver dare not ask him until the plate is in such a condition as to require touching.'[III]
Lit: Rawlinson (Turner), 222.

42

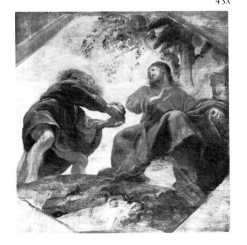

43A

43A

PETER PAUL RUBENS (1577-1640)

***Modello* for the *Temptation of Christ* on the ceiling of the Jesuit Church, Antwerp. 1620**

Oil on panel. 34 x 32
Courtauld Institute Galleries, London (Princes Gate Collection)

The contract[IV] between the Father Superior of the Church and Rubens stated that Rubens was 'to make with his own hand the design of all the aforesaid 39 paintings in small size' but that the ceiling paintings could be executed by his assistants and that he should either make an additional altar painting for a side chapel or give the 39 *modelli* to the Father Superior. Rubens chose to keep the *modelli* and thirteen years later used two of them as the basis for woodcuts.

43B

43B

CHRISTIAN BENJAMIN MÜLLER (1690-1758) AFTER RUBENS

The Temptation of Christ

Red chalk and grey wash. 19 x 30
The Antwerp Print Room

43D

43E

43C

43C

JOHANN JUSTIN PREISLER (1698-1771) AFTER MÜLLER
AFTER RUBENS

**The Temptation of Christ. Ceiling painting in
the Jesuit Church, Antwerp. Published in
Nuremburg, 1735**

Lettered *Non in solo pane uiuit homo, sed in omni uerbo,
quod procedit de ore Dei, Matth, IV.V.4. P.P.Rubens pinx.
JJ.Preissler Pictor Nor. f.* Numbered 4.
Etching. 20.9 x 22.5
VAM 12348.4

This pair are included as a record of the subject as
painted in the Jesuit Church. Müller made a com-
plete set of drawings after the Jesuit Church ceiling
cycle just six months before it was destroyed by fire
in 1718. The lack of finish of the drawings[v] and their
careful adjustment of outline point to them having
been made in the presence of the paintings. More-
over they follow the surviving *modelli* with sufficient
accuracy to suggest that the deviations in composi-
tion which are apparent were the result of changes
made as the *modelli* were transferred to the ceiling
rather than of a lack of conscientiousness on the part
of the copyist.[vi] The print follows the drawing care-
fully in composition but gives greater definition to
the forms. In Christ's head, the process of clarifica-
tion has led to the loss of the halo.
Lit: Martin (Rubens) 6.

43D & E

CHRISTOFFEL JEGHER (1596-1652/3) AFTER RUBENS

**The Temptation of Christ. After the modello
for the ceiling painting of the Jesuit Church,
Antwerp. Printed 1633**

Signed within the design *C.I.* Lettered *P.P.Rub. delin.
& exc. Cum Privilegis. Christoffel Jegher. Sc.*
Woodcuts: proof impression touched with white
heightening; published state. 32 x 42.6
VAM 15038

This print, in reverse of the original, is based on the
modello rather than the ceiling painting itself, for it
follows the modello in such details as the treatment
of Christ's face in three-quarter view and the abs-
ence of Satan's right foot on the foreground rock.
But the format of the composition is different and
many details have been added. A squirrel plays in the
elaborated oak tree and birds fly in the sky, Christ's
halo is very pronounced and the pine tree behind
Christ has been made more prominent and moved to
the other side of the composition. The white height-
ening on the proof instructs the woodcutter to ex-
tend the rays from Christ's halo. A proof in the Bib-
liothèque Nationale, Paris, shows considerable work
from Rubens's hand.
Lit: Myers (Rubens) p.16; Martin (Rubens) 6a.

44

44

Gravure en Lettre.
Illustration to 'Gravure' from volume 9 of the plates to Diderot's *Encyclopédie, ou Dictionnaire raisonné des sciences, des arts, et des métiers, 1771*

VAM, National Art Library

The lettering of this plate: *Aubin Scrip .et Sculp. Benard Dir.* indicates that it was engraved not like the others in this volume of the Encyclopaedia by Robert Bénard but by Aubin for the engraving of lettering was a specialist task. Letters were scratched on for proofing by the engravers but the plate was despatched to a professional letter engraver before the printing of the main edition. This plate shows some of the tools required and provides sample alphabets in reverse for copying.

PROOFING

Proofing is equally important for hand-crafted and photomechanical reproductions and proofs continue to be made in their thousands. Being essentially working documents most do not survive.

The old-fashioned engraver needed proofs as he worked in order to see how the composition was progressing and proof impressions were taken in particular between various identifiable stages of the work, for example after the initial etching (fig.41c). Proofs were required also as the image neared completion for comments from the client. Instructions on proofs take the form of both words and overpainting. The dialogue was most often between the engraver, printer and publisher. Particularly valued now, however, are the proofs which show collaboration between the engraver and the original artist (figs.42,45b) although engravers themselves were often trepidatious of such interference. James Ward wrote to his son on the subject in 1848: 'It makes me so afraid of little alterations, one little thing begets another, until the change is a new picture. I remember when a boy, how often this was the case with Sir Joshua Reynolds, to the annoyance of J.R.Smith and my brother.'[19]

Proofs of photographically produced colour reproductions are printed from each of the four plates and in combinations of the plates in order to show up individual and composite shortcomings. These progressive proofs are worked over by the printer and the publisher and marked with precise indications (fig.48), some of which will require a further contribution from the hand-retoucher and may require the production of substitute plates. Other criticisms may call for a lighter or heavier flow of ink or even the addition of an extra colour printing. Before the days of four-colour presses, each separation of the final proof, approved by the client, was a vital working tool for the printer to match against at each stage of the printing. On the four-colour press the printer uses a final proof as a guide in order to ensure consistency within the edition, tuning the settings of the press throughout the run as necessary.

PRINTING

The very earliest prints, whatever their status, were printed either by hammering the inked printing surface face down on a sheet of paper or by rubbing the back of the sheet, placed face down on it, with a burnisher. Wooden platen presses, derived from wine and oil presses, which exerted vertical pressure on to a flat bed by means of a screw and lever arrangement were probably in use by the middle of the 15th century. They were used mainly for relief work. Roller presses which compressed a sliding printing bed between two rollers were introduced a little later and were used in preference to screw and lever presses for intaglio printing because of the extra pressure of which they were capable. On the introduction of lithography in 1798, lithographs were also printed on flat bed presses but the printing surface was cranked under a 'scraper' which applied the pressure necessary for printing. Once established, the technology of printing, dependent on human energy for its power,

45A

45B

evolved little until the 19th century which saw its transformation from a craft-based to a highly mechanised industry.

The first developments towards mechanisation involved relief presses and were aimed at the printing of texts such as newspapers rather than pictures. Letterpress machines, however, have subsequently been used widely for the printing of reproductions. Moreover, the development of the letterpress machine influenced the later development of offset litho and rotary gravure machines. Conspicuous among the early inventions were the Stanhope Press of 1800,[20] a flat-bed construction of iron instead of the traditional wood in which a system of compound levers replaced the screw method of exerting pressure, and Frederick Koenig's steam-driven cylinder press with automatic inking, which was installed at *The Times* in 1814. Experiments towards the rotary press in which the paper was passed between a cylindrical printing surface and an impression cylinder, an important feature of fast modern machines, were not successful until the 1860s when automatic paper feeders, essential for a high level of mechanisation, were also introduced.[21] The introduction during this century of presses which print four colours, one after the other, has further speeded-up the printing of colour reproductions.

Printing, at least by the time that Marcantonio was working in Rome, was a task of the professional: Vasari records that his plates went to Il Baviero di Carrocci

45A

JOHN CONSTABLE (1776-1837)

Salisbury Cathedral from the Meadows. Exhibited at the Royal Academy, 1831

Oil on canvas. 151.8 x 183.9
The Dowager Lady Ashton

45B

DAVID LUCAS (1802-1881) AFTER CONSTABLE

Salisbury Cathedral: large plate. Fifth progress proof. Published by Hodgson and Graves, 1837

Lettered *J.Constable R A D.Lucas.*
Mezzotint, touched by Constable with white chalk and wash. 61 x 71.1
VAM 1250-1888

Constable discussed the production of this print in twenty-four different letters to Lucas, the first dating from 1834, sometimes drawing explanatory sketches. At one point he exclaimed 'How I wish I could scratch & tear away at it with your tools on the steel — just as old Hicks wanted to fly up Langham Mill & tear the trees & hedges all up by the Roots — but we must do it. & your quiet way — is I well know the *best* and *only* way.'[VII] This proof is energetically scratched and touched with white chalk and wash to show the enlargement of the rainbow, and to emphasize the sparkling lights in the foreground and the disturbance of the water by the cart. Lit: Shirley 39.

46A & B
JOHN MARTIN (1789-1854)

Details from two impressions of *Joshua commanding the sun to stand still* after the oil painting of the same title of 1816, 1827

Mezzotint.
VAM E.538-1968 and E.573-1968

The first of these details is taken from an album of cuttings compiled by Martin himself and shows how rich an early impression could be. The second detail taken from an impression of acceptable, though lesser quality, demonstrates how texture and draughtsmanship disappear leaving the image weakened but with little visible evidence of deterioration. Lit: Balston, Appendix 8,6.

47

Sheet of eighteen postcards, uncut. Printed at The Roundwood Press, Kineton, Warwick and published by the Trustees of the Tate Gallery

Colour offset litho. Size of sheet 71.5 x 50
47 The Trustees of the Tate Gallery

for printing.[22] The licence granted to the 'Communauté' of copper-plate engraving printers in Paris in 1694 both confirms this and shows how the professionalisation of printing led on to censorship on the one hand and to restrictive trade practices on the other. The number of presses to be owned by each master printer was restricted to one and everyone other than syndics and masters of the company was prohibited from having presses except for engravers established in the Galleries of the Louvre and at the Gobelins and six engraver-members of the Academy. As rancour developed between the master printers and engravers the former listed among their complaints the separate activities of Pierre Crozat and Jean de Jullienne, 'men, powerful for their wealth and their reputation, who have no difficulty undertaking all' and the fact that many engravers including Audran, Coypel, Drevet and Cochin, who were permitted presses only on the condition that they restricted their use to their own engravings, printed anything anyone asked them to.[23] In 1734 the Conseil d'Etat upheld the engravers' position but the presses were of course still manned by trained operatives. Indeed, for plates worked in the more delicate techniques such as mezzotint it was essential, for a skilled printer could get from them far more prints before wear began to tell (fig.46).

Printing today is an even more specialised field. Traditional craft skills still have an important place but vital also is a wealth of complicated technical and chemical knowledge. For example, not only does the temperature and the humidity of the paper have to be fixed if a long run of colour plates is to print in register but even the environment in which the printing is done has to be closely controlled. The inks need to be carefully formulated to ensure reasonable lightfastness. Automation has not been achieved without at times the lowering of standards. If the electronic wizardry is not only to make more colour reproductions more quickly but to maximise their quality, it requires above all an experienced eye to evaluate the 'dot gain', the 'ink balance' and the "trapping' of wet on wet inks' and to correct the distorting effects of 'slurring' and 'doubling' among a multitude of other defects unknown in less sophisticated times. Modern printing technology has not only created a new formal language to translate the painter's vision but also its own vocabulary and argot.

Modern fully automated colour reproduction often leads to the printing of a variety of images with colour ranges as varied as say Whistler's muted *Nocturne in Blue and Gold: Old Battersea Bridge* and Warhol's strident *Marilyn Diptych* at one go. Inevitably the resulting reproductions are a compromise for the change in inking which could improve some of the images is likely to upset others.

58

46A 46B

48

48

AFTER DAVID HOCKNEY

Mr and Mrs Clark and Percy. Printed by The Hillingdon Press, Uxbridge and published by the Tate Gallery, London, 1977. Progress proof

Lettered with title etc. Inscribed in chalk and felt tip throughout with instructions to the printer.
Colour offset lithograph. Image 46 x 66
Tate Gallery Publications

A commercial reproduction today usually goes through several stages of proofing. The main comments for 'Re-proofing' on this first proof are:
Blue to be run basically same weight but no heavier
Yelo to be run very slightly heavier
Magenta to be run at same weight.
In addition many areas within the image are marked for detailed attention with an indication of how much more or less of each colour is required.

Chapter 3
The Medium

The engraver John Landseer, anguished by the inferior standing of engravers, declared in a series of lectures on the art of engraving in 1807 'Engraving is no more an art of copying painting, than the English language is an art of copying Greek or Latin. Engraving is a distinct language of Art: and though it may bear much resemblance to painting in the construction of its grammar, as grammars of languages bear to each other, yet its alphabet and idiom, or mode of expression, are totally different.'[1] An immense variety of techniques, capable of producing marks of very different character, have been devised for the reproduction of paintings. Yet however well or badly these marks capture the character of the original, the process of reproduction is always one of approximation achieved with different means. It cannot reproduce the physical constituents of the original, for if it did we would call it a copy. André Malraux pointed out how 'black and white photography tends to intensify the 'family likeness' between objects that have but a slight affinity.'[2] This phenomenon applies also in a wider context. The elision of an original's individuality into a common character is visible across the whole gamut of reproductive techniques, and the immense transformation the process of reproduction imposes on its object gives the most disparate reproductions something more in common with each other than they have with their originals.

LINE

Until the middle of the 18th century the reproduction of paintings involved almost exclusively techniques which relied on the manipulation of line. The ink was transferred onto the paper either from raised surfaces created by lowering the areas to remain blank, a technique most frequently encountered in the form of woodcuts, or more often from hollows created by the direct action of the engraver. The hollows were fashioned in two ways: by engraving and etching. Engraving entailed the use of specific tools to cut grooves into the printing surface, usually a copper plate. The cutting required strength as well as skill and the marks produced were characterised by a sharpness which reflected their cut origins. Etching entailed the action of acid on a line scratched through a protective ground laid on the plate. The lines could be drawn with more or less the same ease as any drawing instrument allowed. The grooves, bitten by acid where the plate had been laid bare, were more ragged along their edges than engraved lines, for the acid seeps beneath the ground and bites unevenly into the metal plate.

49

49

Sculpture, Mouleurs en Plâtre, Moules et Ouvrages

Illustration by Robert Bénard to 'Sculpture' from volume 9 of the plates to Diderot's *Encyclopédie, or Dictionnaire raisonné des sciences, des arts, et des métiers*, 1771
VAM, National Art Library

The reproduction of sculpture contrasts vividly with that of painting. A piece of sculpture, either modelled, carved or cast, sometimes made by one method preparatory to another, often raises complicated questions about its precise status as an original. But its reproduction involves the sculptor's technique of casting from moulds, resulting in a product which comes far closer in bulk and texture to whatever has been selected as the original than is possible when marks made by a brush on canvas are translated into printed marks on a sheet paper.

TIMOTHY COLE (1852-1931) AFTER BOTTICELLI

Head of Flora. See fig.64

50

50

ANONYMOUS AFTER FRA ANGELICO OR ANTONIAZZO
ROMANO

Adam and Eve

Illustration from *Meditationes reverendissimi patris
domini Johannis de Turre cremata sacrosanctae Romane
ecclesiae Cardinalis positae e depictae de ipsius mandato in
ecclesie ambitu sanctae Mariae de Minerva Romae*, 1467
Woodcut. 12 x 17
The British Library

Juan de Torquemada (1388-1468), a Dominican car-
dinal, played a leading part in the development of
printing in Italy. It was at his monastery, St Scholas-
tica at Subiaco, that in 1465 the earliest dated prin-
ted book was set in Italy[1]. His *Meditationes* of two
years later set more records. It was not only the ear-
liest Italian book to contain woodcut illustrations
but these illustrations, purporting to reproduce the
pictures which Torquemada had commissioned to
decorate Santa Maria sopra Minerva in Rome, were
the first set of printed reproductions of specific
works of art to be issued. The original frescoes were
destroyed at the end of the 16th century.
Lit: De Gregori, (General) pp.18-104; Donati, (Gen-
eral) pp.99-128; Lloyd and Ledger (General) 1.

The first printmaking technique was woodcut. The earliest examples show a
reliance on outline for the depiction of form similar to that found in contemporary
manuscript illustrations, the role of which the woodcut was to usurp (fig.50). With
the introduction of the more sophisticated intaglio techniques, woodcut became
increasingly a medium for communication with the masses, and its linear qualities
were not much exploited for the imitation of paintings (fig.51).

15th century intaglio prints also show a dependence on the drawn line, either
in contour as in the work of Israhel van Meckenem (fig.52b), or in diagonal strokes
reminiscent of pen and ink hatchings as in the engravings from Mantegna's circle
(figs.27b & c,115b,136b). Marcantonio Raimondi, however, early the following cen-
tury, also in fact working largely from drawings, devised a vocabulary of lines, dots,
and dashes which used the qualities and propensities of engraving to create printed
images with a depth and corporeal form closer to that of a painting. With a complex
system of cross-hatchings, flecks and scrapings he created an extensive range of
tones and with the curved lines of the burin, laid parallel to one another and tapering
at the end, he suggested the volume of form, thereby bequeathing to future gener-
ations of engravers a dictionary of marks upon which to draw. The fact that Mar-
cantonio's language was inevitably employed by some in a debased and uninspiring
way does not detract from his revolutionary achievement in creating it or from the
real beauty of his 'reproductions'(fig.53).

The swelling and tapering characteristic of the engraved line was taken much
further by future generations. Goltzius revelled in it, cutting in the lines with a
clarity, confidence and space which give to his version of the *Galatea* a jubilance and
luminosity which it can be argued reflects the character of the original more faith-
fully in mood and scale than Marcantonio's carefully modulated rendering: let alone
the brilliant if dry minutiae of Richomme's network of lines (fig.54). Mellan increas-
ingly cut out cross-hatching and dots and dashes from his repertoire, relying on the
variety and density of the line to recreate his subject (fig.55b). And later French
engravers set off such a variety of curls, coils and corrugations against specks, spikes
and spots that the surface they created with the burin competed with that of the
brush in the variety if not in the nature of its textures (fig.56b).

Engraving was a laborious and time-consuming technique requiring immense
skill and was considered, largely for that reason, the most noble and appropriate
technique in which to render the work of the great masters. Frequently, however,
the appearance of the engraved mark was imitated in the quicker and more tractable
technique of etching. It was a matter on which Abraham Bosse, writing in 1645 and
quoted throughout the 18th century, concentrated at length 'If you desire that your
etching with *Aqua Fortis* should look as like graving as may be, you must lean hard
upon your needle in those places where you would have the lines appear deep and
large; that is, so hard, that the needles may make some impression in the copper.
And for the same reason, you are to lean very light on those places, which you would
have appear faint and small...If...you have used an oval point (which is the best to cut
the varnish) you must afterwards, with one of your large needles whetted short and

round, pass in the midst of the said strokes firmly and strongly, but especially in those places which you would have large and deep.'[3] The majority of reproductive engravings from the 17th and 18th centuries were executed largely by such a method with the help also of the drypoint, its line denuded of burr. Sir Robert Strange in particular valued this instrument, attributing to it his power to convey the different textures of 'flesh, sky, linen, silk, gauze, velvet, or other accessories'[4] (figs.57b,58).

During the 18th century etching began to be valued not simply as a time-saving device but rather for its comparative softness and spontaneity. The engravers of more light-hearted contemporary paintings in particular executed the landscape, the gentle movements of the foliage and the subtle effects of the light in this more complaisant medium. The glitter of the scene and the shimmering of the costumes continued to be interpreted with the sharp lines of the burin, creating a sparkling effect particularly in tune with the nature of their subjects (figs.61b,c). In England, William Woollett gave etching still further prominence, exploiting the technique's capacity to reflect almost involuntary movements of the hand, to create vigorous, wriggling marks analogous to brushstrokes (figs.62b,c). Piled up together in parallel lines and bitten to different depths, they created an uneven surface somewhat like the relief of oil paint.

Towards the end of the 18th century this build up of textures was often a contribution to the achievement of tonal variety. But the invention by Wilson Lowry in the 1790s of a range of ruling machines capable of drawing not only lines in parallel but to a point, and in curves and concentric circles gave line work a new impetus. According to Stannard the 'method is in use principally for what is technically called tints (that is, both parallel and gradated lines, either even or irregular), for skys, backgrounds of objects, portraits, &c., either on copper, steel, stone, or wood. By such a machine a rapid effect is obtained with comparatively little labour.'[5]

The steel plate,[6] introduced in the 1820s, also encouraged a new range of effects. The deep incising of copper plates was not simply a factor of style but rather one of necessity to ensure the yield of a large number of impressions before wear impoverished the quality of the line. The hardness of steel not only predisposed engravers towards tighter movements resulting in finer marks. It also allowed more intricate networks of shallower lines to keep their character under the pressure exerted during printing. This character, particularly in combination with the fine gradations produced by the ruling machine, gave to line work a subtle and silvery brilliance beyond the capacity of any other technique (fig.63).

As if in reaction to the plethora of techniques available at the turn of the 18th and 19th centuries pure outline was also re-introduced. In tune with the Neoclassical emphasis on 'silhouette', the technique combined a sense of authority derived from its use by artists like Flaxman, who had studied the subjects of reproduction at first hand, with the simplifying virtues of the diagram. Fast and therefore cheap, it was used particularly for the illustration of texts on art where the aim was primarily analytic or descriptive rather than celebratory (fig.224).

51

51

CHRISTOFFEL JEGHER (1596-1652/3) AFTER RUBENS

The March of Silenus

Signed within the design *C.I.* and lettered *P.P.Rub. delineau & excud. Cum Privilegiis. Christoffel Iegher. Sculp.* Woodcut. 44.7 x 34.2
VAM CAI 750

Rubens's use at the end of his life of woodcut, a technique which had been largely superseded for all but utilitarian work, for nine bold images based on his paintings (fig.43e) and encompassing the full religious, secular and antique aspects of his subject matter, has a programmatic ring. It is as if he wished his images to infiltrate a part of the market which would usually be unaware of them. A preparatory drawing, in reverse of the print which combines features from a number of paintings, is in the Cabinet des Dessins, Louvre.
Lit: Myers (Rubens) p.16.

8. Hans Holbein d. Ä., Geburt Mariae, Kat. Nr. 8

52A

HANS HOLBEIN, THE ELDER (C.1465-1524)

Birth of the Virgin

Oil on panel. 222 x 127.5
Augsburg Cathedral

52B

ISRAHEL VAN MECKENEM (DIED 1503) AFTER
HOLBEIN, THE ELDER

The Birth of the Virgin.
From a set of 12 presenting *The Life of the Virgin*

Lettered *Israhel .V.M.*
Engraving. 16.9 x 18.5
The Trustees of the British Museum

The majority of Israhel van Meckenem's engravings
were based loosely on paintings designed by other
artists.
Lit: M.Geisberg, *Verzeichnis de Kupferstiche Israhels van*
Meckenem, Strassburg, 1905, 10; Bartsch (General)
31.

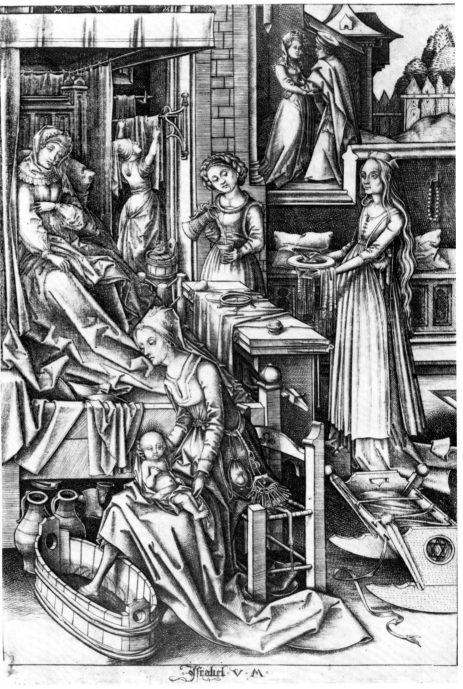

52A

52B

53A

53A

MARCANTONIO RAIMONDI (C.1480-C.1534) AFTER
RAPHAEL

The Judgement of Paris. c.1517-20

Lettered with mongram *MAF* and lettered *Raph. Urbi.
inven.* and *Sordent. Prae Forma Ingenium. virtus. Regna.
Aurum.*
Engraving. Cut to 29.7 x 44.5
The Trustees of the British Museum

53B

**Detail from an early impression from the
same plate**

Bibliothèque Nationale, Paris

No drawing by Raphael for this composition, based
on a sarcophagus relief now in the Villa Medici, is
known but according to Vasari Raphael did supply a
drawing[II] and a similar scene by a member of
Raphael's workshop does appear below the *Parnassus*
in the Stanza della Segnatura[III] in the Vatican. The
technical brilliance of the print is outstanding. Be-
fore being engraved the plate was scored with a
rough surface, perhaps a pumice stone, which gave
to the early impressions a toned background. This
has much the same unifying effect on the whole
composition as the dark preparation of a canvas, and
gives the print a hitherto unrivalled atmospheric
richness.
Lit: Bartsch (General) 245-1; Shoemaker and Broun
43.

53B

53C

MARCO DENTE DA RAVENNA (WORKED 1515-D.1527)
AFTER MARCANTONIO, AFTER RAPHAEL

The Judgement of Paris

Lettered as Marcantonio's engraving, including the
monogram.
Engraving. Cut to 29 x 43.5
The Trustees of the British Museum

This is an unusually careful copy by a leading
member of Marcantonio's workshop but neverthe-
less the breakdown of the master's achievement into
a formula begins to be evident. It is not only the lack
of scoring on the surface of the plate which makes
the effect less brilliant. The lines in the background
are laid with a somewhat mechanical regularity and
those which describe volume are both flatter and
coarser, ending sharply rather than fading away with
dashes and dots. The lighting is harsher; areas of light
and shade stand out against one another rather than
blending smoothly together. Details, such as the eyes
of the figures, are crudely outlined rather than subtly
suggested by the disposition of light and shade.
The collection of the Victoria & Albert Museum in-
cludes two other poorer 16th century printed copies
of this image[IV], which is one of the most influential
in the history of art (fig.154). One study[V] lists thirty-
eight 16th century borrowings from it including re-
ferences on reliefs in stone, silver, and enamels as
well as in paintings and prints.
Lit: Bartsch (General) Marcantonio Raimondi 246;
Shoemaker and Broun, 65.

Inherently similar, there are also obvious differences between these five reproductions of the same image, which span three hundred years of production. Most strikingly, the water and the sky is differently rendered in each. Yet these differences arise from the shared linear vocabulary. The use of line to describe form encourages a heightened definition of it, resulting inevitably in the delineation of detail which does not exist in the original.

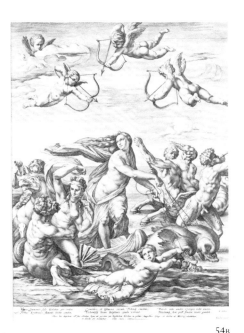

54B

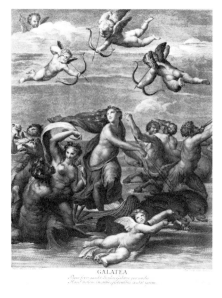

54D

54A

54A

MARCANTONIO RAIMONDI (C.1480-C.1534) AFTER RAPHAEL

Galatea. c.1515-1516

Signed with the tablet.
Engraving. Cut to 39.5 x 28.2
VAM Dyce 1048

Lit: Bartsch (General) 350; Shoemaker and Broun 33; Mason and Natale (Raphael) 82.

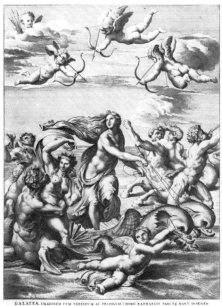

54C

54B

HENDRIK GOLTZIUS (1558-1617) AFTER RAPHAEL

Nerine spumante salo Galatea per undas...

Lettered with six lines of verse by F.Estius and *Opus hoc depictum est suis coloribus Romae ad parietem per Raphaelem d'Urbin, in palatio Augustini Chigi, et ibidem ab HGoltzio adnotatum, et deinde aeri insculptum . Anno . 1592 . C . Visccher Excud.*
Engraving. Cut to 55.7 x 40.8
VAM Dyce 1974

Lit: Strauss 288; Mason and Natale (Raphael) 83.

54C

NICOLAS DORIGNY (1658-1746) AFTER RAPHAEL

Galatea imaginem Cum Nereidum Ac Tritonum Choro Raphaelis Sanctii Manu Insignem Psychis Fabulae Tanquam Corollarium Addere Visum Est In IIsdem Farnesianis Hortis Duplex Opus Et Miraculum

Lettered with title and *Typis ac Sumptibus Dominici de Rubeis Io. Jacobi filij ac Heredis Romae ad Teplum Ste.Mariae de Pace cum priuil. Summi Pontificis et Super. perm, Anno 1693 Nicolas Dorigny Gallus delin. et inc.*
Numbered *12.*
Etching. 52 x 36.2
The Witt Library, London

Lit: Le Blanc (General) 51.

54D

DOMENICO CUNEGO (1727-1794) AFTER RAPHAEL

Galatea. Plate from *Schola Italica Picturae sive Selectae Quaedam Summorum e Schola Italica Pictorum Tabulae aere incisae cura et impensis Gavini Hamilton Pictoris*, Rome, 1773

Lettered with title and two lines of verse *Dum ferri gaudet Siculas Galatea per undas, Haud notum incautis spectantibus excitat ignem* and *Raphaele d'Urbino pinxit in aedibus Frarnes. Dom Cunego Sculpsit Romae 1771.*
Etching. 37.3 x 28.8
VAM Dyce 1656

Lit: Lloyd and Ledger (General) 5.

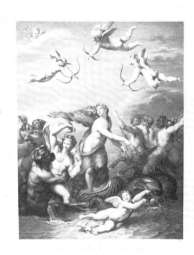

54E

JOSEPH THEODORE RICHOMME (1785-1849) AFTER RAPHAEL

Triomphe de Galatée

Lettered with title and *Dessiné et Gravé, d'après la fresque de Raphael, par Jph Tre Richomme. peint à fresque par Raphael. Dessiné et Gravé, par Jph. Tre Richomme, 1820. Se vend, à paris chez l'Auteur, Rue des grands Augustus, No. 5. Ancien pensionnaire, de l'Ecole des beaux Arts, à Rome. Imprimé par Durand. Deposé au Bureau de Estampes Ecrit par Ambse Richomme.*
With the engraver's stamp of sale.
Etching. 61.5 x 47.3
VAM 21581

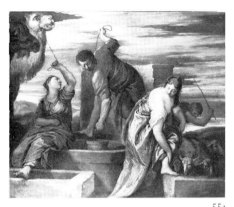

55A

PAOLO VERONESE (C.1528-1588)

Jacob and Rachel at the well

Oil on canvas. 150 x 170
Private collection

55B

CLAUDE MELLAN (1598-1688) AFTER VERONESE

Jacob and Rachel at the Well. c. 1638. In reverse of the original

Lettered *Iacobus Tinctoretus pinxit Cl. Mellan Gall sculp. privilegio connubiis aus pex praelucet profanis, castior, huc unda conciliatur himen. Genes. XXIX. Nobilissimo ac per illustr. Dno. D. Marco-Anthonio Lumague artium cultori hanc tabellam deuouet D. & c. Claud Mellan.*
Engraving. Cut to 39.7 x 43.5
VAM E.3517-1906

The attribution of the painting has changed from Tintoretto to Veronese since the print was engraved. Most of Mellan's engravings reproduced his own drawings and were designed as vehicles to show off his mastery of the swelling and tapering nature of the engraved line. His style of engraving with few hatchings and no dashes and dots was, however, influential in reproductive circles.

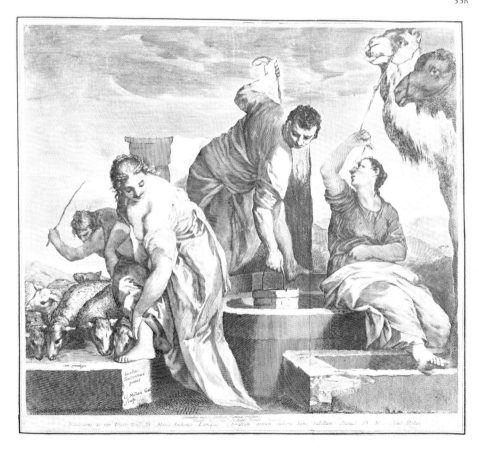

56A

HYACINTHE RIGAUD (1659-1743)

Louis XIV, King of France and Navarre (1638-1715). Portrait wearing coronation robes

Oil on canvas. 279 x 190
Musée du Louvre, Paris

56B

PIERRE DREVET (1663-1738) AFTER HYACINTHE RIGAUD

Louis XIV, King of France and Navarre (1638-1715). Portrait, wearing coronation robes. c.1712. Third state

Lettered with name of sitter and *Hyacinthe Rigaud pinxit P.Drevet sculpsit.*
Engraving. Cut to 68.7 x 51.6
VAM E.224-1965

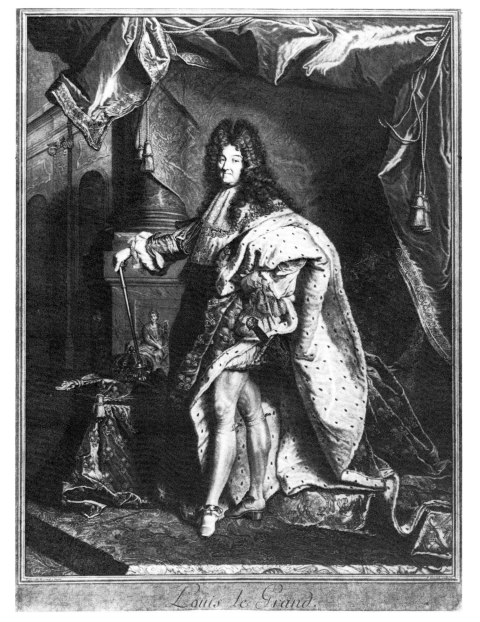

The pose, props and general composition of the French 'coronation' portrait changed little over a hundred years; even Napoleon had himself depicted according to the formula in 1808. The prints after the portraits were also unlike most reproductions of the date, executed exclusively in engraving. The laboriousness of the technique turned the task into an act of homage on the part of a subject to his king while placing the image by means of a shared reproductive vocabulary on a par with the highest art. According to Mariette, who considered this Drevet's greatest print, it was engraved at the request of the King for his cabinet.

Lit: Didot 55; Taylor (General).

68

57A

58

57A

RAPHAEL (1483-1520)

St Cecilia

Oil on canvas. 320 x 136
Pinacoteca, Bologna

57B

ROBERT STRANGE (1721-1792) AFTER RAPHAEL

St Cecilia, attended by the Magdalen, St. Paul, St. John, St. Augustin & C. Plate from *A Collection of Historical Prints, Engraved from Pictures by the Most Celebrated Painters of the Roman, Florentine, Lombard, Venetian, and Other Schools*. In reverse of the original

Lettered with title and *From the painting of Raphael, in the Church of St.Giovanni in Monte, at Bologna* in English and Latin and *R.Strange Academiae regiae artis Graphices Parisiis, et Academiarum Romae, Florentiae, atque Bonoiae, Socius, Academiae item Parmensis Professor, Bononiae Ao. 1763, atque Ao 1771 Aere incidit Londini.*
Etching. 51.5 x 36.2
VAM Dyce 2876

Strange stands out among his generation for the importance he attached to the reproduction of the old masters hoping by this means to 'ameliorate national taste'. In the introduction to this collection he claimed that 'To form a historical engraver, something more is required than the mechanical arrangement of lines. He should be well instructed in the principles of design, and in so much at least, of the anatomy of the human body as regards osteology, and the external situation of the muscles. An acquaintance too with local colours of a painting is necessary that he may be better able to substitute, by a few, that variety of tints which is to be found in the works of the great painters.' He was a stalwart of the view that line engraving alone was a worthy vehicle for the reproduction of the old masters but his own so-called 'engravings' employed the imitative etching technique expounded by Bosse and the drypoint which he learnt from the Parisian, Le Bas. Embittered by the refusal of his native Royal Academy to admit engravers on an equal footing with painters, he listed in the lettering of his prints all the august foreign institutions that had opened their doors to him.
Lit: Dennistoun 2 pp.258-9; Rix (General) 8.

58

PIETRO BETTELINI (1763-1829) AFTER RAPHAEL

La Madonna dei Candelabri. With an enlarged detail

Lettered with title and *Raffaele Sanzio dip. Pietro Bettelini inc. In Roma presso Enanzio Monaldini in Piazza di Spangna No. 79.*
Etching. 41.5 x 36.8
VAM Dyce 1808

The cleanness of the line in this print gives the impression that it is the product of the burin. In fact, the tool used was the *échoppe*, twisted and turned to simulate the linear vocabulary of the engraver. The painting is illusionistically presented as if in a pierced mount on which the patina of hammered gold is suggested by meticulously repeated hieroglyphics. Bettelini, an Italian who studied in Paris before joining Bartolozzi's milieu in London, was typical of many run-of-the-mill engravers of his generation both in his physical migration and in his vision of the old masters. The original painting is now in the Walters Art Gallery Baltimore.
Lit: Le Blanc (General) 9.

57B

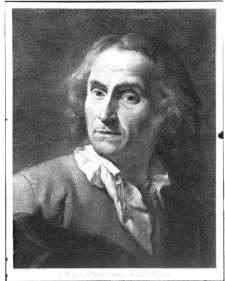

59

59

59

GIOVANNI MARCO PITTERI (1703-1786) AFTER
PIAZZETTA

**Portrait of the etcher. With an enlarged
detail**

Lettered *Marcus Pitteri Venetus in aere Incisor Ioannes
Baptista Piazzetta Venetus pinxit Marcus Pitteri Veneyus
Sculpsit C.P.E.S.*
Etching. Cut to 45.8 x 35.7
VAM 26748

Pitteri's technique, consisting solely of etched lines,
was peculiar to himself but nevertheless a symptom
of the new interest in etching. The lines lie in parallel
undulations across the surface of the image modula-
ted not as in the work of Goltzius or Mellan by the
swelling and tapering which the burin facilitated but
by a stuttered exaggeration of the raggedness in-
herent to line made by the action of acid on a metal
plate.
Lit: F. Mauroner, *Incisioni del Pitteri*, Bergamo, 1944, 1.

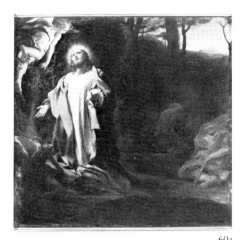

60A

ANTONIO ALLEGRI, CALLED CORREGGIO (C.1494-1534)

The Agony in the Garden

Oil on panel. 37 x 40
VAM, Wellington Museum 1585-1948

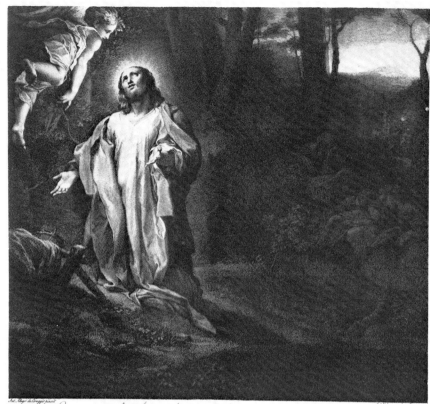

Cum pervenissset Jesus ad montem Olivarum, positis genibus orabat. Luc Cap XXIV 40
Ex Tabula Madriti in Pinacotheca Regis

60B

60B

GIOVANNI VOLPATO (1733-1803) AFTER CORREGGIO

Cum pervenisset Jesus ad montem Olivarum, positis genibus orabat. luc. cap. XX11V. 40

Lettered with title and *Ant. Allegri da Correggio pinxit Joh. Volpato sculpsit Romae 1773. Ex tabula Madriti in Pinacotheca Regis.* Numbered *18.*
Etching. 35.2 x 37
VAM Dyce 1709

The workmanlike nature of the line of this print is typical of the majority of reproductive prints being produced by the second half of the 18th century and expresses allegiance neither with the engraving nor the etching camp. The system of lines, crossing one another more or less closely and thereby creating smaller or larger interstices, builds up the image in much the same way, and probably with as little disturbance to those accustomed to it, as the dots of a modern half-tone.

A comparison of the print with the painting highlights how easily false conclusions about an engraver's faithfulness to an original can be drawn. It appears as if the engraver has falsified the figures to the right and added the tiny figures of Judas and the soldiers behind them. The former, however, only became visible when the picture was cleaned in 1949-50 at which point Judas and the soldiers were removed on the grounds that they were found to be later additions.

Lit: C.M.Kauffmann, *Catalogue of Paintings in the Wellington Museum*, 1982, 32.

71

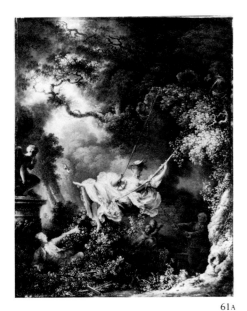

61A

61A

JEAN HONORE FRAGONARD (1732-1806)

The Swing

Oil on canvas. 83 x 66
The Wallace Collection

61B

61B

NICOLAS DE LAUNAY (1739-1792) AFTER FRAGONARD

**Les Hazards Heureux de l'Escarpolettes.
1782. Progress proof. In reverse of the
original**

Etching. Detail, cut to 49.4 x 33.8
Fitzwilliam Museum, Cambridge

LES HAZARDS HEUREUX DE L'ESCARPOLETTES

61c

Published state of the same print

Lettered with title and *Peint par H. Fragonard de l'Académie Royale de Peinture et Sculpture. Gravé par N. de Launay, de la même Académie, et de celle des Arts de Dammarck. P.P. Choffard del. N. de Launay Sc.* and with the addition of a cartouche designed by Choffard. Etching and engraving. Cut to 58.9 x 44.2
Fitzwilliam Museum, Cambridge

It was in the reproduction of Watteau's paintings (fig.2c) for the *Recueil Jullienne* in particular that the gentler character of the etched line was first featured in contrast with the sharpness of the engraved line. A comparison of the etched and the final states of this later print from the same tradition clarifies the role of the two media. The shifting frivolity of the scene on which the distinctive charm of the painting is based is conveyed by etching but it is the engraving which provides the graphic image with a sharpness comparable with the sparkle of the original.
The print follows the painting closely except for the addition of plumes to the lady's hat. This detail is recorded on a lost replica which may have provided the engraver with his model.
Lit: Carlson and Ittmann (General) 88.

61c

73

62A

RICHARD WILSON (1713?-1782)

The Destruction of the Children of Niobe. c.1759-1760

Oil on canvas. 147.3 x 188
Yale Center for British Art, Paul Mellon Collection

62B

WILLIAM WOOLLETT (1735-1785) AFTER WILSON

Niobe. 1761. In reverse of the original. Progress proof

Etching and dry-point. 47.9 x 60.6
The Trustees of the British Museum

62C

Published state of the same print. With enlarged detail

Lettered with title and *Richard Wilson Pinxit J.Boydell excudt. William Woollett Sculpsit. See Ovids Metamorphos. Page 17. Published according to the Act of Parliament by J.Boydell Engraver in Cheapside; London 1761.* and with measurments of the painting.
Etching and engraving. 47.9 x 60.6
VAM Dyce 2860

Richard Wilson was active in the efforts made by British artists to obtain professional recognition and social respect. This painting (known in three versions)[vi], executed shortly after his return to England from Italy and exhibited with great acclaim at the first exhibition of the Society of Artists, played a programmatic part. A landscape painted in the grand style, familiar from the work of such relatively modern old masters as Poussin and Claude, it flattered, like their compositions, the erudition of the painter and his public with its many tiered references to the hallowed ancient themes. It was, therefore, a brilliant choice on the part of Boydell, in search of a wholly British product to export to the Continent to balance the flow of French prints into Britain. Woollett's rendering, relying heavily on a bold use of etched line with engraving relegated to a wholly supporting role, in the sky and in the delicate shading of the figures, was a great success. According to John Pye its sale abroad with Woollett's other

prints after Wilson 'left no doubt, notwithstanding that they displayed the genius of that great painter stripped of its charm of colour, of their having had their full share, with the prints after Hogarth, and the mezzotinto portraits after Reynolds, in dissipating, at this early period in the history of British Art, the delusive theory so often promulgated by philosophers of France and Germany, as to the impossibility of rearing talent in the fine arts amidst the fogs of Great Britain'[vii]. The print made the reputations of both Wilson and Woollett but the financial reward went to Boydell, who paid Wilson £80 for the painting and Woollett £150 for the plate, and is said to have made for himself something in the region of £2000.
Lit: Fagan 42; Alexander and Godfrey (General) 36.

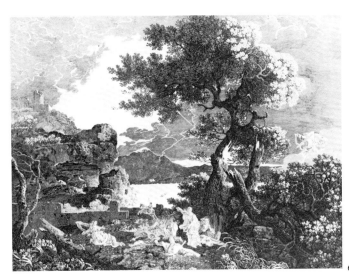

62B

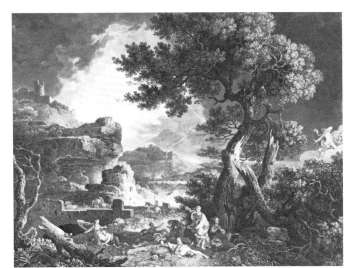

62C

63A

JAMES TIBBITS WILLMORE (1800-1863) AFTER TURNER

Mercury and Argus. Progress proof

Lettered with scratched letters *J.M.Turner RA J.T.Willmore.*
Etching. 68.5 x 48.3
V&A E.4931-1946

63B

The same print. Third published state

Lettered with title and *To the Right Honourable Sir Robert Peel, Bart. M.P. This engraving from the Original Picture painted by J.M.W.Turner, Esqre. R.A. Is with permission most respectfully dedicated by his very Obliged and humble Servant Fras.. Grahm.. Moon Painted by J.M.W.Turner. R.A. London, Published nov 1, 1841, By F.G.Moon, Printseller by special appointment to her Majesty & H.R.H Prince Albert, 20, Threadneedle Street Engraved by J.T.Willmore.* Stamped with the mark of Turner's own collection.
Etching and scraped drypoint. 68.5 x 48.3
VAM E.4934-1946.

This image, printed from a soft steel plate, shows the finer gradations of which the alloy was capable. The proof was taken when the plate had been etched to two levels and before its tinting with the ruling machine. T.A.Prior, another of Turner's engravers, claimed that copper gave only between fifty to a hundred first rate impressions whereas steel gave many hundreds. Initially Turner was against the use of steel plates fearing that the higher yield they gave would devalue the product. But by 1830 he had adopted it for most of his smaller prints although its use for large subjects such as this was not usual until the last years of his life.
Lit: Rawlinson (Turner) p.xl and 650.

64

TIMOTHY COLE (1852-1931) AFTER BOTTICELLI

Head of Flora; detail from *La Primavera*. For enlarged detail see chapter opening

Lettered *T.Cole. Acc. Di Belle Arte Florence.*
Wood-engraving on India paper.16.5 x 13
VAM E.185-1901

Timothy Cole's use of linear wood-engraving years after photo-based techniques were an economical option shows a deep belief in the superior value of line as a vehicle for the reproduction of paintings.

65A

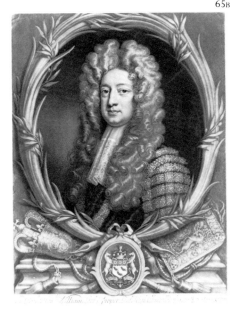

65B

The first technique developed especially for the reproduction of paintings and which allowed the build up of an image by essentially tonal means was mezzotint[7]. It is worked with toothed instruments which create a regular system of cavities to hold the ink. An amateur artist, Ludwig von Siegen of Utrecht, used a spiked roulette to provide a localised roughening akin to mezzotint in about 1640, but it was in England that the technique was perfected, becoming known on the Continent as the *manière anglaise*. In its most characteristic form, the mezzotint plate is pitted in advance in such a way that it prints an even velvety black (fig.65). The design is formed by the varying reduction of the existing roughness so that different areas of the plate hold different quantities of ink and will, thus, print as different tones of grey. Highlights are achieved by burnishing the plate quite smooth, so that when it is wiped no ink remains on these areas.

Such a technique organised the depiction of tones from dark to light, as was the pratice of the oil painter, and was able to translate the painter's tonal gradations with great panache. J.T.Smith, Keeper of Prints and Drawings at the British Museum and an acquaintance of Reynolds, recorded that 'Of all the various styles of engraving, Sir Joshua Reynolds considered that of mezzotinto as the best calculated to express a painter-like feeling, particularly in portraits'[8]. The scraping gesture of the mezzotinter was particularly suited to the translation of broad effects of light and shade, and the way in which such a leader of style as Reynolds handled paint may well have been influenced by the exigencies and potential of this fashionable reproductive medium[9]. Certainly Reynolds was impatient with those who were too literal in their translation of his compositions. Edward Fisher was considered 'injudiciously exact' and criticized for wasting time 'making every leaf on a tree with as much care as he would bestow on the features of a portrait'[10] whereas McArdell,even though he was capable of tampering with the sitter's features (fig.69b), was given the accolade that his production 'would perpetuate his pictures when their colours should be faded and forgotten'[11].

According to Vertue six mezzotints could be made in the time it took to make one line engraving[12]. While the number of prints produced by engravers in mezzotint does not bear out this differential[13], mezzotint was clearly in some ways a more economical technique. The laborious laying of the ground could be done by apprentices and the scraping process was certainly not as time-consuming as engraving a multitude of lines. The disadvantage of mezzotint was the low number of good quality impressions printed from a plate, before the introduction of steel[14]. The technique was therefore unsuitable for the reproduction of pictures for which a very high demand was expected.

This factor may have contributed to the development of stipple engraving by reproductive engravers during the second half of the 18th century although a similar technique had been used to decorate the wares of goldsmiths since the Middle Ages (fig.71,72). The technique involved the massing of dots and short flicks created by a

mixture of etching and engraving. First the contours and planes of the design were dotted through an etching ground and bitten with acid and then the resulting pits were sharpened up and added to by a burin with a specially curved stem to facilitate the pecking motion. Allegedly given impetus by a surplus of metal punchers thrown out of work by a shift in fashion from decorated to plain shoe buckles[15], stipple was criticised by traditional line engravers on the grounds that it could be done without arduous training. According to William Sharp 'It is not only easy in its process, but they have advantages over either the line manner of engraving or mezzotinto, by assistants which can be easily procured, and which assistants can without any knowledge of drawing, or any natural taste perform the greatest part of labour'[16]. Whereas Sir Robert Strange, denigrating engravers in this manner as 'manufacturers', predicted that they would 'ultimately tend to depreciate the fine arts in general, to glut the public and to vitiate the growing taste of the nation'[17].

The inherent fineness of the stipple technique did not complement grand compositions (fig.74) but it was in keeping with the less ambitious nature of the subject matter and the reduction in scale of the more intimate images which were becoming popular towards the end of the 18th century. Used particularly to reproduce decorative mythological (fig.73b), classical and pastoral themes, many of which were designed specifically for multiplication by stipple engraving, the technique has the distinction of creating as much as reflecting the fashion for this class of painting.

The invention of lithography in 1798 provided an entirely different means of reproduction. The printmaker no longer needed to cut, scrape or dot his design into a metal plate but could simply draw or paint it in a greasy substance on a porous printing surface, which in the early years was usually stone. A very versatile technique — the thumb print on the plate in Hullmandel's *The Art of Drawing on Stone* shows how faithfully the stone could print any mark made on it (fig.67) — one of its chief virtues and therefore in practice a limiting influence, was seen as its ability to reproduce the effects of the intaglio printing techniques more quickly and cheaply than the various techniques could themselves. From the outset Senefelder stressed this characteristic and by 1859, under a sub-heading of 'Fac-similes', Stannard claimed 'The process has been brought to such perfection as to produce prints from drawings, possessing nearly all the beauty and delicacy of copper-plate or steel engravings'[18]. The technique was, however, also used for the reproduction of paintings, particularly from public collections (fig.75,76), and produced in talented hands effects of great tonal range and richness, although the surface of a lithograph does not have the tactile quality of some intaglio prints.

As if to show to disadvantage the lithograph's flatness, developments in tonal printing from intaglio plates in the 19th century were characterised by a superimposition of techniques, each of which had been used independently in the 18th century. To the lines, dots and dashes of the line engraver, to the velvety tones of the mezzotinter, and to the meticulous dottings of the stippler were added aquatint — another tonal method devised primarily to reproduce the flat washes of watercolour (figs.6c,130b), marks made with roulettes, and the tints of the ruling

65A & B
JOHN SMITH (C.1652-1742) AFTER KNELLER

The Right Honble William Lord Cowper Lord High Chancellor of Great Britain & c. Progress proof and published state

The latter dated *1707* and lettered with title and *G.Kneller S.R.Imp. et Angl. Eques Aur. pinx. I.Smith fec. Sold by I.Smith at the Lyon & Crown in Russell Street Covent Garden.*
Mezzotint. Cut to 38.2 x 29.5; 40.5 x 29.8
The Hon. Christopher Lennox-Boyd

The proof shows the print before the scraping of the head and before additional work on the border.
Lit: J.E.Wessely, *John Smith*, Hamburg, 1887, 72; Chaloner Smith (General) 65.

66

JAMES MCARDELL (1729-1765) AFTER VAN DYCK

Time clipping the Wings of Love

Lettered *Ant. Van Dyck Eques Pinxt Jas Mc.Ardell Fect. From the Original in the Collection of His Grace the Duke of Marlborough at Bleinehim 5 feet 11 inches High. 3 feet 8 inchs. Wide.*
Mezzotint. 50.2 x 35.1
The Hon. Christopher Lennox-Boyd

Mezzotint is associated with contemporary portraits but its use for the reproduction of the old masters played an important part in establishing a good reputation for its practitioners.
Lit: Goodwin 209.

machine. The purity of each of these techniques was sacrificed in order to achieve a surface with such surprising encrustation of ink that it did on occasion compete with the impasto of paint. Even more remarkable than the evident variety of effects achieved in black and white, was the claim that monochrome could suggest actual colours. In 1829 Sir Thomas Lawrence told the poet Thomas Moore that an engraver 'can so meander his shadows as to convey (to the painter's eye at least) the idea of blue, and (I believe) one or two other colours'[19].

67

67

CHARLES JOSEPH HULLMANDEL (1789-1850)

Plate 11 from *The Art of Drawing on Stone*

Lettered *Drawn on Stone by C.Hullmandel Printed by C.Hullmandel London Pub by R.Ackermann, 101, Strand June 1824.*
Lithograph. 22 x 16
VAM, National Art Library

This plate from a manual of lithography demonstrates what not to do. It includes errors caused by drops of saliva and by thumb prints. The saliva dampens the stone and therefore stops the greasy drawing chalk impregnating it. The thumb print deposits grease on the stone which acts in the same way as the drawing medium. The illustration shows thus how responsive the technique was to the character of different marks.
Lit: Twyman (Technique) p.117.

68

68

ROBERT LAURIE (C.1755-1836) AFTER STUBBS

The Lion and Horse. Proof before letters. Published by Robert Sayer, 1791

Mezzotint. 45.8 x 55.9
VAM E.575-1959

This is a subject much painted by Stubbs (fig.131). The original painting of this version was owned by Luke Scrafton and is now lost. This print follows Benjamin Green's mezzotint published in 1769 closely and is likely to have been based directly on it. Laurie's plate replaced Green's in Laurie and Whittle's catalogue of stock in 1795[VIII].

69B

69A

JOSHUA REYNOLDS (1723-1792)

Mrs Hugh Bonfoy. 1754 or 1755

Oil on canvas. 124 x 100
Private collection

69B

JAMES MCARDELL (1729-1765) AFTER REYNOLDS

Mrs Bonfoy. 1755. Unrecorded proof before letters

Stamped with unidentified collector's mark.
Mezzotint. Cut to 37.2 x 27.5
VAM E.273-1905

McArdell has subtly rearranged the background foliage and given the sitter fuller features. In keeping with this sweetening of the image, the sitter's name is not recorded even on lettered impressions, an omission which converts the image into a 'fancy' picture. It was subsequently copied by the mezzotinter, Richard Purcell, and entitled 'Lucinda'.

The fact that the smudged border of this proof was not trimmed off along with the other borders is an indication of the value attached to impressions which announced their status as proofs.
Lit: Chaloner Smith (General) 23; Goodwin 44.

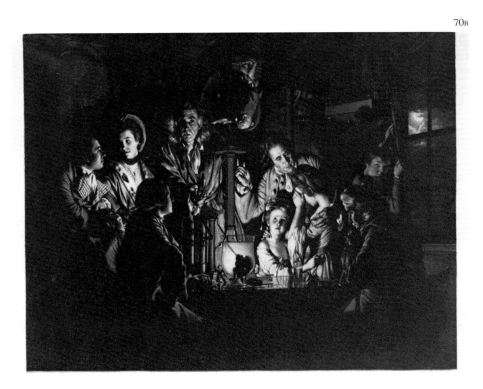

70A

JOSEPH WRIGHT (1734-1797)

Experiment with the Air Pump. 1768

Oil on canvas. 184.1 x 243.8
National Gallery, London

70B

VALENTINE GREEN (1739-1813) AFTER WRIGHT

The Air Pump. First state

Lettered in scratched letters *Jos. Wright Pinxit, 1768 Val. Green fecit. et excudit. 1769.*
Mezzotint. 47.8 x 58.3
VAM 29445.1

There is a propriety about the rendering of night scenes by mezzotint. A technique in which the design is scraped out of darkness yet one that is capable of gleaming whites, it was particularly suited to the reproduction of the eerie atmosphere of candlelight. Mezzotints which catch the tone and form of their originals as faithfully as this example are difficult to distinguish from the original when both are presented as black and white photomechanically produced reproductions.
Lit: Whitman 167.

71

BERNARD ZAN (WORKED LATE 16TH CENTURY)

Design for a cup and cover. With enlarged detail

Signed and dated *B.Z. 1.5.8.1.*
Punch-engraving. Cut 28.3 x 12
VAM 28545

Goldsmiths since the Middle Ages had decorated their surfaces with dots produced by punch and hammer. Towards the end of the 16th century they began printing the designs on paper. The outlines were achieved by regular sized dots placed side by side while the appearance of modelling was given by a gradation of dots, again in lines, with the rows crossed in the shadows. The aim must have been to provide goldsmiths with patterns executed in their own tools although ware decorated solely in this way is rare. The effect, however, particularly where a certain amount of retroussage has been used in the printing, is strikingly close to that of fine chalk. Such work must surely have contributed to the development of stipple engraving and etching in the crayon manner.
Lit: J.F.Hayward, *Virtuoso Goldsmiths and the Triumph of Mannerism 1540-1620,* 1976, p.238.

71

72

JAN LUTMA 11 (?1624-1688)

Janus. Lutma. Batavus. With enlarged detail

Lettered with title and within the design *Ne Te Quaesivens Extra* and *Per Se Opere Mallei 1681.*
Punch-engraving.30 x 22
VAM E.270-1887

Goldsmiths were also, it appears the first to recognise the pictorial potential of dotting. Jan Lutma, father and son, leading goldsmiths in Amsterdam, produced several remarkable prints lettered in Latin 'Made with the work of the hammer' where the technique's tonal qualities were used to express the three-dimensional quality of sculptural forms rather than the modelled but essentially flat decoration conveyed by Zan. The print includes a few guiding etched lines but the image is almost entirely built out of a system of dots which vary in size, shape and density. The rendering of the locks of hair closely resembles similar passages in Bartolozzi's reproductions of Holbein's portraits.

73A *See colour plate VIb*
ANGELICA KAUFFMANN (1741-1807)

The Disarming of Cupid

Oil on canvas. Diameter 63.5
The Iveagh Bequest, Kenwood House

At least four other versions of this painting are known.

73A

73B

73B *See colour plate VIa*
WILLIAM WYNN RYLAND (1733-1783) AFTER
ANGELICA KAUFFMANN

Etiam Amor Criminibus Plectitur. 1777

Lettered *Angelica Kaufman Pinxit. Wm. Wynne Ryland Sc.*
Stipple engraving printed in sanguine. 36.9 x 31.5
VAM 26581

Ryland (fig.126) is usually credited with bringing knowledge of stipple engraving and of the crayon manner back with him from France, where he is said to have worked with Boucher and Le Bas in the 1750s. It was however in England that stipple engraving took root. Often printed in shades of brown and red, stippled prints were intended primarily for framing as 'furniture' prints rather than as additions to the connoisseur's portfolio. Andrew Tuer, the biographer of Bartolozzi, the most prolific engraver in this manner, writing in 1885 vividly described the fortunes of this kind of print: 'Bartolozzi's engravings have literally had their ups and downs: first ascending to the drawing room, later climbing to the bedroom, and eventually to the attic or lumber room, where they remained half or perhaps wholly forgotten, until a revival in taste...brought them down by the same degrees to the drawing room and boudoir'[IX].

FRANCIS HAWARD (1759-1797) AFTER REYNOLDS

Mrs Siddons as the Tragic Muse. Third state

Lettered *Sir Joshua Reynolds pinxt: Frans: Haward A:R:sculpt: To the Kings most excellecnt Majesty, This Plate of Mrs: Siddons in the Character of the TRAGIC MUSE, is with His Gracious Permission humbly Dedicated; by His Majesty's most dutiful Subject and Servant, Francis Haward. London publish'd June 4th: 1787, by Frans: Haward, no: 29, Marsh Street, Lambeth, near the Turnpike. Printed by C:F:Gouthier* and with the Royal Arms. Lettered within the design on the hem of the sitter's robes *JOSHUA REYNOLDS PINXIT 1784.*
Stipple and line etching printed in brown.62.8 x 44.7
VAM Dyce 2889

Any print after a painting of a theatrical star by the president of the Royal Academy was bound to be popular and Valentine Green, who had already engraved in mezzotint some twenty portraits by Reynolds, asked that he should engrave this subject also. The commission was however engraved in stipple at the request of the sitter who was attracted by his print after Reynolds's 'Infant Academy' and may have felt that mezzotint was old-fashioned. The higher yield of which stipple was capable may also have influenced the decision but there is no doubt that the grandeur of this image and its challenging light effects would have been better rendered in mezzotint.
Lit: Hamilton (Reynolds) p.131; Whitley (General) 2, pp.3-13; Griffiths (Reynolds) pp. 38-9.

74

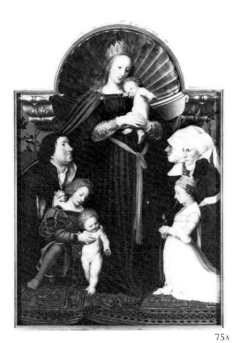

75A

75A

HANS HOLBEIN THE YOUNGER (1497/8-1543)

The Madonna of the Burgomaster Meyer

Tempera on panel. 146.5 x 102
Princes Von Hessen und bei Rhein, Darmstadt

75B

FRANZ HANFSTAENGEL (1804-1877) AFTER HOLBEIN

The Madonna of the Burgomaster Meyer

Lettered *Die Madonna von Hans Holbein Hohe 5' 9"
Breite 3' 8" Königl Gemälde-Galerie in Dresden Her-
ausgegeben v.Franz Hanfstaengel N d Original auf Stein
gez.v.Fr. Hanfstaengel Dresd 1838 Gedruckt bei dem Her-
augeber.* Blind stamped with the stamp of Hanfst-
aegl's 'Koenigl. Gemaelde Galerie Dresden'.
Lithograph. 61.3 x 38.7
VAM 23723-10

The print shows the tonal richness of which litho-
graphy was capable but which it seldom achieved.
The values of the colours differ considerably from
those of the original: the robe of the figure on the
right in the background is light rather than dark.
This alteration allowed the different figures to be
clearly distinguished from one another in mono-
chrome.

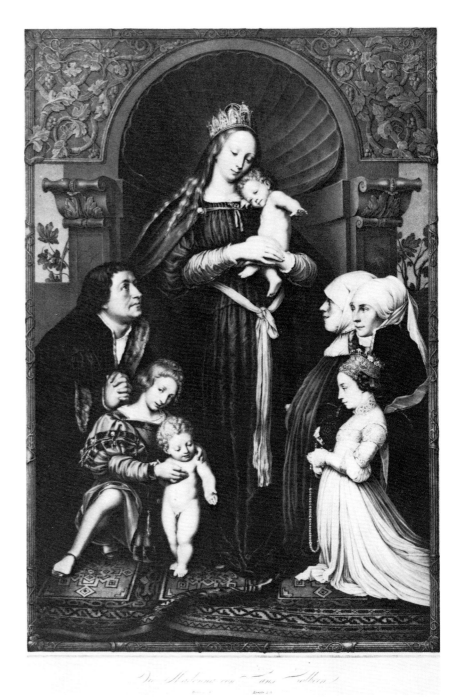

Die Madonna von Hans Holbein

75B

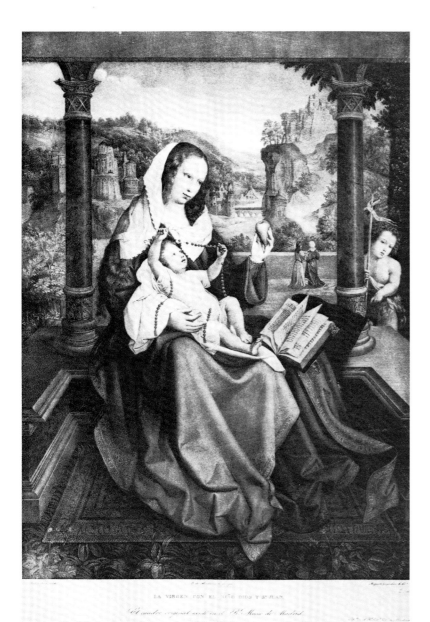

76B

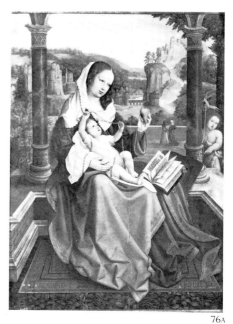

76A

76A

BERNAERDT VAN ORLEY (C.1491–1542)

Virgin and child

Oil on panel. 98 x 71
Prado, Madrid

76B

AUGUSTO GUGLIELMI (WORKED MID 19TH CENTURY)
AFTER VAN ORLEY

La Virgen Con el Nino Dios Y Sn. Juan

Lettered with title and *Autor desconocido J. de Madrazo
lo dirigio. Augusto Guglielmi lo lito. El cuadro original existe
en el Rl. Museo de Madrid Est. do en el Rl. Esto. Lito. de
Madrid.* With the stamp of the Royal Museum of
Spain.
Lithograph. 43.2 x 31.2
VAM 20500

The print was acquired by the Museum in 1864 with
thirty-four other lithographs of paintings in the
Royal Collection of Spain. The translation of the
tones of the original into subtle silvery gradations is
masterful but the scene is transcribed with a senti-
mentality, lacking in the original, which expresses
the print's 19th century manufacture.

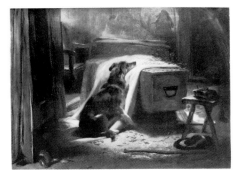

77A

EDWIN LANDSEER (1802-1873)

**The Old Shepherd's Chief Mourner.
Exhibited 1837**

Oil on panel. 46 x 61
VAM

77B

FREDERICK HOLLYER (WORKED 1860s)
AFTER LANDSEER

The Old Shepherd's Chief Mourner

Lettered *London Published June 5th. 1869 by J.McQueen,
37 Great Marlborough St.* With the stamp of the Print-
sellers' Association *OSR.*
Mixed mezzotint. 65.5 x 71
VAM E.165-1970

The dimensions of prints and paintings converged to
a domestic scale during the 19th century. Landseer's
painting is virtually the same size as the printed
image. Intaglio printmakers in the 19th century tried
also to make the surface of their prints vie with that
of the originals creating a surface which corresponds
in textural weight if not in detail to that of the orig-
inal.

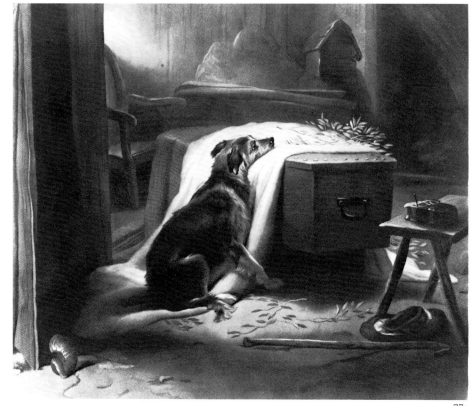

77B

'Want of colouring is the capital deficiency of prints' claimed Horace Walpole in 1763.[20] Since the 15th century the theorists and historians of art had discussed the relative importance of line and colour in the formation of images. Orthodox opinion, promulgated in the Academies of Art which grew up in the 17th and 18th centuries, was broadly in favour of line. Drawing was the fundamental discipline of the visual arts, and in promoting and disseminating the skills of draughtmanship, teaching books illustrated by line engravings, etchings, and occasionally by one of the facsimile or tone processes, played an important part. Printmaking was therefore fundamentally associated with draughtsmanship, and was correspondingly dissociated from colour: colour being as it were a grace note, added to the image, unnecessary to the true connoisseur and possibly a distraction from the elegance and significance of the image. As we have seen, even in the 19th century, the acutest critics of prints were maintaining that black and white, cleverly modulated, could transmit information about actual colours; to the high-brow colour printing remained a subject of some suspicion and the technology, without high status patronage, was slow to develop. There are examples of prints decorated with colour with no reference to an original before the 16th century; during that century a method of producing the effect of a colour wash drawing from a series of blocks was also developed (figs.117b & c). Except for a few isolated examples,[21] however, no colour prints after paintings were made prior to the 18th century and only within this century has colour reproduction been capable of consistently reproducing an original painting more faithfully than black and white.

In fact one of the earliest methods of colour printing to be invented used the three-colour principle which lies at the heart of modern methods. Developed by J.C.Le Blon early in the 18th century this is less surprising than it seems for the process was derived from Newton's theory of light, propounded during Le Blon's youth. The idea of the three primary colours was first applied to the pigments used by painters, rather than to light, in the 1708 The Hague edition of Boutet's *Traité de la Peinture en Mignature*.[22] At this date Le Blon is recorded as a miniature painter in Amsterdam experimenting with printing in colour. The underpinning of Le Blon's process by this theory was articulated in the 1720s when he was in business in London and his chief backer, General Guise, informed the horticulturalist Richard Bradley, that the invention demonstrated 'that all the varieties of colour are express'd by means of three only, viz. yellow, red and blew.'[23] The only real difference between Le Blon's and modern methods is that the division of the picture's full range of colours into proportions of the primary colours had then to be judged by the eye, rather than as now, photomechanically with the aid of filters.

Le Blon's company was called 'The Picture Office', and consisted of a considerable workforce of engravers, colourers, printers and framers. The intention was to provide colour reproductions of the old masters including the Carracci, Titian, Correggio, and Van Dyck, which would have a comparable presence to an original

FIG. VII

78A

JACQUES CHRISTOPHE LE BLON (1667-1741)

Plate from *Coloritto, or the harmony of colours in painting*, 1725

Colour mezzotint. Cut to 26.9 x 21.2
The British Library

Coloritto explained the theory of Le Blon's three-colour process in relation to the practice of painters. This plate illustrates a passage on the mixing of colours but oxidisation of the whites has altered the effects. Its application to printing was not published until after Le Blon's death in *L'Art d'Imprimer les Tableaux Traité d'après les Écrits, les Opérations & les Instructions Verbales*, Paris, 1756, by A.Gautier de Montdorge in a bid to protect Le Blon's position as inventor of the process against the rival claims of Jacques-Fabian Gautier-Dagoty. Montdorge reported that the plates were printed in the order of blue, yellow, red.

(fig.78b).[24] In 1721 Lord Percival, another backer, felt able to write excitedly to his brother that 'Our modern painters can't come near it... with their colours, and if they attempt a copy make us pay as many guineas as now we give shillings.'[25] But by the following year Le Blon was being accused of cheating his shareholders and was removed from his post of director. The story of incompetence or deceit is difficult to unravel but what does seem to be clear is that Le Blon was as interested in his process as process, as much as for its power of reproduction, for on his removal to Paris in ignominy he began issuing sets of separations with the finished reproductions, thus converting his invention into a curio befitting the connoisseur's cabinet.[26]

The process was featured at length in Robert Dossie's *The Handmaid to the Arts* of 1758 but as one which was no longer in use in England. It had, however, followers in France, including the Gautier Dagoty family (fig.81b) and in particular Jacques Fabian, who obtained a thirty year privilege to use the process after Le Blon's death. But it was more often applied to the illustration of the natural sciences than to the reproduction of works of art. Its chief legacy was not the far-sighted three-colour approach but the inking of separate plates with each colour and their successive printing. This method was adopted particularly by French engravers whereas their English counterparts tended to favour the inking of a single plate with several colours and printing in one operation.

Printing from a succession of plates multiplied the job of engraving by how many plates as were used. Even without employing the three-colour process the engraver had the difficult task of selecting colours which would work together and look well in superimposed printing. Futhermore, the different plates had to be printed exactly in register. A surviving manuscript note entitled *Le Pastel en Gravure inventé et executé par Louis Bonnet 1769* accompanying a set of progressive proofs of Bonnet's *Tête de Flore* (fig.32a), printed from eight plates, records which colours he used and in what order and with what intention. It shows what an intricate and time-consuming method it was if the effect were to compete in colour range with the original.[27]

The printing of several colours in one operation from a single plate meant in practice that the subject was copied afresh by hand for each impression, usually from a standard coloured copy which the printer had beside him for reference. The colours were dabbed on with rag balls on the end of a stick, a method of inking which became known as inking *à la poupée* because of the resemblance of the dabbers to rag dolls. The printer had first to decide on a ground tint, usually brown, black or grey, according to the generally prevailing tone and the plate was inked with it as if to print a monochrome impression but then wiped off so as to leave only a very slight residue. 'This slight tone' according to Mrs Frankau, who based her statements on the folklore of colour printers still working at the close of the last century, 'dominated the picture, lightened or deepened the plate, changed the relation of all the colours, and affected the ultimate result in every detail'.[28] The printer then applied the other broad areas of colour before turning to the flesh tints which required a different ground from the rest of the image if they were to have the same depth of

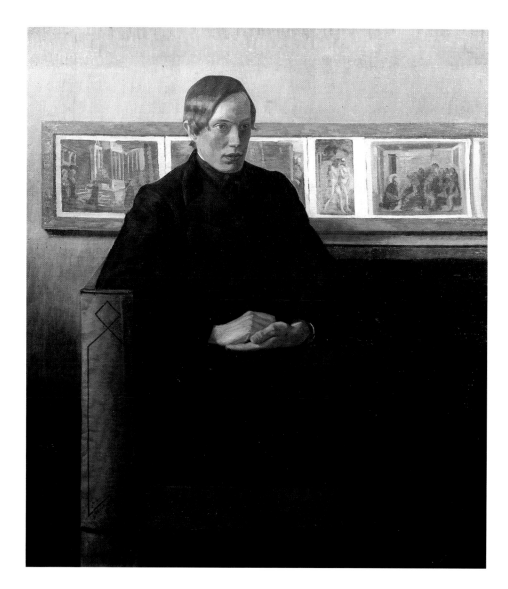

I

Portrait of a young man, the painter Thorvald Erichsen
Oil on canvas
(fig.208)

II

Stripped colour separation of Landseer's ***The Highland Drovers: Scene in the Grampians,*** from left to right yellow, blue, yellow and blue, red, yellow blue and red, black, and all four together.

These illustrations show the four continuous tone separations into which modern four colour printing methods break down a painting before it is reassembled, with the four images printed one on top of the other, into a full colour reproduction. Plates are proofed on presses which print a single, or sometimes two colours at a time, and each proof is inspected before the next colour or combination of colours is printed to see if corrections to subsequent plates are required. The colours are proofed in order of the quantity of ink being deposited on the sheet, the heaviest first, which usually results in the yellow plate being printed first, then the blue, then the red and finally the black. The tackiness of the ink in four colour press work means that better results are achieved if the order is reversed, the colour involving the least ink being printed first and that involving the most, last.

Colour control strips

III

RICHARD EARLOM AFTER VAN HUYSUM

A Fruit Piece

Second and third states and colour mezzotint from same plate.

(figs. 85a,b,c)

91

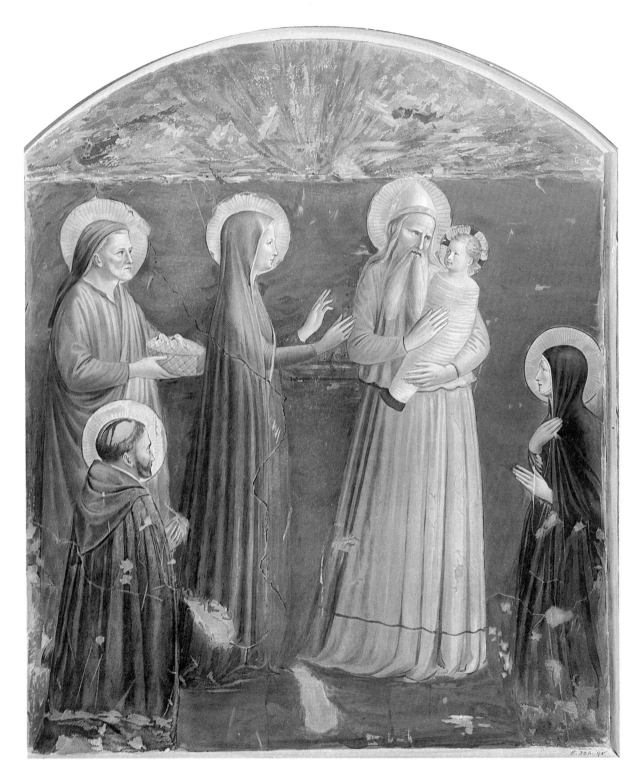

92

IV

WILLIAM GREVE'S FIRM AFTER COSTANTINI AFTER FRA
ANGELICO

The Presentation in the Temple

Colour lithograph for the Arundel Society

(fig. 93)

VA

AFTER J.M. NATTIER

La Duchesse de Chartres as Hebe

Hand photogravure

(fig. 106)

VB

JEAN-FRANCOIS JANINET AFTER GAUTIER DAGOTY

Portrait of Marie-Antoinette

Colour etching and engraving

(fig. 81)

VIA

WILLIAM WYNN RYLAND AFTER KAUFFMANN

Etiam Amor Criminibus Plectitur

Stipple engraving printed in sanguine

(fig. 73b)

VIB

ANGELICA KAUFFMANN

The Disarming of Cupid

Oil on canvas

(fig. 73a)

VIIA

FRANCOIS DAVID SOIRON AFTER MORLAND

A Tea Garden

Colour stipple engraving(fig. 83b)

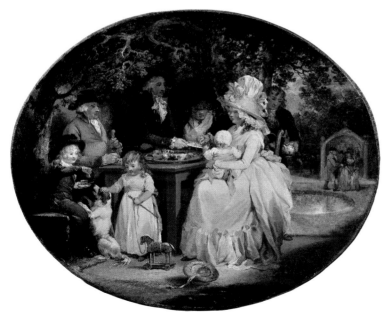

VIIB

GEORGE MORLAND

A Tea Garden

Oil on canvas

(fig. 83a)

VIII
MARCEL BROODTHAERS
La Soupe de Daguerre
Colour photographs and screenprint
(fig.20)

modelling but not look muddy. Over 'a ground of carmine and white, or carmine and burnt sienna, or carmine alone, or blue and white or a hundred other combinations, the effect of which had to be laboriously sought, the flesh had to be built up, the features, eyes and brows, shadows and lips' painted into the plate.[29] During all this work, the plate had to be kept warm enough to keep the inks viscous but not so warm as to make them run. Before the plate was printed all the tints had to be blended in at their points of contact and the surface of the plate had to be wiped clean so that the ink was held only in the hollows. The intricacy of the colouring and therefore its possible closeness to the original depended on the printer's skill and the time he was allowed for the 'painting-in' process. The number of impressions produced a day was, inevitably, small (figs.82-84).

Both methods of colour printing were unable to exploit fully the mass-production possible in one colour printing. Whether executed in France or England the majority of 18th century colour prints share a prettiness and sentimentality of subject matter which suggests that the engravers had identified a specific market to which they catered almost exclusively. That the French engravers in particular were in the industry of lavish trinkets is suggested by the decoration of the ornamental borders around their prints with gold leaf even though its use, being restricted to certain trades, was for them illegal (fig.81).

In fact printing in colours required more skilled and therefore more expensive labour than hand-colouring which continued to supply the demand for cheaper reproductions in colour. That printsellers traditionally sold their wares hand-coloured is known from surviving catalogues.[30] Even more must have been coloured up by their owners. According to *The Excellency of the Pen and Pencil* published in 1668 'To wash maps or printed pictures is nothing else but to set them out in their proper colours... I have seen a printed picture printed upon fine parchment, only washed with water-colours, which could hardly be distinguished from a limned piece, and there are many now in England very excellent at it. If any ingenious spirit that delights in picture, and hath not time or opportunity to study to be a proficient in painting in oyl or limning, I would advise him to practise this, which is very delightfull and quickly attained'[31]. Towards the end of the 18th century prints were produced increasingly in outline, sometimes intentionally to provide a skeleton for the hand-colourist (fig.87).

That there was a market for coloured reproductions that were closer to the appearance of oil paintings is suggested by the establishment of the Polygraphic Society, which held its first exhibition in 1784 and displayed the original paintings beside the reproductions.[32] Polygraphs were produced by a method which the inventor, Joseph Booth, claimed was capable of 'multiplying pictures in oil colours, with all the properties of the original paintings; whether in regard to outline, size, variety of tints'[33] and including a canvas support. But although we are told that Reynolds 'with a protecting hand, generously assisted him in his invention in a manner truly great and noble' and West 'indulged the artist with the use of one of his pictures'[34] the method is not divulged and remains an enigma today.

78B

The rendering of tone was as important to the appearance of Le Blon's reproductions as their colour. Initially he experimented with a number of different methods of achieving the effect of tone including stipple and a primitive form of aquatint. Mezzotint was found to be the most effective and its popularity in England probably contributed to the ease with which he found backers for his business in London, where this print was manufactured.
Lit: Singer p.267.

79A

JOHN BAPTIST JACKSON (1700/1–AFTER 1773) AFTER
JACOPO BASSANO

The Burial of Christ. Plate from *Titiani Vecelii.*
Pauli Caliarii, Jacobi Robusti, et Jacobi de Ponte,
opera selectiora a Johanne Baptista Jackson Anglo,
ligno coelata, et coloribus adumbrata, **Venice,**
1745

Lettered within the design *J:B:Jackson Delin. Sculp &*
excudit 1739 and below *In signem hano Tabulam a Jacobo*
de Ponte depictam. Clarissimo Vivo Jacobo Facciolato Semi-
narii Pabavum Praesidi, Archigymnasa ornamento ingenu
doctrinae, & in primis Latina eloquentice laude celeberrimo.
J.B.Jackson D.C.

Woodcut printed from four blocks. 55.7 x 38.7
VAM Dyce 2683

The 'mechanical paintings' of Matthew Boulton and Francis Eginton, also on canvas, were a similar venture of the same period.[35] Although there is evidence of the use of an aquatint base, it is through documents that the 'paintings' are most easily identified. Letters suggest that they were widely used by architects to decorate grand rooms. For example Charles Wyatt wrote to Boulton 'Tell Mr Eginton that I mentioned to James Wyatt what he desired me about pannels. Jim thinks he can use a great many, he gave me 4/- a piece for the heads which Mr. Eginton copied. I saw a ceiling where 18 of Clay's pannels, at 3gs. each, were to be introduced.'[36] Obviously 'mechanical paintings', although they are likely to have been much touched up by hand, were able to undercut the more familiar papier mâché panels supplied by the Birmingham manufacturer, Henry Clay. Angelica Kauffmann's paintings in particular were multiplied in the technique. *The Disarming of Cupid* is recorded as one of the subjects which probably explains the considerable number of versions in which the painting is known (fig.24).

Strides forward in colour printing on paper were not, however, taken until well into the 19th century. In 1852 the *Daily News* expressed the view that 'We are not without hope that e'er long we shall have methods of repeating colours as truly as the Calotype process repeats form. This will be a great victory for popular art, and its ultimate result must be the abolition of much or all that now goes by the name of art among people; for no one will think of giving fifty pounds for a bad picture or fifty shillings for a poor engraving, when he can get a real Raphael or a real Claude (to all substantial purposes) for say, as many pence. Cannot Mr Baxter who has advanced so far, achieve this final success.'[37] But Baxter did not rise to the challenge using his invention, which actually deposited oil colours on the sheet, primarily to create fancy pictures after minor contemporary artists. When he did press it into the service of the old masters he was as keen to imitate the novel appearance of a photograph as to reproduce the full colours of the original (figs.90,91).

Lithographers had experimented with colour almost from the outset but used it largely to embellish an essentially black and white image rather than as a means of approximating to an original (fig.86). It was only in 1837 that the French lithographer Engelmann, coining the term chromolithograph to describe his process, was granted a ten year patent for printing lithographs in colour. Like Le Blon, he based his technique on an understanding of the power of the three primaries. During the second half of the century large numbers of brilliantly coloured lithographs reproducing old and modern masters were produced, sometimes from as many as twenty-five stones, and it was in the development of this process that responsibility for the creation of the printing surface shifted from being essentially the work of an individual with status as an artist/craftsman to that of an industrialised team contributed to by workers who saw themselves as technicians. Perhaps this change in the print's origins contributed to a sense that there was a loss as well as a gain. The Arundel Society's first colour lithographs were accompanied by apparently more edifying line engravings of details of the originals, and even George Rowney and Co. enticed buyers of their gloriously full colour rendering of Turner's *Ulysses Deriding Polyphemus*

(fig.89) with a giveaway woodcut of the same subject.

It was the colour lithograph's misfortune to develop along side the photograph. The Arundel Society, with the monochrome accuracy of the photograph ever before them and even used by one of their copyists as a base for colour, debated whether they should restore the dilapidated originals to their former glory or show the damage of the ravages of time. One copyist was instructed 'to avoid all restoration of parts injured or destroyed, and to aim at rendering the existing rather than the supposed original tone of colour[38]', and a new recruit 'pledged himself to daguerreotype the minutest crack upon plaster'[39] (fig.93). But there was no denying that the colour lithograph was the product of many re-drawings and the photograph did not involve any re-drawing at all.

André Malraux has pointed out the effect the poor quality of the imitation of colour in reproduction has had on the appreciation of works of art arguing that 'The reason why the impression that Byzantine art was paralysed so long prevailed is simply, that its drawing was conventional — whereas its life-force, genius and discoveries were recorded in its colour.'[40] As late as 1949 he claimed that 'Until quite recently its history was the history of its drawing - and in it drawing counted not at all.'[41] In fact it is only during the last generation that relatively accurate colour reproduction has become economical enough for the redress of this imbalance and even so the attractiveness of the colour plate has brought its own distortions. To what extent has it contributed to a re-evaluation of masters of colour and encouraged the use of a colourful palette by contemporary artists?

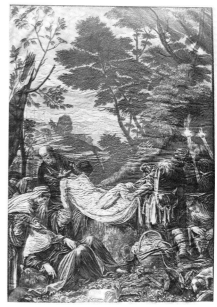

79B

79B

The same print, photographed in raking light

The series consisted of twenty-four plates after seventeen paintings, the larger paintings being reproduced on several sheets. Jackson's use of woodblocks printed in a range of tones applied techniques developed in the reproduction of drawings (figs.117,149) to the reproduction of paintings. What was entirely new was the extent to which he embossed the sheet adding cast shadows to his range of printed tones. The boldness of the prints made them particularly suitable for decorative purposes and Jackson subsequently emerged as a wallpaper manufacturer. Of the series Walpole wrote in a description of Strawberry Hill: 'The bow-window below leads into a little parlour hung with a stone-colour Gothic paper and Jackson's Venetian prints, which I could never endure while they pretended, infamous as they are, to be after Titian, & c., but when I gave them this air of barbarous bas-reliefs, they succeed to a miracle: it is impossible at first sight not to conclude that they contain the history of Attila or Tottila, done about the very era.'[x] The original of this print is in S. Maria in Vanzo, Padua. Lit: Kainen 19.

80A

80A *See colour plate IX*
LOUIS-MARIN BONNET (1736-1793) AFTER BOUCHER

Tête de Flore

Signed and dated in facsimile *F Boucher 1757* and
signed and dated *Bonnet 1769.*
Colour etching in the crayon manner with mezzo-
tint, printed from eight plates. Sight size 40.6 x 30.5
VAM Jones 540-1882

The print was advertised in *Avant-Coureur* at six livres
unframed and ten or fifteen livres framed, depending
on the moulding. Not only were eight plates in-
volved but three of the plates were selectively inked
à la poupée with more than one colour. There are a
number of versions of Boucher's pastel but that
thought to be the original is in a private collection in
Paris. They are all in the same sense as the print.
Lit: Herold 380; Jean-Richard (Boucher) 192; Car-
lson and Ittmann (General) 63.

TÊTE DE FLORE.
Gravé par Bonnet d'après le Dessin de Monsieur Boucher
A Paris, chez Bonnet, rue St Jacques.

80B

80B
LOUIS-MARIN BONNET (1736-1793) AFTER BOUCHER

Tête de Flore. 1773

Lettered with title and *Gravé par Bonnet d'après le Des-*
sein de Monsieur Boucher. A Paris, chez Bonnet, rue St
Jacques. Numbered *No. 192.*
Colour etching in the crayon manner, printed from
three plates. Cut to 45.7 x 35.7
The Trustees of the British Museum

The printing of the eight plates was an unusually
intricate business which was further complicated by
the fact that some plates appear to have worn out
before others. In 1773 Bonnet issued a three plate
edition. This was not only easier to print but prolon-
ged the commercial usefulness of two of the original
plates now used for the red and blue inks while the
black was printed from either a reworked or a re-
placement seventh plate, found only in later im-
pressions of the full-colour version.
Lit: Herold 380; Jean-Richard (Boucher) 192.

81

81 *See colour plate Vb*
JEAN-FRANÇOIS JANINET (1752-1813) AFTER
JEAN-BAPTISTE-ANDRÉ GAUTIER-DAGOTY

Portrait of Marie-Antoinette. 1777

Lettered on the printed mount *Marie-Antte D'Autriche Reine de France et de Navarre.*
Colour etching and engraving on two sheets, printed from several plates. 40.8 x 31,9 complete
VAM E.422-1905

The oval portrait, reproducing a gouache by J.-B.-A.Gautier-Dagoty, was printed from four rectangular plates in red, blue, yellow and black according to Le Blon's three-colour process, the privilege of which had been acquired by Dagoty's father. Superimposed on it is a cut out frame printed in blue, orange and gold inks, the latter made of gold leaf, also printed from separate plates. The use of gold leaf was restricted to certain trades excluding engravers. Beneath the frame, in uncut examples, the print is lettered with Janinet's name and address in the normal way. The masking of this lettering not only increases the effect of the print as a full-blown picture but also made the engraver, whose use of gold leaf was illegal, less vulnerable to prosecution.
Lit: Carlson and Ittmann (General) 66.

82A
GIOVANNI VENDRAMINI (1769-1839) AFTER WHEATLEY

Hot Spice Gingerbread Smoking hot! From the set *Cries of London* published by Colnaghi & Co., London, 1793-97

Lettered with scratched letters with title and *Painted by F Wheatley RA Engraved by G Vendramini London. Pubd. May 1t. 1796. by Colnaghi & Co. 132 Pall Mall.*
Stipple engravings. 42.5 x 33
VAM 29698.10

82B

the same print from a later state of the plate

Lettered *Cries of London* and with title in English and French and *Painted by F.Wheatley R.A. Engraved by Vendramini Plate 12 London. Pubd. as the Act directs May 1, 1796, by Colnaghi & Co. No. 132 Pall Mall.*
Colour stipple engraving, printed from a single plate, with additional colour by hand. 42.5 x 33
VAM E.117-1963

Twelve of the *Cries* in this series were engraved and published in pairs between 1793 and 1796 and the thirteenth in 1797. A press cutting of 1795 noted that Schiavonetti, the principle engraver with Vendramini, 'is proceeding very successfully with his series of the Cries of London, which Wheatley contrives so well to convey through the medium of little *groups* that form an assemblage of interesting incidents. Schiavonetti is also engaged on a work of heigher order, viz. a set of plates to represent the custom and dresses of the University of Cambridge...'[XI] This quotation gives an insight into the relative standing of these works. The prints were issued by Colnaghi with a wrapper entitled *The Itinerant Trades of London in thirteen engravings, by the first artists, after paintings by Wheatley in monochrome and coloured sets,* and sold at 7/6 and 16/- respectively. The long lasting popularity of the series is indicated by the large number of versions that have and continue to be issued not only as prints but also as decoration on such diverse objects as table-mats, lampshades and waste-paper baskets. The fashion for them reached its height perhaps in the 'twenties when the fourteenth subject, 'Pots and pans to mend' was engraved for the first time and one complete set fetched £3300 at auction, an exceptionally large sum for the period.
Lit: Brinckmann and Strange (Wheatley) pp.27-45; Webster (Wheatley) pp.81-85.

82A

82B

83A

83B

A Tea Garden. 1790

Lettered *Painted by G. Morland Engraved by F.D.Soiron.*
Colour stipple engraving, printed from one plate,
with additional colour by hand. Cut to 45.1 x 53.3
VAM E.130-1963

This subject and its pair, *St James's Park* also by Soiron
after Morland, stand out among colour prints of this
kind for the intricacy of their printed colouring. At
least five different colours instead of the more
normal two or three have been used. Its colour range
is, nevertheless, much more restricted than that of
the painting with the result that details like the red
linings to the mens' jackets are not picked out. A
colour impression in the Fitzwilliam Museum, Cam-
bridge, uses a slightly different range of colours
suggesting that more elaborate impressions in colour
were pulled to order rather than in a batch and were
subject therefore to the vagaries of different printers
and to the availability of certain colours. The print
was also issued in monochrome.

A Tea Garden

Oil on canvas. 40.9 x 50.2
The Trustees of the Tate Gallery

84A

Mrs Musters as Hebe. Exhibited 1785

Oil on canvas. 238.8 x 144.8
The Iveagh Bequest, Kenwood House

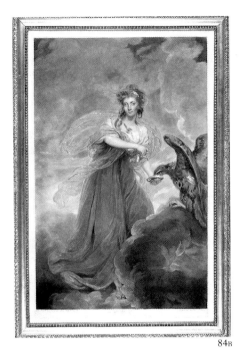

84B

**Hebe. 1785. First State. In a contemporary
frame**

Lettered in open letters with title and *Painted by Sr.
Joshua Reynolds Engraved by C H Hodges London Published*
(the date illegible) *John Raphael Smith No.83 Oxford
Street.*
Colour mezzotint, printed from one plate, with
additional colour by hand. 61 x 38.1
Rob Dixon

It is frequently claimed that mezzotints were printed
in colours only when they had lost their brilliance as
a ploy to revitalize a weakened plate and thus pro-
long its commercial use. The existence of this proof
impression shows that this was not always the case.
Lit: Chaloner Smith (General) 25.

A Fruit Piece. Second state

Inscribed in scratched letters *Van Huysum pinxt Richd
Earlom sculp 1781 Published Sept 1st 1781 by John Boydell
Engraver in Cheapside London, John Boydell excudit 1781.*
Mezzotint. 55.3 x 41.5
VAM 19971

85A

85C

85B *See colour plate IIIb*

The same print. Third state

Signed and dated in facsimile within the design *Jan Van Huysum fecit. 1723.* Lettered with title and *In the Cabinet at Houghton. Size of picture 2f .. 2I by 2F 7 I high Published Sep r. 1st. 1781 by John Boydell Engravers in Cheapside London. Van Huysom Pinxit. Joseph Farington delint. John Boydell excudit 1781 Richd. Earlom sculpsit.* Mezzotint, coloured by hand. 55.3 x 41.5
VAM 28264.3

The toned base of a mezzotint printed lightly in black provided the hand-colourist with built in modelling thereby facilitating his task.

85C *See colour plate IIIc*

The same print from the same state of the plate

Colour mezzotint, printed from one plate.
VAM 28264.2

Printed *à la poupée* from the single plate used for the uncoloured version of the mezzotint, this colour print demonstrates in comparison with the hand-coloured impression the limitation this method of printing imposed on the palette.
Lit: J.E.Wessely, *Richard Earlom, Verzeichniss seiner Radirungen und Schabkunstblätter,* Hamburg, 1886, 145.

85B

86

JOHANN NEPOMUK STRIXNER (1782-1855) AFTER ROGIER VAN DER WEYDEN

The Annunciation. Left wing of the Three Kings Altarpiece from St.Columbia Cologne. From *Die Sammlung Alt-Nieder-und Ober-Deutscher Gemälde der Bruder Sulpiz und Melchior Boisserée und Johann Bertram. Lithographiert von Johann Strixner,* **Stuttgart, 1820-36**

Lithograph printed in buff and black. 56.5 x 29.7
VAM E.2569-1920

Strixner worked first with Senefelder and then with Johann Christian von Mannlich, director of the Bavarian Royal Museums and Galleries who took over Senefelder's printworks with a view to promoting German painting through the new medium of lithography. He was subsequently invited to Stuttgart to master-mind the publication of the Boisserée collection of paintings. His use of tint stones with the whites scraped out gives the image a grace which reflects the spirit of the original although it does not imitate it in any literal sense.
Lit: Twyman (Technique) pp.21-2; Friedman (Technique) 118-9.

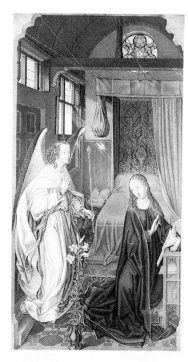

86

87A

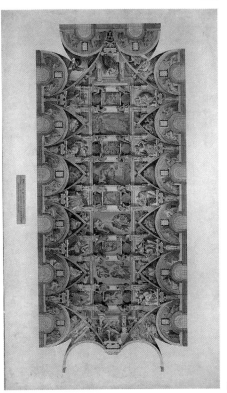

87B

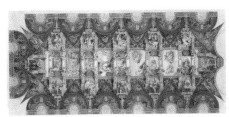

88

87A

DOMENICO CUNEGO (1727-1794) AFTER VINCENZO DOLCIBENE AFTER MICHELANGELO

The Sistine Ceiling

Lettered *Opus Elegantissimum in Vatican Sixtino Sacello A Michale Angelo Bonarotio Coloribus expressum. Vicen. Dolcibene del. Do,.Cunego Sculp. Rom. Longitud. palmm. Rom. 171. unc. 8. Latitud. palmm. Rom. 59. unc. 6.*
Etching. 107 x 104
VAM E.6228-1906

The lettering's reference to Michelangelo's expression in colour appears to be an inducement to the colourist to return the image, represented here purely by line, nearer to the effect as 'originally' executed in the Sistine Chapel.

87B *See colour plate XIII*

The same print

With a label: *Drawing of the 'Frescoes' on the Ceiling of the 'Sistine Chapel', 'Rome'. Michelangelo - 1509-12*
Etching, coloured by hand in watercolour and gold paint. Cut to 49.3 x 107.5
VAM 430

This impression has been taken with the plate only lightly inked and the lettering masked so that the printed line acted as no more than a faint guide to the colourist. Its mass-produced origins are almost disguised.

88

F. STORCH (MID 19TH CENTURY) AFTER PRATESI AFTER MICHELANGELO

The Ceiling of the Sistine Chapel

Lettered *Executed and printed in colours under the direction of F.Storch at the lithographie Institute of Winckelmann & Sons at Berlin 1852-32. The rest cut. Le.Gruner direxit. To Charles Lock Eastlake, President of the Royal Academy, &c.&c. &c. Whose Works and whose Influence have ever tended to foster a taste for the highest style of Art: -this Lithographic Print of the Ceiling of the Sistine Chapel by Michael Angelo executed at the expense of J.S.Harford, Esqre. of Blaise Castle, is inscribed by him with every sentiment of respect & esteem.*
Colour lithograph printed on two sheets, joined irregularly along the line of the architecture. Cut to 47 x 101
VAM E.746-1886

J.S.Harford, banker and patron of the arts, commissioned the production of this lithograph, under the direction of Ludwig Gruner in Berlin, in connection with the monograph he was preparing on Michelangelo. First published by Colnaghi in 1854 in an edition of 229, there was a subsequent edition of 300 in 1857. It was the product of forty-two separate printings. Harford's wife recalled the arrival of the first copies in London in 1852 'we sent for Colnaghi to come and inspect - he was charmed and astonished - and said to me 'a statue of gold ought to be erected to Mr Harford, having made the means of accomplishing such a work' - and when we were in Rome in 1852-1853 - the beautiful print was several times laid out on a table in the Sistine Chapel, while he beautifully explained its various compartments to circles of admiring friends - who by means of small looking glasses (such as dressing boxes contain) could each bring down from the original a figure, or a compartment and compare it with the copy lying before us'[XII]. *The Times* considered the print as 'one of the most extraordinary specimens of art or polychromic or coloured lithography which we have yet seen'.[XIII]

Lit: Ledger (Arundel Society) pp.79-81.

90

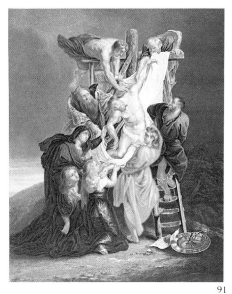

91

91

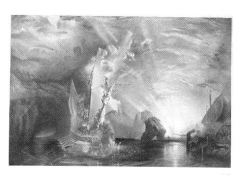

89 *See colour plate XIa*

JOHN CONNELL OGLE (WORKED 1844 TO 1864) AFTER TURNER

Ulysses Deriding Polyphemus. Published by George Rowney and Co.Ltd., c.1856

Colour lithograph. 45.5 x 68
VAM E.5446-1946

A label on the back states 'The Picture is generally esteemed as the finest work of this great master;' and Rawlinson, the author of *The Engraved Work of Turner*, regarded it among the triumphs of English chromo-lithography.
Lit: Rawlinson (Turner) 860.

GEORGE BAXTER (1804-1867) AFTER RAPHAEL

SS. Peter and John Healing the Sick. From a set of prints after *The Raphael Cartoons*. c.1860

Baxterotype, printed in black and buff. Cut to 14.3 x 21.3
VAM E.2932-1932

It was claimed that Baxter's prints after the Raphael Cartoons were drawn from the originals although they imitate the tones of an albumen print and were likely to have been influenced by the famous large photographs taken by Thurston Thompson (fig.99) at about the time of their production. In 1859 Baxter patented this method of imitating photographs with wood blocks.
Lit: Lewis 249.

GEORGE BAXTER (1804-1867) AFTER RUBENS

The Descent from the Cross. 1852

The mount embossed with the title and *G. Baxter Patentee Gt.Britain, France, Belgium, Germany & c.*
Baxter print. 20.5 x 16.6
VAM E.4393-1897

Baxter's process, patented in 1835, combined intaglio and relief printing methods. The foundation plate, which printed the main features of the design was etched (often through an aquatint ground) or stipple engraved, and oil colours were superimposed from wood blocks. Fourteen blocks were used in the production of this image which reproduced the painting in the cathedral at Antwerp. It is said to have sold in large numbers in Roman Catholic countries.
Lit: Lewis 236.

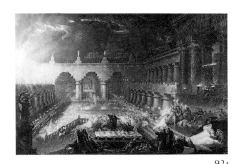

92A

JOHN MARTIN (1789-1854) AFTER HIMSELF

Belshazzar's Feast. 1826

Mezzotint. Cut to 54.6 x 74.5
VAM E.569-1968

This subject was Martin's most popular composition. When the painting on which the print was based was shown at the British Institution in 1821 it had to be roped off to protect it from the pressing crowds. The print was his first large mezzotint and sold so well that he was led to replace the first plate when it became worn with a second. This version is frequently encountered hand-coloured, a factor which may have encouraged George Cargill Leighton to select it as the subject for one of his colour wood-engravings.
Lit: Balston Appendix 8a, 5; Wees 29.

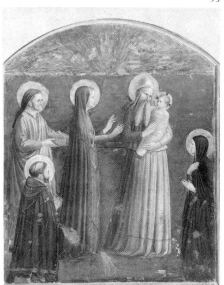

93

93 *See colour plate IV*

WILHELM GREVE'S FIRM AFTER EMILIO COSTANTINI
AFTER FRA ANGELICO

The Presentation in the Temple. Printed by Wilhelm Greve, Berlin, and published by the Arundel Society, London, 1889

Colour lithograph. 41 x 34.3
VAM E.326-1895

An example in which the Arundel Society decided to present its members with the fresco in its current state of disrepair rather than with a restoration. Lithography was more advanced in Germany and France than in Great Britain. The Arundel Society's first lithographs were printed by the London firm of Vincent Brooks but they quickly turned to more sophisticated foreign firms like Storch and Kramer, Berlin, and later Wilhelm Greve, also of Berlin, and Hangard Maugé of Paris.
Lit: Johnson (Arundel Society) p.7.

92B *See colour plate XIb*

LEIGHTON BROTHERS (WORKED BETWEEN 1855-C.1886) AFTER JOHN MARTIN

Belshazzar's Feast

Lettered with title and *From a Picture by John Martin, K.L. Leighton Brothers.*
Colour wood-engraving. 44.4 x 59.3
VAM E.566-1966

George Cargill Leighton (1826-1895), the leading partner of Leighton Brothers was trained by George Baxter but to circumvent the latter's patent dropped the intaglio plate from his process, printing only from wood blocks. Cargill's colour plate in the 1855 Christmas Supplement of the *Illustrated London News* provided journalism with its first colour picture and he subsequently became the magazine's printer and publisher from 1858 to 1885. Large plates like this were given away in special numbers. Although all the work was done manually, the large blocks were made up of a considerable number of smaller pieces, screwed together. Once the design was on the blocks, either drawn directly on to them or transferred to them photographically, the block was taken to pieces and the labour of engraving shared by a considerable workforce. Such division of labour allowed wood-engravings to be produced at a speed which competed with images made by the new technology right up to the end of the century.
Lit: Balston (Martin) p.61.

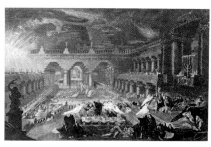

92B

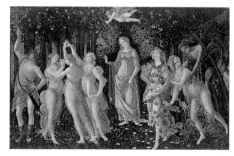

94

WILHELM GREVE'S FIRM AFTER EMILIO COSTANTINI
AFTER BOTTICELLI

Primavera. 1888

Colour lithograph. 52.3 x 82.1
VAM E.553-1888

Botticelli was largely forgotten until the second half of the 19th century. His reputation was resurrected when the Pre-Raphaelites emulated his elongated figures with their flowing tresses. Reproductions of the *Primavera* were, according to Robert Ross, encountered with monotonous frequency on the walls of Oxford undergraduates: 'When uncles and aunts came up for Gaudys and Commem. while *Temperantia* and the *Primavera* were left in their places, *Love dying from the breath of Lust, Antonius* and other drawings by Solomon' which provided 'little notes of illicit sentiment' were taken down'[xiv].
Lit: Johnson (Arundel Society) pp.26-7.

These with one virtuous touch
The Arch-chemic Sun, so far from us remote,
Produces'

Paradise Lost, 13.11,v.608

Thus reads the dedication in William Stirling's *Annals of the Artists of Spain*, much celebrated as the first art history book to be illustrated with photographs (fig.98). The idea of the 'sun' picture has magic and it was as much a search to lay hold of that magic as any fully realised idea of a use for photography which inspired the research which led to its discovery. William Henry Fox Talbot, while sketching with the aid of a camera obscura, reflected on 'the inimitable beauty of the pictures of nature's painting which the glass lens of the camera throws on the paper in its focus – fairy pictures, creatures of a moment, and destined as rapidly to fade away. It was during these thoughts that the idea occurred to me ... how charming it would be if it were possible to cause these natural images to imprint themselves durably, and remain fixed upon the paper!'[42] As photography became less a dream and more a reality, uses for it were enthusiastically enumerated (fig.95). But what comes out most clearly in the writings of all those involved in its early development is excitement over the medium itself.

Its history has, however, been interwoven with that of reproduction from the outset for the first successful image to employ the action of light in its creation was a reproduction of an etching made by J.N.Niépce in 1827 (fig.96). Since 1813 he had been trying to fix an image made by the action of light and achieved his aim by applying the principles of photography to the production of a traditional printing surface. He took an ordinary etching made transluscent by waxing and placed it on a metal plate coated with a substance which hardened on exposure to light, and put it in a strong light for a long time. When the print was removed from the plate the coating had hardened where it had been exposed to the sun but had remained soluble where it had been protected by the lines of the print. These soft areas were dissolved away, leaving bare metal exposed in a network of lines reproducing the design of the original. The plate was then etched and printed like a traditional etching. Thus a reproduction of the original print was produced without any laborious hand-work, although of course the method required a print or some other sort of hand-drawn image, which was destroyed in the process.

The first invention which competed with the traditional artist's autonomy as a picture-maker was the Daguerreotype (fig.97), made public in 1839. This process fixed a positive image from nature by the action of the light of the sun through a lens on to a highly polished light-sensitised silver-plated copper sheet. The fine detail portrayed captivated the imagination of the world but as a pictorial medium, let alone as a medium of reproduction, the Daguerreotype had its problems. The images were formed by minute changes in the polished surface of the silver which could

95

LONDON STEREOSCOPIC COMPANY AFTER ROBERT GRAVES AFTER GAINSBOROUGH

The Duchess of Devonshire. 1876

Carbon print. Size of card 10.8 x 16.4
Howarth-Looms Collection

This print was issued on the theft of the original painting from Messrs. Agnew, Bond Street, London, shortly after the firm acquired it for 10,100 guineas, the highest price ever paid at that date for a picture at auction. The retrieval of stolen property was one of the uses Talbot cited for his invention in *The Pencil of Nature*. The use here of a handcrafted print as the original for the photograph stemmed from a more dire inaccessibility of the original than was usually the case.

96

JOSEPH NICÉPHORE NIÉPCE (1765-1843)

The Cardinal d'Amboise. 1827

Heliogravure plate inked up. 18 x 13.9
The Royal Photographic Society

This image, which pre-dated the photography of Daguerre and Talbot, was the first successful photomechanical reproduction.

easily tarnish and could only be seen when the plates were held at an angle to catch the light. Moreover, each Daguerreotype was unique: in order to make a replica the whole process had to be done afresh. Although these disadvantages were partially overcome by Dr Joseph Berres who produced an ink-printed image from an etched solid silver Daguerreotype in 1840 and by Hippolyte Fizeau, who made electrotypes of Daguerreotypes from which images could also be printed in ink the following year, it was the Daguerreotypes themselves which were the curios it was desired to reproduce and they, in their turn, seldom reproduced works of art in more traditional media.

Talbot's first successes were made by placing the chosen object on a sensitised sheet of paper, a method he used on occasion to reproduce drawn images but one which like Niépce's necessitated the waxing of the original and therefore its destruction. It was because this procedure was followed that the sketch of *Hagar* by Francesco Mola in *The Pencil of Nature*[43], published in 1844, was reproduced from a facsimile rather than from the original. Talbot's Photogenic Drawing process announced only days after Daguerre's process[44], however, made possible a repeatable positive image from a single developed negative, and thus provided the conceptual breakthrough which underpins photomechanical reproduction. The Calotype process announced in 1841 allowed the creation of a latent image by chemical means, speeding up the required exposure time (fig.98).

In 1851 Frederick Scott Archer published details of a new photographic process which produced negatives on glass plates still wet with sensitising solution and was therefore known as the wet collodion negative technique. Combining the fine detail of the Daguerreotype with the unlimited number of prints from a single negative, characteristic of Talbot's processes, it made photography a viable alternative to the well-tried manual techniques of reproduction. At this date it was recommended that the Louvre should collect and exhibit photographs of works of art not represented in its collections[45]. The Alinaris founded their photographic enterprise, Fratelli Alinari Fotografi Editori in 1854, and were soon in a position to offer tourists to a wide range of European cities photographic souvenirs of their visits to museums and art galleries (fig.230) as well as, of course, topographical views. Prince Albert was shortly assembling his complete photographic corpus of the works of Raphael. By 1856 Thurston Thompson (fig.99) had an unofficial position as photographer to the South Kensington Museum and Roger Fenton had a similar relationship with the British Museum. In 1859 the South Kensington Museum began selling photographs to the public.

As the public became accustomed to this new form of reproduction uncritical excitement gave way to more measured if subjective response. Delacroix, a supporter, was compelled to point out how photography showed up imperfections masked in the presence of the original by the impact of its colour and the bravura of its handling.[46] And Ruskin, ambivalent, chose to stress the moral value of human labour as against the impersonal chemistry of the new process: 'Believe me, photography can do against line engraving just what Madame Tussaud's wax-works can do

against sculpture. That, and no more. I tell you...a square inch of man's engraving is worth all the photographs that ever were dipped in acid (or left half-washed afterwards, which is saying much) only it must be man's engraving; not machine's engraving.'[47] Practitioners were particularly anxious about the camera's ability to do justice to paintings. According to William Lake Price 'taking a really good copy from an oil picture is the most difficult ...The effect of the colours, as seen in the picture, may probably be transposed in the photograph, and thus a light yellow drapery in the high light of the composition, and a deep blue in the dark portion will, in the photographic copy, produce startling and precisely opposite effects from those which they did in the original...The varnished surface is so much exposed to receive reflexions, from surrounding objects, that, if the greatest care be not taken to guard against them, the subject, in such parts, becomes obliterated in a sheen of light'[48].

Another more universal problem of the photographic print was its changeability in contact with the atmosphere. The residual silver compounds which remained in the albumen coating after fixing reacted with sulphur compounds in the air to produce a yellow stain in the highlights. This effect could be somewhat counteracted by the use of tinted papers and by toning with gold, a procedure which turned the reddish brown of a fresh print to a purpler brown, but it encouraged the search for more permanent methods by which to print photographic images. Among the most widely used for the reproduction of works of art was the carbon print (fig.103), perfected in 1864 by Sir Joseph Swan. This process consisted of a tissue of bichromated gelatin, impregnated with carbon or some other colourant depending on the tone required, which was treated to make it light sensitive in order to form, on exposure to a traditional negative and after the washing out of the unhardened gelatin, a tissue which was thinner or thicker depending on the density of colour required. Superficially carbon prints look like conventional photographic prints but they are not susceptible to fading because of the use of a stable pigment. The Woodburytype, patented in 1865, was an adaptation of this process. It used the gelatin relief to make a mould in which the image, made of pigment suspended in gelatin, was cast.

Photogravure was another technique which produced comparatively permanent prints. It built on the technique of the Woodburytype, using the gelatin film as a resist on an intaglio plate, usually prepared with a fine aquatint ground. When it was immersed in the etching fluid the acid bit quickest through the gelatin to reach the plate where the gelatin was thinnest, and therefore etched those areas deeper than where the gelatin was thicker. Printed in the same way as a traditional intaglio plate, it produced images which looked not unlike engravings executed in the mixed method by hand (fig.102) and remained popular with a public which hankered after prints with a traditional appearance long after fine colour prints were on the market.

Collotype, a related photo-based technique, actually uses a gelatin film as the printing surface. It is dependent on the fact that light-sensitised bichromated gelatin hardens in proportion to the amount of light to which it is exposed and accepts ink in inverse proportion to the moisture it retains. First used effectively in the 1870s, it

97A & B
MINIATURE, WITH DAGUERREOTYPE TAKEN FROM IT
Each 7.2 x 50.2
Howarth-Looms Collection; courtesy the Science Museum

The Daguerreotype process was not a technique of mass-production although it was used here to reproduce a miniature. The intention must have been to show the Daguerreotype to advantage beside a product of the miniature painter with which the Daguerreotype was in competition. This example is reversed but mirrors could be fitted in the camera to produce an image in the same sense as the original.

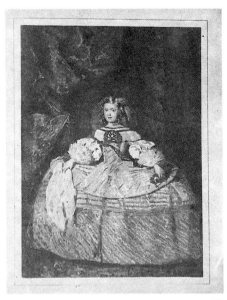

98A

THREE PRINTS FROM THE SAME NEGATIVE AFTER AN
ENGRAVING BY PIERRE AUDOUIN (1768-1822) AFTER
VELASQUEZ

**The Infanta Margarita Maria. Published in
the volume of illustrations made by Nicolas
Henneman to William Stirling,** *Annals of the
Artists of Spain,* **1847. The text published 1848**

Calotype. Image 11.8 x 8.4
The Science Museum

The volume of illustrations was limited to 25 copies.
The variation in colour between the prints stems
from the different effects produced by the use of
chemicals in uncontrolled conditions.

was the last continuous tone process to be developed specifically for reproduction
and the first photographic process to provide high quality colour reproductions of
the Old Masters. Medici Prints (fig.104), first issued in 1906, were outstanding.
They were greeted by such plaudits as 'No feat of facsimile imitation is beyond the
power of this Medici process' from *The Burlington Magazine,* which went so far as to
claim in 1909 'Only when the reproduction is examined with a magnifying glass does
its full excellence become apparent.'[49] What the magnifying glass shows in fact is the
painting's detail suffused with the imprint of the gelatin's texture.[50] The disadvant-
ages of the process are that it is not compatible with a high level of mechanisation
and the gelatin plates, being fragile, do not give a high yield. Although still used by a
handful of specialists, its commercial application is now rare.[51]

A vital step towards the automation of the reproduction industry was the in-
troduction of the cross-line screen which organised the representation of tone into a
regular system of dots. Its application to photogravure in the 1880s provided an
even surface from which to wipe the excess ink and made possible the application of
the automated rotary press principle, pioneered by relief printing, to intaglio plates.
Rotary gravure was first used by the textile industry but was employed from the
outset by The Rembrandt Intaglio Printing Co. established in 1895 to print repro-
ductions. Colour photogravure printing at this date however continued to involve
the manual application of colour to the photographically produced plate (fig.106).

It was in the half-tone relief process which has come to be known as 'let-
terpress' that photomechanical three-colour printing was pioneered. Successful
specimen prints, using initially the three primaries only, began appearing in the
1880s but as late as 1897 a writer in *The Penrose Annual* could still reflect on 'printers
who regard this new process of colour printing as only a nine-day's wonder.'[52]
Although Senefelder, the inventor of lithography, had predicted in his treatise that
the process would not be perfected 'until the impression can be produced wholly by
good machinery'[53] its mechanisation, like that of gravure, lagged behind that of re-
lief printing. The wetting of the stone provided an extra hurdle but the crucial pro-
blem was the incompatability of the flat stone with the speedier rotary machines.
This was not overcome until the introduction of the offset method, by which the
image is transferred first to a rubber cylinder and then to the surface receiving the
image. Developed for printing on tin in 1875, offset was not applied to printing on
paper until the 1890s. The flexibility of the cylinder allowed the use of 'Any class or
type of paper... hard, plain hand-made papers, as well as soft-sized, machine makes'
even 'crocodile marked and fancy ribbed'[54] giving lithography an advantage over
letterpress for which coated papers were essential. But, although the sleeving of
cylinders with metal plates of the kind suitable for lithography in the early years of
this century was another breakthrough, it is only since the 1960s that offset litho has
ousted letterpress as the most widely used technique for printing reproductions.

Photogravure, letterpress and offset litho are all available to a limited extent
today. Photogravure printed on good quality cartridge paper achieves rich results in
monochrome although in colour work the ink can look too full. The initial manu-

facture of the etched cylinders is, however, expensive and so the process tends only to be used if a long run is envisaged or if a print of a particularly velvety quality is required. The crispness of letterpress, the process held until the last year or two to produce the most densely coloured reproductions of paintings, has now been equalled in offset litho, which has a number of advantages. Since the Second World War greater resources have been put into the development of litho presses and the plates are not only quicker to ink but better adapted to time-saving photo-setting; moreover, it still allows the use of more sympathetic papers. The basic decision as to which process to use is perhaps only the simplest. Once taken, a multitude of other decisions about the colour, weight and texture of the paper, the fineness of the screen, and the transparency of the inks has to be made which will have a considerable effect on the resulting image. The hand of man may not be involved in actually copying the image but it is the mind of man that decides what the image in its new form will look like.

In 1888 William Powell Frith said 'in photogravure, so popular now, the place of the second mind (i.e. the engraver) is supplied by a machine, which often does its best to destroy or mutilate the efforts of the first (i.e. the painter); but sometimes, I admit, reproduces the effect of a picture with extraordinary accuracy. But accuracy, in my opinion, is not enough; I want at the same time the taste and skill, which amount almost to genius, with which the great engraver changes into black and white the colours of the picture before him.'[55] More recently John Piper has expressed a comparable view: '...when a painter's work is reproduced in colour, by whatever method, he should ask for a lively parallel to his work, not an imitation of it, in colour or in any other particular...He should ask, in fact for the same kind of result he would get if he translated a work of his own into another medium.'[56] The artists recognize that a reproduction is inevitably a subjective reconstruction which they ask should add creatively to their work. It can be argued that because the modern four colour reproduction disguises this fact more convincingly than its hand-crafted counterpart, it is the more misleading. The camera's power to pick out details and blow them up, allowing the representation of, for example, a view glimpsed through a window in the background of a picture as a full-scale landscape, can re-create images in a form in which they have no previous existence. Photographic dexterity also makes the actual level of accuracy difficult to assess without comparison with the original, and encourages the viewer to forget that however faithful in visual terms a photographic reproduction is, it comes no closer to presenting the physical structure of the original than any of the traditional techniques.

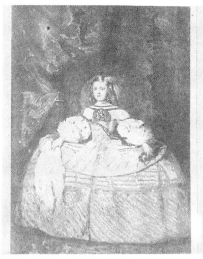
98B

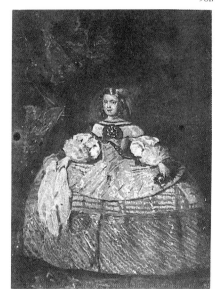
98C

CHARLES THOMPSON THURSTON (1816-1868) AFTER
RAPHAEL

**The Miraculous Draught of Fishes. From
negatives made in 1858**

Inscribed in ink with notes on condition and *This
cartoon is in a tolerable state except that the whole of sky on
the right side is wholly repainted in the coarsest manner and
many of the parts marked as rubbed the colour is much off
RR 5/5/65.*
Albumen print. 55.2 x 68.3
VAM 76602

The light was seldom good enough to photograph
paintings in situ. The Raphael Cartoons were photo-
graphed upside down in the courtyard at Hampton
Court with scaffolding erected specially for the pur-
pose. Wet plate photographers found enlarging a
difficult and impractical process. If a large photo-
graph was required, then generally a large camera
was used to make a large negative. The three foot
collodion-coated glass plates used for the Car-
toons were carried in an apparatus measuring twelve
foot long which ran on a small tramway. The results
were highly praised: 'These photographs are all but
as valuable as the originals. You can see even the
pleats in the paper, the great wave lines, the flower
stalk curves of grace, the beauty as of the bent rose
or the wind-tossed lily are here; and,come fire or
sword to the long corridor at Hampton, the Car-
toons are now safe and sown over the world for ever.
Great works of Art are now, when once photo-
graphed, imperishable and must last while the world
lasts.'[XVI]
These prints were used to record the condition of
the Cartoons on their physical transfer to South
Kensington and show how much more effective than
the manual techniques of reproduction a photo-
graphic image is for that kind of documentation. The
notes were made by Richard Redgrave, painter and
the first Keeper of Paintings at the South Kensington
Museum.
Lit: Physick (Technique) pp.6-7; Fawcett (General)
p.192.

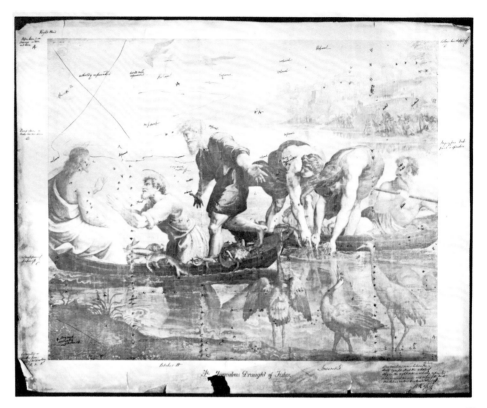

99

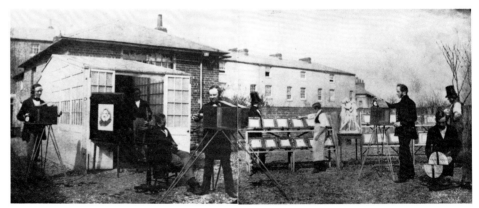

100

100

**Talbot's printing establishment at Reading.
c.1845**

The Science Museum

L'Ile de Cythère by an anonymous artist after Watteau printed with different densities of screen

Colour offset litho
François Heugel

Whichever technique is used to reproduce an 'original', the density of the screen is vital. A fine screen provides a subtler modulation of tone but less contrast. Against these general considerations have to be weighed the requisites of specific types of reproduction. Obviously a reproduction which is meant to make its impact from a distance can support a larger screen than say a book illustration but even within these constraints great variety is called for. An image which is full of detail needs a finer screen to prevent a clumsy appearance than, say, an abstract painting with large expanses of unmodulated colour.

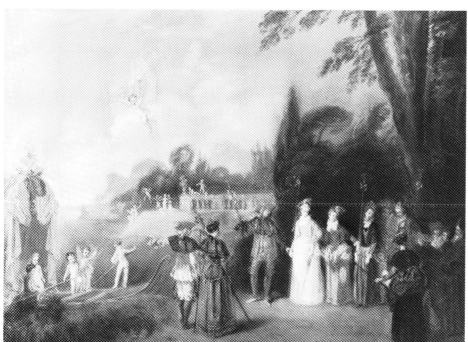

102

AFTER LORD LEIGHTON

The Garden of the Hesperides

Lettered *Painted by Sir Fred. Leighton P.R.A. London, Published February 1st 1893 by Arthur Tooth & Sons, 5 & 6 Haymarket S.W. Copyright Registered by the British Art Publishers Union Ltd. New York and Stiefbold & Co. Berlin. Printed in Berlin.*
Hand photogravure printed in sepia. 73 x 69.2
VAM E.183-1970

As photogravure was an intaglio process requiring etching, the photographic base could be worked on by hand to sharpen up the image or to provide the increasingly valued touch of the individual. Impressions were printed in the same way as traditional prints usually either in black ink so that they resembled the more traditional mixed method engravings or in tones of brown, as here, an acknowledgment of their photographic origin.

103

HENRY HERSCHEL HAY CAMERON AFTER WATTS

Hope. In a contemporary frame. Between 1886-1890

Inscribed in ink *From Life by G.F.Watts R.A. H.H.Cameron Studio, 70 Mortimer St.W.1.*
Carbon print. Frame size 65 x 53
Private Collection

G.F.Watts, considered the Titian of his time, was a neighbour of the Cameron family and an important

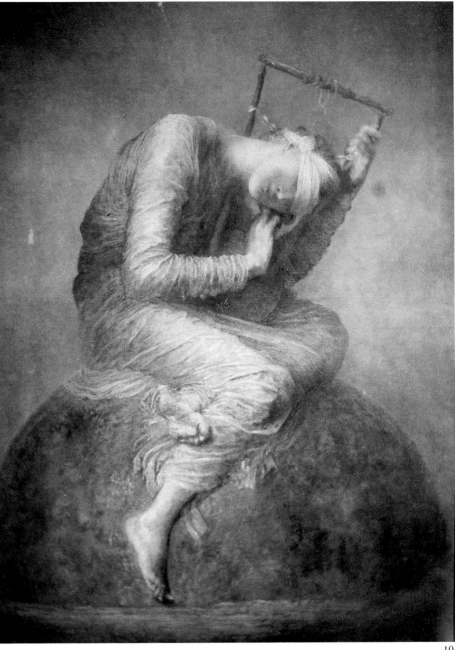

103

influence on Julia Margaret Cameron, Henry Herschel Hay's mother. He admired her work greatly and believed that 'her work will satisfy posterity that there lived in 1866 an artist as great as Venice knew.' Beneath one of her portrait photographs he wrote 'I wish I could paint such a picture as this'[XVII]. Watts' own reputation owed much to the easy availability photography brought to popular paintings. His *Hope* and his *Sir Galahad* were in particular much reproduced.

114

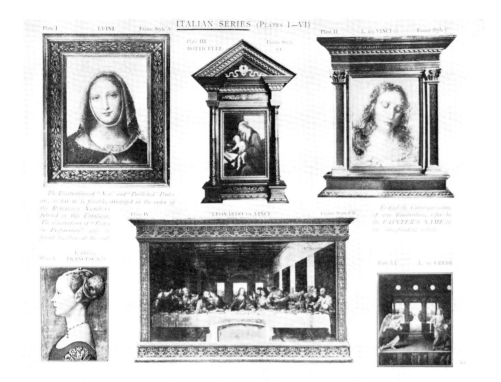

Page from a catalogue of the Medici Society, 1910

The Medici Society Ltd.

Following the success of the Medici series of colour reproductions issued in 1906-07, the Medici Society was founded in 1908 'in order to publish at the lowest price commercially possible a selection of perfect, direct reproductions after paintings by the Great Masters'.

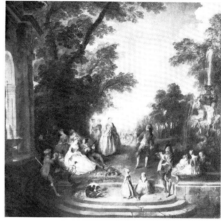

105A

105A
NICOLAS LANCRET (1690-1743)

La Danse entre les Deux Fontaines. c.1920

Oil on canvas. 42 x 56.5
Dresden Museum

105B
AFTER LANCRET

Detail from *La Danse entre les Deux Fontaines*

Colour photogravure, moulded and varnished. 62.8 x 83.5
Stephan Adler

The camera has taken the central area of action in the painting and blown it up larger than the entire original thus creating a new image. The reproduction is presented just like a painting, varnished, mounted on linen and wrapped around a stretcher, and actually looks at first glance like a painting. But the leadenness of the brushstrokes, impressed from a mould, gives it away as does the lack of register of the printing visible along the edges.

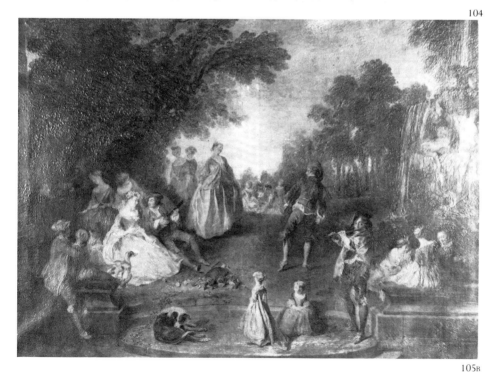

105B

106 *See colour plate Va*

MANZI, JOYANT & CO. AFTER J.M.NATTIER

La Duchesse de Chartres as 'Hebe'. c.1890

Lettered *Printed in Paris, Published by Manzi, Joyant & Co.*
Hand photogravure, printed in colours, from one plate. Image 44 x 34
June Drew

Manzi, Joyant & Co. were the Parisian printers of the London and Paris based, dealer and publisher Goupil & Co. Their colour photogravure prints were produced from a single plate inked afresh by hand for each impression. The number of impressions produced a day was small. Colour photogravure printing from successive separate plates which made possible the production of several thousand reproductions an hour was introduced during the first decade of this century by the Rembrandt Intaglio Printing Company in England and the Van Dyck Gravure Company in the USA. The orientation of this technique towards the reproduction industry is suggested by the names adopted by the firms.
Lit: Burch (General) p.222.

106

107

107

AFTER SIR JOHN EVERETT MILLAIS

The Boyhood of Raleigh. c. 1930. With an enlarged detail

Lettered with title and by *Sir.J.E.Millais. P.R.A.*
Colour offset litho, printed on textured paper, with a plate mark. Including frame 52.5 x 60.7
Private Collection

Another popular image, a version of which was given away as an incentive with a subscription to the *Daily Herald* in the 'thirties. This example is confused about its intentions. The false plate mark passes it off as a hand-crafted print, presumably an attempt to capitalize on the craze for them, but the texturing of the paper simulates the effect of canvas.

Maestri della Tavolozza · n. 1014 G. · Claude MONET · *Les Coquelicots* · Paris,

108

AFTER CLAUDE MONET

Detail from *Les Coquelicots*. Printed in Italy, 1963. With an enlarged detail

Offset litho on a synthetic skin, mounted on cloth. 40.7 x 54.7
Tate Gallery Publications (trade sample)

Attempts to imitate the physical nature of the painting are seldom successful. In fact the grain of canvas is often not visible through the paint and, if it is, it is usually finer in proportion to the whole than it is rendered in a reduced reproduction.

109

AFTER HENRY HOLIDAY

Dante and Beatrice. c.1930

Colour letterpress, stamped in relief. 13.2 x 20
Private Collection

The translation of paintings into reliefs is frowned upon by purists but the process vivifies such a small interpretation. The image is perhaps better adapted to it than some for Holiday, as well as painting the figures from life, painted the setting from a three-dimensional model. The painting used to be represented among the small dioramas at Madame Tussaud.

109

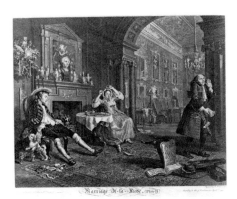

110

BERNARD BARON (1700?-1780) AFTER HOGARTH

Marriage à la Mode. Plate 2. 1745. Third state

Lettered *Invented Painted & Published by Wm Hogarth Engraved by B.Baron According to Act of Parliament April 1st 1745.*
Etching and engraving. Cut to 38.1 x 46.3
VAM F.118(21)

This series of six plates was aimed at a more aristocratic audience than the earlier *Progresses*. Thus, instead of working the plates with his own functional lines Hogarth had them 'engrav'd by the best Masters in Paris' taking particular care 'that there may not be the objection to the decency or elegancy of the whole work'[xviii]. The other engravers to work on the project were Gerard Scotin and S. and R.F. Ravenet, all engravers with the cachet of having worked on the *Recueil Jullienne*.
Lit: Paulson (Hogarth) 229.

A drawback of this essentially chronological account, beginning with the comparatively crude woodcut and ending with photographic veracity, is that it imposes on the creators of the works singled out a false role as protagonists in a purposeful drive towards a method of reproduction which represented its original ever more faithfully. In fact, consideration of which technique to use at any particular moment was governed by quite other factors. Markets tend to impose a certain uniformity of presentation on objects and the choice of medium was therefore considerably influenced by market expectations. There were conventions for the reproduction of certain sorts of subject matter by certain kinds of technique, and even within broad categories there were technical subdivisions, or methods of manipulating the technology, in order to appeal to the desired public.

The work of Hogarth stands out in this context. His choice of line, to which he was predisposed by the skills he had acquired as apprentice to the silver engraver, Ellis Gamble, was in itself a statement about the seriousness of his art. The character of his line, however, varies according to the sector at which the image was aimed. Always aware of his own inability to attain 'that beautiful stroke on copper'[57] he felt competent to work the plates with his functional lines if the images, like those of the two *Progresses* (figs.10b & c,152a), were destined for the merchant classes. If, however, as in the case of *Marriage à la Mode* (fig.110), he wished to attract the aristocracy, a class at home with the shimmering brilliance of the french virtuosi engravers, he employed professionals trained in the most sophisticated Parisian workshops. At the other end of the scale as in *The Four Stages of Cruelty* he increased the crudeness of the intaglio line as if in emulation of woodcut, even having two subjects cut on wood in an attempt to break into the broadside market (fig.111).[58]

The development by the graphics industry over so many centuries of a visual language to target certain market sectors remains one of its most potent forces. Most obviously apparent in the magazine and newspaper industries — for example in the way that *Harper's & Queen* looks different from *Womans Own* — it is a consideration which continues to have a major influence on what a reproduction is made to look like.

111A

111B

111A

JOHN BELL (WORKED MID 18TH CENTURY) AFTER HOGARTH

Cruelty in Perfection

Lettered with narrative within the design and *J.Bell sculp Invd. & Publish'd by Wm. Hogarth Jany 1st 1750.*
Woodcut. 45.2 x 37.6
VAM E.603-1985

Hogarth had two subjects of the series of *Four stages of Cruelty* published later as coarsely worked etchings, cut first on wood, the medium with which the working classes were most familiar. Presumably the expense of hiring a woodcutter, when he could etch the plates himself, made the publication in this medium uneconomical.

111B

WILLIAM HOGARTH (1697-1764)

Cruelty in Perfection. Plate 3 from *The Four Stages of Cruelty*

Lettered with title and three verses *Price 1s. 6d. Published according to Act of Parliament Feb. I. 1751. Designed by W. Hogarth.*
Etching. 38.8 x 32.1
VAM Dyce 2778

The Four Stages of Cruelty, designed according to Hogarth, 'in hopes of preventing in some degree that cruel treatment of poor animals' could 'not be done in to(o) strong a manner as the most stony heart were meant to be effected' and needed 'neither great correctness of drawing or fine engraving' which would on the contrary have 'set the price of them out of the reach of those for whome they were chiefly intended'[XIX]. The etchings were printed on two qualities of paper and sold for one shilling, the coarser, and sixpence extra, the finer.
Lit: Paulson 189.

Chapter 4
The Textures of Drawing

During the whole history of printmaking drawing has been held to hold a special place in the creation of works of art. Cennino Cennini, writing his treatise on painting in 1400, advised the aspiring painter that 'In the first place you must study drawing for at least one year', and although the next six year's training would concern activities such as laying grounds and the grinding and application of colours, the apprentice should also draw 'without intermission on holidays and work days'.[1] This practical advice sprang from a quasi-sacramental belief that the creative process of the artist, most clearly visible in the preliminary sketch, was a sort of ritual, re-enacting of the creation of the world. A reverence for drawing was reiterated in many drawing manuals. For example W.Gore's edition of Gerhard of Brugge's *An Introduction to the General Art of Drawing*, published in 1674, claimed that 'The art of drawing... may justly be called a bearing mother of all the arts and sciences whatever, for whatsoever is made begets thorow the same a good aspect and well-being; and besides all this the art of drawing is the beginning and end, or finisher of all things imaginable, wherefore she may be called a sense of the poesie, because that she, thorow falshoods and masked faces, represents unto the beholder the truth of things present and past, and by pleasant resemblances makes us in a manner believe to see that, which indeed we see not. A second nature she is called, because she teacheth thorow drawings, to imitate and to set forth all the works of the Creation.'[2] With such prestige attached to drawings, great ingenuity went into developing ways of making them more widely available, reproduced as convincingly as possible.

The fact that the physical properties of a drawing are far closer than those of a painting to those of a printed reproduction, must have given this aspect of the industry encouragement. The first prints which used the multiplication inherent to printmaking to make known the work of painters, actually reproduced their drawings rather than their paintings. The similarity between the bold hatchings of Mantegna's pen strokes and the slanting lines of the engravings after his work cannot be fortuitous (figs.27b & c,115b,136b). The graphic language of the drawings thus provided the relatively new medium of engraving with a potential vocabulary less reliant on outline than that used by their predecessors. The faithful reproduction of line drawing was further advanced by the invention of etching which allowed the etcher to make his marks with none of the physical constraints imposed by the act of cutting a line into metal. The essentially linear techniques of engraving and etching were not, however, easily able to render textures of wash or chalk (figs.112,118b).

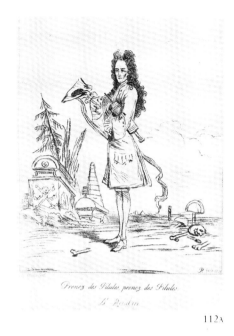

112A

112A
ARTHUR POND (1705-1758) AFTER WATTEAU

Prenez des Pilules, prenez des Pilules. Dr Misaubin. With enlarged detail

Lettered with title and *Watteau del. AP. fecit.1739.*
Etching. 29 x 20.8
VAM E.4964-1920

This plate, and the two following plates, are taken from a series of twenty-two caricatures issued by Arthur Pond between 1736 and 1742, in which traditional etching was manipulated to simulate the effect of drawn marks. Here, the crumbling quality of chalk is conveyed by a synthesis of tiny wriggling etched lines and dots.

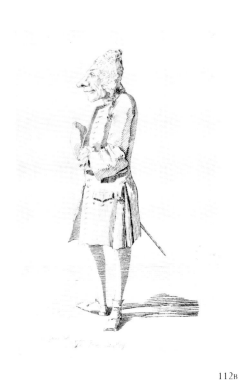

112B

112B
ARTHUR POND (1705-1758) AFTER PIER LEONE GHEZZI

Dr. Tom Bentley. With enlarged detail

Lettered with title and *Cavr. Ghezzi. del.*
Etching. 34 x 21.8
VAM E.4969-1902

A vivid impression of the variety of pen lines is achieved by the laying together of several etched lines so at times they merge and at others they part, creating a double line suggestive of the parted nib of a pen.

Early in the 16th century prints which looked like facsimiles of wash drawings on toned papers began to be produced by a technique now known as the chiaroscuro woodcut. This technique involved the printing of a succession of blocks inked with a range of tones of the same colour, and allowed in some hands for the outline to be dispensed with entirely. In 1516 Ugo da Carpi petitioned the Venetian Senate for the copyright of his exisiting and future prints of this kind on the grounds that he was the inventor of the technique. There are, however, several apparently earlier chiaroscuros connected with Lucas Cranach and Hans Burgkmair. Many of these prints reproduced drawings made especially for reproduction in this way and sometimes the production was supervised by the creator of the image (fig.149). But others seem to have been based on engravings rather than drawings. Ugo da Carpi's version of Raphael's *Massacre of the Innocents* (fig.141g) shows the figures clothed as in Marcantonio's engraving. And it has even been convincingly suggested that his masterpiece, the magnificent *Diogenes* (fig.117) after Parmigianino, was made from Caraglio's print of the drawing, rather than from the drawing itself or as a result of collaboration with the artist. Certainly the fact that it was, over the years, printed in different colours indicates that faithfulness to an original was not important. Such prints resembled and could even be passed off as drawings, but they were not necessarily records of them.

Kirkall, an English engraver of an experimenting bent, built on the technique of Ugo Da Carpi[3], combining intaglio printing with relief in a group of twelve prints after Italian drawings produced between 1722 and 1724 (fig.113). According to 18th century commentators[] the relief element was printed not from wood but from pewter plates with holes cut out to create the remarkable raised whites which are such a feature of his work. As well as representing pen and ink by etched lines as in the roughly contemporary *Recueil Crozat* (fig.169b) and in Pond's slightly later *Imitations of Drawings* (fig.114), Kirkall modelled the darkest tones with mezzotint. Vertue considered this method an improvement on his predecessors' since the edges of the mezzotint tone could be blended more gradually into the relief tone, creating 'an agreeable and harmonius effect far beyond (in some respects) what has been done in Italy by the famous cutters in wood'[5].

A completely different convention for describing form is the dot. The engravings of Giulio Campagnola stand out at the beginning of the 16th century for their use of dots to build up the image. A miniature painter and a cutter of typepunches as well as an engraver, Campagnola would have been aware of the descriptive qualities of massed dots, for they were part of the standard vocabulary of the miniaturist. Similarly decorative dotted punches were a basic part of the metalworker's equipment. His innovatory use of them on the engraver's plate, however, is likely to have sprung from a desire to achieve a specific effect and it has been suggested that the effect he was after was the graininess of Giorgione's drawing[6] (fig.120).

Certainly comparison between Ottavio Leoni's portrait drawings and his engravings after them suggests that his use of stipple, frequently cited as a forward-looking occurrence of the medium in the 17th century, sprang from a search for a

printed equivalent of the effects achieved with stumped chalk in his drawings, rather than from a desire to innovate for its own sake. Known primarily as a portrait draughtsman, he took up engraving late in life in order to capitalise on the growing market for images of virtuosi. The subtle nuances which were conventionally conveyed in the 17th century by the finest of cross-hatchings took years of training to achieve. Leoni used this convention where the modelling in the original was broad, for it could be faithfully rendered by looser and more facile hatchings. But for the finer modelling of the sitters' complexions, he used dots applied more or less densely according to the density of the chalk on the original (fig.121).

The dotted method developed specifically for the reproduction of chalk drawings during the 18th century was, as its name makes clear, the crayon manner. Unlike the method used by Leoni, the technique involved the use of specially manufactured toothed maces and roulettes which pierced the etching ground in a texture similar to that of a chalk line. Closely allied to stipple engraving and often used in conjunction with it (fig.123b), it had the advantage that the use of easily manipulated roulettes allowed the printmakers to lay on the chalk-like lines with gestures of the arm not unlike those made by the draughtsman (fig.125). Devised in France in the middle of the century, it encouraged there in particular the production of light-hearted drawings especially for multiplication by the technique (fig.124). But it was widely used in England for the reproduction of old master drawings (fig.127).

By the middle of the 18th century the collection of drawings had become a fashionable pastime which was stimulated and satisfied as much by the production of imitations of drawings as by originals. Frequently the prints were sold trimmed to the image, to remove the tell-tale platemark. Their resemblance to actual drawings was further increased by the perfection of a new range of techniques, of which the crayon manner was one, aimed especially at rendering in facsimile the varied textures of different kinds of drawings.

Aquatint[7], a method of etching in tone, was announced in one version by Jean Baptiste Le Prince in 1768. It was introduced as a means of portraying the effect of pen and wash drawings with the use of a metal plate only, in place of the combined intaglio and relief process used earlier in the century (figs.113,114). It is a technique which involves the successive stopping out of uniform tones until the darkest are bitten and it therefore builds up the image in a way akin to the laying of washes from light to dark. As a result it was specially effective at capturing the spirit of wash originals. Used particularly in England, to imitate the effect of watercolours (fig.130b), the technique was refined by Paul Sandby (fig.6c) so that the protective ground itself could be layed on like a wash in a liquid by brush.

Soft ground etching (figs.122,131), which was sometimes used in conjunction with aquatint, allowed the artists' marks to be rendered even more directly. As the name suggests, it differs from ordinary etching in the recipe for the ground, which was considerably more impressionable. The drawing can be made with any drawing implement which applies a little pressure on a thin sheet of paper laid on the ground. The paper sticks to the ground in proportion to the pressure exerted, so

112c

112c

ARTHUR POND (1705-1758) AFTER FRANCESCO MOLA

A comic figure. With enlarged detail

Lettered *F.Mola delin. In the Collection of Dr. Peters.*
Etching printed in brown. 20.3 x 15.3
VAM E.4973-1902

The etched lines are drawn so close together and so finely as to give an effect of tonal washes similar to that achieved later in the century by aquatint.

113
ELISHA KIRKALL (C.1682-1742) AFTER GIULIO ROMANO[xii]

The Disputation in the Temple

Inscribed *Julio Romano delin. E. Kirkall Sculp: Lond: 1722.*
Etching and mezzotint printed in dark brown, with a light brown printed in relief. Cut to 44 x 58.5
VAM 12634

Lit: E.Hodnett, 'Elisha Kirkall', *The Book Collector*, Summer, 1976, pp.195-209; Friedman (Technique) 3,4; Hyde (Technique) 5.

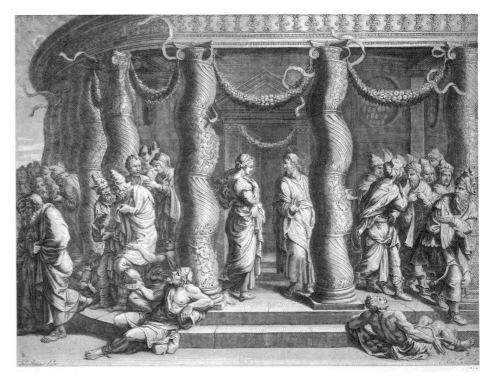

113

that when it is peeled off it removes the ground with it, leaving areas of bare metal which correspond exactly to the marks made by the artist. The technique was used in the 17th century by G.B. Castiglione[8] but there is no evidence that it was exploited at that date. Presumably it was worked out afresh in the later 18th century. The faithfulness with which the technique reproduced the effect of pencil encouraged artists such as Gainsborough and Girtin to compose directly in the medium and gave rise to a spate of imitations of masters of landscape drawing (fig.132).[9]

Both aquatint and soft ground etching were used predominantly, but not exclusively, for the reproduction of contemporary drawings. A technique closely related to the latter but capable of achieving the tonal effects of aquatint was, however, developed by Ploos van Amstel, a timber merchant by profession, specifically for the reproduction of a collection of essentially old master Dutch drawings on which work began in 1765 (fig.128). His method excited considerable interest and is recorded in his account of its demonstration to Prince William V. Thick gum was pasted on to a counter proof of a tracing of the desired image on to which was scattered a 'secret' powder.[10] The prepared sheet was then wrapped around the etching plate, grounded in the normal way, and the lines of the drawing gently indented so that the powder was pressed through the ground on to the plate. Every line appeared on the plate as a series of dots giving a granular texture similar to the marks made by chalk

or graphite depending on the fineness of the powder. An example of the technique in its pure form is the coat of arms Ploos printed on the back of the prints to prevent their sale deceptively as drawings (fig.164). Tone could be given to the whole plate by the subjection of a prepared sheet and plate to overall pressure; roulettes worked over the prepared sheet could render localised shadows, although darker tones, of course, called for longer etching in the normal manner.

The invention of lithography at the end of the 18th century, capable of reproducing the inherent textures of any of these printed media as well as the effects of the full gamut of drawn marks, more or less put an end to this ingenuity. Aspirations towards the facsimile reproduction of drawings concentrated on lithography, and reproductions of drawings were issued in ever greater numbers (fig.22). But although the technique was capable of faithfully reproducing pen, chalk and wash, and was the conveyor of some remarkable productions, the ease of execution made the prize not worth having. The real challenge for lithography was the reproduction of colour (fig.135) rather than line, and attention to the latter often slipped so far that so-called facsimiles of monchrome drawings were extremely poor in quality, just at the time when public expectation had risen (fig.134).

Whatever the inherent power of lithography as a facsimile technique, by the last quarter of the 19th century it was simply outclassed by the near perfection achieved with the help of the camera. Only microscopically is the metal deposited in the paper by the platinum process used by Frederick Hollyer distinguishable from the graphite of the pencil. Photography in fact revolutionised the reproduction of drawings as much as the reproduction of paintings. But because photographs can be printed on paper similar to that on which the originals are drawn, they can also deceive in a way that photographs of paintings never can. Frederick Hollyer was working with Burne-Jones as early as 1875 photographing his slightest sketches as well as fully worked-up designs. Proofs of the results were submitted for Burne-Jones's approval before publication. Examples of these prints catalogued as drawings were found not long ago in a major public collection and many more may lurk undetected among the very large number of Burne-Jones drawings on the market and in private and public collections. Every print room keeper and connoisseur has a Hollyer story to tell.

114 114

ARTHUR POND (1705-1758) AFTER LUCA CAMBIASO

Saint Anthony pursued by Demons. Plate from *Prints in Imitation of Drawings*. 1736

Lettered *Luca Cangiagio. del. E Musaeo Hugonis Howard Armig: AP. fecit. 1736.*
Etching, printed in brown, with wood blocks. 43.6 x 28.4
VAM E.426-1964

Prints in Imitation of Drawings was the first series issued in England which announced an intention to reproduce the actual texture of drawings. It consisted of seventy plates of Italian master drawings from English collections. The effect of wash was printed from a number of wood blocks cut by professional wood engravers[viii], a method pioneered in the *Recueil Crozat* (fig.169b).
Mariette criticised the second rate quality of the drawings selected for reproduction but the publication reflected British taste and was as a whole admired by contemporary British connoisseurs. According to Vertue the originals were imitated 'truly so well... that it is hardly possible to avoid taking the prints for drawings' and even improved on similar French productions 'excelling all others done beyond sea, especially in the justness of the tinctures'.[ii]
Lit: Hyde (Technique) 7.

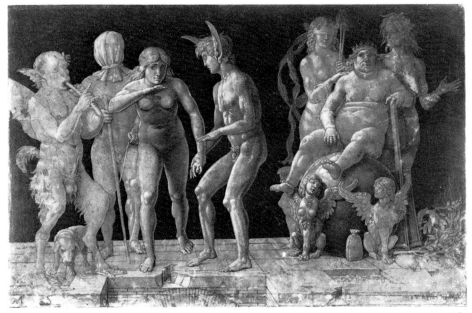

115A

115A

ANDREA MANTEGNA (1431-1506)

**Allegory of Ignorance: Virtus Combusta.
1490-1500**

Inscribed *AM* and *Virtus Combusta.*
Pen and ink and brush in brown on a brown ground,
heightened with white; the background black over
red. 28.7 x 44.3
The Trustees of the British Museum

The existence of this fully worked up drawing of a
composition otherwise known only through en-
gravings adds weight to the thesis that Mantegna
supplied engraver's with drawings made specifically
for reproduction.

115B

ATTRIBUTED TO ZOAN ANDREA (ACTIVE 1475-P.1519)
AFTER MANTEGNA

**Allegory of Ignorance: Virtus Combusta',
c.1495-1500**

Lettered within the design *Virtus Combusta*
Engraving. Cut to 29.7 x 42.9
VAM CAI 601

This engraving reproduces with great fidelity the
drawing in grisaille by Mantegna. It is not only the
same size and in the same sense as the drawing but it
also recreates its effect of relief. The fine hatchings
which model the figures stop just short of the heavy
outlines which enclose them, so that they stand out
against the densely hatched background. But the en-
graver has been unable to render the effect of wash
in facsimile.
Lit: Hind (General) 22; Levenson, Oberhuber,
Sheenan (General) pp. 222-227.

116A

LEONARDO DA VINCI (1452-1519)

Study for an equestrian monument. c.1484

Silver point on white paper, covered with a blue pre-
paration. 11.6 x 10.3
Windsor Castle, Royal Library (C) Her Majesty The
Queen

This design is thought to be one of the first to be
submitted for the Sforza monument which, realised
only as a full-size clay model, was destroyed by the
French on the entrance of Charles VIII into Milan in
1499. As artists became increasingly self-conscious
such thoughful jottings came to be valued by col-

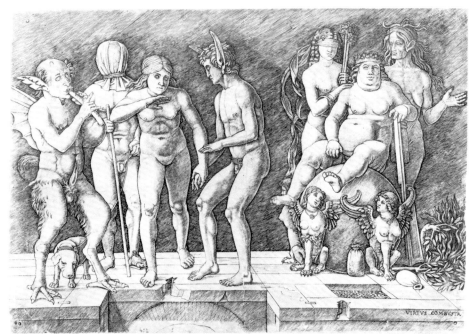

115B

lectors as a means of getting nearer the artist's magical moment of creation and became, therefore, commercially viable subjects for the reproductive engraver. The pose of horse and rider is echoed in the lower left-hand study on the engraving. The only significant difference is that the rider's armour has been replaced by classical dress.

116A

116B

IN THE STYLE OF ZOAN ANDREA (ACTIVE 1475-P.1519) OR G.A. DA BRESCIA (ACTIVE C.1490-P.1525) AFTER LEONARDO

Four studies of an equestrian statue. Early 16th century

Engraving. Cut to 21.6 x 15.9
The Trustees of the British Museum

This print is based either on a lost sheet of sketches or on an amalgamation of several small sheets of the kind shown in fig.116a. As well as containing ideas for the statue of Francesco Sforza, it has connections with the proposed memorial to Gian Giacomo Trivulzio. It provides thus an early example of a reproduction making the tentative thoughts of the artist rather than his fully worked-out and public composition available to a large public.
Lit: Hind (General) 7.

116B

127

117A

117A

GIOVANNI JACOPO CARAGLIO (C.1500-C.1570) AFTER PARMIGIANINO

Diogenes. c.1526

Lettered with monogram.
Engraving.28.7 x 21.8
The Trustees of the British Museum

A follower of Marcantonio Raimondi, Caraglio was recruited in Rome by Parmigianino to engrave his designs. Two out of the four designs he executed are dated 1526. After the Sack of Rome early the next year, Caraglio fled to Venice and contact between them ceased but the existence of a sketch by Parmigianino on the back of a working proof of one of Caraglio's engravings[II] suggests that for a brief period at least they collaborated closely. Fragmentary drawings relating to this print have survived[III] but a comparison between fully worked-up drawings by Parmigianino for other compositions engraved by Caraglio[IV] shows that it was the engraver's practice to follow his model with painstaking accuracy. If this was the case with the *Diogenes* we can extrapolate that Ugo da Carpi in his version (figs.117b,c) has transformed the image: the figure is enlarged, details are omitted and the background has been translated into a magnificent whirl of textures. It was his treatment, however, that made the image famous.

Lit: Bartsch (General) 61; Popham (Parmiginanino) 1969, repr. with known studies, pp.266-267.

117B & C *See colour plate Xa/Xb*
UGO DA CARPI (C.1450/C.1480-1532) AFTER PARMIGIANINO

Diogenes. c.1527

Lettered *Franciscus Parmen. Per. Ugo. Carp.*
Chiaroscuro woodcuts, printed from four blocks each, one in shades of brown, the other in shades of green. Cut to 48.3 x 35.5; 47.6 x 34.7
VAM E.43-1885; 16323

The inscription on this print provides the only firm evidence of a relationship between Ugo da Carpi and Parmigianino. Vasari's testimony, despite his presence in Bologna in 1529, is confused. In the life of Parmigianino he tells us how the latter arrived in Bologna and had made a number of 'engravings in grisaille', among them 'a large Diogenes', making no mention of Ugo[V], while in an excursus on Ugo in the life of Marcantonio he claims that many others took up his chiaroscuro technique including Parmigianino, who engraved 'a Diogenes, more beautiful than anything of Ugo'[VI]. While such statements do not lead us to doubt Ugo's authorship, they do cast doubt on the proposition that he was working at Parmigianino's side. It seems more likely that his immediate source was the print by Caraglio and that his chiaroscuro version may have been issued without Parmigianino's authority.

That these prints have been highly valued as works

117C

of art in their own right for centuries is suggested by the care with which these two examples, although much damaged, have been preserved.

Lit: Johnson 15.

117B

IX

LOUIS-MARIN BONNET AFTER BOUCHER
Tete de Flore
Colour etching in the crayon manner
(fig. 80a)

129

X

UGO DA CARPI AFTER PARMIGIANINO

Diogenes
Chiaroscuro woodcuts, one in shades of brown, the
other in green
(figs.117b and 117c)

XIA
JOHN CONNELL OGLE AFTER TURNER
Ulysses Deriding Polyphemus
Colour lithograph
(fig. 89)

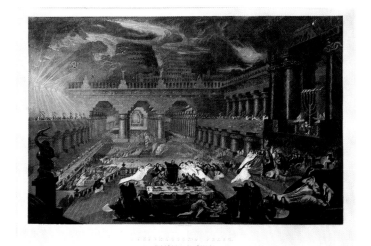

XIB
LEIGHTON BROTHERS AFTER JOHN MARTIN
Belshazzar's Feast
Colour wood-engraving
(fig. 92b)

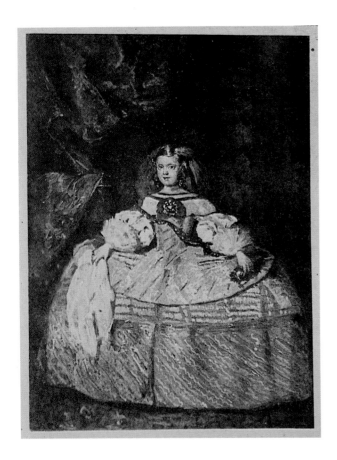
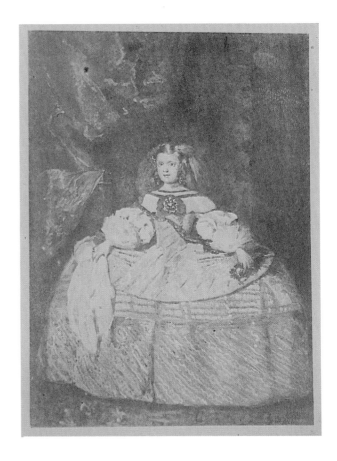

XII

The Infanta Margarita Maria

Two calotypes

(figs. 98a,b)

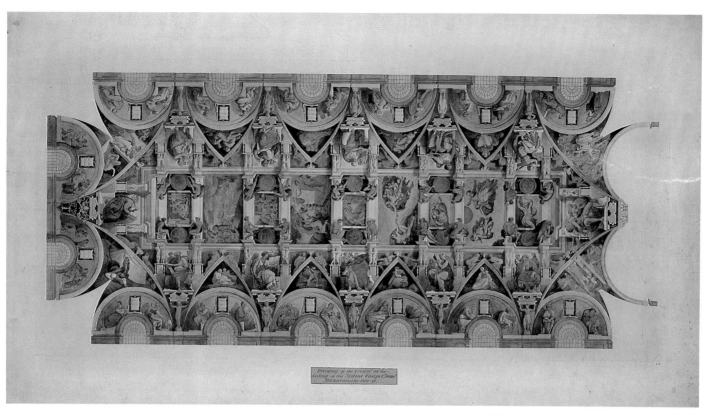

XIII
DOMENICO CUNEGO AFTER DOLCIBENE AFTER
MICHELANGELO
The Sistine Ceiling
Etching coloured by hand
(fig. 87b)

133

XIVa

VALENTINE GREEN AFTER ANNIBALE CARRACCI

The Murder of the Innocents

Mezzotint coloured by hand

(fig.193)

XIVb

FRANCES VIVARES AFTER (?) POUSSIN

Landscape

Etching coloured by hand

(fig.192)

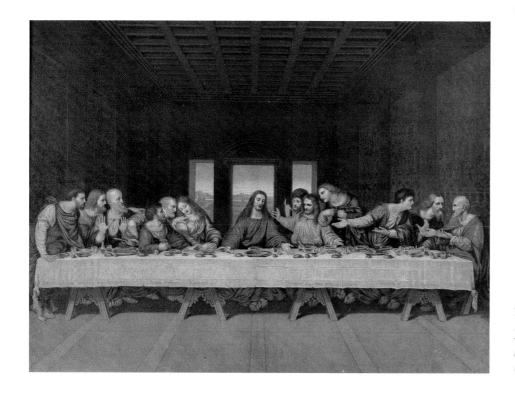

XVI
WILLIBALD RICHTER
The Closet at Lancut
Watercolour
(fig. 183)

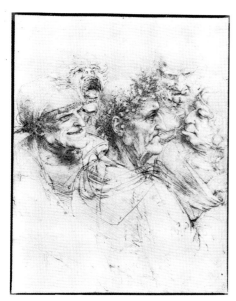

118A

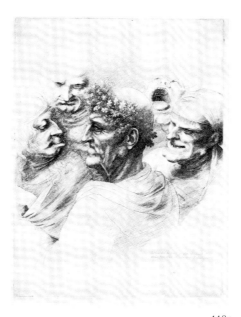

118B

The print shows a tendency to tidy-up the sketchiness of the original and to over-define its detail but the overall composition is followed closely. Hollar has even followed Leonardo's left-handed hatchings which, as the print is in reverse, appear as right-handed.
Lit: Pennington 1609.

119A

SCHOOL OF LEONARDO

Four grotesque heads, including a caricature of Dante

Red chalk. Size of sheet 19.4 x 14.5
Windsor Castle, Royal Library (C) Her Majesty The Queen

119B

WENCESLAUS HOLLAR (1607-1677) AFTER LEONARDO

A pair of deformed male and female heads facing one another, the male a caricature of Dante

Inscribed *Leonardo da Vinci inu W.Hollar fecit 1645.*
Etching. 7.3 x 11.3
VAM E.2502-1920

Etching through a hard ground was not able to reproduce the effect of chalk and here Hollar has not followed the modelling lines of his source.
Lit: Pennington 1594.

118A

LEONARDO DA VINCI (1452-1519)

Five grotesque heads

Pen and ink. 26 x 20.5
Windsor Castle, Royal Library (C) Her Majesty The Queen

118B

WENCESLAUS HOLLAR (1607-1677) AFTER LEONARDO

Five grotesque heads

Inscribed *Leonardus da Vinci sic olim delineauit WHollar fecit, 1646. ex Collectione Arundeliana.*
Etching. 24.5 x 18.6
Windsor Castle, Royal Library (C) Her Majesty The Queen

119A

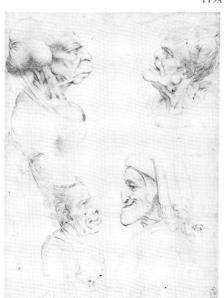

119B

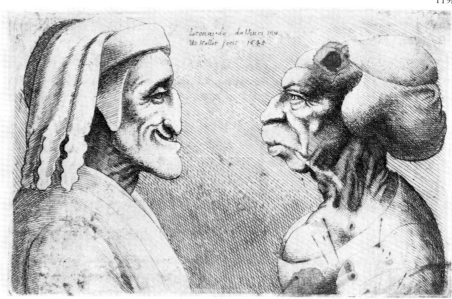

120

121

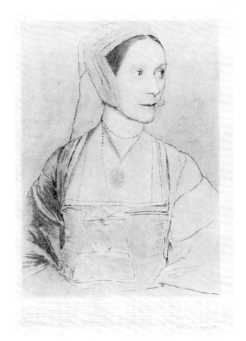

122

120

GIULIO CAMPAGNOLA (C.1482–AFTER 1515)
PROBABLY AFTER GIORGIONE

Venus reclining in a landscape. c.1508-09

Engraving, perhaps worked with a punch. 12 x 18.1
The Trustees of the British Museum

Most of Campagnola's prints combine dots with
lines but this subject is conveyed solely by the mas-
sing of dots. Opinions differ over the extent to which
Campagnola designed the compositions he en-
graved. Certainly he worked in close harmony with
Titian and Giorgione, and motifs passed freely be-
tween them. Their contemporary, Morelli, recorded
a miniature painting on vellum by Campagnola sim-
ilar to this composition which showed a 'nude
woman reclining with her back turned, derived from
Giorgione'. That the print reproduces a drawing,
now lost, by Giorgione is further suggested by the
sophistication of the composition, which recalls the
work of Giorgione and distinguishes it from Campa-
gnola's own compositions[x].

Lit: Hind (General) 13; Levenson, Oberhuber,
Sheehan (General) pp.399,400.

121

OTTAVIO LEONI (1578-1630)

Self-portrait

Dated and lettered *Eques Octavi Leonus Roman' pictor
fecit 1625 Superiorum permissu.*
Engraving. Cut to 14 x 11
VAM E.863-1888

Leoni's use of stipple was a self-taught method of
engraving in tone which provided him as an amateur
engraver with a remarkable equivalent to his smooth
chalk modelling. He did not, however, use the same
technique as became popular in the second half of
the 18th century, for his prints were executed solely
with the graver with no preliminary etching.

138

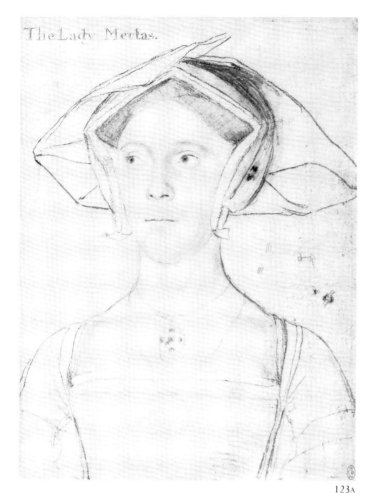

The Lady Meutas.

123A

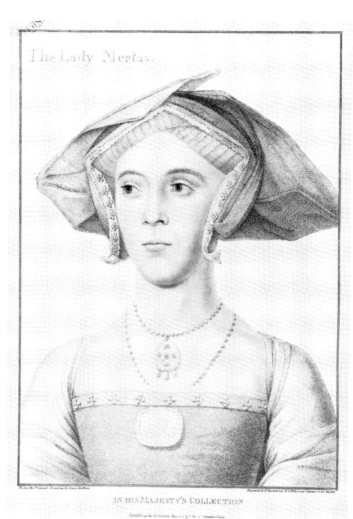

The Lady Meutas.

From the Original Drawing by Hans Holbein Engraved by F.Bartolozzi R.C Historical Engraver to his Majesty

IN HIS MAJESTY'S COLLECTION

Published on the Act. June 1.º 17.. by J. Chamberlaine

122

FREDERICK CHRISTIAN LEWIS (1779-1856) AFTER HOLBEIN

Cecily Heron

Soft-ground etching, coloured by hand. Cut to 37.2 x 27

Windsor Castle, Royal Library (C) Her Majesty The Queen

An inscription on the print apparently by the painter, A.W.Callcott, and written on 22 July 1844, records that 'When Bartolozzi's prints after the Holbein drawings in the Royal collection were nearly completed, Chamberlain their publisher thought it might answer his purpose to give the public a smaller edition, if he could find any engraver of less celebrity and at a smaller price to supply Bartolozzi's place in this second series. His first application, and his only one, was to Frederick Lewis the engraver of this print, and in order the more effectually to test his power, he gave him the original drawing requiring it to be rendered the full size of the original. When Lewis had completed his task, he took an impression to Chamberlain who on seeing its truthfulness when compared with Bartolozzi's print felt convinced that the reputation of the great work would be inevitably destroyed if the public once had their means of comparing such a faithful rendering as Lewis' with the false and mannered prints of Bartolozzi. He therefore desired Lewis to let him have the plate. As there have been no impressions seen but those few proofs which Lewis had taken himself there is no doubt Chamberlain had the plate destroyed. This impression is one of those proofs, Lewis kindly gave me about 25 years ago'.

123A **123B**

HANS HOLBEIN THE YOUNGER (1497/8-1543)

The Lady Meutas

Lettered with the name of the sitter
Coloured chalks on pink toned paper. 28.1 x 21
Windsor Castle, Royal Library (C) Her Majesty The Queen

123B

FRANCESCO BARTOLOZZI (1727-1815) AFTER HOLBEIN

The Lady Meutas. Plate from *Imitations of original drawings by Hans Holbein in the collection of His Majesty, for the portraits of illustrious persons of the court of Henry VIII*

Lettered with title and *From the Original Drawing by Hans Holbein In His Majesty's Collection Engraved by F.Bartolozzi R.A.Historical Engraver to his Majesty Publish'd as the Act Directs Aug 12. 1793. by I.Chamberlaine.*
Stipple engraving, printed in colours from one plate, on pink paper. 32 x 23.5
VAM, National Art Library

The series of eighty-four portraits were issued in fourteen parts between 1792 and 1800; each plate was accompanied by a biography of the person represented. Although the stipples were described as imitations and trouble was taken to print the images on papers which corresponded in colour to the toned papers of the originals, Bartolozzi transformed what were studies for paintings, with all the suggestions and ommissions inherent in work of that kind, into neatly finished compositions. The repeating pattern across the top of the sitter's dress, represented by one repeat in the drawing, is drawn out in the print, and the necklace, only suggested in the drawing, is rendered in print with meticulous completeness.

124A

FRANÇOIS BOUCHER (1704-1770)

Shepherdess

Red chalk. 20.3 x 19.5
The Trustees of the British Museum

124B

GILES DEMARTEAU, CALLED DEMARTEAU L'AINE (1722-1776) AFTER BOUCHER

Shepherdess

Lettered *F. Boucher inv del. Demarteau Lné. sculp. Du Cabinet de Madame de la Haye A Paris chez Demarteau Graveur du Roi rue de la Pelterie à la Cloche.*
Etching in the crayon manner, printed in red. 19.2 x 13.2
VAM 29973.3

Demarteau, the son of a master armourer was apprenticed in Paris in a metal-engraving workshop and began his print business with the publication of suites of ornament prints. It was his use of punches and toothed wheels borrowed from the equipment of the ornamental metalworker which gave Jean-Charles François, his collaborator on a publication, the idea of having tools manufactured along the same principles but with teeth which would imitate the irregular effect of chalk. François's action, done with secrecy finished their friendship, but it was Dem-

124A

arteau, once he too had mastered the method, who used it best to commercial advantage. From 1759 when he began reproducing Boucher's drawings until the painter's death in 1770 such prints constituted about eighty per cent of his publications. Moreover, the fact that many of the prints reproduce dated drawings suggests that Boucher was actually supplying Demarteau with works expressly for reproduction.
Lit: Jean-Richard (Boucher) 765; Carlson and Ittmann (General) 40.

125

125

LOUIS-MARIN BONNET (1736-1793) AFTER CARLE VAN LOO

Portrait of a Girl. Third state

Signed in facsimile within the design *Carle Vanloo.* Lettered *Dessiné par Carle Vanloo Gravé par Louis Bonnet Dediée A Monsieur Carle Vanloo A Paris, chez L Ve. de F.Chereau Par son très humble et très* the rest cut off.
Etching in the crayon manner, printed in black and white from two plates, on blue paper. Cut to 38.5 x 28.7
VAM 27182

Bonnet was attached to the workshop of Jean-Charles François in about 1756 at the moment when the latter was perfecting the crayon manner method of etching. He was instrumental in passing knowledge of the method to Demarteau, in whose workshop he was employed around 1759. Bonnet's particular contribution to the development of the technique was the invention of a formula for a white ink which did not oxidise, an essential ingredient for the success of prints of this kind.
Lit: Herold 55a.

124B

126

127A

127B

127B

WILLIAM BAILLIE (1723-1810) AFTER REMBRANDT

Elephant

Lettered *Engraved by Capt. Baillie from a Drawing of Rembrandt: Aug ye. 1, 1778.*
Etching in the crayon manner. 23.9 x 31.4
VAM 28458

William Baillie, an amateur artist and collector, is better known for his etchings after Rembrandt and is infamous for his reworking of the 'Hundred Guilder' plate.

126

WILLIAM WYNN RYLAND (1733-1783) AFTER VAN DYCK

Plate from Charles Rogers' *A Collection of Prints in Imitation of Drawings*, London, 1778. See chapter opening for enlarged detail

Lettered *Ant. Van Dyck delt. In the Collection of George Earl Cholmondeley. CR edit. W W Ryland sct. 1762.*
Etching and drypoint. 32 x 30.5
VAM 15139.52

Largely worked by Ryland, the plates in this collection display an astonishingly rich variety of facsimile techniques. This example, rendered with evident passion, primarily in drypoint enhanced by a considerable amount of plate tone, gives a vivid sense of the act of creation often missing from facsimile work. Ryland's career was cut short by a sentence of death on his conviction for forgery. The drawing on which the print is based is now lost.

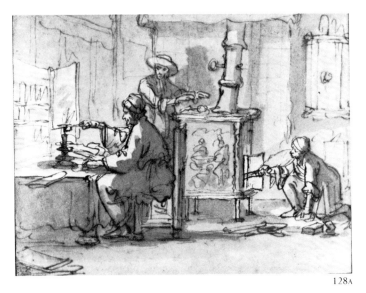

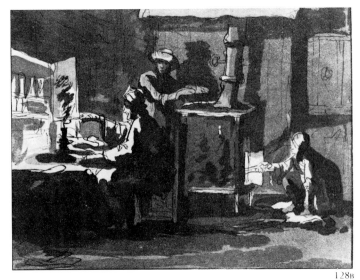

<div align="right">128A</div>

<div align="right">128B</div>

128A

JAN LUYKEN (1649-1712)

Interior with three figures, including a man trimming a candle

Inscribed by Ploos van Amstel on the back *J: Luiken f* and with measurements.
Pen and brown wash. 9.4 X 12
Amsterdams Historisch Museum

Christiaan Josi, who republished Ploos van Amstel's prints, claimed that the publication of reproductions increased the value of the originals. He cited this drawing as an example. It was bought by Ploos for 40 florins and sold after his death for 70 florins.

128B

CORNELIS BROUWER (DIED C.1810)

AFTER JAN LUYKEN

Interior with three figures, including a man trimming a candle. 1782, published by Ploos van Amstel, 1787. First state

Inscribed in ink on the back *2* (i.e. 2nd print) and dedicated to Frans Hemsterhuis.
Transfer print, printed in brown. 9. 2 x 12
VAM E.1482-1984

Ploos made the plates for the first eight of his prints himself but as the publication got underway his role became increasingly supervisory. Cornelis Brouwer was in his employ from 1775 and was particularly skilled at the transfer technique, being able to achieve with it the effect of pen and ink line as well

as of wash. The print follows its original in outline and shading but its foreground is washed with greater variety of colour and its overall tonality is of a distinctly darker shade of brown.
Laurenthius (Ploos van Amstel) 45.

129A

CLAUDE LORRAIN (1600-1682)

Coast View with the Rape of Europa

Inscribed by a later hand *Claude fecit Rome. 1670.*
Pen and dark brown wash, heightened with white, on paper tinted brown. 24.8 x 34.6
The Trustees of the British Museum

The drawing is a record of a painting, now at Buckingham Palace, which was itself a repetition of an earlier composition.

129B & C

RICHARD EARLOM (1743-1822) AFTER CLAUDE

A Landscape, with the story of Europa. First and second states. Plate 6 from *Liber Veritatis; or a Collection of Prints after the Original Designs of Claude Le Lorrain. Executed by Richard Earlom, in the Manner and Taste of the Drawings...*', volume III, first published 1819

Both signed and dated in facsimile *Claude fecit Rome. 1670.* Both lettered *No.6. Claude delint. Pub. Jan. 20. 1802, by J.& J.Boydell, No. 90, Cheapside; & at the Shakespeare Gallery, Pall Mall. R.Earlom sculpt.* The second

<div align="right">129A</div>

state in addition *From the Original Drawing in the Collection of R.P.Knight, Esqr.*
Etching; Etching and mezzotint printed in brown.
26.7 x 36
VAM E.546-1913 and National Art Library

The first two volumes of Earlom's *Liber Veritatis,* published in 1777 by Boydell, reproduced drawings made by Claude as records of his paintings in a single album, formerly in the collection at Chatsworth, but now broken up. The third volume, from which this subject was taken, reproduced drawings from other sources and was added when the popularity of the first two volumes led to their re-publication in 1819. The line in the original drawings is reproduced by etching and the tone by selectively applied mezzotint. The impact of the publication is suggested by the fact that the title, *Liber Veritatis,* coined for it, has been taken over to describe the original compilation.
Lit: M.Kitson, *Claude Lorrain: Liber Veritatis,* 1978, pp.31-32; Hyde (Drawing) 13.

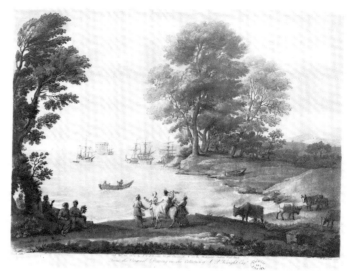

129B

129C

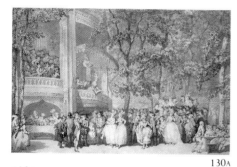

130A

130A

130B

THOMAS ROWLANDSON (1756-1827)

Vauxhall Gardens. Exhibited 1784

Pen and ink and water-colour. 48.2 x 74.8
VAM P.13-1967

130B

FRANCIS JUKES (1746-1812) AND ROBERT POLLARD
(1755-1838) AFTER ROWLANDSON

Vauxhall. In a verre églomisé frame

Lettered with title and *Drawn by T.Rowlandson Aqua-
tinto by F.Jukes. Engraved by R Pollard London Published
June 28th 1785 by J.R.Smith No 83 Oxford Street.*
Aquatint. Coloured by hand. 55.2 x 78.3
VAM E.124-1963

The fashionable new medium of aquatint was here
applied by one printmaker and the lines were etched
by another.

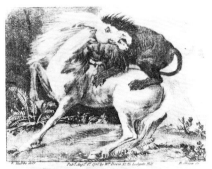

131

131

BENJAMIN GREEN (1739-1798) AFTER STUBBS

The Lion and the Horse

Lettered *G.Stubbs delt. Pubd. Augst. 1st. 1780 by Wm. Davis No 25 Ludgate Hill B.Green Sc.*
Soft-ground etching. 9.6 x 12.4
VAM E.6118-1905

Benjamin Green was drawing master at Christ's Hospital. He was among the first printmakers to use soft-ground in Britain, for his earliest prints in the medium date from 1771. In 1775 he issued a *Complete Drawing Book in Imitation of Chalk Drawings* pub-

132A

lished by Hooper and Davis. This print belongs to a similar compilation in the Victoria & Albert Museum which lacks a title-page. Its later date reflects a re-issue by Davis, who took over the firm[XI].

132A

WILLIAM FREDERICK WELLS (1762-1836) AFTER GAINSBOROUGH

Wooded landscape with figure. Plate from *A Collection of Prints, illustrative of English Scenery, from the drawings and sketches of Thos. Gainsborough, R.A. in the various collections of The Right Honorable Baroness Lucas; Viscount Palmerston; George Hibbert, Esq; Dr. Munro; and several other Gentlemen. Engraved and published by W.F.Wells, and J.Laporte.*

Lettered *T.Gainsborough Del. Published as the Act directs Jany 1st. 1802 W.F.Wells. Sculpt. From the Original in the Collection of Geo Hibbert, Esqr.*
Soft ground etching. 24.2 x 31
VAM E.4708-1905

132B

LOUIS THOMAS FRANCIA (1772-1839) AFTER GAINSBOROUGH

Wooded landscape with figure. Plate from *Studies of Landscapes by T.Gainsborough, J.Hoppner R.A., J.Girtin, Wm Owen R.A., A.Callcott, A.S.Owen, J.Varley, J.S.Hayward and L.Francia. Imitated from the originals by L.Francia, 1810*

Soft-ground etching on pinkish-buff paper. Cut to 17.5 x 25.2
VAM E.3913-1902

These prints are all trimmed to the image and printed on a range of different papers including a strong blue and a dark brown as well as the pinkish-buff of this example.

133

JOHANN NEPOMUK STRIXNER (1782-1855) AFTER HANS BALDUNG

Head of a bearded man. Plate from *Les Oeuvres lithographiques. Contenant un choix de dessins d'apres les grands maîtres de toutes les écoles, tiré des Musées de sa Majesté le Roi de Bavière, 1810-1816*

Signed in facsimile *O.W.K*[XII].
Lithograph, printed in black and beige, with reserved whites. 33 x 24.8
Stephen Calloway

The print is based on a drawing by Hans Baldung[XIII] in the Landesmuseum, Brunn. The publication in which it was issued consisted of seventy-two monthly parts of six lithographs each. The stones were drawn in ink or chalk, depending on the technique of the originals, and show a more ambitious use of tint stones than employed hitherto. Here, the reserved whites play a vital role in the delineation of the image and suggest the tattered corner of the sheet. The ruled borders are also executed in lithography. In spite of these attempts at verisimilitude the print has the feel of a product aimed at an educational rather than at a collector's market, and it is no surprise to find that the publication was directed by Johann Christian von Mannlich, the Director of the Bavarian Royal Museums and Galleries.

Lit: Twyman (Technique) p.22.

133

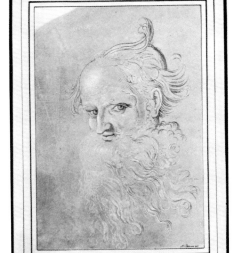

5. *Bel tête barbue, par O. Uk.*

134A

134B

134A

ATTRIBUTED TO ROBERT PITE

(WORKED 16TH CENTURY)

Triumphal Arch representing the Apotheosis of Henry VIII

Dated *1546*. Lettered with commentary within the design.
Pen and wash in brown and grey on parchment. 67.5 x 43.7
VAM 3337

134B

CHARLES JAMES RICHARDSON (1806-1871) AFTER ROBERT PYTE

Unused frontispiece designed for the artist's *Architecture in England of the Transition Period,* **1836**

Lettered as in the original and *a facsimile of an old drawing on Parchment, the Work of Robetus Pyte, an English Artist of the Reign of Henry VIIIth drawn on Zinc by Chas. Jas. Richardson, Archt. as a frontispiece to Vol. 1st. of his Examples of the Transition Period of Architecture in England, 1836. Proof. Day & Haghe Lithrs. to the King.*
Lithograph. 73.5 x 48.5
VAM 14435.27 & 418

Although the print claims to be a facsimile of the drawing reproduced as fig. 134a, the image is reversed with the result that the figures are presented left-handed and the lettering has become jumbled.

135

LOUIS HAGHE (1806-1885) AFTER DAVID ROBERTS

Tombs of the Caliphs, Cairo. Plate 98 to volume lll of *Egypt and Nubia,* **part of** *Sketches in the Holy Land, Syria, Idumea, Arabia, Egypt, and Numbia,* **printed by Day and Son, and published by F.G.Moon,1842-1849**

Lettered in facsimile with title and *David Roberts.R.A. L.Haghe lit.*
Tinted lithograph printed from three stones, with additional colour by hand. 51 x 33.4
VAM L.645-1920

The Holy Land... consisted of two hundred and forty-eight lithographs after drawings made by Roberts on a journey in the Middle East in 1838-39. The publisher, F.G.Moon, paid Roberts £3000 for the drawings and raised an additional £20,000 by means of subscription arousing interest in the drawings by their exhibition at various venues around the country. A pamphlet issued in 1840 which served both as a catalogue for the exhibitions and as a prospectus for the prints states 'the publisher proposes to give facsimiles of these drawings, of the size of the original, executed in lithography, under the inspection of the artist...'[xiv]. The compositions were all drawn on stone by Haghe, perhaps with help from assistants. The original of this lithograph is in the Whitworth Art Gallery, Manchester but, like so many of Roberts' watercolours, it is now too faded for it to be possible to judge how close the lithograph came to it. But Roberts' method of working with pencil outlines beneath a series of transparent washes was ideally suited to reproduction by lithography, elaborated with tint stones.
Lit: Twyman (Technique) pp.220-225; Miller (Technique) p.42.

135

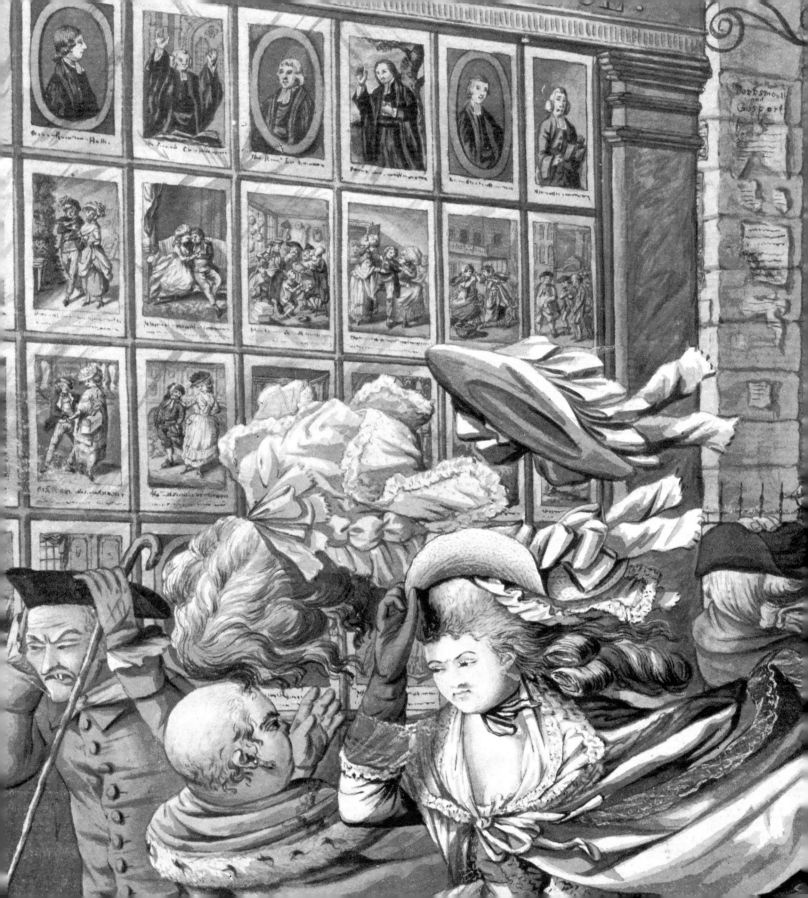

Chapter 5
Organisation of the Print Trade

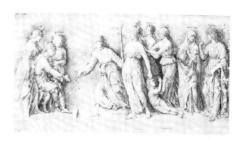

136A

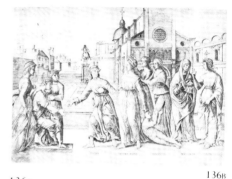

136A 136B

ANDREA MANTEGNA (1431-1506)

Calumny of Apelles

Pen and ink, with occasional touches of white.
20.7 x 38
The Trustees of the British Museum

136B

GIROLAMO MOCETTO (C.1454-58-P.1531) AFTER
MANTEGNA

Calumny of Apelles. First state

Lettered with identification of the figures.
Engraving. 32.7 x 44.8
Fitzwilliam Museum, Cambridge

The bulk of Mocetto's engraved work was quin-
tessentially reproductive. The figures in this print
reproduce in the same sense but considerably enlar-
ged the drawing by Mantegna which was likely to
have been made for the purpose. The background,
however, has been added by Mocetto suggesting a
collaborative rather than servile approach on the
part of the engraver for it even contains a personal
reference. The view shows in reverse the Piazza of
SS.Giovanni from Mocetto's home town of Venice,
including Verrocchio's equestrian statue of Bar-
tolommeo Colleoni unveiled in 1496.
Lit: Hind (General) 12; Levenson, Oberhuber and
Sheehan (General) pp.382-385.

CENTRES OF ACTIVITY

The presence of great paintings, a thriving tourist trade, easy export routes and state
patronage were important conditions of prosperity in the engraving trade. Repro-
ductive prints have been made over the five centuries covered by this study in many
different centres but production has been clustered, according to the relative bal-
ance of these stimuli, in different places at different periods. The crude concentra-
tion evident in this account on Rome in the 16th century, joined by Antwerp in the
17th, and superseded by Paris early in the 18th, does reflect some simplified truth.
Moreover, England's political dominance and relative wealth during the later 18th
and 19th centuries suggests that the concentration on British production at that
date stems from more than chauvinism.

THE PROTAGONISTS

There are four parties with a vested interest in the production of a reproductive
print: the painter of the original picture, the owner of the picture, the engraver of
the reproduction and its publisher. These protagonists, some of whom are some-
times the same person, have played more or less prominent parts at different points
in the history of the subject although at any time almost any one of them might have
instigated the making of a reproduction.

Painters played a dominant part in the early years for they quickly realised the
advantage of the fame that reproduction of their images brought. The first doc-
umentary evidence of a painter attempting to employ an engraver concerns Man-
tegna and Simone di Ardizzoni, the latter a painter and engraver who turned down
Mantegna's offer of work on his arrival in Mantua in 1475. According to a petition
lodged with Mantegna's patron, the Marchese Lodovico Gonzaga, by Simone asking
for protection from Mantegna, the latter responded to the refusal with threats, viol-
ence and false accusations of sodomy[1]. Curiously no prints by Simone have been
identified but the importance that Mantegna attached to hiring engravers with the
right skills is suggested by this story. That he had an active group of engravers repro-
ducing his designs is shown by the variety of influential prints, engraved by different
hands yet in his own manner, that have survived (figs.27,136). Little is known about
the business arrangements which surrounded their production but it was with Zoan
Andrea (figs.27b,136b), an engraver in Mantegna's style, that Simone chose to work,
suggesting some measure of autonomy on the part of the engravers.

147

137

Not much more is known of the business arrangements made between Raphael and Marcantonio Raimondi. At one point Vasari tells us that when the latter arrived in Rome 'he made a beautiful copper engraving of a drawing of Raphael...executed with such finish and beauty that, when it was shown to Raphael, he was disposed to issue some prints himself from his own designs'.[2] But at another point Vasari provides conflicting evidence, claiming that 'Having seen the engravings of Albert Dürer, Raphael was anxious to show what he could do in that art, and caused Marco Antonio of Bologna to study the method.'[3] All that is clear is that once collaboration between them was underway, Marcantonio worked for no other artist. Even Giulio Romano did not presume to ask for his services until after Raphael's death.[4]

It is likely that Marcantonio usually worked from drawings made by Raphael for the purpose rather than from the paintings. A considerable number of detailed drawings related in scale as well as composition to the engravings exist yet no paintings related to some of the more famous engravings are known (figs.141a-c). But on whose initiative and on what grounds it was decided what should be engraved and when is conjectural. There is no apparent logic behind the selection of subjects, some of which were engraved on completion of the originals and others only years later. The engravings do, however, reflect the master's work in all its complexity except that the large decorative schemes tend to be represented by engraved details. That Marcantonio approached the task of engraving with artistic independence is shown by an incident after Raphael's death, concerning his engraving after Baccio Bandinelli's *Martyrdom of St. Lawrence*. When the artist expressed his dissatisfaction with the engraving, Marcantonio appealed to the Pope who, after comparing the print and the drawing, observed that Marcantonio 'had not made any errors, but had corrected many of Baccio's of no small importance, and his engraving was more skilful than Baccio's original.'[5] Such a reaction presents the engraver on an equal footing with the originator of the image. His aim was to produce as fine a composition as possible which could even transcend its source.[6]

Marcantonio's plates after Raphael were printed by Baviero di Carrocci, who appears both as Raphael's studio assistant and as his business representative. Little information is available on Il Baviero except that Vasari tells us that the sack of Rome, seven years after the death of the master, left him alone with the resources to commission work from less fortunate painters and engravers because 'he had the prints of Raphael'[7], suggesting that the plates at that stage belonged to him. Whether they were his by way of payment or by inheritance is not clear. A picture of his life emerges, however, as an artisan-cum-businessman, acting as a link between artists and engravers, which became a pattern among print publishers of future centuries.

During the 17th century Rubens provides a notable example of a leading painter who controlled the production of prints after his work, gathering around him on his return from Italy in 1608 an impressive group of engravers. The hiring and, in some cases, training of engravers was for him an extension of the normal division of

labour between assistants and painters practised by the great masters. That control over the quality of engravings after his work was of the utmost importance to him is shown by his comment early in his collaboration with Lucas Vorsterman: 'I should have preferred to have an engraver who was more expert in imitating his model, but it seemed a lesser evil to have the work done in my presence, by a well-intentioned young man, than by great artists according to their fancy.'[8] And the breakdown in their relationship seems to stem at least partly from Vorsterman's growing sense of his own value. In 1622 animosity between them reached such a pitch that the Infanta Isabella decreed that Rubens should be granted special protection because of Vorsterman's threats on his life. At this time Rubens wrote 'Unfortunately we have made almost nothing for a couple of years, due to the caprices of my engraver, who has let himself sink to a dead calm, so that I can no longer deal with him or come to an understanding with him. He contends that it is his engraving alone and his illustrious name that give these prints any value.'[9]

More often however, at this date, engravers hovered in groups around painters without actually being employed by them. In spite of the engravers' leading role in the creation of reputation, most painters did nothing to ensure that the engravings being made gave a balanced view of their achievement with the result that the concentration on a fashionable aspect of a painter's work frequently led to the distortion of his reputation. It was, for example, to Poussin's austere masterpieces (fig.137) rather than to his more light-hearted and sensuous subjects that the engravers were drawn, thereby creating the orthodox view of him as an exclusively intellectual painter and, even today, Guido Reni is known primarily for his emotive visions of either the Virgin, her eyes cast down (fig.138), or of the human Christ abused, his eyes cast heavenward.

Leading painters in the 17th century openly despised engravers. Poussin went so far as to claim in 1654 that 'nothing has been engraved of my work, with which I am not very angry.'[10] But by this date the political machines of Europe were beginning to appreciate the propaganda value of engraving: the reproduction of art treasures, monuments and building projects spread knowledge of these emblems of power far and wide. The court of Louis XIV was particularly active in the provision of patronage for engravers. In 1660 the collection of engravings amassed by the great connoisseur, Michel de Marolles was acquired for the Royal Collection, thereby laying the foundation of the Cabinet des Estampes in the Bibliothèque Nationale. The same year the Edict of Saint Jean-de-Luz guaranteed French engravers the right to exercise their profession freely[11] and the restructuring of the Académie Royale by Colbert led to the admittance of a group of engravers to concentrate on the engraving of reproductions and of portraits.[12] In 1670 the King set in motion his 'Cabinet du Roi' with which he hoped to provide an engraved record of the visible achievements of his rule.[13] Engravers like Gérard Audran, who had acquired good reputations in Rome, were ordered home in order to use their skills to add to the glory of the state.[14]

The collector's desire to publish his collection is discussed in chapter 6, but the

138

138

FRANÇOIS DE POILLY (C.1622-1693) AFTER GUIDO RENI

Nomen Virginis Maria

Lettered with title and *Guid. Ren: Bon. pin. F.Poilly scul. et ex cum. privi. Regi.*
Engraving. Cut to 38.7 x 29.2
VAM E.4270-1919

Engravers, working without reference to Reni himself, engraved his Madonnas and 'Ecce Homos' in large numbers at the expense of his more ambitious compositions. As a result Reni's vision became the popular incarnation of piety but his artistic achievement was minimised.

139

FRANCIS WHEATLEY (1747-1801)

Interior of the Shakespeare Gallery, afterwards the British Institution, Pall Mall. 1790

Watercolour. 31.7 x 47.6
VAM 1719-1871

The Shakespeare Gallery was opened in Pall Mall in 1789 and provided Boydell's business with a fashionable West End outlet in addition to its Cheapside address. This gathering shows Alderman Boydell with his nephew, Josiah, left of centre, welcoming the Dukes of York and Clarence, the King's sons. Between the royal visitors is Sir Joshua Reynolds with his ear trumpet. Behind, the Duchess of Devonshire, clutching a catalogue, converses with the dramatist Brinsley Sheridan. To the right is the Countess of Jersey, with her hands in a muff. The gallery consisted of three rooms on the first floor. The watercolour shows the 18th century method of double hanging. On either side of the central archway are paintings by the Reverend Matthew Peters for *The Merry Wives of Windsor* and *Much Ado About Nothing*, which were among the few received by the public with any enthusiasm. From 1791 the prints were exhibited on the ground floor.

owners of paintings were called upon to make them available also for more blatantly commercial ends. The charging for access to originals to enable the making of reproductions seems to be a relatively modern phenomenon but in the past such access would often have been provided as part of a larger negotiation. Arthur Pond, a connoisseur, picture dealer, portrait painter, printmaker and publisher (see figs.112,114,191,192) at just the moment the print trade took off in England, must have combined many of the characteristics which had brought success to publishers in other countries and at other times. Based in London, he travelled regularly on the Continent both to study and to make useful contacts. Early in his career he spent several years in Italy where, as well as consorting with members of the British nobility on the grand tour, he was taken under the wing of Pier Leone Ghezzi, caricaturist and portrait painter holding the offices of Pittore di Camera to the Pope and Curator of the Papal collections. On his journey home through Paris he fraternised with Mariette, with whom he was to correspond for the rest of his life. Through such contacts he built up a sound body of specialist knowledge of a scholarly and commercial kind; not only could his 'eye' be relied upon but he was well versed in the practical matters of shipping and customs. He was able thus to provide his clients with a complete service. He could paint their portraits and restore their pictures, he could also give advice as to how their collections should be improved and fill the gaps with authentic works purchased abroad. In return they rewarded him with more than money. In an atmosphere of mutual trust he was able to gain access to that all important ingredient of the reproductive print trade, fine originals.

Many engravers were publishers and sellers of their own prints. Indeed it was the goal of most engravers to set up their own print shops and as the 18th century progressed those who were more successful at the entrepreneurial aspects, like Alderman Boydell (see figs.14a,62c,139) in England or Laurent Cars in France, gave up engraving to concentrate on the administration of their businesses. The painters, too, struck by the huge profits made by the publishers were by the end of the 18th century in England, at least, beginning to co-publish their works in order to have a share in the rewards of what was becoming an ever more lucrative business (fig.144).

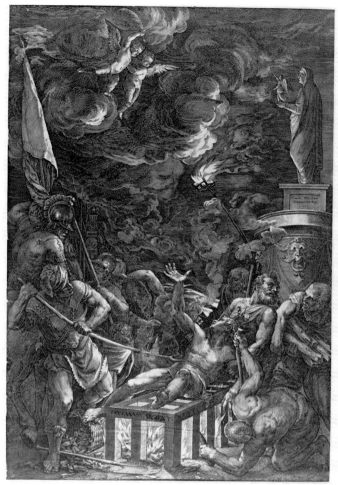

140A & B

CORNELIS CORT (1533-1578) AFTER TITIAN

The Martyrdom of St Lawrence. Two versions

Lettered and dated *Titianus invent Cornelis cort fe. Cum preul 1571* and with a dedication to Philip II of Spain.
Engravings. Cut to 49.7 x 35.2
Dyce 1962; Dyce 1963

These two hardly distinguishable[VI] impressions of the same subject - fig.a slightly brighter than fig.b - were printed from different plates engraved in the same year. Their existence is a measure of the lengths the engraver was willing to go to achieve the desired results. The composition takes elements from Titian's two painted versions of the subject. The dedication to Philip II of Spain links it to the painting commissioned by him in 1554 and completed in 1567, as do the cherubs in the sky, but the arrangement of the figures recalls the earlier version of 1548-59, now in the Jesuit Church, Venice.[VII] As Cort was visiting Titian at the time he engraved it, the amalgamation of the two paintings must have had the painter's blessing and is likely to show his intervention in the new form of the composition, of which five engraved copies are recorded.

Lit: Bierens de Haan 139, 140.

141A

141B

141D

141A
RAPHAEL (1483-1520)

Study for the *Massacre of the Innocents,* c.1512

Pen, with red chalk under two figures on the right; outlines, except of these figures, pricked for transfer. 23.2 x 37.7
The Trustees of the British Museum

The dimensions of this drawing correspond closely to those of the engraving as does the composition. Only the pursuing and fleeing figures on the left are different and they are not pricked for transfer. Not all the figures are, however, drawn in and those that are are naked. It is the only known drawing to include the squared pavement and the head of the dead child, here torn at the appropriate place, but drawn in isolation at the top of the sheet.

141B
RAPHAEL (1483-1520)

Study for the *Massacre of the Innocents,* c.1512

Red chalk over lead point, with pouncing in black chalk. 248 x 411
Windsor Castle, Royal Library (C) Her Majesty The Queen

This drawing is based on the drawing illustrated as fig.141a for its pounced outlines correspond to its pricked outlines. Some of the figures are worked-up in greater detail and five additional figures, which correspond closely to their counterparts in the engraving, have been added.

141C

141C
RAPHAEL (1483-1520)

Study for the *Massacre of the Innocents,* c.1512

Pen and two brown inks. 26.2 x 40
Museum of Fine Arts, Budapest

This drawing appears to be Marcantonio's model for the engraving although its authenticity as a work emanating from Raphael's workshop has been doubted[1]. It follows the engraving closely in most respects - even the figures have their draperies - but the dead children and the squared paving on which they lie are not drawn in and nor is the background. Such ommissions make it unlikely that the drawing is a copy of the engraving but an even more finished version, now lost, could have acted as the engraver's guide.

141D
FOLLOWER OF DOMENICO GHIRLANDAIO

View of the Tiber downstream towards the Ponte Giudeo. From Codice Escurialensis. Late 15th century

Pen and ink.
Courtesy Patrimonio Nacional, Spain

The background of Marcantonio's engraving of the *Massacre of the Innocents* depicts this scene in reverse. As this drawing left Rome in 1508, it is unlikely to have served itself as the source which must have been either a copy of it or a shared prototype[II]. The inversion of the composition has the advantage that the fall of light matches that on the figures.

141E
MARCANTONIO RAIMONDI (C.1480-C.1534) AFTER RAPHAEL

The Massacre of the Innocents. c.1512. With the fir tree

Lettered *Raph.Urbi. Inve.* and with monogram *.MA.*
Engraving. Cut to 28.3 x 43.4
Fitzwilliam Museum, Cambridge

As well as the three studies illlustrated as figs.141a-c, three other sketches of related details by Raphael are known[III]. Together they testify to the care with which he conceived this composition. As there is no record of a painted version of the subject, it is tempting to conclude that the engraving was the intended end product.
Lit: Bartsch (General) 19; Shoemaker and Broun 21.

141E

141F

MARCANTONIO RAIMONDI (C.1480-C.1534) AFTER RAPHAEL

The Massacre of the Innocents. c.1513-15. Without the fir tree

Lettered *Raph Urbi inven* and with mongram *MAF*.
Engraving. Cut to 28 x 42.5
Fitzwilliam Museum, Cambridge

Controversy[IV] surrounds the authorship of both versions of this engraving. The consensus of opinion now is that both were engraved by Marcantonio, the one with the pine tree, first, and the one without, second, suggesting that the engraver was not averse to re-engraving popular compositions if the demand was there. The *Lamentation of the Virgin*[V] is another subject of which Marcantonio engraved two plates. Many other subjects were re-engraved by his workshop (fig.53) and both Agostino de Veneziano and Marco da Ravenna made their versions of the *Massacre*.
Lit: Bartsch (General) 20; Shoemaker and Broun 26.

141G

UGO DA CARPI (C.1450/C.1480-1532) AFTER RAPHAEL

The Massacre of the Innocents. c. 1517

Lettered *Raphael. Urbi Ugo*.
Chiarscuro woodcut, printed from four blocks in different shades of grey. 43.3 x 28
Fitzwilliam Museum, Cambridge

Ugo's lettering gives his own name virtually the same prominence as Raphael's, placing their contributions on an equal footing. It is as if he believed his interpretative skills to be the product of as much creative effort as the invention of the original conception.
Lit: Johnson 8.

141F

141G

142

142

PELTRO WILLIAM TOMKINS (1760-1840) AFTER FUSELI

Prince Arthurs Vision. 1788

Lettered with title and *H Fuseli pinxt. P.W.Tomkins sculpt.. late Pupil of F.Bartolozzi No.1 of the British Poets Vide Spencers Fairy Queen.*
Stipple engraving, printed in brown. Cut to 45 x 36
VAM E.1189-1886

This was the first image published in Thomas Macklin's Poet's Gallery which, like Boydell's Gallery announced two years earlier, aimed to stimulate production of history painting by drawing on the poetic mythology of England. Robert Bowyer's Historic Gallery followed in 1792 and taking its subjects from David Hume's *History of England* aimed not only 'to rouse the passions, to fire the mind with emulation of historic deeds' but 'to inspire it with detestation of criminal acts'[x]. All these ventures relied on the sale of engravings for their commercial viability and were as much a sympton of a shift of patronage away from the aristocracy as contributors to that shift.

Lit: Boase (Publishers) pp.148-155.

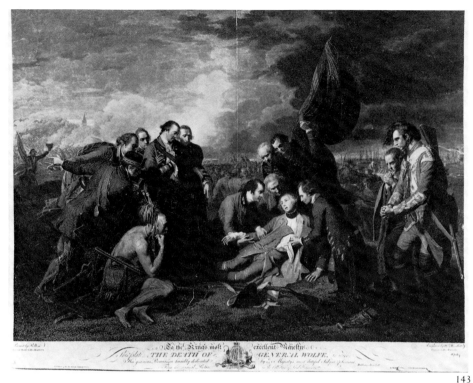

143

143

WILLIAM WOOLLETT (1735-1785) AFTER BENJAMIN WEST

The Death of General Wolfe

Lettered with title and *To the King's most excellent Majesty. This plate, is with His gracious Permission humbly dedicated by his Majesty's most dutiful Subject & Servant, William Woollett. From the original Picture in the Collection of Lord Grosvenor. Painted by B.West, Historical Painter to His Majesty. Engraved by Wm Woollett. Engraver to His Majesty. Published as the Act directs, January 1st. 1776. by Messrs. Woollett, Boydell & Ryland, London.*
Etching and engraving. Cut to 47 x 60.8
VAM 27189

Being an American, Benjamin West's early knowledge of European art must have been based almost entirely on engraving. Perhaps for this reason he was willing to acknowledge the value of the engraver's role and was the only painter to contest their exclusion on an equal footing from the Royal Academy. The painting of this subject, first shown at the Academy in 1771, appealed to the imagination of a patriotic public and provided a model for a modern class of 'History' painting. When George 111 saw it he conferred on West the title of 'Historical Painter to the King'. Woollett was similarly honoured with the title 'Historical Engraver to his Majesty'. The print was very successful in England and on the Continent where copies of it were also circulated. Such was its impact that even the painter's glory was at times eclipsed. West told Farington that Lord Elgin, on a visit to his studio 'seeing the pictures of Genl. Wolfe and the Battle of the Hogue said he had the fine prints which were engraved from these pictures & he asked who painted them. West sd. he had met with other instances of like ignorance'[xi].

Lit: Alexander and Godfrey (General) pp.33-32; Rix (General) 10.

154

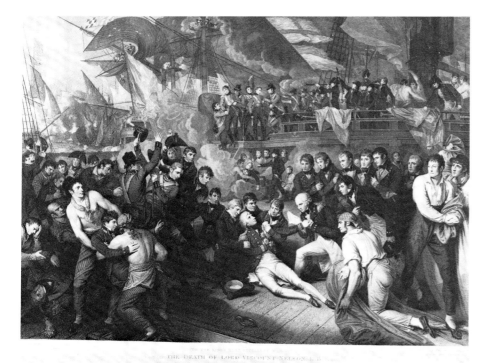

144A

144B

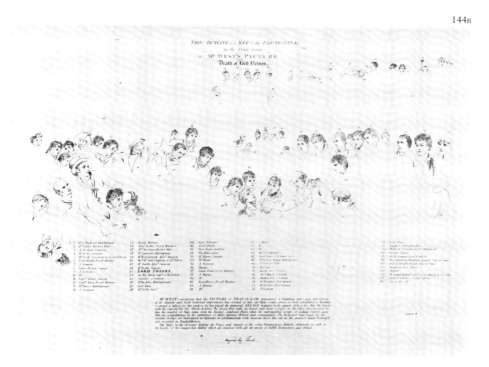

144A & B

JAMES HEATH (1757-1834) AFTER BENJAMIN WEST

The Death of Lord Viscount Nelson. K.B. Issued with a Key to the identity of the portraits

Lettered with title and *To the King's most excellent Majesty. This plate is with his gracious permission humbly dedicated by his Majesty's most dutiful Subjects and Servants Benjamin West and James Heath. Painted by B.West. Presdt. of the Royal Academy, Historical Painter to His Majesty. Engraved by JAs: Heath, Historical Engraver to His Majesty, & to H.R.H. the Prince Regent. Published May 1st. 1811. by Benjn West. No.14 Newman Street and by JAs. Heath, No.15 Russell Place, Fitzroy Square, London.*
Etchings. 50.4 x 62; 43 x 63
VAM 25837 & a

The production of this print, co-published by the painter and the engraver, was an attempt over thirty years later at achieving the success enjoyed by the *Death of General Wolfe* (fig.143). The key, in addition to a numbered reference to all those represented, is lettered with the an explanatory narrative: 'Mr. West conceiving the Victory of Trafalgar demanded a Painting everyway appropriate to its dignity and high national importance, has formed it into an Epic composition as best calculated to heighten so grand a subject for this purpose he has placed the immortal Nelson wounded on the quarter deck of his Ship (The Victory) with the Captain (Sir Thos Hardy,) holding the dying Hero with one hand, and from a paper in the other announcing to him the number of Ships taken from the Enemy's combined Fleets, while the surrounding Groups of gallant Officers and Men are sympathizing in the sufferings of their expiring Friend and Commander. The Wounded and Dead in the several Groups are introduced as Episodes to commemorate with honour those who fell in the greatest Naval Triumph ever recorded in the English History. The Ships in the distance display the Flags and Signals of the Triumphant British Admirals as well as the Vessels of the vanquished Enemy which are marked with all the wreck of Battle, Destruction, and Defeat.'
Lit: Alexander and Godfrey (General) 144.

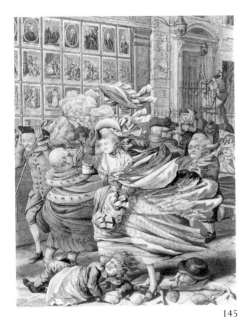

145

ROBERT DIGHTON (C.1752-1814)

A real scene in St Pauls Church Yard, on a windy day. c.1783

Watercolour. 32.1 x 24.5
VAM D.843-1900

The number of printsellers in London increased enormously during the 18th century. When Hogarth and his contemporaries lobbied parliament about the engraver's plight there were only twelve printsellers of note in London and Westminster[XII]. A hundred years later Pigot's *Directory* recorded seventy-two[XIII]. The explosion of print shops gave rise to a genre of print depicting them. This watercolour was published as a mezzotint in 1783. It depicts the premises of Carrington Bowles, the publisher of the mezzotint, for whom it would have served as an advertisement. The prints in the window, ranging from portraits of well-known divines like John Wesley to humorous scenes with bawdy overtones, give an idea of the breadth of the stock. The passing crowd suggests the clientele.
Lit: Stephens and George (General) 6352.

Vasari tells us that Marcantonio's prints after Raphael were sold 'whole-sale or retail to all who might want them... and considerable profit realised.'[15] From the beginnings of the reproductive trade, business must have been carried on from shops which would frequently have consisted of a room in the house in which the dealer and his family lived. Descriptions of shops before the 18th century are rare but they were probably usually simply furnished like that of Jacques Van Merle, a Flemish immigrant dealer in Paris towards the end of the 17th century. At his death the contents of his shop were listed as 'a large oak counter, with a drawer, two little benches, and two shelves...sixteen planks, neither large nor small, for laying out print stocks.'[16] By the mid-18th century, however, printshops had become places for social as well as commercial exchange and part of the fashionable circuit. Stocking a wide range of images, they attracted a broad spectrum of the public and were credited by some with the same kind of influence as television today. The author of *A Satirical View of London* at the commencement of the 19th century lamented that 'The caricature and printshops, which are so gratifying to the fancy of the idle and licentious, must necessarily have a powerful influence on the morals and industry of the people ... thither the prostitutes hasten, and with fascinating glances endeavour to allure the giddy and the vain....'[17]

Prints were also sold through advertisements in the press and through the publication of catalogues. The earliest extant print publisher's catalogue is that of 1572 issued by Antoine Lafrery,[18] a Burgundian expatriate in Rome, who like so many successful publishers brought a sound knowledge of foreign as well as local taste to his selection of subjects. Many of the images offered in catalogues could be printed to order, the plates being touched up as wear became disfiguring, but stock was also exchanged by dealers on a wholesale basis, sometimes on sale or return.[19]

Engraving was a lengthy process and required money up front to pay engravers. One solution, borrowed from the book trade, was the subscription system. Not only did it raise funds at the outset of a project but it ensured also a market for the completed product. Subscribers to ambitious publications like the *Recueil Crozat* (see figs.168,169) had the cachet of having their names listed in the publication and usually paid less than was asked for it after publication. For an artist like Hogarth, who published his own compositions, it provided a method of direct selling which kept the profits away from middlemen. Heavy advertising in the press alerted the public to the proposed publication but subscription tickets were available only from Hogarth's premises where the paintings could also be viewed by potential subscribers.

The exhibition of easel pictures played an increasingly significant role in the sale of reproductions of them (figs.139,142). The development of a new type of civic morality during the 18th century, associated with conspicuous acts of charity in hospitals and other such humane institutions, brought paintings in England before the public eye for the first time. Opportunities for public display were greatly

augmented on the foundation of the Society of Artists in 1760 and of the Royal Academy in 1768. Contact with paintings promoted a desire for ownership of at least a surrogate work in a public which had previously had little knowledge of this type of art. Direct access to this wider public encouraged a more speculative approach to their work on the part of both painters and engravers for the former were no longer dependent on private patronage and the latter could rely on sales to exhibition visitors who were not in the market for an original work. At exhibitions of the Society of Artists the prints, for example Edward Fisher's mezzotint after Reynolds's portrait of the *Rev. Laurence Sterne* [20], were sometimes on exhibition at the same time as the originals. Popular subjects were reproduced in a number of sizes catering for every income. Sporting pictures, in particular, were given this treatment. Thomas Burford mezzotinted James Seymour's *Fox Hunting* series in a large and a small size in 1754, adding an intermediate size in 1779. [21]

The right to exhibit a painting became an important ingredient of the engraving rights. The publisher, Ernest Gambart negotiated the loan of Frith's *Derby Day* (fig.147) not only so that Blanchard, the engraver, could have it in Paris to copy but also so that it could act as a trailer for the print. After the painting's great success at the Royal Academy in 1868, Gambart gave it a second London showing at Leggatt, Hayward & Leggatt in the Cornhill. It was then sent off on a world tour which lasted for over five years and extended as far as Australia, where it was shown at five different venues. A replica of the painting commissioned by Gambart kept the image before the eyes of the British public. [22]

146

146

THOMAS HULLEY (WORKED C.1798-1817)

Old Wells & Pump Room, Cheltenham

Signed and dated *T.Hulley 1812.*
Watercolour. 18.2 x 26.4
VAM P.38-1920

This watercolour shows the premises of Joseph Fasana, the printseller, known for a similar establishment in Bath. The location of print shops in spas is indicative of the kind of public their trade attracted. The image was published in aquatint by R. Ackermann, 1 June 1813.

147A

WILLIAM POWELL FRITH (1819-1909)

The Derby Day. 1856-8

Oil on canvas. 101.6 x 223.5
The Trustees of the Tate Gallery

147B

AUGUSTE THOMAS MARIE BLANCHARD (1819-1898)
AFTER FRITH

The Derby Day. Published by Gambart and Co. Declared 1858

Signed in pencil on the left *W.P.Frith* and on the right *Aug Blanchard* With the stamp of the Printsellers' Association.
Etching and engraving. 49.6 x 110.5
VAM E.560-1969

The ploy of exhibiting the original painting to whip up interest in its reproduction was often, as was the case with *The Derby Day*, combined with selling by subscription for the system outwitted the pirates. In Gambart's words 'before an engraving is issued, the public is induced to subscribe for the print while no piracies can be offered in competition with it, as it is not yet issued, and without a copy of it no photographic pirate can act'[XIV]. But as he went on to explain selling in advance encouraged malpractice for if the sales were already assured, the temptation was to put less effort into the manufacture of the product.

147B

148

148

Entry from the Medici Society's 'Special Marks Book'

The Medici Society Ltd.

The entry reads: 'Three dots in open space of ornamental piece of halo above curls in centre of infants forehead. Line from star on shoulder of Virgin's robe carried downwards from upper to lower flame ornament. New thorn added to crown hung on childs arm at top right hand corner where it twists round on robe over Virgins left arm. These marks are not very discernable except by side light.'

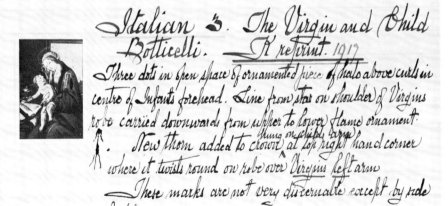

The idea of copyright, which implies an exclusive right to publish a text or image for a stipulated number of years, arose with the invention of printing as a means of protecting the unprecedented investment for which the new technology called. At that date it was known as privilege. Privileges were granted by a variety of authorities such as universities and the church as well as by kings and governing bodies and signalled a machinery to confiscate unauthorised plates and to impose fines on transgressors. The first recorded privilege was granted by the Venetian Senate in 1469 and gave the German, John of Speyer, a monopoly to set up as a printer from type in Venice. Fortunately his death soon after left the way open to other printers. The privilege remained, however, closely associated with the book trade and as late as the 18th century in France the system, even when it concerned the reproduction of paintings, was administered by the Communauté des Libraires et Imprimeurs.

The inventor of an image was not felt to own it more than others involved in its manufacture. When Dürer complained about Marcantonio Raimondi's sale of copies of his prints, the latter was enjoined only to omit Dürer's monogram. Any of the protagonists in the production of a reproductive print could apply for a privilege. Thus Ugo da Carpi (see figs.117b & c) petitioned the Venetian Senate in 1516 for a monopoly over all his existing or future chiaroscuro woodcuts on the grounds that he was the inventor of the technique. Whereas Titian petitioned the Council of Ten in 1566 for similar rights over the publication of Cornelis Cort's engravings after his paintings on the grounds of the labour involved in the preparation of drawings for them and his considerable expenses (fig.140). Even collectors could apply. It appears to have been because of Jean de Jullienne's ownership of paintings by Watteau that he obtained a privilege from the French government for their reproduction in 1727.[23] The lettering[24] on a print shows the existence of a privilege but does not show in whom it was vested. Where, rarely, this information is known it suggests who shouldered the financial risk and contributes, therefore, to our knowledge of how the trade was organised.

Although the privilege system was outwardly a method of protecting the print industry and of ensuring a standard of production, it was exploited by some authorities as a means of building up a collection. The deposit of one impression of an image was necessary as a pattern against which to check imposters. The French government came to stipulate, however, the deposit of a considerable, although frequently changing, number of impressions which were allocated to different bodies and even sold or exchanged by the Royal Library for missing desiderata. Moreover from 1741 censorship was incorporated into the system.[25] A censor was appointed whose approval of the image had to be obtained before the issue of a privilege. The whole system was paid for by the applicant and, according to Basan, who referred to the cost of privilege fees as a 'prix d'argent', rendered engraving uneconomic.

Early in the 18th century the position of engravers in England was even worse for there was no system of redress whatever. In 1734 a group including George

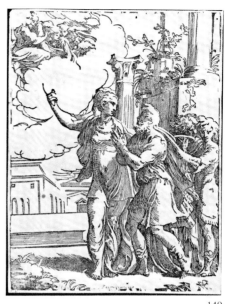

149

ANTONIO FANTUZZI, CALLED ANTONIO DA TRENTO (C.1508-C.1550) AFTER PARMIGIANINO

Augustus and the Sibyl

Inscribed in ink *Parmigianino* and *n:3.*
Chiaroscuro woodcut printed from two blocks in buff and black. Cut to 13.3 x 26
VAM 29894

Antonio da Trento was employed by Parmigianino to produce woodcuts made directly under his supervision. According to Vasari the partnership ended when Antonio 'one morning while Francesco was still in bed, broke open a chest and robbed him of all his copper and wood engravings and designs, and disappeared, never being heard of again.'[xv] Parmigianino is said to have recovered the prints, which had been left with a friend in Bologna, but not the drawings. Antonio's willingness to abscond thus suggests how valuable original drawings by a leading master were to the reproductive woodcutter.

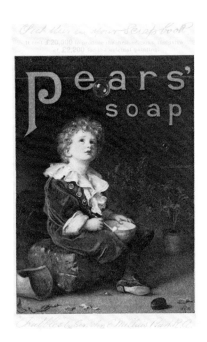

150

150

AFTER MILLAIS

'Bubbles' transformed into an advertisement for Pears' Soap

Lettered *Put this in your Scrap book. It cost $20,000 to produce the first editions, inclusive of £2,200 for the original painting. 'Bubbles' by Sir John E.Millais. Bart. R.A. A perfect facsimile in miniature. The original is in the possession of Messrs. Pears.*
Colour lithograph. Size of sheet 22.2 x 14.6
VAM E.2335-1889

This picture of the painter's grandson, painted in 1885, was acquired at that date by Sir William Ingram of *The London Illustrated News* who issued it in reproduction as a supplement to the magazine. It was subsequently sold to Messrs. Pears, who added the bar of soap and used it to promote the sale of their product. It provides thus an early example of the use of a well-known painting by the advertising industry. This use did not have Millais' authority, but not having registered his ownership of its copyright with the Stationer's Hall, as the copyright law at that date stipulated, he was powerless to prevent it.
Lit: J.G.Millais, *The Life and Letters of Sir John Everett Millais*, 1899, pp.186-192.

Vertue (fig.173), Joseph Goupy, George Lambert, John Pine, Gerard Van der Gucht, Isaac Ware and, of course, Hogarth lobbied parliament and a pamphlet entitled *The Case of Designers, Engravers, Etchers & etc.*[26] advertising their plight was drawn up. It explained how engravers were dependent on a few printsellers for the sale of their products and how the printsellers insisted on an extravagantly large percentage of the profits and moreover, would increase their profit from a popular image at the expense of the engravers by selling in its place a cheap copy engraved by a hack. These copies it was claimed were 'imposed upon the incurious for the originals, or at least are industriously dispatched to all parts of the country, where the original is never suffer'd to appear.'[27] The engraver was then driven 'for a present supply, to part with the original prints returned upon his hands, his plates, and all to these very men at their own price; which you may be sure, will be very low, as they know he has no other chance of disposing of them: and soon after, seeing how vain it is to attempt any thing new and improving, he bids farewell to accuracy, expression, invention, and everything that sets one artist above another, and for bare subsistence enters himself into the lists of drudgery under these monopolists.'[28]

In response parliament passed the Engravers' Act[29] on 24 June 1735. It forbade the publication of unauthorised engraved copies for fourteen years from the date of the original's publication (the period of time was doubled in 1767) and imposed the forfeit of the offending plate and a fine of five shillings for every pirated impression found. The copyright was vested in the proprietor whose name, with the precise date of publication, was to be 'truly ...engraved on each plate'. No more was required to bring the copyright into force, so it was considerably less cumbersome than the privilege systems practised on the Continent. The act worked well for engravers like Hogarth who published their own prints, but as publishing became increasingly divorced from the act of engraving it still allowed the exploitation of engravers. For example Boydell paid Woollett a total of £150 for *The Destruction of the Children of Niobe* (fig.62c) but made a profit of £2000 for himself.[30]

Sir Thomas Lawrence is said to have been the first painter to charge a fee for the reproduction of one of his paintings[31] but, as is well known, by the middle of the 19th century the right to engrave a picture was a commodity which could be sold separately from the painting itself. Frith's *Derby Day* (fig.147a) was sold to Jacob Bell even before it was painted for £1500, but the engraving rights, retained by the painter and passed on to Gambart, made Frith an additional £2,250.[32] This practice was consolidated in England by the Fine Arts Copyright Act of 1862 which granted the author of paintings, drawings and photographs the reproduction rights of their work for their life, plus seven years after death, subject to registration at the Stationers' Hall.

Interestingly photography, although a medium of multiple rather than unique images, was included but traditional printmaking techniques were not. Yet photography was able to reproduce handcrafted prints with great ease. Gambart was quick to point out the injustice: the photographer 'need not work at my printer's or touch my plate – all he requires is to place his camera before my engraving for a few

minutes; in that time he obtains a 'negative,' from which he may take any number of copies at a trifling cost – he requires no costly presses, no skilled workman ... but can do everything in the privacy of his 'studio', while he has the additional advantage that, besides being able to compete with me in the sale of fac-simile copies of my engravings, he can produce them of all sizes – small enough to go into a breastpin, and large enough to cover a wall. He can do all this without the trouble of acquiring any artistic talent or knowledge beyond the power of using his camera and mixing a few chemicals. His is not even a colourable imitation; it is not even a questionable copy; it is my engraving itself, printed from my very plate. In short the progress of science has enabled the pirate to take away my property without breaking into my premises...'.[33]

The engraving trade was vulnerable also to the lack of international copyright agreements. A study of prints by French printmakers after the paintings of David Wilkie[34] has recorded four versions of *The Letter of Introduction*, five of *The Village Politicians*, and six each of *The Rent Day* and *The Blind Fiddler*. The image of which there are most, however, is *Blind Man's Buff* with eight, including one in which participants in the scene have donned Breton costume. The situation was not greatly improved by the International Copyright Act passed in 1844, for it required the copyright holder to register the print in every country in which he wished to own the copyright. 'Imagine' complained Gambart 'a publisher, having to register in a hundred different countries every one of his publications, and at a cost for correspondence and agency, of at least ten shillings in each case (it now costs about twenty shillings for registration in Berlin): add to this, that a hundred proof impressions of all his plates will often outvalue the probable remuneration.'[35]

Modern copyright of paintings belongs to the artist for his life and to his heirs for fifty years after his death unless it is sold or given away. No-one owns the copyright of older works. Owners of paintings do not own the copyright in them but can make their own terms for allowing access to them.[36] The copyright of reproductions of any work belongs to whoever commissions the making of the reproduction. The universal use of photomechanical reproductive processes has made the infringement of copyright in this kind of product difficult to detect. In its early years The Medici Society included deliberate mistakes in their reproductions (fig.148) to enable them to see when they had been used without authority as the starting point for someone else's reproduction. But there are tell-tale signs. The printing of a screened image from separations based on a screened 'original' results in what is called screen clash, creating a moiré patterning across the image.

151

151

SALVADOR DALI (BORN 1904)

Christ of St. John of the Cross 1951

Oil on canvas. 204.8 x 115.9
Glasgow Art Gallery and Museum

This is one of Dali's best-known and most reproduced paintings. Its copyright has often been infringed: the more resourceful infringements include the repainting of the whole canvas and the addition of the dove of peace.

161

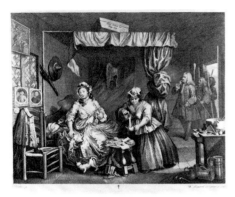

152A

WILLIAM HOGARTH (1697-1764)

A Harlot's Progress. Plate 3. 1732. Second state

Lettered *W.Hogarth invt pinxt et sculpt* and numbered *Plate 3*.
Etching and engraving. 32.3 x 39
VAM Dyce 2719

The Harlot's Progress, a set of six prints engraved by Hogarth after his own paintings, told the misadventures of a country girl coming to London and being ensnared in a life of prostitution. Here she is shown in a disreputable house, about to be apprehended by a magistrate. The set was sold for one guinea - a half guinea on subscription and the rest on delivery of the prints - and brought in the handsome sum of a little over £1200. A gimmick of the subscription was that no prints would be sold to non-subscribers. More or less true to his word, Hogarth did not issue a second edition until 1744. The paintings on the same theme were destroyed by fire in 1755.
Lit: Stephens and Hawkins (General) 2061; Paulson 123.

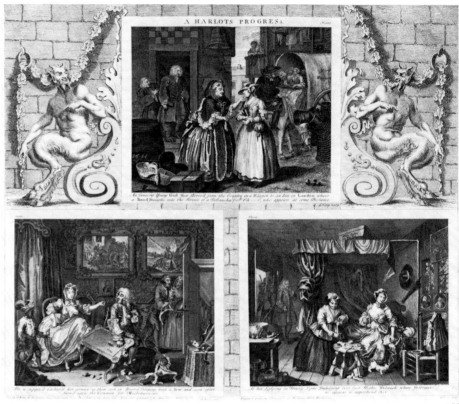

152B

152B

GILES KING (D.1746) AFTER HOGARTH

A Harlot's Progress. Plates 1-3. 1732. In reverse of Hogarth's plates

Lettered *Sold by G.King at the Golden Head in Brownlow Street Drury Lane & the Booksellers Printsellers of London & Westminster* and *Engraved from the Originals of Mr. Hogarth by Permission*. Each image lettered *G.King sculpt.* and with an explanation of the scene and, within the design, with identification of the characters.
Etching. 47.5 x 56
The Trustees of the British Museum

Hogarth promised his subscribers the prints on 10 April 1732. On 19 April the *Daily Journal* announced the imminent publication of cheap but authorised copies of the plates comprising *A Harlot's Progress* 'with Ornaments and Explanations'. Printed on two sheets only, they were published on 21 and 28 April. Although intended for a poorer market the price soon competed with that of the originals. By 1741 Philip Overton is recorded as selling these copies at 18 shillings the set yet in 1765 the originals could still be had from Hogarth's widow for one guinea.
Lit: Stephens and Hawkins (General) 2033,2048, 2063; Paulson 121-126.

152D

152C

152C

ANONYMOUS AFTER HOGARTH

**A Harlot's Progress. Plate 3. 1732. In reverse
of Hogarth's plate. Published by Thomas
Bowles in St Pauls Churchyard and John
Bowles at the Black Horse in Cornhill**

Etching. 23.4 x 30.9
The Trustees of the British Museum

In spite of the attempt to discourage the pirates by
the publication of an authorised down-market set,
the flow of unauthorised versions continued; thir-
teen different sets executed in woodcut and litho-
graphy as well as in etching are recorded.
Lit: Stephens and Hawkins (General) 2062-2074;
Paulson
121-126.

152D

ELISHA KIRKALL (1682?-1742) AFTER HOGARTH

**A Harlot's Progress. Plate 3. 1732. In reverse
of Hogarth's plate**

Lettered *Who give themselves to lust too soon will find / Tis
the least fault of their corrupted Mind. / Then theft and
drunkenness deceit and pride/ Ensue, with ev'ry shocking
Crime beside. / In the dark race of Vice, when once begun, /
we start on Evils we most wish to shun;/ Till from dishonour,
we to ruin fall, / And one disjointed Virtue loosens all. See
here an Instance and retreat betimes; For Justice sure,tho'
late, will reach our Crimes. / The Busy Knight, surpriz'd
feels soft alarms; But arm'd with Virtue, he defies her
Charms.* and *Wm. Hogarth inv. et pinx. E Kirkall sc.*
Mezzotint, printed in green. 33.3 x 37.4
The Hon. Christopher Lennox-Boyd

The publication of this version was advertised on
November 18 1732 in *The Country Journal; or the
Craftsman* as 'six prints in chiaro scuro...from the des-
igns of Mr Hogarth, in a beautiful green tint, by Mr
E.Kirkall with proper explanations under each print.
Printed and sold by E.Kirkall in Dockwell Court,
White-fryers; Phil. Overton in Fleet-Street;
H.Overton and J.Hoole without Newgate; J.King in
the Poultry; and T.Glass under the Royal Exchange.'
Hogarth's name was important for the promotion of
the image although he did not gain by its sale.

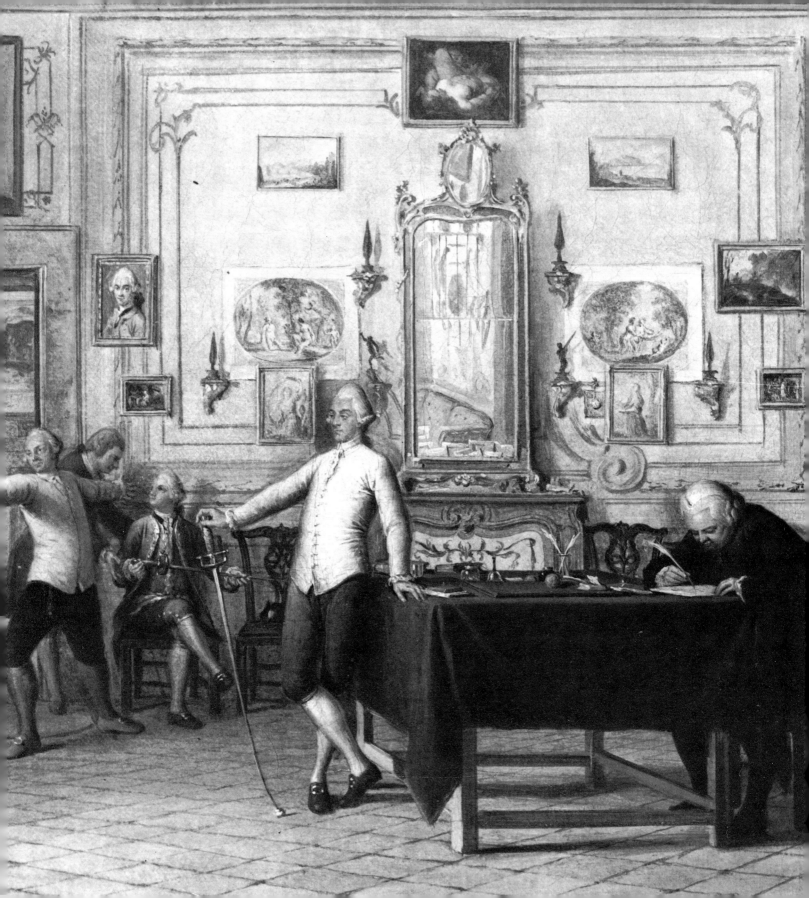

Chapter 6
The Market for Reproductions

It has frequently been pointed out how the invention of printmaking, like that of printing itself, revolutionised communication and so speeded up the movement of ideas. It is not surprising that it was the makers of these images who not only supplied the product but seem also to have created the first coherent market for it, for contact with reproductive engravings enabled provincial artists to follow what was happening in metropolitan centres and to update their work accordingly. A study of the influence of Marcantonio Raimondi's engravings restricted to Germany, the Netherlands and France has enumerated over 500 borrowings within the 16th century alone[1]. The speed with which engraved compositions were taken up is suggested by the appearance of the bodies of the slain babies and the figures of the executioner and the fleeing mother from Marcantonio's engraving after Raphael's Massacre of the Innocents (fig.53a) on a ceiling painted by Alessandro Araldi in the Convent of San Paolo, Parma, only two or three years after publication of the image (fig.153).

In spite of Vasari's statement that 'Marcantonio engraved the twelve Apostles in various ways, and many saints, of which poor painters unskilled in design can make use at their need'[2], grandiloquent quotations such as Araldi's were not considered a sign of weakness but rather as showing a commendable awareness of iconographic tradition. It was of course from printed sources, such as the images in standard handbooks of iconography like Cesare Ripa's *Iconologia, overo descrittione delle imagini universali, casuate dalle statue & medaglie antiche, & da buonissimi auttori Greci & Latini...,* issued in 1602, that the painter's repertoire of gestures and pictorial motifs was derived. Without this organised structure of conventional meaning, promulgated by the printed image, the capacity of painting to generate comprehensible statements was limited. Even an artist as inventive as Poussin, who was notable for his expression of contempt for the engraving trade, used prints as a source of information on the treatment of subject and the organisation of composition. According to Bellori, who knew Poussin personally, reproductive prints provided him with his most useful instruction before his arrival in Rome[3]. Once there, as analysis of his paintings proves, engraved sources continued to be of importance to him for some echoes of Raphael in his paintings stem from compositions only available in printed form[4]. His *Apollo and the Muses on Parnassus,* for example, a loose adaptation of Raphael's fresco in the Stanza della Segnatura, includes elements which appear only in a related engrav-

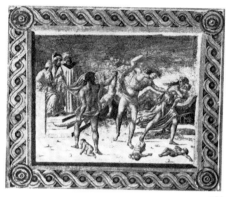

153

153

ALESSANDRO ARALDI(1460–C.1530)

Massacre of the Innocents. From a ceiling in the Convent of San Paolo, Parma. 1514

Fresco
Convent of San Paolo, Parma

154

154

EDOUARD MANET (1832–1883)

Study for *Dejeuner Sur L'Herbe*. 1863

Oil on canvas. 98.5 x 115
Courtauld Institute Galleries, London

Three and a half centuries divide the execution of these two works yet both are derived from prints by Marcantonio Raimondi after Raphael (see figs.53,141). Such borrowings were expected when the ceiling decoration was executed; the provincial Convent of San Paolo would even have been proud to have the Roman source of its design recognized. By contrast when Manet's source of inspiration was discovered he was criticised as a cheat.

ing (figs.155,156). It is not, therefore, surprising that at his death a large collection of albums containing prints after Raphael and Giulio Romano and a considerable number of loose impressions after Mantegna, Caravaggio, Titian and the Carracci were found in his studio [5].

Many northern artists like Rembrandt, for example, never even went to Italy but their work shows nonetheless a familiarity with Italian art. This must have been based largely on printed reproductions. The inventory made of the contents of Rembrandt's studio in 1656, at the time of his bankruptcy, shows that he possessed large numbers of engravings including four volumes after Raphael, 'the precious book of Mantegna', 'almost all the work of Titian' and a volume 'full of the work of Michelangelo Buonarotti'[6]. Parallels in composition between Rembrandt's images and those of Renaissance masters, like the similarity of the stance of Tobit in his etching *The Blindness of Tobit* to that of Elymas in Raphael's *The Blinding of Elymas*, which he could have known from Agostino Veneziano's engraving [7], suggest that he used his print collection as an information resource. Proof that he made copies after engravings is provided by one of his drawings after Leonardo's *Last Supper* (fig.159) which includes a dog, found only in an engraving (fig.215) and not in the original.

The relationship between artists and their sources became, however, increasingly complicated. The theme of Reynolds's sixth Discourse, delivered to the students at

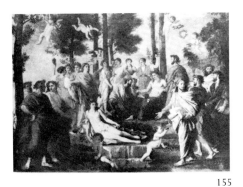

155

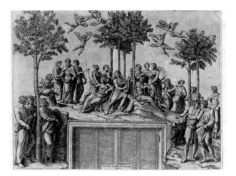

156A

156B

155

NICOLAS POUSSIN (1594-1665)

Apollo and the Muses on Parnassus. c.1630

Oil on canvas.145 x 197
The Prado, Madrid

This painting provides proof that Poussin worked from engravings even when the original was near at hand. Painted while in Rome and loosely based on Raphael's fresco in the Stanza della Segnatura in the Vatican, it includes the flying putti from Marcantonio's engraving after a preparatory drawing by Raphael (fig.156a) which do not appear in the fresco (fig.156b).

156A

MARCANTONIO RAIMONDI (C.1480-C.1534) AFTER RAPHAEL

Apollo and the Muses, the Stanza della Segnatura. From a lost preparatory drawing

Signed *MAF* and lettered *Raphael Pinxit in Vaticano.*
Engraving. 35.5 x 47.3
VAM Dyce 1041

In spite of the lettering and the reference to the architectural setting, the print differs considerably from the fresco. It contains, however, details that recur in Poussin's painting.
Lit: Shoemaker and Broun 48b.

156B

GIOVANNI VOLPATO (1733-1803) AFTER RAPHAEL

Apollo and the Muses. From the Stanza della Segnatura, the Vatican

Lettered *Pio Sexto Pont. Max. Johannes Volpato D.D.D.V. Steph. Tofanelli del. Johannes Volpato sculpsit, et vendit Romae.* and within the design *Raphael Sanctus Pinx In Aedibus Vaticanus.*
Etching. 57 x 75.4
VAM 19591

This print shows Raphael's composition as painted.

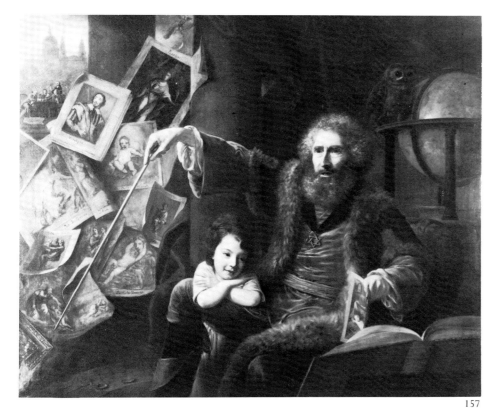

158

157

157

NATHANIAL HONE (1718-1784)

The Pictorial Conjuror, displaying the Whole Art of Optical Deception. 1775

Oil on canvas. 145 x 173
National Gallery of Ireland, Dublin

This painting, submitted to the annual exhibition of the Royal Academy in 1775, is a satire at the expense of Reynolds, the Royal Academy's president. The conjuror has the features of George White, a model Reynolds used frequently in his subject pictures at this date, and he is dressed in Rembrandtesque robes of the kind in which Reynolds liked to depict himself. The conjuror's wand weaves its spell over a shower of reproductive engravings which are falling into flames in the bottom left-hand corner apparently fueling the production of a painting in a gilded frame glimpsed emerging from the furnace. In the lower right hand corner is a heavy tome entitled 'Advantag/euoscopies/ from variou./ mas....' Borrowings from all the prints depicted can be traced in Reynolds's paintings.

158

CHARLES BARGUE (DIED 1883) AFTER FILIPPINO LIPPI

Head of a young man. From 'Cours de Dessin avec le concours de J.L.Gerome. II partie. Modèles d'après les maîtres de toutes les époques et de toutes les écoles'. Published by Goupil et Cie, 1868

Lettered *No. XII. Ecole Florentine, 1460-1505. Filippino Lippi, Pinx. Bargue Lith. Lemercier et Cie., Imp. Paris.* Lithograph printed on toned paper with the label of the 'Cours de Dessin' etched in red. Sheet 57.9 x 44.6
VAM 22615.5

This image formed part of the drawing course at the French Academy Schools. The image stands for a long line of reproductions aimed specifically at the student artist. The fine paper on which it is printed was mounted on a sturdier sheet to help it withstand handling.

167

159

159

REMBRANDT VAN RIJN (1606-1669)

The Last Supper after Leonardo. c.1635

Red chalk. 36.5 x 47.5
The Metropolitan Museum of Art, Robert Lehman
Collection, 1975.1.794

Rembrandt never went to Milan so he can only have
known this composition, of which he made three
drawings, in reproduction. The spaniel to the right
indicates that here his source was the engraving il-
lustrated as fig.215.

160

**Corner of Braque's studio, Rue Caulaincourt,
Paris. c.1910**

A reproduction of Van Gogh's *Sunflowers* drawing-
pinned to the wall confronts a tribal mask. On the
ledge below, African sources of Braque's imagery
mingle with objects from his still-lives.

the Royal Academy, London, at the end of 1774, was 'imitation'. He advised his contemporaries to learn all they could through study of the work of their hallowed predecessors, which he pointed out was made easier for his generation than that of Raphael by the ready availability of engravings. 'Invention' he claimed 'is one of the great marks of genius; but if we consult experience, we shall find, that it is by being conversant with the invention of others, that we learn to invent.' His message was that 'art' was acquired through imitation rather than as a result of innate inspiration and that 'a painter must not only be of necessity an imitator of the works of nature... but he must be as necessarily an imitator of the works of other painters...to open the mind, to shorten our labour, and to give us the selection made by those minds of what is grand or beautiful in nature'. The transplanting of specific details 'a particular thought, an action, attitude, or figure' into an artist's work he construed as plagiarism only if the borrowing was not disguised or improved upon for 'Borrowing or stealing with such art and caution, will have a right to the same lenity as was used by the Lacedemonians; who did not punish theft, but the want of artifice to conceal it'[8].

The fact that Reynolds's own frequent 'borrowings' did not go undetected (fig.157) was symptomatic of the increasing value which was coming to be attached to innovation. In 1759 Edward Young's *Conjectures on Original Compositions* had urged his contemporaries to 'build our compositions with the spirit, and in the taste, of the antients; but not with their material'. A hundred years later Manet was pilloried in the press when his borrowings from Raimondi's engraving after Raphael's *Judgement of Paris* were discovered (fig.154). But as the photograph (fig.160) of a corner of Braque's studio testifies, artists have continued to draw inspiration from their predecessors. Reproductions still have their place in the studio, and the inspirational net is cast increasingly wide.

STUDIO APPARATUS

There was also a place in an artist's collection of reproductive engravings for prints after his own work. In 1491 Mantegna wrote to his patron, Gian Francesco Gonzaga 'I have heard that your excellency has sent the small painting to Milan, I am sending another, since I have the prints to produce others'[10] suggesting that even at this early date prints acted as *modelli*. Certainly they must have provided an easily transportable version of a composition to send to prospective clients.

Prints were particularly useful to the portrait painter for clients could select from past compositions the pose in which they wished to be painted. According to Northcote, Reynolds's student and biographer, Reynolds 'kept a port-folio in his painting-room containing every print that had been taken from his portraits; so that those who came to sit had his collection to look over, and if they fixed on any particular attitude, in preference, he would repeat it precisely in point of drapery and position; as this much facilitated the business, and was sure to please the sitter's fancy'[11].

During the earlier years of printmaking, reproductive engravings tended to enter the collections of scholars and connoisseurs largely on the grounds of their subject matter, as part of an encyclopaedic gathering of knowledge. But they were also collected on their own merit as examples of a developing technology. From the 1560s, for example, Cardinal Scipione Gonzaga assembled a collection of engravings and woodcuts which consisted 'of the leading things made in the art'[12] arranged in great volumes filled exclusively with the work of individual engravers, regardless of whether or not the work was in our terms reproductive. Early in the 17th century Daniel Nys, a Northerner resident in Venice, is recorded as housing the metal plates of engravers in his cabinet, including the three which made up Agostino Carracci's *Crucifixion* after Tintoretto which he is said to have had gilded as protection against further use[13]. The collection of prints along with the other ingredients of the cabinet was a statement of the collector's place in a world of ever expanding knowledge and made him to a certain extent the possessor of that knowledge.

There are, however, by the middle of the 16th century at least, signs of an interest in prints for the light that they shed on painted and drawn masterpieces. Fragmentarily records show collectors on the look out for prints after certain artists. For example Vincenzo Borghini wrote from Florence in 1552 to Vasari in Rome asking him to find from among available 'prints of drawings': 'all those printed from Michelangelo, because I want to have all those I can near to me'[14]. And when, unusually, publishers listed a print by artist rather than subject, it was the name of the designer not the engraver that was cited. From what is known of how collections were kept at this date seems that Italian prints, fittingly given that they tended to be based on drawings by the masters, were stored as if representative of the drawing, alongside actual drawings in the collection. Moreover, it seems that collectors sought from engravings the same kind of pleasure as from drawings. Certainly when Aretino wrote thanking Salviati for an impression of the *Conversion of St Paul* engraved by Enea Vico he praised the quality of the engraving but it was on the characteristics common to the original drawing that he lingered[15].

As time passed a collection of prints became less a source of aesthetic pleasure for the connoisseur and more a necessary tool of his studies. The process of collecting leads the collector to look carefully at an object and to try to distinguish it from similar objects and counterfeits. Such a method requires a corpus of accredited examples for analysis. According to Roger de Piles writing at the end of the 17th century 'nothing is more necessary than good prints' for those who would be 'more gentleman-like' for 'They may fill their memory with the most curious things of all times, and all countries, and in learning the different histories, learn the several manners of painting: They will judge readily, by the facility with which they may open a few leaves, and so compare the productions of one master with those of another, and by this means, in sparing their time, they will spare their expence also; for 'tis almost impossible to put the pictures of as many masters together in a room, as will suffice

161

Three Graces distressing Cupid. English, Derby. c.1780

Biscuit porcelain. 38.8 high.
VAM C.59-1924

Reproductive prints were a source of inspiration and instruction not only to 'fine' artists but also to industry and have been collected as reference material by craftsmen and designers working in a wide range of decorative media. As a result it is not surprising to find compositions designed in two dimensions translated into three. This biscuit group, probably modelled by Pierre Stephan, has Angelica Kauffmann's painting reproduced by W.W. Ryland as its source (figs.73a & b). It was also manufactured in soft paste porcelain enamelled in colours and gilt.

162

162
HENRIK VAN DER BORCHT II (1614-1654) AFTER
PARMIGIANINO

**Prints from a set of at least 14 from *Libretto di
diverze figurine dis original da Frau Parmensis et
Conservata nella Colletne Arondly*[II], 1637-8**

Etchings, printed on blue paper. Trimmed to the
platemark, various sizes in an album 54 x 39
VAM 29036.2-9

These prints reproduce prints from the Arundel col-
lection. Vertue recorded that Arundel 'had several
gravers constantly at work with a design to make a
large volume of prints of all pictures, drawings &
other rarities'[III]. Certainly he brought Van der
Borcht to England to act as custodian of his collec-
tion and had in his employ also Lucas Vorsterman
and Wenceslaus Hollar but no such comprehensive
work appeared. These etchings are housed now in an
album which bears Horace Walpole's earliest book-
plate[IV] in use from 1733-1760. It is devoted to the
work of Parmigianino, containing over three hun-
dred compositions engraved by a variety of en-
gravers.

to form a perfect idea of the work of each master, and when at a vast charge a man
has fill'd a large chamber with pictures of different manners, he cannot have above
two or three of each, which is not enough to enable him to make a nice judgement of
the character of the painter, ... whereas, by means of prints, one may easily see the
works of several masters on the table, one may form an idea of them, judge by com-
paring them one with another, know which to chuse, and by practising it often
contract a habit of good taste, and a good manner.'[16]

Moreover it is only recently that travel within a single country let alone abroad
has become widespread. Many connoisseurs never went abroad and those that did
made only one extensive journey rather than repeated visits. First-hand experience
of original paintings was at best a more or less embroidered memory and it was on
reproductions that knowledge of the masters was based. The entry on the 'print' in
Watelet's *Dictionnaire des Arts de Peinture, Sculpture et Gravure* of 1792 states: 'The orig-
inals of the antiquities discovered at Herculaneum are conserved at Naples, but
prints have made knowledge of them familiar to all the 'curieux'. You can see,
without leaving a cabinet in Paris or London, all the pictures of Italy, of Flanders, of
France.'[17] Catalogues of collections began to be published in the form of repro-
ductions in the 17th century; they greatly increased in number in the 18th century
and must have been given impetus by the collector's pride, the lust for knowledge
and the desire for tools with which to study their own less extensive collections. The
taste for this sort of knowledge became a badge of membership of the social elite[18],
and the increasing size of the literate and leisured classes must have helped to give
the printmaking ventures a measure of commercial viability.

The earliest illustrated catalogues made public the great collections which were
founded by the ruling families of Europe and which provide today the core of
Europe's national collections. *Le Théâtre des Peintures* (fig.29c) was masterminded by
David Teniers the Younger, court painter to Archduke Leopold Wilhelm of the
Netherlands, and keeper of the Royal Collection in Brussels. It was issued as separate
plates from 1658 and in gatherings from 1660, providing at this date an early ex-
ample of the princely catalogue, typical in its concentration on the Italian paintings
in the collection.[19] Each print is accompanied by the painter's name and the dim-
ensions of the original picture but except for a brief introduction describing the
appearance of the gallery there is no text. Famous for its scale, consisting of nearly
250 plates, it has been criticised for the quality of its reproductions all of which are
in reverse of their originals. Charles Patin, visiting the collection in 1696, noted
'There are also engrav'd prints of the best pieces of this inestimable collection; in-
deed the project was well contriv'd, and the reputation of Teniers, who is the graver,
would have been much more considerable if he had taken care to put his design in
execution with greater success. But these sorry copies only serve to disguise the
originals and to disfigure the finest draughts in the world.'[20]

The *Cabinet de Crozat* (fig.168), issued in two volumes in 1729 and 1742, set a
standard by contrast for both the scholarliness of the information and the quality of
reproduction expected from catalogues of collections of paintings. The first volume

dealt solely with the Roman School and the second volume with the remainder of the Roman School and the Venetian school with one Bolognese subject. Totalling 140 large plates after 99 paintings and 41 drawings, it was the first printed historical and stylistic account of Italian painting from the Renaissance to the present which included not only paintings but also drawings. Reproducing works from the French collections only, it also documented French holdings of Italian art. The text was the combined effort of Pierre Crozat and the two other most influential collectors in Paris at the time, Pierre Jean Mariette and the Comte de Caylus. The importance of the engraved reproduction in their approach to the masterpieces is indicated by the preface which shows the same kind of belief in the power of the engraved images as is now sometimes ascribed to photography. Regretting that paintings were not as durable as sculpture and that none of the paintings described by writers in antiquity had survived, they rejoiced that 'There was found in the 15th century an art capable of giving to their masterpieces the same immortality as the art of printing assured Tasso's *Jerusalem* and the Tragedies of Corneille. The art of engraving… can transmit to all the countries of the world, and to future centuries that which is the most precious and most devine in the works of excellent painters'.[21] There is a brief biography of each of the artists whose work is reproduced with references to the deliberations of earlier writers and each work represented is described with an explanation of its purpose, an analysis of its technique and a note on its provenance, where known. The prints were engraved by a large number of the most celebrated French engravers which would have included Watteau but for his premature death.[22] The sizes of the original paintings were given and the drawings were reproduced actual size. Particular care was taken in the reproduction of the drawings to capture the effect of pen and ink and wash on toned paper (fig.169).

The prominence given to drawings in this publication was a reflection of an increasing preoccupation among connoisseurs with the artist's process of creation, which brought with it a new sense of the value of artistic personalities. The first artist to be honoured with the reproduction of something approaching his total oeuvre was Watteau. The task was undertaken by his contemporary Jean de Jullienne, a historian, amateur artist and avid collector of Watteau's work, shortly after the painter's death. The *Recueil Jullienne,* as the complete work is known, is made up of two distinct parts: the *Figures de Différents Caractères…* (fig.165) consisting of 350 plates which reproduce the drawings exclusively and *L'Oeuvre Gravé* (fig.2c) consisting of 287 plates which includes designs for arabesques and even some of Watteau's own etchings but concentrates on his painted output. Paintings owned by Jullienne or by collectors in his circle formed the nucleus of the images, but his desire for completeness was such that he advertised also in the press for owners of other pictures and even included plates first published by others. Jullienne's motives are not recorded. It has been tentatively suggested that the opus may have been some kind of sale catalogue assisting in the sale of originals and providing a compositional source for copies.[23] The publication constitutes, however, the first comprehensive visual catalogue of the work of a single artist and serves, thus, as a pioneer in a long

163

163

JACQUES-ANDRE-JOSEPH AVED (1702-1766)

Comte Carl Gustaf Tessin (1695-1770)

Oil on canvas. 149 x 116
Nationalmuseum, Stockholm

Count Tessin, a great collector and patron of French art, was the Swedish ambassador to France from 1739 to 1742 and subsequently became the Kanslipresident of Sweden. By choosing to be portrayed holding an engraving after Raphael's *Galatea* rather than a more intrinsically valuable possession, he suggested a grasp of a body of knowledge and thereby expressed his place within an intellectual elite.

164

Cornelis Ploos van Amstel's Identifying mark

Transfer print. Size of mark 6 x 4
VAM

The basis of Josi's publication was Ploos Van Amstel's stock of prints and plates reproducing Dutch drawings which he acquired some time after the latter's death. Each of Ploos's and Josi's impressions was printed on the back with this mark to prevent them being sold deceptively as drawings. Why Ploos, a businessman involved in the foundation of the Netherlands Society of Industry and Commerce, embarked on his publication is not known. Certainly it was not a commercial venture. Of the 350 impressions made of each image, many like fig.128b were presentation copies bearing inscriptions in his own hand and the price of those which were sold was not commensurate with the labour involved. Simple images were available at 1 or 2 guilders and even the large coloured ones were little more than 15 guilders. Nor does it seem to have been a project of self-glorification for the selection does not reflect the admired balance between Classical idealism and the Northern tradition evident in his own impressive collection of some 7000 drawings. Perhaps Josi's claim in the extended publication that the intention was to redress the traditional neglect of Netherlandish drawings should be believed.

line of illustrated monographs which have become since the second half of the 19th century a staple tool of art historical inquiry.

The cost of the production of these elaborate reproductions led inevitably to a limitation on the extent of their circulation. The *Cabinet de Crozat* was published in an edition of 800, of which 100 were kept by the King, 500 went to subscribers, leaving only 200 for general distribution. This meant that it was seen as a rarity and sought for just that reason by collectors. Some played frankly on this phenomenon. Christiaan Josi in his facsimile reproduction of Dutch and Flemish drawings (fig.164) expressed his intention of doing for the drawings what Decamps [24] and Le Brun [25] had done for the paintings and Basan [26] and Bartsch (fig.174) for the prints, yet limited the size of the edition to 100 copies in the hope that 'This work, becoming more and more rare, will become more sought after; and that then the price of forty guineas for subscribers, and of fifty for non-subscribers will progressively increase' [27].

The 19th century saw a greatly increased production of collectors' publications aimed at a less exclusive market. The outline method of representation provided a more economical technique of reproduction, capable of producing very large runs without deterioration (figs.28e,224). And the expansion of the engraving trade at just the moment photography threatened to remove the engravers' livelihood, provided a willing work-force to supply printed galleries of old and modern masters to the bourgeoisie (fig.166,167).

The invention of photography has transformed the work of the scholar. It achieves in reproduction the appearance of a brushstroke. The existence of relatively accurate reproductions which allow the immediate comparison of a wide range of works by different artists has actually made possible the science of attribution. Bernard Berenson is reputed to have said 'Photographs, photographs. In our work one can never have enough.' [28] By 1949 André Malraux considered that 'For the last hundred years art history...has been the history of that which can be photographed' and pointed out that 'the mere act of grouping together a great number of works of the same style creates the masterpieces of that style, by constraining us to grasp its meaning' [29]. Yet curiously the earliest art history book to be illustrated with photographs, William Stirling's *Annals of the Arts of Spain,* took all but ten of its sixty-six photographs from drawn or printed reproductions of the originals (fig.47). Their inaccessibility in distant lands and dark buildings could be argued to account for this, were it not for the tone of Stirling's introduction where he makes clear his intention to promote the work of Spanish printmakers: 'In the selection of subjects I have been guided by a desire to exhibit ... the genius both of the Spanish pencil, and of the lesser known Spanish graver. Whenever a print, executed in the Peninsula, was to be had, I have preferred it on that account, even to a better work produced this side the Pyrenees'. Ironically the easy availability that photography has given to the reproduction was to banish this kind of respect. To Vasari, Marcantonio was the 'wonder of Rome' [30] and to Bartsch he was 'the leading Italian engraver who had raised his art to a perfection unknown until then in his country' [31], but to Hind in 1923 he was 'the harbinger of the host of servile engravers' [32].

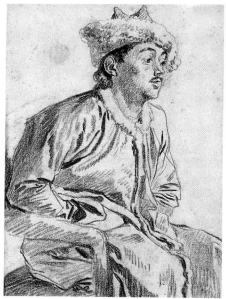

165A

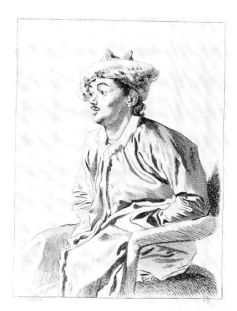

165B

165A

ANTOINE WATTEAU (1684-1721)

Persian in a fur hat, seated, half-length, and facing to the right

Red and black chalks. 29 x 19.5
VAM Dyce 593

165B

FRANÇOIS BOUCHER (1703-1770) AFTER WATTEAU

Persian in a fur hat, seated, half-length and facing to the left. Plate 215 from *Figures de différents caractères, de Paysages, et d'Etudes dessinées d'après nature par Antoine Watteau Peintre du Roy en Son Académie Royale de Peinture et Sculpture gravées à l'Eau forte par des plus habiles Peintres et graveurs du Temps. Tirées de plus beaux cabinets de Paris*, vol.2, 1728

Inscribed *Watteau. del. B.Sc* and numbered *215*.
Etching. 32.3 x 24
VAM E.2274-1919

Boucher, whom Jullienne discovered while still a student at the French Academy, contributed 119 plates to the publication on which fifteen other engravers were involved. Although Watteau was renowned for his drawings it was a remarkable departure to reproduce so many drawings by one artist, especially one who was neither Italian nor long dead.
Lit: Jean-Richard 105.

166

166

Wrapper for the third part of *The Turner Gallery*, 1859

Black letterpress on pink paper. 44.7 x 32.4
VAM

The advertisement inside the wrapper for photographic views by Francis Frith of Cairo, Sinai, Jerusalem and the Pyramids of Egypt gives an idea of the market at which the prints were aimed.

167

JAMES TIBBITS WILLMORE (1800-1863)

AFTER TURNER

The Fighting Temeraire. Engraver's proof. From *The Turner Gallery*

Inscribed in pencil *Fourth Part Approved* and signed and dated *J B Pyne Sept. 24. 60.*
Etching. 18 x 25.7
VAM E.5152-1946

The Turner Gallery in its initial form consisted of sixty subjects, largely in the national domain, issued in sets from 1859-61. Although published nearly 10 years after Turner's death it was worked on by the same engravers as had worked with him and J.B.Pyne, a disciple of the master's Italian style, oversaw the project for quality. The plates were accompanied by descriptive texts by the historian and populariser, Ralph N.Wornum. The 1875 edition of the *Gallery* issued with a few alterations claimed to be the first edition to be printed from the original plates, stating that the first edition had been printed from electrotypes. There have been many reprints.
Lit: Rawlinson (Turner) 690-750.

167

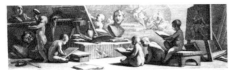

169A

168

169B

168

Title-page to the first volume of the *Recueil d'estampes d'après les plus beaux tableaux et d'après les plus beaux dessins qui sont en France dans le Cabinet du Roy dans celuy de Monseigneur le Duc d'Orleans & dans d'autre cabinets divisé suivant les différents écoles avec une abrégé de la vie des peintres & une description historique de chaque tableau*, Paris, Imprimerie Royale, 1729

Engraving and letterpress.
VAM, National Art Library

The collection is known as the *Cabinet de Crozat* or *Recueil Crozat* because of Crozat's role as the leading organiser and financier of the project and the fact that it reproduced more works from his collection than from any other.
Lit: Lloyd & Ledger (General) 29.

169A
GIOVANNI FRANCESCO PENNI, KNOWN AS IL FATTORE (1496-1528)

The drowning of the Egyptian army in the Red Sea

Pen and ink and wash over black chalk, heightened with white, on faded green paper; fan shaped. 12.7 x 39.1
VAM D.365-1885

169B
ANNE-CLAUDE PHILIPPE DE TUBIERES, COMTE DE CAYLUS (1692-1765) AND NICHOLAS LE SUEUR (1691-1764) AFTER PENNI

Plate 75 from the *Recueil Crozat*, 1729

Lettered *Les Egyptiens submerges dans la Mer Rouge Dessein de Jean Francois Penni dit le Fattore, qui est dans le Cabinet de Mr Crozat gravé a l'eauforts Par Mr le C.. de C .. et en bois sous son conduite par Nicolas Sueur.*
Etching, printed in black, and two wood blocks printed in two shades of green. 12 x 35
VAM E.1384-1885

The print is the same size as the drawing but of a slightly different shape and the image is reversed. The design is reproduced faithfully, right down to many of the *pentimenti* but the bluey-greens of the print are considerably brighter in tone. It may have been made from a brighter version of the drawing or this drawing may have faded since the print was made. Other drawings in the *Recueil* even have their collectors' marks reproduced.

Penni's biography in the *Recueil* is accompanied by references to Vasari. The description of the drawing explains that its fan-like shape was an indication that it was intended for painting on faience, which was produced in Lombardy at the time of Raphael and sought after by 'les curieux'.

174

170A

GUERCINO (1591-1666)

St Prosper, a woman (probably the Madonna), and a putto who is carrying a model of Reggio Emilia

Pen and wash. 25.7 x 16.5
Windsor Castle, Royal Library (C) Her Majesty the Queen

170B

FRANCESCO BARTOLOZZI (1727-1815)

AFTER GUERCINO

St Prosper, a woman (probably the Madonna), and a putto who is carrying a model of Reggio Emilia

Lettered *Guercino inven F.Bartolozzi Sculps. Londra 1764.*
Etching, with plate tone, printed in brown on India paper. 28 x 20.8
The Trustees of the British Museum

Francesco Bartolozzi left Italy for England in 1764 at the suggestion of Richard Dalton, the keeper of the King's drawings and medals. His first commission was to reproduce the eighty-two drawings after Guercino in the Royal collection. Guercino was perhaps the most consistently reproduced artist throughout the 18th century; this contribution provided the first fully illustrated catalogue of a single artist's drawings in a single collection. The prints were made from 1764 to 1784. The early ones, although often reversed like this example, show a more genuine attempt to present the original untampered with than many of Bartolozzi's later reproductive prints (see fig.123b). The brown printing ink is presumably an attempt to reproduce the colour of the original's iron gall ink, black when fresh but turned brown by the 18th century. Boydell's republication of 1835 does not do the earlier impressions justice.
Lit: Vesme and Calabi 2136; Hyde (Technique) 4.

171

TOMMASO PIROLI (C.1752- AFTER 1824) AFTER CARLO CENSIONE AFTER GIOTTO

St. Francis appearing in a dream to a Pontiff... Plate 15 from W.Y. Ottley's *A series of plates engraved after the paintings and sculptures of the most eminent masters of the early Florentine School; intended to illustrate the history of the restoration of the arts of Design in Italy,* 1826

170A
170B

171

Lettered with title and *Giotto Di Bondone. Carlo Censione del ab Orig. 1793 Tommaso Piroli sc. Painting in fresco in the upper Church of S.Francesco at Assisi. London Pub. March 1. 1825 by W.Y.Ottley Proof.* Numbered *PlXV.*
Etching on India paper. 35 x 32.4
VAM

William Young Ottley, collector, artist and author, became Keeper of the Prints and Drawings Department at the British Museum in 1831. This publication, dedicated to Flaxman and executed in a linear technique influenced by his illustrations, consists of 54 plates made from drawings copied from the originals either by Ottley or under his supervision between 1792-8. The purpose was to 'illustrate the history of the Revival and Gradual Advancement of the Arts of Design in Italy during the 13th, 14th and 15th centuries'. It was argued that 'there must have been something in the system of study and processes of the early Florentine masters, and in the principles by which they were governed, which was of a nature to lead to a genuine excellence, and rendered them safe teachers of their art; but that in the novel principles and methods which were by degrees introduced by the artists of later periods there was something fallacious.'
Lit: Lloyd & Ledger (General) 8.

175

172

Volume from the print collection of Samuel Pepys showing an engraving by Gérard Edelinck (1640-1707) after Charles Le Brun of *Crucifixion*, folded to fit

By permission of the Master and Fellows, Magdalene College, Cambridge

Pepys's print collection is one of the few from the 17th century to have remained intact. Arranged as a mnemonic tool it consisted of four main categories: portraits, topography, 'prints general', and a collection of frontispieces. Only in the albums devoted to 'pitture celebri' in the atlas of Rome are the prints arranged according to artist rather than subject. Lit: Van der Waals (General).

173

Traditionally prints were part of a library. Until the end of the 17th century at least they were usually acquired from the same auctions as books. Like drawings, they were stored in volumes often crowded on to leaves, with outsize examples folded to fit (fig.172). The collection formed by Mariette early in the 18th century for Prince Eugene of Savoy, for example, was stored in 470 large red morocco bound folio volumes of 100 to 120 sheets with gilt edges, containing approximately 250 prints each. A century later Bartsch (fig.174) lamented the damage caused by folding the sheets, recommending that 'newly acquired sheets of large format should be laid on cardboard and kept in a large or extra-large portfolio. A fold cannot be permitted ... except in cases where there is an inscription in the lower border'.[33]

How the prints were organised within the volumes depended on the collector's particular interests. If collected on the encyclopaedic principle, they were arranged by subject either within categories such as the Old or New Testaments, secular history or mythology, or in topographical atlases. Thus reproductions of paintings in Rome were frequently placed in the atlas devoted to that city, sections of which would encompass also views of the buildings and surrounding landscape and even such souvenirs as invitations received during a visit to the city. But as the size of the atlases increased, reproductive prints began to be treated separately and stored according to a system of classification based mainly on the schools of the original painters. Carl Heinrich von Heinecken, dismissed from the post of director of the great gallery and print cabinet at Dresden on the accusation of fraud, described one such system in *Idée générale d'une Collection Complète d'Estampes* in 1771 enumerating twelve categories largely of a national character but including also thematic divisions, such as portraits and antiquities. This system remains current, though adapted to the special needs of individual collections, in many of the great print rooms of the world.

As drawings came to the fore as objects of particular delectation, collections of prints reproducing them received increasingly elaborate treament. Some were sold loose, in sets, trimmed and ready for mounting according to the the particular collector's desire (fig.176b); others were printed in groups to simulate the effect of an album (fig.177b).

Choice examples of the collection have also always been displayed, either in the form of galleries (fig.179) to facilitate study or as outward emblems of a scholar's inner life. Sheets were often unceremoniously pinned up among more permanently displayed aspects of the collection (fig.180) but they were also framed as decorative elements. The engraver and historian, George Vertue, chose to commemorate his marriage by depicting himself and his wife in front of a display of 'heads' arranged to complement the rhythm of the panelling on which they were hung, thus placing his partnership in a lineage (fig.173). Equally structural was the arrangement of the prints of antique paintings in the breakfast room of Sir John Soane, source material for the architect's own designs, but presented as measured rectangles of activity on the walls, echoing the rectilinear pattern of the carpet (fig.182).

173

WILLIAM HUMPHREY (1740-C.1795) AFTER VERTUE

George Vertue and Margaret his Wife, in the very Habits they were Married; Feby 17th Anno Domini 1720

Lettered with title and *From the Original Drawing in the Collection of the Rte Honble Lord Cardiff G.Vertue del. W.Humphrey fect.*
Etching. Cut to 37.3 x 43
VAM 22927

George Vertue (1684-1756), antiquary and official engraver to the Society of Antiquaries, is remembered today for his rambling notes on the arts in England. They were written in forty manuscript volumes, which were purchased at his death by Walpole and served as the basis for the latter's *Anecdotes of Painting in England,* 1762-1771. Published in extenso by the Walpole Society earlier this century, they still constitute one of the scholar's principal sources on the 17th and 18th centuries.

174

ADAM VON BARTSCH (1757-1821) AFTER A DRAWING
FORMERLY ATTRIBUTED TO REMBRANDT

Mardochée monté sur une mule, ... Plate from *Recueil d'estampes ... d'après les desseins originaux de différens maîtres qui se trouvent à la Bibliothèque Imp: et Roy: de Vienne,* 1794

Lettered *Rembrand del A.Bartsch sc: 1783*
Etching and aquatint printed in brown. 29 x 39
VAM 20473,4

Bartsch is remembered for his pioneering work as a print historian which culminated in the publication of his 21 volume *Le Peintre Graveur* from 1803 to 1821. In spite of the title Bartsch was as interested in prints reproducing other artists' compositions. Recognising printmaking as an independent art form, he treated the practitioner as the painter's equal and surveyed his work systematically with the kind of attention hitherto paid only to paintings. His magnum opus is still the basic tool of print scholarship and is even now being re-published in an illustrated edition.

The information was based largely on the collection of the Imperial Library in Vienna, where Bartsch was employed from 1777. The Director summed up his qualifications for the post as 'distinguished by incomparable abilities in the arts of both drawing and writing'[v]. His engraving skills allowed him, as curator, to enrich the public knowledge of his collection while capitalising on the fashion for facsimiles.

174

175

175

JOHANN HEINRICH MUNTZ (1727-1798)

Horace Walpole seated in the Library. 1755-59

Pen and ink wash and body-colour. 50.8 x 38.1
Private Collection

Walpole acquired a copy of Carl Heinrich von Heinecken's *Idée générale d'une collection complètte d'estampes* and arranged his collection along the lines it suggested. Here he is shown with bookcases C and D on which were shelved volumes containing engraved portraits. His collection of 'heads' amounted to nearly 8000 examples. They were valued for their anecdotal interest and were pasted on both sides of a leaf in albums arranged chronologically by reign and subdivided into professions such as 'Dignified and other clergy' and 'Statesmen'. Other categories included 'Female Sex' and 'Remarkable characters and phenomena'.
Lit: S.Calloway, M.Snodin and C.Wainwright, *Horace Walpole and Strawberry Hill,* exhibition at Orleans House, 1980, 89.

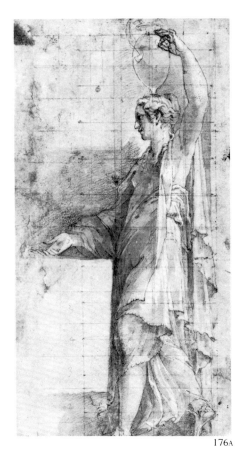

176A

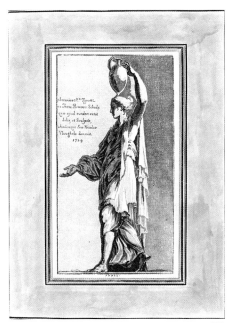

176B

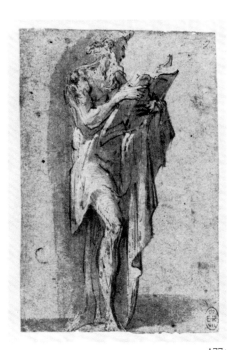

177A

176A

GIROLAMO FRANCESCO MARIA MAZZOLA, CALLED
PARMIGIANINO (1530-1540)

**Canephoros facing to the left. Study for a
figure in the vault of S.Maria della Steccata**

Pen and brown ink and brown wash, heightened
with white; squared in pen and ink. 27.6 x 14.3
Uffizi, Florence

176B

ANTONIO MARIA ZANETTI (C.1680-1757) AFTER
PARMIGIANINO

**Canephoros facing to the left. Plate 37 from
Part 1 of _Raccolta di varie stampe a chiaroscuro
tratte dai desegni originali di Francesco Mazzuola,
detto il Parmigianino, e d'altri insigni autori da
Anton Maria Zanetti, Qm. Gir. che gli stessi
disegni possiede_, Venice, 1749**

Inscribed and dated _Antonius Ma Zanetti ex Franc. Par-
mensis scheda quae apud eumdem extat delin; et Sculpsit
Amicoque suo Nicolao Veughels donauit, 1724._
Woodcut printed from three blocks in different sha-
des of grey-brown. 27 x 14.7
VAM 15145.37

To reproduce his collection of drawings by Par-
migianino the connoisseur and practising engraver,
Zanetti, revived the chiaroscuro technique used to
reproduce the master's drawings during his life (see

figs.117,149). Like their prototypes, Zanetti's chiar-
oscuros alter the original in order to create attractive
images in their own right. They do not necessarily
produce either the quality of the line or of the tone
of the original composition accurately. Whatever the
technique of the original the prints give an impres-
sion of wash and most images were reproduced in a
variety of colourways which bore no relationship to
those of the original. What we have here is an 18th
century vision of a Parmigianinoesque figure, elegant
and self-contained, not unlike Boucher's shepherds
and shepherdesses, rather than a strict reproduction
of one of Parmigianino's working drawings for the
Steccata vault.

There are two sets of the publication in the Victoria
& Albert Museum. They have the same printed in-
troduction and descriptions but the prints are
mounted on different papers with different borders.
This set has been mounted, in some cases several to a
page, with elaborately ruled and washed borders,
with a gold fillet.

177A

GIROLAMO FRANCESCO MARIA MAZZOLA, CALLED
PARMIGIANINO (1503-1540)

**A bearded saint standing to the right reading
from a book**

Pen and brown ink and grey wash on blue paper,
heightened with white. 11.2 x 7.4
Windsor Castle, Royal Library (C) Her Majesty The
Queen

177B

CONRAD MARTIN METZ (1749-1827) AFTER
PARMIGIANINO

**Plate from *Imitations of Drawings by
Parmigianino In the Collection of his Majesty*,
published by the engraver, 1790**

Lettered *Parmegiano. In the Collection of His Majesty
CM sc.*
Aquatint and line etching, printed in brown. 15.8 x
29.5
VAM 15140.12

Each page of this publication gives the impression
that it not only renders each drawing faithfully but
also the arrangement of the drawings on a specific
album sheet. In fact, as comparison with one of the
originals shows, the aquatint is used to make the
prints look convincingly like drawings, rather than
actually to reproduce the drawings as accurately as
possible, for the drawings are in reverse, and this
example is on a blue not a brown sheet. No album
containing the drawings is recorded. What we have
is an alluring collector's piece rather than an ac-
curate facsimile of a specific volume.

178

ADOLPHE BRAUN (1812-1877) AFTER GUIDO RENI

**Three studies of children. From a set of 122
prints issued on 50 mounts of 'Decorative
Designs of the Old Masters', selected by Sir
M.Digby Wyatt, F.S.A. from the Gallery of
the Uffizi, Florence. Published by the
Autotype Company Ltd., London, c.1870**

Carbon prints, printed in reddish brown. Sheet 47.5
x 61.5
VAM 70.112-114

Braun ran an Alsatian firm of photographers which
photographed twenty-two collections of drawings,
ten of paintings, four of sculpture and four series of
frescoes, employing at its peak over a hundred work-

177B

178

man. Even photographs of drawings were presented
in a way which emulated the presentation of the
drawings themselves. These examples are mounted
on blue card reminiscent in tone of that used by
Mariette as a mount for his drawings. The sheet is
printed with the heading 'Musée de Florence' and
with the artist's name in a museological tablet. The
ruling and washing has been done by hand.
Lit: N.Rosenblum, 'A 19th Century Career in Photo-
graphy', *History of Photography*, 1979, 3, pp.357-372.

179

KARL FRIEDRICH SCHINKEL (1781-1841)

Project for a Raphael Room, New Pavilion at Charlottenburg

Watercolour. 30 x 36.5
Staatliche Schlosser und Garten, Berlin

Giovanni Volpato's prints after the frescoes in the Vatican Stanze and other prints after Raphael are ranged around the rooms with a classical regularity. The overmantel mirror straddling the corner reflects the *Sistine Madonna.*

180

180

PIETRO FABRIS (WORKED SECOND HALF OF THE 18TH CENTURY)

Lord Fortrose at Home in Naples. c. 1770

Oil on canvas. 35.5 x 47.6
Scottish National Portrait Gallery

The interior is hung with framed paintings and drawings arranged symmetrically around a pier glass so that their frames interact with the decorative borders painted on the panelling. On either side in the centre are two engravings after scenes by Francesco Albani temporarily tacked up. It was customary to show prints without frames long after it was fashionable to frame drawings but their central position here, suggests that they were recent additions to the collection pinned up for the assembled company to admire.

181A

ANGELO CAMPANELLA (1746-1811) AFTER A DRAWING BY ANTON VON MARON (1733-1808) AFTER A ROMAN WALL PAINTING

Plate 5 from a set entitled *Die Antiken Wand - und Deckengemalde de Landhauses Negroni, welche Villa zwischen dem Weinhügel und dem Esquilinium im Jahre 1777 entdeckt und ausgegraben wurde...*, Rome 1778-1802

Lettered *Equiti Josepho Nicolao de Azara Potentiss. Caroli 111 Hisp. Reg. Catholici apud S.Sedem Pro-Legato Procuratorique Generali aequo Bonarum Artium aestimatori et c. Parietinas Picturas inter Esquilias et Viminalem Collem anno MDCCLXXVII detectas in ruderibus privatae Domus Divi Antonini Pii aevo depictas facili elegantique Arte et Ornamentorum simlicitate spectandas servata proportione in Tabulis expressas Camillus Buti Artchitectus Romanus D.D.D.MDCCLXXXI Cum Privilegio SS DNPii VI Eques Antonius Maron delin. Aug. Campanella sculp.* Numbered *V.*
Etching. 56 x 80.4
VAM 19600

181A

181B

Hand-coloured impression of the same print

Cut to 48.6 x 74.9
VAM E.522-1890

The excavation of the Villa Negroni in 1777 with its Roman wall paintings intact caused great excitement. A publication to record the paintings in situ was planned under the management of Mengs, the most celebrated painter in Rome, and before his death he made some of the drawings from which the engravers worked. Impressions were to be sold at six paoli each, plain, and five zecchini each, coloured. Announcing the publication Camillo Buti, the architect in charge of the excavation, declared that the ancients 'so far published are either copied from detached pieces and therefore do not give an idea of the whole, or are restored and the additions confused with the true antique, or are copied with such thoughtlessness that they are not delicate enough. Wherefore our rooms are drawn (before being removed from the walls) with the most scrupulous exactness and with the same colours, in order that it can be seen what was the effect that the parts made with the whole, and finally so that one can form an idea of the taste of the ancients in this type of mixed ornamental and figural painting.'[VI] It is ironical to note therefore that in some coloured sets the draughtsmanship has been falsified by the skilful veiling of genitalia beneath draperies, presumably to make them more widely acceptable in the decorator's market.

Lit: Joyce (General).

182

JOHN LE KEUX (1783-1846) AFTER H. SHAW

House of J.Soane Esq. Lincolns Inn Fields, Ante Library. Plate from J.Britton and A.Pugin, *Illustrations of the public buildings of London, with historical and descriptive accounts of each edifice,* **1825-28**

Lettered with title and *Edifices of London - Private Houses.Pl.1.J.Britton dirext. H.Shaw del. J.Soane R.A.&c Archt. J.Le Keux sculpt. London. Published Novr. 1, 1823, by J.Taylor, High Holborn. MQ.*
Etching. Image size 11.5 x 16.5
VAM, National Art Library

Soane had been in Italy from 1778 to 1780 and had been patronised by the purchaser of the Villa Negroni frescoes. On completion of his house, built in 1812, he hung the breakfast room with the unbowdlerised coloured impressions of the first eight plates reproducing them, trimmed and framed in dark wood frames of simple moulding.

183

183 *See colour plate XVI*

WILLIBALD RICHTER (WORKED 1824-1850)

Closet at Lancut

Water-colour.
Jagellonian Library, Krakow

The salon is decorated with hand-coloured impressions of the prints after the Negroni frescoes and after Raphael's frescos in the Vatican Stanze, inlaid in panels on the walls and ceiling, as if part of the painted decoration.

The Print Room in Woodhall Park, Hertfordshire, photographed c.1948

Courtesy Country Life

A drawn record of this print room is inscribed 'Designed & Finished by R.Parker, 1782' but Parker has not been identified.

185A

185B

185C

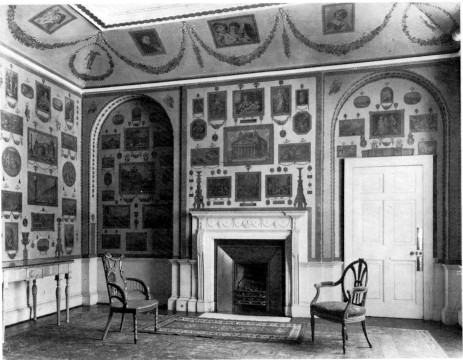

184

185A-C

FRANCIS VIVARES (1709-1780); PETER MAZELL (WORKED 1755-AFTER 1797) AND OTHERS

A selection of frames, bows, swags and borders

Etchings. Various sizes
VAM

Print room borders were most often printed in black but there are examples in the Victoria and Albert Museum printed in shades of red and brown.

186

MARY ELLEN BEST (1809-1891)

The drawing room in the Remaier Hof, Worms. Early 1850s

Watercolour. 33.7 x 26.7
Caroline Davidson, *The World of Mary Ellen Best*, Chatto & Windus and the Hogarth Press, London

The mounting of prints on screens remained popular into the present century.

186

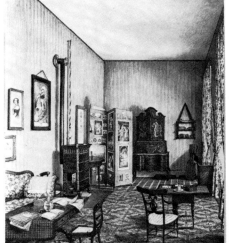

The 1775 catalogue of Sayer and Bennett, a run-of-the-mill London print publisher, described their 'fine prints in sets' as 'proper for the collections in the cabinets of the curious; also elegant and genteel ornaments when framed and glazed, and may be fitted up in a cheaper manner, to ornament rooms, staircases,&c. with curious borders representing frames, a fashion much in use, and produces a very agreeable effect'.[34] The decoration of rooms with prints cut out and pasted directly on to the walls was, however, a fashion not restricted to the less wealthy but indulged by a wide range of society including kings and dukes, among them the Duke of Wellington,[35] and even amateurs of the print such as Horace Walpole (figs.184,185).

The fashion took off first in Paris from where, writing in 1726, the celebrated Circassian *princesse,* Mademoiselle Aïssé, reported the 'new passion for cutting up coloured engravings' and pasting them upon sheets of pasteboard, which were afterwards varnished and made up into wall hangings and screens. This new occupation, she added, had quite ousted cup and ball. Books of engravings worth one hundred livres were being sacrificed to the craze and some 'women were mad enough to cut up engravings each costing one hundred livres'.[36]

In England the craze caught hold somewhat later and was usually confined to black and white prints often set off by a coloured background. Horace Walpole spoke in a letter dated 1753 of a room at Strawberry Hill hung with yellow paper and prints 'framed in a new manner invented by Lord Cardigan, that is with black and white borders printed. Over this is Mr Chute's bedchamber hung with red in the same manner'[37]. And Mrs. Lybbe Powys noted in her Diary in 1771, a room at Fawley Court hung with 'the most beautiful pink India paper, adorned with very good prints'[38]. The work was carried out by both professional decorators and by amateurs as a hobby. Thomas Chippendale's bill for the decoration of a dressing-room at Mersham-le-Hatch in 1767 shows a charge of £14 10s was made for 'cutting out the prints, borders and ornaments and hanging them in the room complete'[39]. Whereas Mrs Delany writing in 1750 from Ireland commented 'It rained furiously so we fell to work making frames for prints' and a year later 'I have received the six dozen borders all safely, and return to you, my dear brother, many many thanks for them. They are for framing prints. I think them much prettier than any other sort of frame for that purpose, and where I have not pictures, I must have prints'.[40] The diaries of house guests are littered with references to halls, dining, bed and dressing rooms decorated in this way.[41] The fact that few survive to-day is an aspect of their fashionableness. Like the wallpapers that imitated them, they have been pasted over or stripped off to give the room a more up-to-date appearance (fig.187).

REPRODUCTIONS AS SUBSTITUTES FOR PAINTINGS

There is evidence that from the beginning printed images were seen as cheap alternatives to paintings. Paintings show them tacked up crudely for reasons of religious ritual rather than as interior decoration (fig.188). A very few early examples survive

187

187

Wallpaper imitating the effect of a print room. c.1760

Stamped on the back with a Georgian excise stamp. Colour print from wood blocks. 81.6 x 54.4
VAM E.474-2914

Framed motifs are presented in a decorative arrangement on a blue ground as if actually hanging. The scene of lovers on a garden seat is copied from a print by or after C.N.Cochin the younger, which was published by Vivares. This fragment was rescued from Doddington Hall with another wallpaper with similarly framed motifs; both are likely to have formed part of the alterations which the Hall underwent from 1760-64.

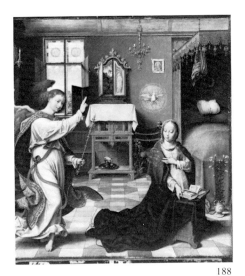

188

JOOS VAN CLEVE (C.1485-1540/1)

The Annunciation. With enlarged detail

Tempera and oil on panel. 86.4 x 80
The Metropolitan Museum of Art, Bequest of
Michael Friedsham, 1931. The Friedsham Collection
32.100.60

In the background is a trompe l'oeil representation
of a hand-coloured woodcut probably by Jacob Cor-
nelisz van Oostsanen, pinned to the wall. The image
is of Moses, traditionally the typological character of
Christ.

stuck on panel, indicating that they were pasted on to structural elements of a room and were presumably to that extent more formally incorporated into its arrangement, perhaps as the central image of a house altar (fig.189). Series of engravings, richly coloured by hand, were arranged into imposing decorative schemes linked and framed by printed borders especially designed for the purpose. Several such arrangements of *The Life of the Virgin and of Christ* to which the *Annunciation* reproduced as figs.3b & c belongs are known.[42] And a composition like Titian's monumental twelve sheet woodcut, *The Submersion of Pharaoh's Army in the Red Sea,* could only be appreciated displayed on a large expanse of wall.[43] That the print market posed a threat to painters in Venice early in the 17th century is suggested by the imposition of sanctions by the painters' guild against those who passed off hand-coloured prints as real paintings.[44]

English print catalogues indicate an established market for prints of the scale of paintings early in the 18th century. John Overton, a London publisher, had on offer in his 1707 catalogue addressed to 'all gentlemen, merchants and country chapmen', 'A large print of Moses, Aaron and Joshua, with the Decalogue, curiously engraven on 4 copper-plates... well-becoming any churches or chapels in the country; also gentlemens houses, or any publick school & c', 'a very large flower-pot finely coloured... designed to put before a chimney when no fire is us'd' and, imported from Paris, 'Several sorts of large prints for chimney-pieces, about 4 or 5 foot long'[45]. Early accounts of Le Blon's business report the shipment of chestfuls of his large prints to Italy and Spain (fig.78b). But the extent of the market for such prints is difficult to infer. Not only were the prints not protected by glass but they were also frequently varnished. The *Dictionarium Polygraphicaum: or The Whole Body of Arts* published in 1735 included directions on how to apply the varnish and how to polish the surface once it had dried 'until it will appear as clear as glass' concluding with the observation that if the print is 'at any time ... sullied with flyshits, you may clean it by washing it with a sponge and water'[46]. But practical as the varnish may have been in the short term, it darkened with time, obscuring the image, and also rotted the paper itself. Moreover because such prints looked like paintings, we cannot pick them out in painted views of interiors and, because their owners thought of them as 'pictures', they are described verbally in the same terms as genuine paintings.

Publishers, however, hedged their bets. Prints were packaged so as to catch as wide a market as possible. The print which was for one customer a visual reference could provide for another an overmantel picture. The use of this kind of print as wall decoration is easier to follow. Collectors' prints were traditionally sold in series and enterprising publishers capitalised on this practice to provide sets which grouped together on the wall could provide the same kind of visual weight as an oil painting. The *Progresses* of Hogarth, saved for future generations in the portfolios of the connoisseur, were intended primarily for the walls of the people at whom moral instruction of the kind intended by Hogarth was aimed. The 'original prints of the Progresses of a Rake' were available from the shop of Philip Overton in 1735, a few days after the subscription to the series ended, 'neatly framed in the newest and

cheapest manner'[47]. Arthur Pond's *Italian Landscapes* published in ten sets of four provided for the connoisseur a complete visual catalogue of all the landscapes by Claude and Poussin in England in the middle of the 18th century but capitalised also on the shortage of originals available to decorate the walls of the growing number of nouveau riche households. Pond supplied painted copies at £14 a canvas but a set of prints at five shillings for four provided a cheaper alternative[48] (figs.191,192). The style and tastes of gentlemen were made more and more generally available. Even a knowledge of pictures, one of the more recherché marks of gentility, could be cheaply simulated.

The relatively small size of these prints was important not only to give them a place in the portfolio but also to enable them to be glazed. The most suitable glass available for glazing before the middle of the 19th century was blown in a globe and, although it underwent a flattening process, it remained a section of a curve which could not be cut into large flat sheets. The only other glass available was plate or cast glass used for shop fronts which, being thick, was heavy, difficult to handle, and affected the colour of the image. Moreover, it was even more expensive, and the cost increased disproportionately the larger the sheet[49]. Engravings were therefore glazed as small as the image allowed, unmounted and with almost no margins. That glazed prints were particularly valuable and still in the minority in England in 1745 is confirmed by the wording of the will of Philip Overton, who left to one 'Widow Griffin' 'forty shillings and all the framed prints that I have at Kentish Town excepting those with glass before them'[50]. That the glazing of black and white prints was, however, fashionable is suggested by the increasing selection of glazed instead of loose prints as subjects for the trompe l'oeil artists' skills (figs.198,199).

Frames used on prints tended to be less elaborate than those used on paintings. The inventory of possessions made at the death of Jacques Van Merle in 1682 recorded the presence of 'twenty picture frames, of which five were gilded and the others of darkened wood, which contained prints' showing that gilded frames were used on prints in the 17th century. The earliest identifiable class of frame particularly associated with prints, however, consisted of simple fruit wood mouldings, usually polished black. By the middle of the 18th century it had become common for the dark polish to be alleviated by a touch of gold, either in the form of a gilt sand slip (fig.196) or in the pattern now universally known as the 'Hogarth' and erroneously associated with the painter, rather than with the framer and printseller of the Haymarket (fig.190).

Few prints in gilded frames from before the second half of the 18th century survive, but a study of frames in the USA has shown that some of the more elaborate dark frames were blacked over gilt[51]. Late in the century coloured frames seem also to have been available for 'Minshull's Looking Glass Shop', advertising in a 1775 issue of the *New-York Journal; or, the General Advertiser*, announced the arrival of a selection of choice prints from London which could be supplied in glazed frames 'finished white, or green and white, purple, or any colour that suits the furniture of the room, or gilt in oil or burnished gold'[52]. Certain frame types became associated with

189

189

ANONYMOUS, NORTHERN ITALIAN

Virgin and Child. c.1475

Woodcut, partially coloured by hand, pasted on panel. 60.3 x 45.7
VAM 321a-1894

The scale of this image is such that it would provide a commanding focus for worship.
Lit: Hind 1935 (General) pp.160-162.

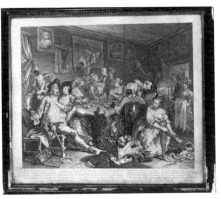

190

190

A 'Hogarth' frame containing plate 3 from Hogarth's *A Rake's Progress* with a detail from the back of the frame showing the stamp of Hogarth Printseller, Mounter of Drawings, Picture-Frame Maker, 6 Haymarket London

The Hon. Christopher Lennox-Boyd

The Hogarth frame acquired its name from the Hogarth family of frame-makers, recorded at 60 Great Portland Street in the 1830s and in the Haymarket by 1846. This style of frame has been employed for a variety of different genres of horizontally proportioned prints but is particularly associated with the work of Hogarth, the painter. This example bears the label designed to identify works from the collection of Charles Dickens entered in the sale of his effects after his death. Dickens admired Hogarth greatly and had a substantial collection of his prints.

specific genres of print. Mezzotinted portraits were frequently framed in wider waved mouldings with a metal ornament nestling in their corners (fig.197). Furniture prints were more often set off in verre églomisé, a process which masked the borders of the print by the water-gilding of the inner side of the glass and its over-painting in black; sometimes a transparent window was left for the lettering.

The introduction of 'gilder's compo', a composition of glue-resin, whiting and oil, in the middle of the 18th century made possible the mass-production of the effect of carving. As its use for the manufacture of picture frames became standard towards the end of the century, it became economically viable for reproductions to be displayed in frames which used the same language of ornament as the individually carved frames designed for original paintings in earlier periods (fig.202). Moreover the remittance of Excise duty on glass, at least in England, in 1845 made glazing cheaper and provided the glass industry with the impetus to develop methods to manufacture larger sheets of glass at low cost. The ensuing exuberance in frame design was inevitably balanced by a lobby in favour of more discreet effects. Charles L.Eastlake, architect and nephew of Sir Charles, President of the Royal Academy and Director of the National Gallery, in *Hints on Household Taste in Furniture, Upholstery and other details* first published in 1868 advocated that 'Frames made for engravings can scarcely be too simple in design, and when two or three prints of the same size and general character have to be hung in one room, it is well to group them side by side in one long frame divided into compartments by a light fillet or beading'[53] (fig.208). When, however, the frame of a painting was designed by its painter to elaborate its message it could be reproduced on a smaller scale for the print (fig.204).

The high level of formal accuracy achieved with the camera's help by some full-colour reproductions early this century encouraged publishers to promote special frames for their wares. The Medici Society's view was that to obtain the best effect from their 'facsimile' reproductions 'as much care and thought must be given to their framing as would be given to an original'[54]. Accordingly they provided a variety of frames (figs.104,205,214), designed to suit all pockets, which ranged from frames described as 'Italian Style', 'an inexpensive adaptation of an old Florentine style' or 'English Style', 'in the tradition of the XVIII century, suitable for English and French pictures of that period' to copies of the actual frames which surrounded the original, sometimes like Van Eyck's *Man with a Turban*, reproduced actual size. A patented varnishing process in place of glass was advocated for darker subjects and museological brass plates engraved with title and artist's name were also available.

Ideas of 'truthfulness' interpreted according to the Modern Movement aesthetic combined with the passing fashion for white walls has had a sobering influence on the way reproductions are presented. Fancy gilded frames continue to decorate the reproductions available from the furniture departments of the traditional department store, but specialists in the field tend to recommend that reproductions should not be mounted in elaborate frames resembling those of the originals but in simple frames which acknowledge the lowliness of their status. Will the new aesthetic of Post-Modernism bring a challenge to this?

191

JAMES MASON (1710-c.1780) AFTER A PAINTING
ATTRIBUTED TO CLAUDE LORRAINE

Landscape

Lettered *Claudio Gillée Lorenese pinx. J.Mason Sculp.
Published by Ar. Pond Feby. 11th 1744 In the Collection of
the Honble. Majr: Genl: Guise. 4 feet 1 inch. wide. 3 feet 2
inch. high.*
Etching. 31.5 x 41
VAM Dyce 2849

Each set of *Italian Landscapes* contained works attri-
buted to either Claude or Poussin except for the
eighth set which contained prints by Filippo Lauri,
Salvator Rosa, Bourgognone and Rembrandt. The
collection to which each print belonged was featured
in a central position usually reserved for the title. A
leather binding at a cost of five shillings was offered
to collectors of the complete set of 40 prints.
Lit: Lippincott (Pond), p.139

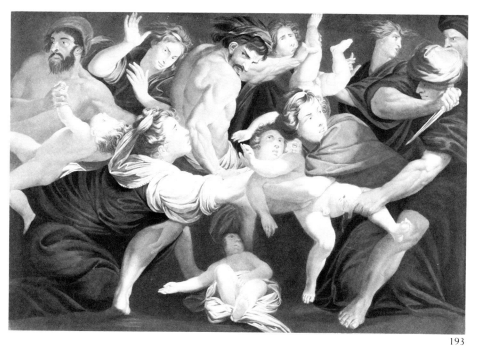

193

192 *See colour plate XIVa*
FRANCIS VIVARES ((1709-1780) AFTER A PAINTING
ATTRIBUTED TO POUSSIN

Landscape

Lettered *Gaspar Poussin pinx. Vivares sculp In the Collec-
tion of Peter Delme Esqr. Published March 25. 1741. by
C.Knapton. 3 feet 3. inch: wide. 2.f. -4 inch: high.*
Etching, coloured by hand. 30.5 x 39
VAM W.27.U-1947

Knapton, the publisher of this print, was Pond's par-
tner and was responsible for the publication of some
early numbers of *Italian Landscapes*. This impression
has been drummed on to three additional sheets of
paper of the kind on which it is printed, a by-
product of mounting on a stretcher for colouring,
suggesting that the hand-colouring was done by the
same establishment as the printing. Pond's records
for his next series, *Roman Antiquities*, show that he
offered a hand-colouring, framing and glazing ser-
vice at an extra cost of £1 11 s 6 d and that of 544
impressions sold, 81 were coloured and framed up
by his assistants. No doubt far more were coloured
by amateurs. But as collectors tended to value un-
touched black and white impressions and coloured
prints have tended to be subjected to the vagaries of
the decorators' market, the latter are now rare.
Lit: Lippincott (Pond) p.143.

193 *See colour plate XIVb*
VALENTINE GREEN (1739-1813) AFTER ANNIBALE
CARRACCI

The Murder of the Innocents

Lettered with title in English and French and *To His
Most Serene Highness Charles Theodore, Elector Palatine,
Reigning Duke of Bavaria, &c. &c. &c. This PLATE En-
graved by his gracious Permission from the Original Picture
in the Electoral Gallery of Dusseldorf, is dedicated by His
Most Devoted and Obedient Humble Servants Valentine
Green. Rupert Green.* and *Painted by Annibal Carracci En-
graved by V.Green Mezzotinto Engraver to his Majesty &
the Elector Palatine. In Mons: Pigage's Catalogue of the
Dusseldorf Gallery, this Subject is No.114. Published April
14. 1801 by R.Cribb, 288 Holborn London.*
Mezzotint, coloured by hand. 45.7 x 65.8
VAM 15543

This plate was first published as a black and white
image on May 31 1792 by Valentine Green and his
son Rupert and was sold at one guinea. Robert
Cribb's later impression was probably printed inten-
tionally light to provide a foundation for paint. Even
the modelling of the forms is as dependent on the
work of the watercolourist as on the printed base. A
print conceived as a rich, chiaroscuro rendering of a
painting was thus transformed into an image which
reads as a painted copy.
Lit: Whitman 265.

192

195

CLAUDE MELLAN (1598-1688)

Francois Theodore de Nesmond

Signed *CMellan del et S.*
Engraving. Cut to 32.1 x 25.3
VAM E.3437-1906

The engraved portrait is represented as itself pinned up on display. The margins of the print rendered in trompe l'oeil are noteworthy for wide margins on prints of this date are seldom encountered to-day.
Lit: A. de Montaiglon, *Catalogue Raisonné de l'oeuvre de Claude Mellan d'Abbeville,* Abeville, 1856, 219

194

EDWAERT COLLIER (WORKED 1673-C.1702)

Trompe l'oeil after an engraved portrait of Erasmus secured with wax to a wooden plank

Signed and dated *E.Collier fecit Londonis 1695.*
Oil on canvas. 35.2 x 31.7
Private Collection

The painting reproduces an engraving published by Peter Stent (worked c.1640-c.1667) after the portrait by Holbein, now in the Metropolitan Museum, New York. The seals impressed with the heads of the Roman emperors associate Erasmus, the cleric, with temporal power.

196

Plain fruit wood frame, ebonised, and with gilt sand slip. c.1780

49.3 x 36
The Hon. Christopher Lennox Boyd

The slip was made in a mould and was therefore capable of mass-production.

196

197

Fruit wood frame, with scalloped gilt and gilded lead corner decoration. c.1790

53 x 44.4
The Hon. Christopher Lennox-Boyd

The mezzotint boom early this century brought with it a revival of these frames. The corner decorations were made by pressing lead into metal dies. Sometimes 18th century dies are used on 20th century frames.

197

LES ENFANTS DE SYLÈNE LIBERI SYLENI

198

198

GABRIEL OR GASPARD GRESLY (1712-1756)

Trompe l'oeil after *Les Enfants de Sylène* engraved by Pierre Dupin (b.c.1690) after Watteau

Signed *G.Gresly* in place of the engraver's name.
Oil on canvas.
Private Collection

199

ANONYMOUS, FRENCH SCHOOL, MID 18TH CENTURY

Trompe l'oeil after *St. John* engraved by Nicolas Dorigny (1657-1746) after Domenichino

Inscribed with lettering from the engraving.
Oil on canvas. 63.5 x 50
C-G.Marcus Collection

The painting reproduces a print from Dorigny's series of the Evangelists of 1707 after Domenichino's frecoes on the spandrels beneath the dome of Sant'Andrea Della Valle, Rome.

199

200

VALENTINE GREEN (1739-1813) AFTER RUBENS

The Descent from the Cross with The Visitation and The Presentation in the Temple, which comprise the Altar-piece in the Cathedral Church of Antwerp, 1790. In a gilded compartmentalised wooden frame

Mezzotint. Size of frame 105 x 143
Rob Dixon
Lit: Whitman 262

201

GEORGE SIGMUND FACIUS (C.1750-C.1814)
AND JOHANN GOLTLIEB FACIUS (C. 1750-C. 1802)
AFTER ANGELICA KAUFFMANN

Hector Reproaching Paris, published by Boydell, 1788. In a gilded verre églomisé frame, the title lettered in gold leaf.

Colour stipple engraving. Size of frame 85 x 110
VAM

Verre églomisé became fashionable as a method of framing coloured prints towards the end of the 18th century at which date it was also used frequently to frame embroidered pictures.
Lit: Manners (Kauffmann) p. 225.

202

202

DAVID LUCAS (1802-1881) AFTER CONSTABLE

Salisbury Cathedral: large plate, known as 'The Rainbow', 1837. In a frame of 'gilders' compo' made by B. Brooks[VII], c.1840-1850

Mezzotint. Size of frame 81 x 94
VAM E.19-1987

The print is mounted on linen on a stretcher, its back unprotected, in the manner of an oil painting. A tablet bearing the title 'Rainbow' is an integral part of the frame's design. The corded bow top-knot made its debut in 18th century pattern books and was presumably an allusion to the decorative use of cords and bows in picture hanging which originated in the 17th century. Prints like this were worked in a bold fashion so that they would tell like paintings from a distance but the discoloration of this example shows how they suffered and explains why few impressions presented as pictures survive.

203

Detail from the stock book of Charles F. Bielefeld, papier mâché works, showing a frame bearing the emblem of the Art Union of London. c. 1840

Inscribed within the frame *Any pattern selected can be mounted with emblems appropriate for the Art Union prints at a slight advance in price* and in ink with a price guide.
Lithograph with hand-colouring.
VAM

Papier mâché provided an alternative mouldable material to 'gilders' compo' for frames. It was used by eight or nine rival firms in London during the 1840's and '50s.
The first British Art Union was set up in Liverpool in 1834. The particularly influential Art Union of London was founded in 1837, and announced its aim as 'to cultivate and extend a love of the Fine Arts and to give encouragement to artists beyond that at pre-

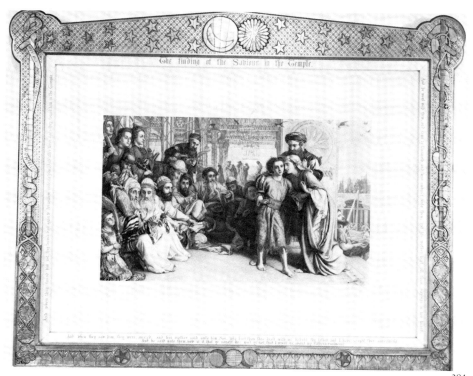

203

AUGUSTE BLANCHARD (1819-1898) AFTER HOLMAN HUNT

The Finding of the Saviour in the Temple, 1858. In a replica of the frame designed by Holman Hunt for the painting, made by Hasse, Carver and Gilder, Printseller and Picture frame maker, Leeds

Engraving and etching. Size of frame 85 x 110
Private Collection

The frame on the painting provided symbolic comment on its subject. According to Stephens, Hunt's friend and biographer, 'the cross staff that sustained the brazen serpent' referred to the 'olden law of Moses' and 'the cross of thorns, with a garland of flowers about it, expresses the New Law'.[IX] The cross of thorns missing from the replica is obscure on the painting's frame also. The reduced replica was not Hunt's idea. In 1867 he expressed his preference for simple frames 'altho' the very elaborate one, adapted from the frame of the picture by Stephens really looks well beyond my expectation for it seemed it must be too heavy for the subject as given in the print without colour'.[X]
Lit: Roberts (Frames) p.166.

205

sent offered by individual amateurs[VIII]. In fact Art Unions were straightforward lotteries in which the prize was a work of art. Many, however, provided the subscribers with a presentation engraving, sometimes engraved after the prize work, which acted as a lure to attract new members while further honouring the commitment to contemporary production. The popularity of the London Art Union at the outset was such that for the 1842 ballot they were obliged to hire the Theatre Royal, Drury Lane, in order to accommodate all the members who wished to witness the draw.
Lit: Smith (General).

205

THE MEDICI SOCIETY AFTER LEONARDO

Portrait of a Woman. First published 1909. In a Medici Society frame

Colour collotype. Sight size 45 x 32.4
The Medici Society Ltd

The print reproduces the painting actual size. The frame, described by the Society as 'a fine reproduction of an early tortoiseshell and ebony model' was hand-made in 'red imitation tortoiseshell, with black and wood beading'[XI].

206

206

JOHN EVERETT MILLAIS (1829-1896)

Mrs James Wyatt Junior and her daughter. 1849-50

Inscribed *JEM* in monogram.
Oil on panel. 35.6 x 45.1
The Trustees of the Tate Gallery

Decorating the wall behind the figures hang an engraving after Leonardo's *Last Supper* flanked by engravings after Raphael's *Madonna della Sedia* and *The Alba Madonna*. The prints have wide margins and are framed in matching gold frames of simple moulding. At this time, only a year or so after the foundation of the Pre-Raphaelite Brotherhood, Millais held Raphael in contempt. The prints therefore provide a dialogue not only between idealised and actual motherhood but also between Raphaelite and Pre-Raphaelite art.

207

207

SEBASTIAN GUTZWILLER (1800-1872)

Family Concert in Basel. 1849

Oil on canvas. 61.5 x 77.5
Offentliche Kunstsammlung, Basel

A reproduction of Leonardo's *Last Supper* is placed at a focal position in the interior and given emphasis in the painting by the converging nature of linear perspective.

208

208 *See colour plate I*

LUDVIG FIND (1869-1945)

Portrait of a young man, the painter Thorvald Erichsen

Signed and dated *Find 97.*
Oil on canvas. 113 x 97.5
Den Hirschsprungske Samling, Copenhagen

The painter is portrayed as an aesthete seated before a plain, horizontal, wooden frame, containing a row of sepia photographs separated by gold fillets. The photographs visible are of Taddeo Gaddi's *Presentation in the Temple*, Masaccio's *Expulsion from Paradise* and Duccio's *Washing of the feet*.

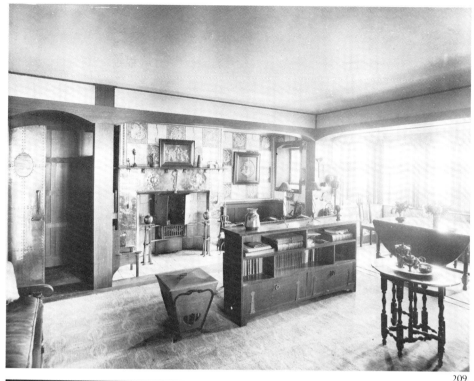

209

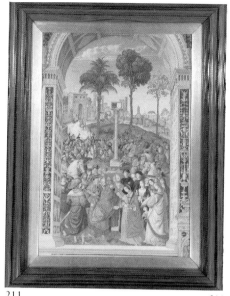

WILHELM GREVE'S FIRM AFTER A WATERCOLOUR BY
EDUARD KAISER AFTER PINTURICCHIO

**The Betrothal of Frederick III. In the
Piccolomini Library, Siena. Published by the
Arundel Society, 1895.**

Lithograph. Frame size 84.3 x 64.5
Private Collection

The Arundel Society, named after Thomas Howard,
2nd Earl of Arundel (see fig.162), was founded in
1848 to promote knowledge of art. Its publications
included books on art, both classic texts and newly
commissioned histories, as well as reproductions of
the works of art themselves. It was intended that the
subjects selected for reproduction should be in-
structive rather than popular and 'in their execution,
that manner will be preferred which truthfully ex-
presses the original rather than that which presents
the greatest attractions to the eye.' The prints were
however frequently framed as wall decoration. In
1874 the *Saturday Review* observed it to be 'a good
sign of the mental condition of the inmates of a
country mansion when we have been greeted in the
hall or corridor with chromolithographs of An-
nunciations, Nativities, Crucifixions and Ascensions.
We need not say that such themes show a family to
be better read and more widely travelled than the
households who use as wall furniture horses by
Stubbs, pigs by Morland, or even the Meeting of the
Hunt by Sir Francis Grant.'[XIII]
Lit: Noel Johnson (Arundel Society) 100; Lloyd &
Ledger (General) pp.121-133.

210

209

**The Sitting Room, Daleside, Harrogate.
Photographed 1902**

The National Monuments Record

Reproductions of early Renaissance paintings were
frequently encountered in Arts and Crafts interiors.
Botticelli's *Primavera* hung in solitary splendour in
the library in William Morris's house at Kelmscott[XII]
and here it and his *Madonna del Magnificat* are impor-
tant features in an interior designed by Frederick
Rowntree.

210

**Prints in 'Oxford' frames in the Luttrell
Arms, Dunster. Photographed by Francis
Frith & Co. c.1870**

Clive Wainwright

An eclectic pub interior which combines Chippen-
dale chairs, Japanese fans and reproductions of pain-
tings by Landseer and Wilkie. The frames, crossed at
the corners in a similar manner to the printer's Ox-
ford corners, took their name from their association
with publications of the Oxford Movement.

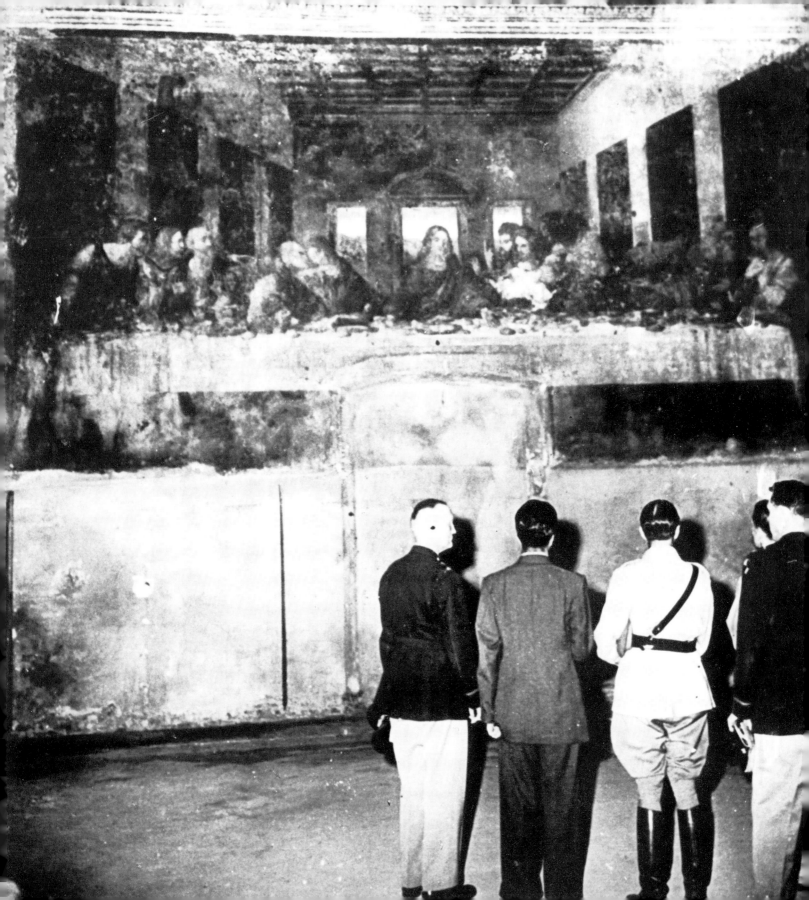

Chapter 7
Leonardo's Last Supper in Reproduction

Leonardo's wall-painting of *The Last Supper* is a good subject through which to study the effect of reproduction on our vision of a masterpiece. Famous even while Leonardo was at work on it at the end of the 15th century, it is unusual in never having fallen into obscurity. Since its creation it has been much reproduced in a great range of media, from textile to stained glass, and it has even been translated into three dimensions[1]. The printed reproductions after it cover a wide variety of techniques and span in date all but the earliest years of printmaking. The extent to which it has entered the consciousness of recent generations more than four hundred years after it was painted is attested by the instant recognition with which its living reconstruction was met as the Beggars' Banquet sequence in the film *Viridiana*, directed by Luis Buñuel in 1961 (fig.233).

Moreover the intractable location of the painting on the north wall of the refectory of the monastery of S.Maria delle Grazie in an obscure quarter of Milan and its sheer size (almost ten metres wide) draw attention to some of the essential truths of an original which a reproduction cannot recreate. Benjamin Haydon pointed out, with reference to Sir Thomas Lawrence's project to supply the Royal Academy Schools with painted replicas of the Prophets and Sibyls from the Sistine Chapel, the absurdity of pulling 'things from dark recesses, sixty feet high – things which were obliged to be painted lighter, drawn fuller, and coloured harder than nature warrants, to look like life at the distance, and to bring them down to the level of the eye in the drawing-room, and adore them as the purest examples of form, colour expression, and character'.[2] How much more distorting must reproductions which use a different medium from the original be?

A reproduction's claims to present the original are further qualified by the fact that the terms on which one has access to it are themselves not immutable. *The Last Supper* provides a poignant example of an original which, though fixed, has undergone more changes in presentation than most. Its very environment has been shattered. Hit by a bomb in the Second World War, the monastery was demolished and only the wall bearing the painting, which was protected by sand-bags, was left standing (chapter opening). Rebuilding has recreated the structure but its overriding sense of itself as a museum rather than as a working refectory affects our approach to the masterpiece and transfers our sense of its sacramental significance from the re-

212

A view of the refectory in Santa Maria delle Grazie vacated by copyists. Photographed c.1900

This photograph gives an idea of the teams of copyists who were drawn to the masterpiece itself at this date, in spite of its poor condition.

AFTER LEONARDO

The *Last Supper* spared by war is viewed by Field Marshall Sir Harold R.L.G.Alexander and U.S.Major General Willis D.Crittemberg. Photographed c.1946

The Witt Library

The presence of the army officers standing back to view the fresco gives a sense of its monumental proportions.

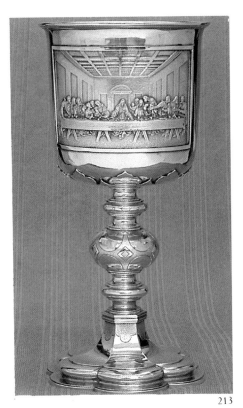

213

RUNDELL, BRIDGE AND RUNDELL

Chalice. 1823

With the mark of Philip Rundell.
Vicar and Churchwardens of the University Church
of St Mary the Virgin, Oxford

The decoration of a huge refectory is here scaled
down to provide an illustration of the initiation of
the Eucharist on the hand-held instrument of that
ceremony. Thus, curiously, the relationship between
the decoration and the thing decorated is preserved.
Lit: J.T.Evans, *The Church Plate of Oxfordshire*, 1936,
pl.XXIX.

ligious into the aesthetic discussion. Even if a reproduction is made directly from the original, it reproduces it only at that particular moment and that moment can be more or less true to the original conception. That the surface of *The Last Supper* itself has been tampered with is well-known. Showing signs of decay within years of its completion, it was described by Vasari in 1556 as 'so badly affected that nothing is visible but a mass of blots'.[3]

In fact in the past reproductions were often made from copies. *The Last Supper's* history of deterioration illustrates how unnecessary a viable original in anything but title was to the engraving trade and emphasises how different in a literal sense reproductions can be from their original. Only four engravings (figs.215-217) and one woodcut[4] are thought to have been made while the painting was in good condition. One of these may have been copied from the original but is as likely to have been based on one of the painted copies made at the time. At least two of the prints appear to have one or other of the engravings as their starting point (figs.216,217). Certainly during the late 18th and early 19th century it was through copies that people knew the composition. The secularisation of the Hieronymite monastery at Castellazzo, near Milan, late in the 18th century made the copy on the outer wall of its refectory[5], which was painted while Leonardo was himself in Milan, accessible for the first time. On the basis of this apparently authoritative version a mass of copies, called 'restorations' were made and marketed. It was on the Castellazzo copy that Morghen's influential etching was based (fig.221). But the value attached in some circles to prints made even from late and mediocre copies, which can themselves only have been based on copies, is attested by Goethe who observed that 'In the house of a priest who, though without original talent, has devoted his life to art, we saw some interesting copies of paintings which he had reproduced in miniature. The best of all was of the *Last Supper* of Leonardo da Vinci.' He went on to tell of his plans to have an etching made of this or another copy for 'It would be a great blessing if a faithful reproduction could become available to a wide public'[6].

By the middle of the 19th century the sort of awe we now feel for the status of the original made it necessary for there to be an 'authentic' or direct relation between the reproduction and its original. Furthermore, photography as a medium inescapably implied that the exposure would be made in front of the original. This meant that *The Last Supper* came to seem increasingly an intractable subject. The Arundel Society, who advised their copyists 'to avoid all restoration of parts injured or destroyed, and to aim at rendering the existing rather than the supposed original tone of colour'[7] did not reproduce it. William Boxall, later to become Director of the National Gallery in London, wrote of it in 1845 'The picture is fast perishing, and the head of Christ is much changed since I was here before when I made the sketch of it. It has also suffered from retouching since that time ...the original is now little more than a shadow and I fear years more will wear it quite away.'[8] It was obviously too far gone to warrant the attention of their copyists.

Leonardo's version of *The Last Supper* has given rise to considerable debate about its precise meaning: the nature of, and extension in time of the incidents port-

rayed. Does the composition present the whole of the phased narrative surrounding the event or is it an arrested tableau extracting an instant in the drama?[9] The prints after it demonstrate the leading part engravers have played in such discussion. By the alteration of details and the provision of guiding quotations the prints present an interpretation to their public and provide vital evidence of the attitude prevalent in the milieu of their production. The 16th century prints (figs.215-217) show a Renaissance impatience with the idea of presenting anything but temporal simultaneity. The quotation 'One of you will betray me' pinpoints the moment represented: any reference to the statement that the traitor is 'One who has dipped his hand into his bowl' with Christ, hinted at in the original by the interplay of Christ's right hand with Judas's left, is eliminated by a re-drawing of this detail. Soutman's more dramatic Counter Reformation rendering (fig.219), based on Rubens's vision of the masterpiece, retains the apostles' questioning postures, expressive of their 'Lord, can it be me?', but combines this moment of heightened reaction with the later initiation of the Eucharist ceremony. Not only is the table cleared of all debris of a real meal but the passage 'Jesus took bread, and having said the blessing he broke it and gave it to the disciples with the words: 'Take this and eat; this is my body'' is quoted from each gospel so that the character of the scene as spiritual and sacramental, rather than mundane, is emphasized. The audience of the print could be in no doubt about the moment depicted or of its orthodox theology.

Reproductions can provide more than comment on the subject matter under treatment, and may tell us as much about the preoccupations of the period of their manufacture as they do about the often distant, in more senses than time and space, original. The early prints after *The Last Supper* express with the directional fervour of their engraved lines some of the excitement brought by the understanding of the principles of linear perspective. Ryland's print (fig.220), declaring its source as a drawing rather than the painting itself, takes its place in the developing fashion for facsimile reproduction whereas Morghen's print (fig.221), although an etching, masquerades as an engraving showing allegiance to the school that continued to promote line engraving as the only technique worthy of major works of art. The stipple print of Vedovato (fig.222) reflects a softening of this attitude in the 19th century and the later etching (fig.226) provides an example of the 'free spirit' that Gautier had enjoined printmakers to bring to their art.[10] The reorganisation of the space within the composition and the rationalising of the proportions in all the handcrafted prints demonstrate to different degrees the post Renaissance artists' uneasiness with a system of proportions based partly on relative significance rather than entirely on visible reality. It was only with the advent of photography that Christ regained in reproduction the super-human stature in comparison with the apostles that Leonardo gave him. The achievement of that kind of accuracy, however, brought with it subservience to another truth, to other moments in different narratives: the Medici reproduction (fig.214) calls our attention to the moment of its manufacture, before the authenticity of the original was further tampered with by restoration in 1908.

The immediate originals of these illustrations vary in size from nearly two metres wide to only three centimetres wide. Before reaching the pages of this book they have of necessity been translated into photographs of which only the smallest (fig. 223) corresponded in size to its original. The photographs have in their turn been scaled to suit the prescribed layout and reproduced again in photo offset lithography.

214

214 See colour plate XVa
THE MEDICI SOCIETY AFTER LEONARDO

The Last Supper. First published 1907. In a Medici Society frame

Lettered on a label on the back *The Medici Prints, 1913. No. Italian 4. Copyright The Last Supper, after the "oil-fresco" by Leonardo de Vinci, in the Church of Sta. Maria delle Grazie, Milan. Reproduced prior to the 1907-8 restoration. Published by the Medici Society, Ltd., 7, Grafton St., London, W.1 & 63, Bold St., Liverpool.*
Colour collotype. Sight size 40.6 x 79.2
The Medici Society Ltd

Photographed from the original, its label specifies the moment of production so that the reproduction provides evidence of the state of the painting's preservation before it underwent restoration in 1908. The presence of the door, brutally cut into the wall in 1652, alludes to the original's environment, reinforcing the reproduction's value as a record. It was, nevertheless, marketed as a 'picture' itself for framing. It was the first colour reproduction of the mural available to the British public which took the original as its starting point but, nevertheless, the colours owed as much to a 'colour' copy made as a guide (see fig.30c) as to any photographic 'truth'.

ANONYMOUS AFTER LEONARDO

The Last Supper: with the Spaniel. c. 1500; state after the addition of three rays surrounding Christ's head

Lettered on a notice on the hanging part of the table-cloth *Amen Dico Vobis Vn' Vestrum Me Traditurus E.*
Engraving. 29 x 45.3
The Albertina, Vienna

Attributed variously to the Master of the Sforza Book of Hours, Giovanni Pietro da Birago and Zoan Andrea, this is thought to be the first engraving of the fresco and was made shortly after Leonardo finished painting it. The composition differs from that of the fresco in significant details which help to clarify the moment depicted and show the kind of 'improvements' that artists saw it as their job to make to traditional compositions. The notice in the centre of the table-cloth quotes Christ's statement 'One of you will betray me' suggesting that the scene represents the moment after this utterance. Interpretations of the subject which hinge on the interaction between Judas's left and Christ's right hands are ruled out for Judas's hand is somewhat withdrawn and Jesus's is twisted into a movement which echoes that of his left; the dish over which they hover in the fresco is omitted. The spaniel, a refinement of the engraver, may have been added simply as a compositional device to provide interest in the foreground and to contribute to the sense of depth. From this date, however, Judas was often presented as feeding a dog and its presence here may have been a conscious allusion to Christ's words 'Do not give that which is holy unto the dogs' (Matt.7:6), interpreted in Christian teaching as a reference to the giving of the Eucharist to the unworthy.
Lit: Bartsch (General) 28; Hind (General) 9; Steinburg (Leonardo)p.405, 24; Alberici & De Biasi (Leonardo) 38.

216

ANONYMOUS AFTER LEONARDO

The Last Supper: with the Cat. c.1500

Lettered on a notice on the hanging part of the table-cloth *Amen. Dico. Vobis. Quia. Vn' Vestrum. Me. Traditurus E.*
Engraving. 29 x 45.3
The Trustees of the British Museum

Although executed shortly after the fresco was painted the engraver must have based his version of the subject on the preceding print (fig.215) rather than

In spite of the many well-meaning if often damaging restorations *The Last Supper* has undergone, it has never been returned to the 'complete' picture that the ordinary person carries in his mind's eye. This vision is a testimony to the power of reproduction. It exists because in the past engravers filled in what was missing. Now that the camera goes to the original, the process of photographic reduction minimises the impact of the damage and allows the eye to bridge any formal hiatus. The translation of the image into a system of dots on a uniform, and frequently glossy surface, imposes a spurious sense of 'finish'. We all know the composition but how many of us know the original?

215

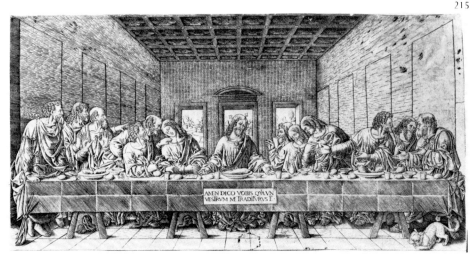

216

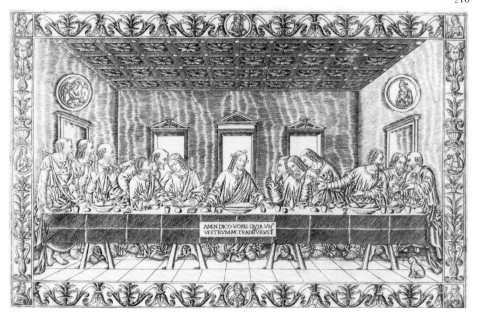

on the original Christ's head is depicted as surrounded by three rays as in the later state of that engraving and all the changes noted in it reappear in this version, except that the dog is transformed into a cat. The features, however, which distinguish it from the engraving are not present in the fresco. These include the pointed architectural elements over the openings in the background wall, the absence of a view through these openings, and the introduction of single openings in the side walls with, overhead, medallions representing the Angel of the Annunciation on the left and the Virgin on the right. The re-arrangement of the space results in the highlighting of the heads of each of the four groups of apostles and of Christ against an opening. The whole scene is framed with a decorative border of scroll work interspersed with medallions containing busts of the saints.

Lit: Bartsch (General) 26; Hind (General) 10; Alberici & De Biasi (Leonardo) 39.

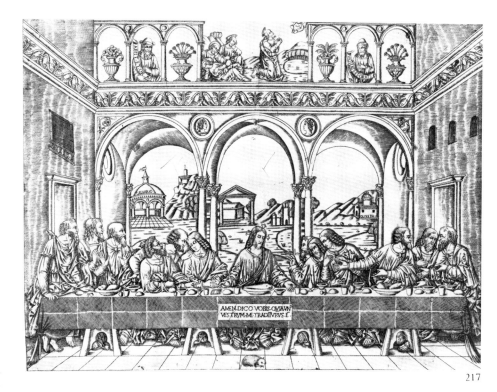

217

217

ANONYMOUS AFTER LEONARDO

The Last Supper: with the Rat

Lettered on a notice on the hanging part of the tablecloth *Amen. Dico. Vobis. Quia. Vn' Vestrum. Me. Traditurus. E.*
Engraving. 32.2 x 42.5
The Albertina, Vienna

The expressions on Christ's and the apostles' faces and the precise inclinations of their heads in this engraving owe more to the engraving reproduced as fig.216 than that reproduced as fig.215, suggesting that the former provided the starting point for this version. It also includes the openings to the left and right of the composition but otherwise the setting has been greatly elaborated and overhead, above a frieze that imitates the scroll work border of fig.216, is depicted the 'Agony in the Garden'. The animal theme is continued in the centre foreground by the depiction of a rat, a symbol of evil and of decay, and thus of the passing of time.

Lit: Bartsch (General) 27; Hind (General) 11; Alberici & De Biasi (Leonardo) 40.

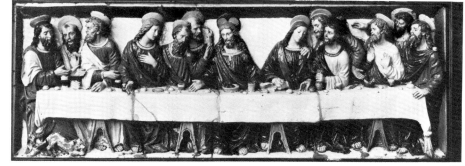

218

218

GIOVANNI DELLA ROBBIA (1469-AFTER 1529) AFTER LEONARDO

The Last Supper. c.1510-20

Relief in polychrome enamelled terracotta. 55.9 x 162.6
VAM 3986-1856

The presence of the spaniel found in fig.215 suggests that this large relief was based on that print or that they shared a common source. Unusually for the composition, the scene is rendered in reverse.

Lit: J.Pope-Hennessy, *Catalogue of the Italian Sculpture in the Victoria and Albert Museum,* 1964, 238; Steinberg (Leonardo) 22.

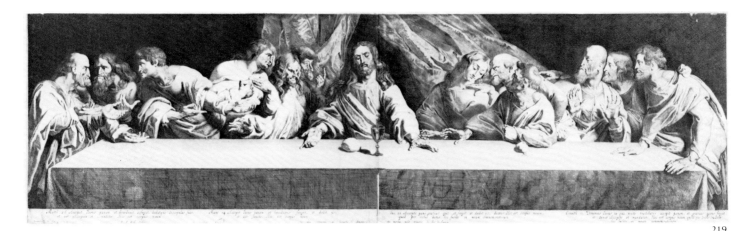

219

PIETER SOUTMAN (1580-1657) AFTER RUBENS AFTER LEONARDO

The Last Supper. Second state

Lettered *Matth. 26 Acceptit Jesus panem et benedixit, ac fregit, deditque discipulus suis et ait, Accipite et Comedite: Hoc est corpus meum. Marc.14 Acceptit Jesus panem: et benedicens fregit, et dedit ys. et ait: Sumite. Hoc est corpus meum. Luc.22 Accepto pane gratias egit et fregit, et dedit ys, dicens: Hoc est corpus meum, quod pro vobis datur: hoc facite in meam commemorationem. Corinth 11 Dominus Jesus in qua nocte tradebatur accepit panem, et gratias agens fregit, et dixit Accipite et manducate: Hoc est corpus meum commemorationem* and *Lionardo da Vinci Pinxit; P.P.Rub. Delin; Cum Priuilegio; La cena stupenda de Leonardo d'Auinci chi moriua nelle braccie di Re di Francia.*
Etching with stipple engraving. Cut to 29.7 z 99.2
The Trustees of the British Museum

Based on a drawing by Rubens[1] and bearing his privilege, this print demonstrates a similar desire to the earlier engravings to clarify the meaning of Leonardo's original conception but the resulting message is different. All signs of a meal have been cleared; the remaining loaf of bread and a very ecclesiastical looking chalice reinforce the quotations from the gospels which present the subject as the initiation of the ceremony of the Eucharist. The gestures of the figures follow those in Leonardo's fresco closely, except that the composition is reversed, and the atmosphere of extreme emotion is intensified by the blank background relieved only by a majestic furl of fabric rising behind Christ.
Lit: Schneevogt (Rubens) 231; Steinburg (Leonardo) 36; Alberici & De Biasi (Leonardo) 42.

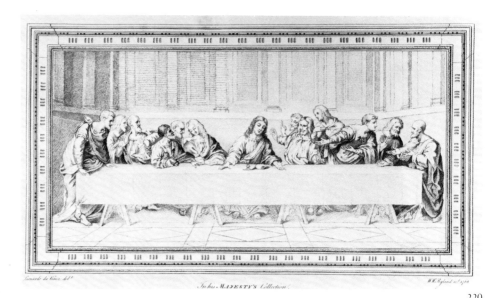

220

WILLIAM WYNNE RYLAND (1732-1783) AFTER LEONARDO

The Last Supper. Plate from Charles Rogers, *A Collection of Prints in Imitation of Drawings*, London, 1778

Lettered *Lionardo de Vinci delt. In his Majesty's Collection. CR edidt. W.W.Ryland sct. 1768.*
Stipple engraving. 26.5 x 34.7
VAM 1539-28

This print faithfully reproduces a drawing, now at Windsor, made of a painted replica of Leonardo's composition as a guide to its dimensions for a framemaker. According to unverifiable tradition the copy was commissioned by Francis 1 of France in about 1517 and placed in St Germain L'Auxerrois, Paris, where, much repainted it can still be seen. The copyist's[II] clearing of the table of all but the essential trappings of the Eucharist is noteworthy.
Lit: Clark (Leonardo) 12541; Steinburg (Leonardo) p.386, n. 24 and no.14; Alberici & De Biasi (Leonardo) 42.

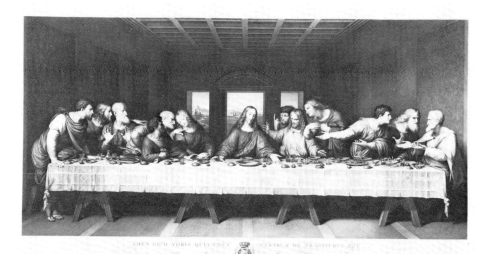

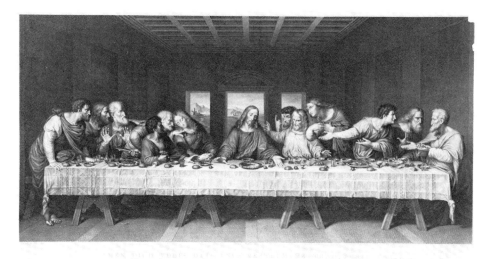

221

222

The Last Supper. 1797-1800

Lettered *Amen Dico Vobis Quia Unus Vestrum Me Tradit-*
urus Est. Matt. cxxvi Ferdinando 111 Austriaco Magno Het-
ruriae Duci and *Leonardus Vincius pinxit. Raphael Morghen*
sculpsit. Tedorus Matteini delineavit. Nicolaus de Antoni
excudit Lionardus a Vincio pinxit Mediolani in caenaculo
Fratrum S.Dominici Raphael Morghen D.D.D.
Etching. Cut to 52.3 x 93.8
The Trustees of the British Museum[III]

Teodoro Matteini (1754-1831) was commissioned
by the Grand Duke Ferdinand III of Tuscany to draw
the copy in the Castellazzo monastery in 1795 specif-
ically to provide Morghen with a document from
which to work. Many of the later reproductions
were based on Morghen's print which was conside-
red amongst the best. Probably closer in detail to the
original than any of the earlier engravings, it is inter-
esting to note that again the engraver has apparently
simplified the message. The dialogue between the
left hand of Judas and the right hand of Jesus is re-
instated but not the glass of wine; Jesus's gesture to
the loaf of bread to his left, a symbol of Christ's body,
is not matched on his right by the symbol of Christ's
blood.
Lit: Steinberg (Leonardo) 41; Alberici & De Biasi
(Leonardo) 44.

222

PIETRO VEDOVATO (1774-1847) AFTER LEONARDO

The Last Supper. 1821

Lettered *Amen, Dico Vobis Quia Unus Vestrum me Tradit-*
uras Est. Mat.C.XXXVI and *Leonardo da Vinci dip. Teodoro*
Matteini dis. Pietro Vedoato inc.
Stipple engraving with etching. Cut to 34.5 x 72.6
VAM E.608-1888

Whether this print was copied from Matteini's
drawing as it claims or from Morghen's print is open
to question but it follows the latter closely in all re-
spects except technique and is representative of a
large number of 19th century prints which shared
this starting point.

223

WILLIAM HENRY WORTHINGTON (C.1790-P.1839)
AFTER LEONARDO

The Last Supper. Illustration to J.W.Brown,
The Life of Leonardo da Vinci, **London, 1828,**
p.179

Lettered in Greek *One of you will betray me.*
Etching. 3.9 x 7.3
VAM, National Art Library

This tiny representation of the subject again takes
Morghen's version as its starting point. Jesus's in-
junction, however, is quoted in Greek rather than in
the 'Catholic' Latin, perhaps a bow towards Prot-
estantism in this small English book on the hero of
the European Renaissance.
Lit: Le Blanc (General) 3; Alberici & De Biasi (Leo-
nardo) 84.

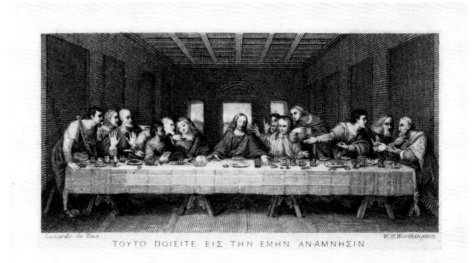

224

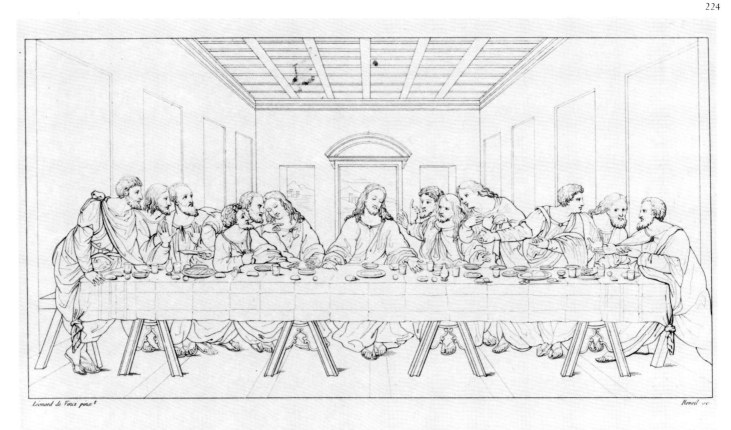

202

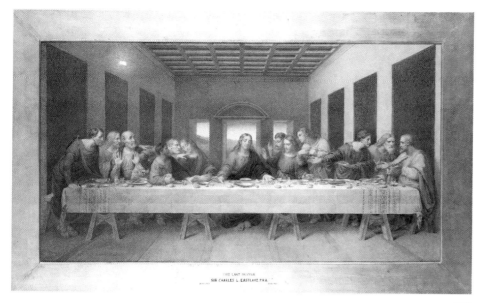

225

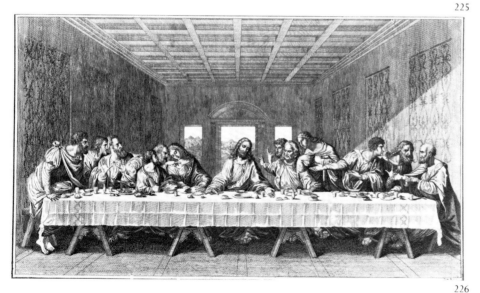

226

225

CHARLES EASTLAKE (1793-1865) AFTER LEONARDO

The Last Supper

Signed and dated *C.L.E. 1847.*
Watercolour. 54.7 x 99.7
Peter Rose and Albert Gallichan

Eastlake painted this copy when he was Keeper at the National Gallery, London, and thus already an established figure in the art world. It is included here to represent the host of copies the fresco has inspired and to suggest the respect in which copies of masterpieces were held until comparatively recently. Although Eastlake had seen the original in 1817 his memory must have been prompted by a source more to hand. The colours follow those of the Royal Academy's copy but other details are closer to the tinted grisaille by Dutertre[IV] now considered the most faithful extant copy of the fresco as it was before the infliction of major damage during the Napoleonic Wars. The discrepancies may indicate the use of another source or simply reflect a lack of slavishness in Eastlake's approach.

Lit: B.Coffey, *Master after Master,* unpublished catalogue of an exhibition presented by Julian Hartnoll, 1981, 8.

226

ANONYMOUS AFTER LEONARDO

The Last Supper. c.1870

Etching. Cut to 17.9 x 30.7
VAM 24321

This rendering is freer than many of the reproductions. But although the arrangement of the dishes on the table differs in detail from that in Morghen's print, the omission of the glass at Christ's right hand suggests that it was to this version that the etcher looked back. The shaft of light on the right of the composition has its origins in the fresco and is reflected in many engravings after it but its dramatic treatment here, drawing our attention to the reactions of the group of apostles furthest to the right, is the etcher's own comment on the spectacle.

224

ACHILLE REVEIL (1800-1851) AFTER LEONARDO

The Last Supper. Plate from *Galerie des peintres les plus célèbres: Oeuvres choisies de Francesco Albani dit l'Albane, Leonardo de Vinci, Titien, Guide et Paul Veronese*, Paris, 1844-45

Lettered *Leonardo de Vinci pinxt. Reveil sc.*
Lithograph. 11.2 x 21.7
The Witt Library

Reveil specialised in publishing compendiums of major works of art from museums, thus creating pocket galleries. A smaller version of this subject by Reveil, also in outline, had appeared in both his *Galerie des arts et de l'histoire, composée des tableaux et statues les plus remarquables des musées de l'Europe,* 1834, and in his *Musée Religieux ou choix des Plus Beaux Tableau inspirés par l'histoire santé aux peintres à l'eau forte sur acier,* 1836.

Lit: Le Blanc (General) 3.

227

ANONYMOUS AFTER LEONARDO

The Last Supper. British, c.1880

Cast plaster relief. Frame size 8.7 x 14
Private Collection

229

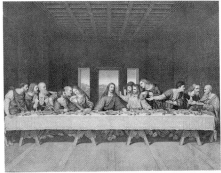

228

228 See colour plate XVb
ANONYMOUS AFTER LEONARDO

The Last Supper. c.1870

Lettered along the edge of the table-cloth with the
names of the apostles.
Colour lithograph. Frame size 47 x 60
Private Collection

Among the earlier colour reproductions of the sub-
ject, this may be the 'chromo-lithograph' issued by
Day & Son which, according to their advertisement,
reproduced in facsimile the reconstruction of the
Last Supper by H.C.Selous. The colours of the apos-
tles' robes differ considerably from those in photo-
graphic renderings of the original (fig.214). No doc-
umented impression of the print has been traced.
Lit: Day & Son (Leonardo) pp.3,4.

230

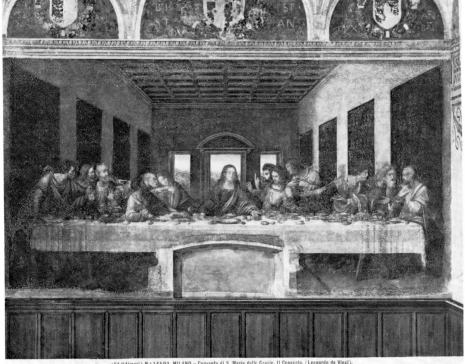

(Ed.^{ne} Alinari) N.° 14502. MILANO - Convento di S. Maria delle Grazie. Il Cenacolo. (Leonardo da Vinci).

229

LEONHARD POSCH (1750-1831) AFTER LEONARDO

The Last Supper. Berlin and Gleinitz, c.1822-3

Lettered *Amen Dico Vobis Quia Unus Vestrum Me Traditurus Est Matt: Cxxv.*
Cast iron relief in an ornamental frame. 37.4 x 67.2
Brian Hillyer

The suggestion of only a restricted space in the fresco made it a particularly suitable subject for presentation as a relief. Monochrome examples are recorded as early as the 15th century. The play of light over an undulating surface gives form to what is delineated with line, tone and colour in the original, flat image.

The relief technique was itself particularly amenable to the taking of copies. Reliefs which appear to have been cast from Posch's mould may in fact be cast from moulds made elsewhere from one of his castings. Copies of Posch's version by Johann Kratzenberg and F.A.Egells, the latter with remodelled heads, are recorded.
Lit: Steinberg (Leonardo) 21; H.Tait ed., *The Art of the Jeweller: a catalogue of the Hull Grundy Gift to the British Museum,* 1984, I, 177.

230

ALINARI STUDIO AFTER LEONARDO

The Last Supper. Photographed c.1915

The Witt Library

This reproduction is presented as a record of something seen rather than as a candidate itself suitable for framing. The arches overhead and the return of the wall visible to the left give a sense of the fresco in situ but there is no sense of its scale nor of the impact it would have from its position high up at the end of a long lofty space.

231

ANONYMOUS AFTER LEONARDO

The Last Supper. 1890

Lettered *Der Formenschatz Art Treasure L'Art Practique L'Art Practica* Numbered no.68 & 69.
Line block printed in black and grey. 23.5 x 48.6
The Witt Library

This photographically produced print follows Morghen's engraving closely which suggests that it was that version which formed the basis of the image which was photographed on to the block. A second block was used to enrich the tone of the essentially monochrome print.

232

232

ANONYMOUS AFTER LEONARDO

The Last Supper

Numbered *24.*
Colour lithograph. Sight measurment 24 x 34.3
Dr Marcia Pointon

Both glass and bread at Christ's right and left hands are missing, making his gesture meaningless.

231

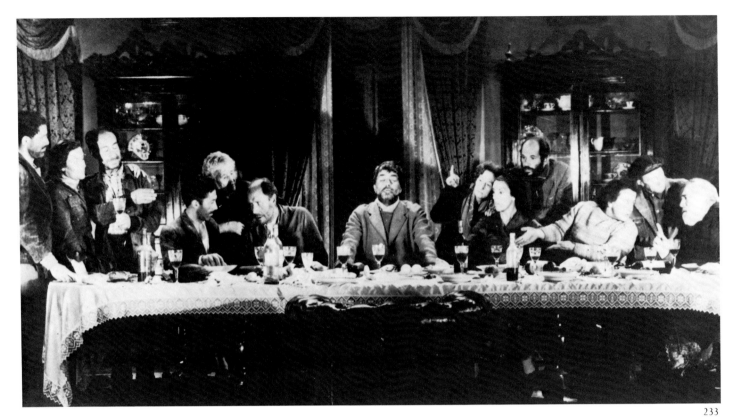

233

233

The Beggars' Banquet tableau from the film
Viridiana, directed by Luis Buñuel, 1961

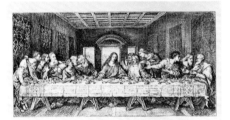

234

234

The Last Supper. Published in *Scribner's*
Monthly, **XV11, 1878. Reprinted as plate 11 to**
Portfolio of Proof Impressions selected from
Scribner's Monthly and St. Nicholas, **New York,**
1879

Signed *T.Cole Sc.*
Wood-engraving. 6.2 x 12.6
VAM E.7980-1905

Cole's technique, capable on occasion of obtaining
the most silvery gradations of tone (fig.64), here
gives the impression of a fleeting sketch.

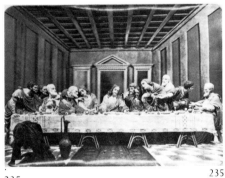

235

235

AFTER LEONARDO

Postcard of the *Last Supper.* *Published by Manhattan*
Post Card Publishing Co., 1972

Super Xograph. 12 x 16.4
The Witt Library

This 3-D photographic rendering is based on a
sculptural model which, in tune with tradition, has
somewhat reorganised the elements of the composi-
tion.

Select Bibliography

GENERAL

D.Alexander, "After-Images' a Review of Recent Studies of Reproductive Printmaking', *Oxford Art Journal*, 1983, 4:1, pp.11-17.

D.Alexander and R.T.Godfrey, *Painters and Engraving. The Reproductive Print from Hogarth to Wilkie*, exhibition catalogue, New Haven, 1980.

A.von Bartsch, *Concerning the Administration of the Collection of Prints of the Imperial Court Library in Vienna*, 1820; reprinted New York, 1982.

J.A.B.von Bartsch, *The Illustrated Bartsch*, New York, 1978-continuing.

H.Beck, *Victorian Engravings*, 1973.

W.Benjamin, 'The Work of Art in the Age of Mechanical Reproduction', *Illuminations*, 1970, pp.219-253.

J.Burnet, *Practical Essays on Various Branches of the Fine Arts*, 1848.

V.I.Carlson and J.W.Ittmann et al, *Regency to Empire French Printmaking 1715-1814*, Baltimore, 1984.

M.Bury, 'The Taste for Prints in Italy to c.1600', *Print Quarterly*, 1985, 2:1, pp.12-26.

J.Chaloner Smith, *British Mezzotinto Portraits*, 1883.

M.Clive, *The Day of Reckoning*, 1964.

L. De Gregori, *Del Chiostro della Minerva e del Primo Libro con Figure Stampato in Italia*, Florence, 1927.

L.Donati, 'Meditationes Johannis de Turrecremata (1467)' in *Studi di Bibliografia e di Argomento Romano in Memoria di Luigi de Gregori*, Rome, 1949, pp.99-128.

A.Dyson, *Pictures to Print, the Nineteenth Century Engraving Trade*, 1984.

T.Fawcett, 'Graphic Versus Photographic in the Nineteenth-century Reproduction', *Art History*, 1986, 9:2, pp.185-212

C.Fox, 'The Engravers' Battle for Professional Recognition in Early Nineteenth Century London', *London Journal*, 1976, 2:1, pp.3-31.

W.Friedman, 'Some Commercial Aspects of the Boydell Shakespeare Gallery', *Journal of the Warburg and Courtauld Institutes*, 1973, 36, pp.396-401.

R.T.Godfrey, *Printmaking in Britain*, Oxford, 1978.

J.Goethe, *Italian Journey*, W.H.Auden trans. and E.Mayer ed., 1970

F.Haskell, *Rediscoveries in Art*, 1980.

A.T.Hazen, *A Catalogue of Horace Walpole's Library*, 1969.

C.H.Heinecken, *Idée Générale d'une Collection Complètte d'Estampes*, Leipzig and Vienna, 1771.

U.W.Hiesinger and A.Percy, ed., *A Scholar Collects, Selections from the Anthony Morris Clark Bequest*, Philadelphia, 1980.

A.M.Hind, *Early Italian Engraving. A critical catalogue with complete reproduction of all the prints described*, 1938-48.

W.M.Ivins, *Prints and Visual Communication*, 1953.

J.B.Jackson, *An Enquiry into the Origins of Painting in Europe*, 1752.

H.Joyce, 'The Ancient Frescoes from the Villa Negroni and Their Influence in the Eighteenth and Nineteenth Centuries', *The Art Bulletin*, New York 1983, 65:3, pp.423-440.

E.Jussim, *Visual Communication and the Graphic Arts*, New York, 1974.

D.Landau, 'Vasari, Prints and Prejudice', *Oxford Art Journal*, 1983, 6:1, pp.3-10

C.Le Blanc, *Manuel de l'Amateur d'Estampes Contenant...un Dictionnaire des Graveurs de Toutes les Nations...*, Paris, 1854-1889.

J.A.Levenson, 'Reproductive Engravings 'Some of the Finest Italian Prints of the Early Renaissance'', *Art News*, New York, March 1974, pp.68-70.

J.A.Levenson, K.Oberhuber, J.L.Sheehan, *Early Italian Engravings from the National Gallery of Art*, Washington, 1973.

L.I.Lipking, *The Ordering of the Arts in Eighteenth Century England*, Princeton, 1970.

C.H.Lloyd and T.Ledger, *Art and Its Images, an Exhibition of Printed Books Containing Engraved Illustrations after Italian Paintings*, The Bodleian Libary, Oxford 1975.

A.Malraux, *The Psychology of Art, Museum without Walls*, S.Gilbert trans., 1949.

A.H.Mayor, *Prints and People: A Social History of Printed Pictures*, New York, 1971.

J.H.Neff, 'The Exhibition in the Age of Mechanical Reproduction', *Art Forum*, Jan 1987, pp.86-90.

C.Newton, *Photography in Printmaking*, 1979.

S.Pantazzi, *Imitations and Facsimiles, an Exhibition of Prints and Books from the Sixteenth to the Nineteenth century*, Art Gallery of Ontario, Ontario, 1979.

M.Préaud, 'Jacques van Merle: A Flemish Dealer in Paris', *Print Quarterly*, 1984, 1:2, pp.81-95.

Printsellers' Association, *A Few Words on Art...Containing...a Short History of the Association*, 1881.

J.Pye, *Patronage of British Art*, 1845.

E.Rebel, *Faksimile und Mimesis*, Mittenwald, 1981.

G.Reitlinger, *The Economics of Taste*, 1961-1970.

J.Richardson, *Two Discourses, containing 'An essay on the whole Art of Criticism as it relates to Painting' and 'An Argument in behalf of the Science of a Connoisseur'*, 1719.

B.Rix, *Pictures for the Parlour: The English Reproductive Print from 1775 to 1900*, exhibition catalogue, Art Gallery of Ontario, Ontario, 1983.

J.T.Smith, *Nollekens and his Times*, 2nd. ed., 1829.

R.Smith, 'The Rise and Fall of the Art Union Print', *Print Quarterly*, 1986, 3:2, pp.95-108.

F.G.Stephens and M.D.George, *Catalogue of Political and Personal Satires, Preserved in the Department of Prints and Drawings in the British Museum*, 1870-1954.

W.H.F.Talbot, *The Pencil of Nature*, 1844; reprint New York, 1969.

S.J.Taylor, 'Le Portrait du Sacré Gravé de Drevet à David', *Nouvelles de l'Estampe*, 1986, 88/89, pp.6-16.

J.Van der Waals, 'The Print Collection of Samuel Pepys', *Print Quarterly*, 1:4, pp.236-257.

G.Vasari, *The Lives of the Painters, Sculptors and Architects*, W.Gaunt ed., 1963.

G.Vertue, 'Vertue Note Books', *Walpole Society Annual Volumes*, 18,20,22,24,26,29,30, 1930-55.

H.Walpole, *A Catalogue of Engravers who have been Born or Resided in England, digested...from the Mss. of G.Vertue...*, 1763.

W.T.Whitley, *Artists and their Friends in England 1700-1799*, 1928.

Artists and Printmakers

Bartolozzi

A. Baudi di Vesme and A.Calabi, *Francesco Bartolozzi*, Milan, 1928.
A.W.Tuer, *Bartolozzi and his Works*, 1885.

Bartsch

F.von Bartsch, *Catalogue des Estampes de J.A. de Bartsch*, Vienna, 1818.
W.Koschatzky, 'Adam von Bartsch an Introduction to his Life and Work', in J.A.B. von Bartsch, *The Illustrated Bartsch*, New York, 1978, 1, pp.7-17.

Baxter

C.T.C.Lewis, *George Baxter. The Picture Printer*, 1924.

Bonnet

J.Herold, *Louis-Marin Bonnet (1736-1793), Catalogue de l'Oeuvre Gravé*, Paris, 1935.

Boucher, see also Watteau

P.Jean-Richard, *L'Oeuvre Gravé de François Boucher dans la Collection Edmond de Rothschild*, Paris, 1978.

Boys

J.Roundell, A.Smart, M.Horsman, *Thomas Shotter Boys, 1803-1874*, 1974.

Campagnola, see also Titian

P.Kristeller, *Giulio Campagnola, Kupferstiche und Zeichnungen*, Berlin, 1907.
U.Middeldorf, 'Eine Zeichnung von Giulio Campagnola', *Festschrift Martin Wackernagel*, Cologne, 1958, pp.141-152.

Cort

J.C.J.Bierens de Haan, *L'Oeuvre Gravé de Cornelis Cort, Graveur Hollondaise, 1533-1579*, The Hague, 1948.

Drevet

A.F.Didot, *Les Drevet et leur Oeuvre Gravé*, Paris, 1876; reprint, Amsterdam, 1979.

Goltzius

W.L.Strauss, *Hendrik Goltzius, (1558-1617): the Complete Engravings and Woodcuts*, New York, 1977.

Green

A.Whitman, *British Mezzotinters: Valentine Green*, 1902.

Hogarth

R.B.Beckett, *Hogarth*, 1949.
W.Hogarth, *Autobiographical Notes*, J.Burke ed., in *The Analysis of Beauty*, Oxford, 1955.
R.H.Paulson, *Hogarth's Graphic Works*, 1965.
F.G.Stephens and E.Hawkins, *British Museum Catalogue of...Political and Personal Satires*, 1877, 3.

Hollar

R.Pennington, *A Descriptive Catalogue of the Etched Work of Wenceslaus Hollar 1607-1677*, Cambridge, 1982.

Jackson

J.Kainen, *John Baptist Jackson*, Washington, 1962.

Kauffmann

V.A.E.D.Manners, *Angelica Kauffmann, R.A.: her Life and Works*, 1924.

Landseer

A.Dyson, 'Images Interpreted: Landseer and the Engraving Trade', *Print Quarterly*, 1984, 1:1, pp.29-43.

Le Blon

J.Gage, 'Jacob Christoph Le Blon', *Print Quarterly*, 1986,3:1, pp.65-67.
O.M.Lilien, *Jacob Christophe Le Blon, 1667-1741: Inventor of Three- and Four-Colour Printing*, Stuttgart, 1985.
H.W.Singer, 'Le Blon and his Three Colour Process', *The Studio*, 1903, 28, pp.261-271.

Leonardo

C.Alberici and M.C.de Biasi, *Leonardo e l'Incisione, Stampe derivate da Leonardo e Bramante dal XV al XIX Secolo*, exhibition catalogue, Castello Corzesco, Milan, 1984.
G.Bossi, *Del Cenacolo di Leonardo da Vinci*, Milano, 1810.
K.Clark, *The Drawings of Leonardo da Vinci ... at Windsor*, 2nd ed., 1968.
Day & Son, *Notices of The Life...of Leonardo da Vinci, with an Analysis...of his Greatest Work, The Last Supper. In illustration of the Restoration...by H.C.S[elous]*, c.1870.
L.H.Heydenreich, *Leonardo: The Last Supper*, 1974.
O.Hoerth, *Das Abendmahl des Leonardo da Vinci*, Leipzig, 1907.
L.Steinberg, 'Leonardo's Last Supper', *The Art Quarterly*, Detroit, 1973, 36:4, pp.297-410.

Leoni

T.H.Thomas, 'Ottavio Leoni - a Forgotten Portraitist 1578-1630', *The Print Collector's Quarterly*, 1916, pp.322-373.

Lowry

H.Donn, *The Illustrated Limited Editions of L.S.Lowry,* Manchester, 1979.
D.McLean, *L.S.Lowry,* 1978.

Lucas, David

A.Shirley, *The Published Mezzotints of David Lucas, after John Constable, R.A.: a Catalogue and Historical Account,* Oxford, 1930.

McArdell

G.Goodwin, *British Mezzotinters: James McArdell,* 1903.

Marcantonio Raimondi

L.Bianchi, 'La Fortuna di Raffaello nell'Incisione' in M.Salmi, ed., *Raffaello: L'Opera, le Fonte, la Fortuna,* Novara, 1968, 2, pp.647-689.
A.Oberheide, *Der Einfluss Marcantonio Raimondis auf die nordische Kunst des 16. Jahrhunderts,* PhD thesis, Hamburg, 1933.
I.H.Shoemaker and E.Broun, *The Engravings of Marcantonio Raimondi,* Lawrence, Kansas, 1981.

Mantegna

E.Tietze-Conrat, 'Was Mantegna an Engraver?', *Gazette des Beaux-Arts,* 1943, 24, pp.375-381.

Martin

T.Balston, *John Martin, 1789-1854: His Life and Works,* 1947.
J.D.Wees, *Darkness Visible, The Prints of John Martin,* Williamstown, Mass., 1986

Parmigianino, see also Ugo da Carpi

A.E.Popham, 'Observations on Parmigianino's Designs for Chiaroscuro Woodcuts', in I.Q.van Regteren Altena, *Miscellanea,* Amsterdam, 1969, pp.48-51.
A.E.Popham, *Catalogue of the Drawings of Parmigianino,* 1971.

Ploos van Amstel

I.Gaskell, 'Cornelis Ploos van Amstel', *Print Quarterly,* 1984, 1:4, pp.283-285.
Th. Laurentius, Dr.J.W.Niemeijer, Jhr. G.Ploos van Amstel, *Cornelis Ploos van Amstel, 1726-1798, Kunstverzamelaar en Prentuitgever,* Assen, 1980.

Pollaiuolo

A.M.Hind, 'Fifteenth-Century Italian Engravings at Constantinople', *Print Collector's Quarterly,* 1933, 20, pp.279-296.

Pond

H.M.Hake, 'Pond and Knapton's Imitations of Drawings', *Print Collector's Quarterly,* 1922, pp.325-349.
L.Lippincott, *Selling Art in Georgian London: the Rise of Arthur Pond,* 1983.

Poussin

A.Andresen, *Nicolaus Poussin, Verzeichniss der nach seinen Gemälden gefertigten gleichzeitigen und späteren Kupferstiche,* 1863.
A.Blunt, *Nicolas Poussin,* 1967.
M.Davies and A.Blunt, 'Some corrections and additions to M.Wildenstein's "Graveurs de Poussin au XVIIe siecle" ', *Gazette des Beaux-Arts,* 1962, 60, pp.205-222.
G.Duplessis, 'Comment les graveurs ont interpreté les oeuvres de Nicolas Poussin', *Revue Universelle des Arts,* 1858,8, pp.5-29.
R.Verdi, *Poussin and his Engravers,* exhibition catalogue, Nottingham,1981.
A.Andresen, 'Catalogue des Graveurs de Poussin' G.Wildenstein trans., *Gazette des Beaux-Arts,* 1962, 60, pp.139-202.
G.Wildenstein, 'Les Graveurs de Poussin au XVIIe Siecle', *Gazette des Beaux-Arts,* 1955, 46, pp.73-371.

Raphael

R.M.Mason and M.Natale, *Raphael et la Seconde Main,* exhibition catalogue, Musée d'Art et d'Histoire, Geneva, 1984.

Rembrandt

K.M.Clark, *Rembrandt and the Italian Renaissance,* 1966.
J.Gantner, 'Rembrandt und das Abendmahl des Leonardo', *Festschrift Friedrich Gerke,* Baden-Baden, 1962, pp.179-184.

Reni

P.Bellini, 'Diffusione dello Stile di Guido Reni e di Taluni suoi Soggetti attraverso le Incisione della sua Scuola, con Particolare Riferimento al Soggetto della Fortuna', in H.Zerner ed., *Le Stampe e la diffusione delle immagini e degli stili,* Bologna, 1979, pp.55-60.

V.Schmidt-Lisenhoff, 'Les Estampes d'après Guido Reni Une Introduction à la Gravure de Reproduction au XVII Siecle', *Nouvelles de l'Estampe,* Paris, 40/41, pp.6-11.

Reynolds

J.Farington, *Memoirs of the Life of Sir Joshua Reynolds,* 1819.
A.Griffiths, 'Prints after Reynolds and Gainsborough' in T.Clifford, A.Griffiths, M.Royalton-Kisch, *Gainsborough and Reynolds in the British Museum,* 1978, pp.29-59.
E.Hamilton, *A Catalogue Raisonné of the Engraved Works of Sir Joshua Reynolds P.R.A. from 1775 to 1822,* 1884.
M.Hamilton-Phillips, 'Sir Joshua Reynolds' *Print Quarterly,* 1986, 3:3, pp.250-255.
J.Northcote, *The Life of Sir Joshua Reynolds,* 1818.
N.Penny ed., *Reynolds,* exhibition catalogue, Royal Academy of Arts, 1986.
J.Reynolds, *Discourses on Art,* R.R.Wark, ed., New Haven, 1975.

Robetta

A.M.Hind, 'Cristofano Robetta', *Print Collector's Quarterly,* 1923, pp.368-402.

Rubens

L.Burchard and R.A. d'Hulst, *Rubens Drawings,* Brussels, 1963.
J.S.Held, *Rubens. Selected Drawings,* 1959.
H.Hymans, *Histoire de la Gravure dans l'Ecole de Rubens,* Brussels, 1879.
L.Lebeer, *P-P.Rubens: Estampes,* exhibition catalogue, Verviers, 1955.
R.S.Magurn, trans. and ed., *The Letters of Peter Paul Rubens,* Cambridge, Mass., 1955.
J.R.Martin, *The Ceiling Paintings for the Jesuit Church in Antwerp,* 1968.
M.L.Myers, 'Rubens and the Woodcuts of Christoffel Jegher', *The Metropolitan Museum of Art Bulletin,* Summer 1966, pp.7-23.
M.Rooses, *L'Oeuvre de P.P.Rubens, Histoire et Description de ses Tableaux et Dessins,* Antwerp, 1886-92.
J.Rowlands, *Rubens, Drawings and Sketches,* exhibition catalogue, British Museum, 1977.
C.G.V.Schneevoogt, *Catalogue des Estampes Gravées d'après P.P.Rubens,* Harlemn 1873.

Sandby

L.Herrmann, *Paul and Thomas Sandby,* 1986.
A.P.Oppé, *The Drawings of Paul and Thomas Sandby in the Collection of his Majesty the King at Windsor Castle,* 1947.

Strange

J.Dennistoun, *Memoirs of Sir Robert Strange and his Brother-in-law Andrew Lumsden*, 1855.

Turner

W.G.Rawlinson, *The Engraved Work of J.M.W.Turner, R.A.*, 1908-1913.

Ugo da Carpi, see also Parmigianino

J.Johnson, 'Ugo da Carpi's Chiaroscuro Woodcuts', *Print collector / Il conoscitore di stampe*, Milan, 1982, 57/58:3/4, pp.2-87.

Vermeulen

A.F.Didot, *Les Graveurs de Portrait en France*, Paris, 1875-9.
M.N.Rosenfeld, *Largillierre and the Eighteenth-Century Portrait*, exhibition catalogue, Montreal Museum of Fine Arts, 1981.

Watteau

E.Dacier and A.Vuaflart, *Jean de Jullienne et les Graveurs de Watteau au XVIIIe Siecle*, 1929.
M.Stuffmann et al., *Jean-Antoine Watteau. Einschiffung nach Cythera, L'Ile de Cythère*, exhibition catalogue, Frankfurt, 1982.
M.Roland Michel, *Watteau, an Artist of the Eighteenth Century*, 1984.
K.T.Parker and J.Mathey, *Antoine Watteau, Catalogue Complet de son Oeuvre Dessiné*, 1957, Paris.

Wheatley

J.Brinckmann and E.F.Strange, *Japanese Colour-Prints and Other Engravings in the Collection of Sir Otto Beit*, 1924 pp.27-45.
M.Webster, *Francis Wheatley*, 1970.

Woollett

L.Fagan, *A Catalogue Raisonné of the Engraved Works of William Woollett*, 1885.
D.H.Solkin, *Richard Wilson, The Landscape of Reaction*, exhibition catalogue, The Tate Gallery, 1982.

THEMES

Arundel Society

R.Cooper 'The Popularisation of Renaissance Art in Victorian England', *Art History*, 1978, 1, pp.263-292.
W.N. Johnson, *A Handbook... to the Collection of Chromolithographs ...published by the Arundel Society*, Manchester, 1907.

F.W.Maynard, *Descriptive Notice of the Drawings and Publications of the Arundel Society*, 1869.
T.Ledger, *A Study of the Arundel Society 1848-1897*, D.Phil. Thesis, Oxford, 1978.

Copyright

P.Fuhring, 'The Print Privilege in Eighteenth-Century France' I and II, *Print Quarterly*, 1985, 2:3, pp.175-193; 1986, 3:1, pp.19-33.
E.Gambart, *On Piracy of Artistic Copyright*, 1863.
C.H.Gibbs-Smith, 'Copyright Law Concerning Works of Art, Photographs and the Written and Spoken Word', *Museums Association Information Sheet No.7*, 1974.
M.Pointon 'From Blind Man's Buff to Le Colin Maillard: Wilkie and his French Audience', *The Oxford Journal*, 1984, 7:1, pp.15-24.
F.G.Stephens, 'Hogarth and the Pirate', *Portfolio*, 1884, 15, pp.2-10.

Frames

J.D.Dolmetsch, 'Colonial America's elegantly framed prints', *Antiques*, New York, 1981, 129, pp.1106-1112.
P.Mason, *Designs for English Picture Frames*, 1987.
L.Roberts, 'English Picture Frames: The Pre-Raphaelites', *The International Journal of Museum Management and Curatorship*, 1985, 4:2, pp.155-172.

Print Rooms

D.Guinness, 'The Revival of the Print Room', *Antique Collector*, June 1978, 49, pp.88-91.
M.Jourdain, 'Print Rooms', *Country Life*, 1948, 104, pp.524-525.

Publishers

T.S.R.Boase, 'Macklin and Bowyer', *Journal of the Warburg and Courtauld Institutes*, 1963, 24, pp.148-177.
J.Ford, *Ackermann, 1783-1983: the Business of Art*, 1983.
A.Griffiths, 'A Checklist of Catalogues of British Print Publishers c.1650-1830', *Print Quarterly*, 1984, 1:1, pp.4-22.
J.Maas, *Gambart, Prince of the Victorian Art World*, 1975.
E.Manning, *Colnaghi's 1760-1960*, 1960.
L.Rostenberg, *English Publishers in the Graphic Arts 1599-1700*, New York, 1963.

Technique

A.Bosse, *Traité des Manières de Graver en Taille Douce sur l'Airain, par le Moyen des Eaues Fortes et des Vernix Durs et Mols...*, Paris, 1645.
A.Blunt, 'The Invention of Soft-ground Etching: Giovanni Benedetto Castiglione', *The Burlington Magazine*, 1971, pp.474-475.
R.M.Burch, *Colour Printing and Colour Printers*, 1910.
C.N.Cochin ed., A.Bosse, *De la Manière de Graver a l'Eau Forte et au Burin...*, Paris, 1745.
B.Coe and M.Haworth-Booth, *A Guide to Early Photographic Processes*, 1983.
T.H.Fielding, *The Art of Engraving*, 1841.
J.Frankau, *Eighteenth Century Colour Prints: an Essay on certain Stipple Engravers and their Work in Colour*, 1900.
J.M.Friedman, *Color Printing in England 1486-1870*, exhibition catalogue, New Haven, 1978.
R.C.B.Gardner, 'De Loutherbourg and the Polygraph Process', *Country Life*, 1948, 104, pp.824-825.
H.and A.Gernsheim, *The History of Photography*, 1969
A.Griffiths, 'The Search for a Facsimile' in M.Melot et al, *History of an Art: Prints*, New York, 1971, pp.164-165.
A.Griffiths, *Prints and Printmaking*, 1980.
A.Griffiths, 'Notes on Early Aquatint in England and France', *Print Quarterly*, 1987, 4:3, pp.255-270.
S.W.Grose, *Catalogue of the G.E.Beddington Collection of Colour-Prints*, Cambridge, 1959.
S.Hyde, *Drawings in Print, the Reproduction of Drawings in Eighteenth Century England*, exhibition catalogue, Courtauld Institute Galleries, 1983.
J.Lewis and E.Smith, *The Graphic Reproduction and Photography of Works of Art*, 1969.
H.Meier, 'The Origin of the Printing and Roller Press', *The Print Collector's Quarterly*, New York, 1941, pp.8-55, 164-205, 338-374, 496-527.
E.Miller, *Hand Coloured British Prints*, 1987.
J.Moran, *Printing Presses: History & Development from the Fifteenth Century to Modern Times*, 1973.
W.J.Stannard, *The Art Exemplar, A Guide to Distinguish One Species of Print from Another*, 1859.
E.Robinson and K.R.Thompson, 'Matthew Boulton's Mechanical Paintings', *The Burlington Magazine*, 1970, pp.497-507.
M.Twyman, *Lithography, 1800-50: the Technique of Drawing on Stone in England and France, and their Application in Works of Topography*, 1970.
M.Twyman, *Printing 1770-1970, an Illustrated History of Its Development and Uses in England*, 1970.
J.Physick, *Photography and the South Kensington Museum*, 1975.
W.Wallace, 'Account of the Invention of the Pantograph, and a Description of the Eidograph, a Copying Instrument Invented by William Wallace...', *Transactions of the Royal Society of Edinburgh*, 13, 1836, pp.418-439.

Footnotes to text

CHAPTER 1

1. For example *Portrait of a Young Boy* by Mary Beale (1632-1697), VAM P.38-1962.
2. Vertue (General) 18, p.47. For more information see Pennington (Hollar), p.xxiii.
3. For example, by Claude Gillot and Bernard Picart. See Michel (Watteau) p.239.
4. Sir H.Herkomer, *Etching and Mezzotint Engraving*, 1892, p.92 and 102.
5. See Benjamin (General) and Malraux (General) for discussion of the symbiotic relationship of reproductions and originals.
6. English translation quoted from D.Rosand, 'Titian and the Woodcut alla Veneziana', *Art News*, New York, 1976, 75, p.56.
7. David Landau pointed this out in a paper at the conference of the Association of Art Historians, 1987.
8. The publisher's descriptive notice is quoted in full in E.B.Chancellor, *Picturesque Architecture in Paris, Ghent, Antwerp, Rouen etc. Drawn from Nature on Stone by Thomas Shotter Boys, 1839*, 1928, pp.xv-xvi.
9. I am indebted to David Alexander who pointed out that 'Boydell's role has been exaggerated since he was a skilled publicist and had to plead patriotic motives when his business became shaky.'
10. I would like to thank David Alexander for bringing this quotation to my notice. It is quoted from Alexander and Godfrey (General) 91 where W.Roberts, *The Cries of London*, 1924, p.12 is given as the source.
11. The address is Colnaghi Sala & Co., Late Torre No 53 Cockspur Street facing Great Suffolk Street, London, cited from Webster (Wheatley) 102. This address is puzzling. Torre gave up the business in 1788 when the address was 132 Pall Mall. The firm moved to 23 Cockspur St. in 1799.
12. Royal Academy General Assembly Minutes, 1812, 3, 90-91. See Fox (General) for more information.
13. Founded in 1880, the Society received a royal charter in 1889.
14. Quoted from Newton (General) p.15.
15. This portfolio is in the Department of Designs, Prints and Drawings, VAM E.1320-1624→1901.
16. See *Art/66*, International Association of Art, 1972, p.7.
17. Quoted from U.K.National Committee of the International Association of Painters, Sculptors and Engravers, *The Definition of an Original Print Agreed at the Third International Congress of Artists, Vienna, September, 1960*, 1963. For more information on the concept of the 'original' print and the definition applied in the U.S.A. see C.Zigrosser, *A Guide to the Collecting & Care of Original Prints*, 1966.
18. See O.Grandsire, 'Protection du Createur et de l'Amateur d'Estampes', *Nouvelles de l'Estampe*, 1979, 44, pp.7-15.
19. Prospectus November 1734. Repr. in Dacier & Vuaflart (Watteau) 2, pp.40-42.
20. Pp. 22-23.
21. A.d'Harnoncourt and K.McShine eds., *Marcel Duchamp*, Phildelphia, 1973, p.275.

CHAPTER 2

1. Walpole (General) p.106: Smith 'was taken to work in Sir Godfrey's house, as he was to be the publisher of that master's works, no doubt received considerable hints from him, which he amply repaid'.
2. 14 July, 1754. Quoted from N.Penny ed. (Reynolds), 21.
3. P.Toynbee, *The Letters of Horace Walpole*, 1918-1925, 4, 629 to Grosvenor Bedford, 9 May 1757: 'I shall be much obliged to you if you will call as soon as you can at M'Ardell's in Henrietta Street, and take my picture from him. I am extremely angry, for I heard he has told people of the print. If the plate is finished, be so good as to take it away, and all the impressions he has taken off, for I will not let him keep one. If it is not finished, I shall be most unwilling to leave the print with him.'
4. Preface, p.1.
5. See Dacier and Vuaflart (Watteau) 2, p.103
6. *Sculptura-Historico-Technica: or the History and Art of Ingraving*, 1747, p.216. It draws heavily on older sources including Bosse (Technique) in the technical sections.
7. Pp.17-18.
8. Quoted from Wallace (Technique) p.422.
9. P.60.
10. Quoted from Wallace (Technique) pp.429-430.
11. Cochin cites Langlois' improved model published only two years previously in *Mémoires de l'Académie des Sciences*, 1743, 7, machine approvée 460.
12. I would like to thank Stephen Johnston for his advice on the development and use of the panto and eidograph.
13. Property of Iain Bain who drew my attention to it.
14. Plate xi.
15. Bosse (Technique) pp.21-22; Cochin (Technique) pp.23-24; Fielding (Technique) p.19.
16. T.H.Fielding (Technique) p.19.
17. Translated from Cochin (Technique) p.61.
18. Translated from quotation in Dacier and Vuaflart (Watteau) 2, p.103.
19. Quoted from C.R.Grundy, *James Ward*, 1909, p.xiv.
20. Iain Bain pointed out in a letter to the author that the Albion Press, introduced in c.1820 was used for proofing well into the present century and, indeed, it was still manufactured up to the Second World War.
21. See Twyman 2 (Technique) pp.48-66 for a mass of information on the variety of machines introduced.
22. Vasari (General) 3, p.74.
23. There are letters of privilege etc. in the Department of Manuscripts of the Bibliothèque Nationale, Paris, ms. franc.22120. See Dacier and Vuaflart (Watteau) 2, pp.87-90.

CHAPTER 3

1. J. Landseer *Lectures on the Art of Engraving*, 1807, p.177.
2. Malraux (General) p.12.
3. Bosse (Technique) pp.23,24; quoted from translation in *Scuptura-Historico-Technica: or the History and Art of Engraving*, 1747.
4. R.Strange, *A Collection of Historical Prints, Engraved from Pictures by the Most Celebrated Painters of the Roman, Florentine, Lombard, Venetian, and other schools*, p.vi.
5. Stannard (Technique) p.5.
6. Thomas Lupton won the Isis medal for his use of a soft steel plate in 1822.

7. The Italianate 'Mezzotinto' translates to halftint, close to halftone, the term which describes tonal photomechanical processes.

8. Smith (Reynolds) 2, p.223.

9. See Godfrey (General) p.48 which led me to the quotations which follow.

10. Northcote (General) I, p.64.

11. Smith (General) II, p.223.

12. Cited by Alexander and Godfrey (General) p.7.

13. See Alexander and Godfrey (General) p.7.

14. Steel-facing, introduced in c.1857, had the advantage that the engraver could work on the more malleable copper while having the yield of steel.

15. 'The comparative merits of line engraving and mezzotinto', Art Union, 1839, p.57.

16. Letter to Charles Warren dated 29 May 1810; quoted from Beck (General) p.20.

17. Dennistoun (Strange), 2, pp.255-256.

18. Stannard (General) p.158.

19. T.Moore, Memoirs, Journal and Correspondence, ed. Lord Russell, 1854, 6, p.95; quoted from Lloyd and Ledger (General) p.8.

20. Walpole (General) p.2, footnote.

21. The most noteworthy example is Johannes Teyler (worked 1650-1700) by whom there is an album of 185 brightly coloured prints, apparently dating from about 1670 in the British Museum. Its title-page declares that each print was printed from a single plate and that Teyler was the 'first' inventor of the process. The album covers a wide range of subjects including portraits by Kneller and Van Dyck but such overt reproductions are in the minority.

22. Quoted from Gage (Le Blon) p.66, whose source was C.Parkhurst and R.Feller, 'Who invented the color-wheel?', Color Research & Application, 1982,7, p.229, n.14. The discussion of colour is unique to this edition.

23. R.Bradley, Treatise on Husbandry and Gardening, 1724, I, p.74. Quoted from Gage (Le Blon) p.66.

24. The Picture Office's 'Prospectus' is published in Lilien (Le Blon).

25. Quoted from Burch (General) p.54.

26. For example see Friedman (Technique) 14 which reproduces separations of the print after Van Dyck's 'Self-Portrait' in the collection of the British Art Centre, Yale.

27. Preserved in the Bibliothèque de l'Arsenal, it is transcribed in Carlson and Ittmann (General) 63.

28. Frankau (Technique) p.62.

29. Frankau (Technique) p.63. Grose (Technique) p.8, note 1 lists prints which credit the printer in the lettering pointing out how few were given credit for what was an immensely skilled job.

30. The earliest known print publisher's catalogue in Britain is that of Peter Stent, dating from 1649-1653, which ends the list of prints encompassing such ranges as portraiture and topography with the covering statement: 'You may have them in colours also'. Cited from Miller (Technique) p.9.

31. P.108.

32. I would like to thank David Alexander for giving me the reference to Gardner (Technique).

33. J.Booth, A Treatise of the Nature and Properties of Pollaplasiasmos..., 1784, p.1.

34. J.Booth, ibid., p.57.

35. Antony Griffiths is shortly to publish an article in Print Quarterly clarifying the Boulton and Eginton process.

36. Quoted from Robinson and Thompson (Technique) p.504, n.45. See this article for more detail on the Boulton and Eginton and the Polygraphic processes.

37. Quoted in Lewis, (Baxter) p.118.

38. 16th Annual Report of the Council, 1865, p.2. Quoted from Ledger (Arundel Society) p.103.

39. Art Journal, 1865, NS 4, p.303. Quoted from Ledger (Arundel Society) p.109

40. Malraux (General) p.32.

41. Ibid.

42. Talbot (General) p.5 (unpaginated).

43. Plate 23.

44. 'The details were, in fact, published earlier.' John Ward, Science Museum.

45. See Fawcett (General) p.191.

46. Journal, ed. A.Joubin, Paris, 1932, 2, 19 & 24 Nov., 21 May, 1853. Fawcett (General), from which this passage is quoted, explores audience reaction to the different technologies in depth.

47. The Cestus of Aglaia, 1865-66, J.Ruskin, The Works of John Ruskin, E.T.Cook and A.Wedderburn ed., 1903-1912, 19, p.89. Quoted from Fawcett (General) p.207.

48. Manual of Photographic Manipulation, 1868, pp.215-216. Quoted from Fawcett (General) pp.201-202.

49. The Burlington Magazine, 1908, 13, p.298; 1909, 14, p.251.

50. It also made possible the photographic reproduction of etchings in their original medium.

51. Collotype is available from one or two firms in the U.S.A. and is rumoured to be in use still in Eastern Europe.

52. P.59.

53. A.Senefelder, A Complete Course of Lithography, 1819, p.180.

54. Penrose Pictorial Annual, 1908-09, p.171.

55. W.P.Frith, My Autobiography and Reminiscences, 1888, 3. Quoted from Newton (General) p.14.

56. Penrose Annual, no.43, 1949. Quoted from Lewis and Smith (Technique) p.12.

57. Hogarth (Hogarth) p.202.

58. See Godfrey (General) p.35.

CHAPTER 4

1. C.Cennini, A Practical Treatise on Painting in Fresco, Oil and Distemper, trans. M.P.Merrifield, 1844, p.63.

2. Pp.1-2. I am indebted to John Murdoch for this reference.

3. Kirkall actually reproduced some of Ugo da Carpi's subjects, e.g. Aneas and Anchises after Raphael.

4. See C.Rogers A Collection of Prints in Imitation of Drawing, 1778, 2, p.243. Cited from Hyde (General) 5.

5. Vertue (General) 29, p.168.

6. H.Tietze and E.Tietze-Conrat, The Drawings of the Venetian Painters in the 15th and 16th centuries, New York, 1944, 709.

7. The technique is described in detail by Laurenthius (Ploos van Amstel) p.331 who reported that examination of a surviving sheet prepared in this way has shown the powder to consist of lepidocrocite and goethite but recent experiments have shown sand, powdered marble and copper sulphate to be equally effective.

CHAPTER 5

1. See Hind (General) 5, p.5.

2. Vasari (General) 3, p.73.

3. Vasari (General) 2, p.237.

4. Vasari (General) 3, p.76.

5. Vasari (General) 3, p.77.

6. See Landau (General) for a different interpretation of the relative status of engravers and painters.

7. Vasari (General) 3, p.130.

8. Magurn (Rubens) p.69, 1619.

9. Magurn (Rubens) p.4.

10. Translated from Davies and Blunt (Poussin) p.27.

11. For a quotation from the Edict see Fuhring (Copyright) I, p.177.

12. Schmidt-Lisenhoff (Reni) p.8.

13. Although not completed as a distinct project, the scheme survives to-day in the 'Chalcographie du Louvre', from which impressions from old plates are still supplied. 'La Regia Calcografia' conceived in Rome in 1738 by Pope Clement XII, had similar aims.

14. Schmidt-Linsenhoff (Reni) p.8.

15. Vasari (General) 3, p.74.

16. From an inventory of possessions, quoted from Préaud (General) p.86.

17. Quoted from Penny ed. (Reynolds) p.366.

18. Published by F.Ehrle, *Roma prima di Disto V; la pianta di Roma du Perac-Lafrery del 1577,* Rome, 1908, pp.53-54.

19. Letter from George Falkner, 15 Nov.1740 to Hogarth: 'Sir, I was favoured with a letter from Mr.Dalany, who tells me that you are going to publish three Prints Your reputation here is sufficiently known to recommend anything of yours; and I shall be glad to serve you...You may send me fifty sets, provided you will take back what I cannot sell.' Quoted from J.Nichols and G.Stevens, *The Genuine Works of William Hogarth,* 1808-17, 1, p.104.

20. Penny ed. (Reynolds) p.198.

21. I am indebted for this information to Christopher Lennox-Boyd who owns impressions of these prints.

22. See Maas (Publishers) for more information.

23. Fuhring (Copyright) I, p.185.

24. Mayor (General), 'Terms and Abbreviations found on Prints', unpaginated, has a useful list of these abbreviations with identification of the issuing bodies with which they are associated.

25. Fuhring (Copyright) I, p.185.

26. The copy in the National Art Library, VAM, is inscribed *Hogarth got this drawn up* and it resembles Hogarth's other publications in style.

27. P.2.

28. P.3.

29. It is published in R.Paulson, *Hogarth, his Life and Times,* New Haven, 1971, 2, pp.489-90.

30. Pye (General) p.158.

31. See W.G.Rawlinson, *Exhibition of Mezzotints Portraits,* Burlington Fine Arts Club, London, 1902, p.22, who claims he habitually charged £100. See also Pye (General) p.244, note, for more details.

32. Reitlinger (General) 2, p.319.

33. Gambart (Copyright) pp.8,9.

34. Pointon (Copyright).

35. Gambart (Copyright) p.24.

36. Gibbs-Smith (Copyright) explains contemporary copyright law simply.

CHAPTER 6

1. Oberheide, (Marcantonio Raimondi); quoted from Shoemaker and Broun (Marcantonio Raimondi), p.20.

2. Vasari (General) 3, p.76.

3. See G.P.Bellori, *Le Vite de' Pittori, Scultori e Archtetti Moderni,* 1672, edition published Turin, 1976, p.423.

4. For example *The Plague of Ashdod* which includes details from *Morbetta* engraved by Marcantonio Raimondi. See also *Ordination* second series (fig.286) in which the arrangment of the planes of the painting recalled Marcantonio's engraving of the *Massacre of the Innocents* (fig.141e), a similarity which is reinforced by the presence of the triple-arched bridge.

5. See P.Desjardins, *Poussin, Biographie Critique,* Paris, 1903, p.95.

6. The inventory is published in Clark (Rembrandt) p.119-121.

7. Both repr. Clark (Rembrandt) pp.51,52.

8. Reynolds (Reynolds), pp.95-107.

9. E.Young, *Conjectures on Original Compositions,* 1759 in P.M.Spacks, ed., *Late Augustan Prose,* Englewood Cliffs, N.J., 1971, p.55; quoted from Solkin (Woollett), p.62.

10. E.Tietze-Conrat (Mantegna) p.241.

11. Northcote (Reynolds) 1, p.83.

12. A.Luzio, *1a Galleria dei Gonzaga Venduta all'Inghilterra nel 1627-8,* reprint of 1913 edition, Rome, 1974, pp.273-4; quoted from Bury (General) p.16.

13. M.Boschini, *La Carta del Navegar Pitoresco,* Venice & Rome, 1966, p.147; cited from Bury (General), pp.17-18.

14. K.Frey, *Der Literarische Nachlass Giorgio Vasaris,* Munich 1923, I, p.326; quoted from Bury (General), p.14.

15. See Bury (General) p.22.

16. Quoted from English translation *The Art of Painting with the Lives and Characters of above 300 of the Most Eminent Painters: containing a complete treatise of Painting, Designing and the Use of Prints...,* 1744

17. Translated from C.H.Watelet, *Dictionnaire des Arts de Peinture, Sculpture et Gravure,* 1792, 2, pp.210-211.

18. See D.Solkin, 'Great Pictures or Great Men? Reynolds, Male Portraiture, and the Power of Art', *Oxford Art Journal,* 1986, 9:2, pp.42-49.

19. Teniers originally planned to produce a volume of plates on the northern schools but the idea was later abandoned. This part of the collection was not engraved until Joseph Prenner, *Theatrum Artis Pictoriae,* 1728. See LLoyd and Ledger (General) 27.

20. C.Patin, *Relations Historiques et Curieuses de Voyages en Allemagne, Angleterre, Hollande, Bohème, Suisse, etc.,* English ed., 1696; quoted from Lloyd and Ledger (General) p.82.

21. P.1.

22. Announcement in the *Mercure de France* cited by LLoyd and Ledger (General) p.85.

23. Roland Michel (Watteau), p.267-269.

24. Jean Baptiste Descamps, *La Vie des Peintres Flamands Allemands, et Hollondois, avec des Portraits Gravés en Taille Douce, une Indication de leurs Principaux Ouvrages, et des Réflexions sur leurs Différentes Manières,* Paris, 1753-64.

25. Jean Baptiste Pierre Le Brun, *Galeries des Peintre Flamands, Hollandais, et Allemands. Ouvrage enrichi de 201 planches gravées d'après les meilleurs tableaux de ces maîtres, par le plus habiles artistes de France, d'Hollande, et d'Allemagne, avec un texte,* Paris, 1792.

26. P.F.Basan, *Dictionnaire des Graveurs Anciens et Modernes depuis l'Origine de la Gravure, avec une Notice des Principales Estampes qu'ils ont Gravées,* Paris, 1767.

27. C.Josi, *Collection d'Imitations de Dessins d'Après les Principaux Maitres Hollondais et Flammands Commencée par Ploos van Amstel..., 1821,* conclusion.

28. O.Ferrari, *Enciclopedia Universale dell'Arte,11,* Venice and Rome, 1963, col.557 under the heading 'Riproduzioni'; quoted from Lloyd and Ledger (General) p.5.

29. Malraux (General) pp.31-2 and 20.

30. Vasari (General) 3, p.74.

31. A.von Bartsch, *Le Peintre-Graveur,* Leipzig & Vienna, 1808-54, 14, p.v.

32. A.M.Hind, *A History of Engraving and Etching from 15th Century to the Year 1914,* 1923, ed.1963, p.91.

33. A.von Bartsch,'Concerning the Administration of the collection of prints of the Imperial Court Library in Vienna', 1820, reprinted as supplement to the 'Illustrated Bartsch', Bartsch (General).

34. P.34; quoted from facsimile reprint,The Holland Press, 1970.

35. See Guinness (Print Rooms) p.89.

36. C.E.Aïssé, *Lettres de Mademoiselle Aïssé a Madame C[alandrini],* Paris, 1787; quoted from Jourdain (Print Rooms) p.524.

37. Toynbee op.cit. 370, 3 June, 1753.

38. Ed., E.J.Climenson, *Passages from thr Diaries of Mrs. Philip Lybbe Powys,* 1899; quoted from Jourdain (Print Rooms) p.524.

39. This is now in the County Archives of Kent.

40. Quoted from Guinness (Print Rooms) p.89.

41. E.g. The Duchess of Northumberland's for 1752 and 1766 quoted in Guinness (Print Rooms) p.88-89.

42. Hind (General) 1, pp.119-121.

43. D.Rosand, op.cit. p.56-59.

44. See Bury (General), p.12

45. See Griffiths (Publishers) 1984, p.7.

46. Quoted from Dolmetsch (Frames) p.1111

47. Advertisement in *London Daily Post,* 30 June 1735; quoted from Paulson (Hogarth) p.8, n.13.

48. Lippincott (Pond) p.64.
49. Printsellers' Association (General) pp.28-32.
50. Guy Shaw generously provided me with this reference.
51. Colonial Williamsburg Foundation; see Dolmetsch (Frames).
52. Quoted from Dolmetsch (Frames) p.1110.
53. Pp. 199-200.
54. *Catalogue of the Medici Prints*, 1929, opposite p.59.

CHAPTER 7

1. In the past the composition provided a pattern for tapestries and to-day lustrous gaudy hangings decorated with it are met with in street markets. There is a full-scale reproduction in stained glass at the Forest Lawn Cemetery at Los Angeles and a life-size three-dimensional sculptural reconstruction in the Protestant Chapel at John F.Kennedy Airport, New York. See Steinberg (Leonardo) pp.402-407 and Heydenreich (Leonardo) pp.99-105 for an account of many of the copies.
2. William Bewick, *Life and Letters of William Bewick, Artist*, T.Landseer ed.,1871, 1 (reprinted East Ardsley,1978). Quoted from Fawcett (General), p.198.
3. Quoted from Heydenreich (Leonardo) pp.16-17, which gives other early accounts of the paintings deterioration.
4. The three engravings reproduced as figs.215-217 and Hind (General) 9a which is close to that repr. as fig. 1 but omits the spaniel. Hind (General) 9, note 1, records a large contemporary woodcut of which only fragments survive.
5. See Steinberg (Leonardo) pp.409,410 for an account of the history of this copy.
6. 25 January,1787; quoted from Goethe (General) p.166.
7. J.H.Liversidge, 'John Ruskin and William Boxall: unpublished correspondence', *Apollo*, January 1967, p.39; quoted from Heydenreich (Leonardo), p.93.
8. See Matthew 26,20-29.
9. See p.32.

Footnotes to captions

CHAPTER 1

I Whitham (Green), p.8.
II Quoted from a recently published, but undated pamphlet entitled *The Fine Art Trade Guild.*

CHAPTER 2

I Dughet was probably living with Poussin when he painted the first series. See Blunt (Poussin) p.55,n.9.
II Quoted from Held (Rubens) p.37.
III Schneevoogt (Rubens) 48.333 states 'Les première épreuves sont avant le millesime de 1631'. The 18th century impression in the VAM no. 15862.A.50 is, however, without this date.
IV A copy of the contract with an English translation is quoted in Martin (Rubens) pp.213-219.
V 37 drawings in red chalk and grey wash are in the Antwerp Print Room.
VI Martin (Rubens) pp.51-3 gives information on Müller and argues this point in more depth.
VII C.W.Radcliffe. Quoted from Rawlinson, (Turner) p.lxviii.
VIII 19 January 1837. R.B.Beckett ed., *John Constables's Correspondence*, 1962-68, X, p.434.

CHAPTER 3

I Lacantius, *Opera,* set by Conrad Sweynham and Arnold Pannartz.
II Vasari (General) 3, p.74.
III Reproduced Biachi (Marcantonio Raimondi) 2, p.663, fig.23.
IV Dyce 1039,1040.
V Oberheide (Marcantonio Raimondi). Quoted from Shoemaker and Broun (Marcantonio Raimondi) p.43, n.14.
VI Fagan (Woollett) p.vii.
VII Quoted from Pye (General) p.159.
VIII Tim Clayton provided this information from his *Engraved Works of George Stubbs,* 93, which is awaiting publication.
IX Tuer (Bartolozzi) p.1.
X P.Toynbee, *The Letters of Horace Walpole,* 3, 370 to Horace Mann, 12 June, 1753.
XI From 'Press cuttings on art' 1795 in VAM, National Art Library.
XII Harford Papers, Box 1: MS. notebook by Louisa Harford, *Slight Recollections of my beloved husband*, dated 18 June 1867, Blaise Castle, p.14. Quoted from Ledger (Arundel Society) p.80.
XIII 17 January, 1855, p.8. Quoted from Ledger (Arundel Society) p.81.
XIV Quoted from R.Ross, *Masques and Phases,* 1909, pp.135-6.
XV Some of these are preserved in the Science Museum. In the print reproduced the background of Hampton Court, visible around the cartoon on the negative, has been masked.
XVI *The Athenaeum,* January 1859, p.86.
XVII Quoted from Gernsheim and Gernsheim (Technique) p.250.
XVIII Advertisement in *Daily Post & Gen. Advertiser,* 2 April 1743. Quoted from Paulson (Hogarth) p.268.
XIX Quoted from W.Hogarth, *The Analysis of Beauty,* J.Burke ed., Oxford, 1955, p.226.

CHAPTER 4

I The composition is completed by a second plate (VAM CAI 602) for which no drawing is known.
II A study related to *Christ healing the sick* on the back of engraving of *Adoration of the shepherds* in the Fitzwilliam Museum, Cambridge, no.3079.
III Studies of arms and legs, Uffizi, Florence, no.13611f; Diogenes' left arm, Chatsworth, no.797b; Diogenes' right arm, Chatsworth, no.786.
IV E.g. *The Marriage of the Virgin,* Chatsworth, 339.
V Vasari (General) 3, p.10.
VI Vasari (General) 3, p.78.
VII Not in F.Hartt, *Giulio Romano,* New Haven, 1958.
VIII See L.Lippincott (Pond) p.186, n.5, Pond's Journal of receipts and expenses 1734-50 BM Add. Mss. 23724 FF22,23 and 9,15,17,21,25,38 indicate that pear blocks were cut by 'Davis' and 'Pennock'. Pennock was probably William Pennock, a wood, copper and seal engraver located at the Tobacco Roll in Pannier Alley, Newgate Street in 1709.
IX Vertue (General) p.192.
X Levenson, Oberhuber, Sheehan (General) p.400. The figure is likened to the gypsy in Giorgione's *Tempest* and the buildings in the background are compared with those in Giorgione's *Three Philosophers* in Vienna.

XI Tim Clayton has provided this information from his *Engraved Works of George Stubbs*, 38, awaiting publication.

XII G.K.Nagler, *Die Monogrammisten*, Munich and Leipzig, 1966, 2721, records this monogram as unidentified.

XIII C.Koch, *Die Zeichnungen Hans Baldung Griens*, Berlin, 1941, 108. The differences between the print and this drawing suggest that it was a copy of the latter which was the immediate source.

XIV F.G.Moon, *The Holy Land, Egypt, Arabia, and Syria, by David Roberts, A.R.A. The historical and descriptive notices by the Rev. G.Groly, 1840, p.1.*

CHAPTER 5

I For an account of opinions see Shoemaker and Bronn (Marcantonio) 21 and cf. P.Joannides, *The Drawings of Raphael*, 1983, 289.

II J.Shearman, 'Raphael, Rome, and the Codex Escurialensis', *Master Drawings*, XV, 1977, p.128 and n.22 tentatively suggests that Raphael may have made a copy of this drawing.

III See P. Joannides, op.cit., 191r,252v, 253v.

IV Different scholars have suggested different versions as the original often attributing the other to Marcantonio's workshop. For an account see Shoemaker and Broun 26.

V Bartsch (General) 34, 35.

VI The easiest way in which to distinguish them is the presence of an additional 's' (Invictiss rather than Invictis) on the dedication to Philip II but a close examination reveals a different engraving of all the lines.

VII The two versions are reproduced in E.von Rothschild, 'Tizians Darstellungen der Laurentius Marter', *Belvedere*, Zurich, Leipzig, Vienna, 1931, 1 pp.202-209, II pp.11-17.

VIII *Recueil de la Société Polytechnique*, May 1849, cited by Bouchitie. Translated from Wildenstein (Poussin) p.165.

IX First published in three volumes between 1754 and 1762.

X Quoted from Boase (Publishers) p.169.

XI Farington Diary, 8 July 1806 (ed. Grieg), quoted from Alexander and Godfrey (General) p.33.

XII *The Case of Designers, Engravers, Etchers, &c.*, *1734, p.2.*

XIII Noted Rix (General) p.60.

XIV Gambart (Copyright) p.21.

XV Vasari(General) 3, p.10.

CHAPTER 6

I See N.Penny ed., (Reynolds) pp.344-354.

II Vertue (General) 1, p.47.

III For the drawings to which they relate, although frequently only to a detail sometimes re-composed see Popham (Parmigianino) 313,719, or 54,523,20,655.

IV The volume is not in A.T.Hazen, *Catalogue of Horace Walpole's Library*, 1969.

V Quoted from Koschatzky (Bartsch) p.ix.

VI There is a copy of this Manifesto in the Department of Designs, Prints and Drawings, VAM, Tatham Album, D.1479-1898. The translation is from Joyce (General) p.438.

VII B.Brooks, carver and picture framer, is recorded in a Hull Directory for 1854-5 but in 1837 there was a Thomas Brooks in Hull in the same street.

VIII First Prospectus, quoted from Smith (General) p.95.

IX F.G.Stephens, *W.Holman Hunt and His Works*, 1860,p.78.

X To J.I.Tipper, 19 Dec, 1867. Ms Henry E Huntingdon Library, California. Judith Bronkhurst generously provided me with this quotation.

XI Quoted from a Medici catalogue of 1929.

XII See D.G.Rossetti, *Dante Gabriel Rossetti and Jane Morris*, 1976, p.205.

XIII *Saturday Review*, XXXVI (1874), p.156. Quoted from Ledger (General) p.151.

CHAPTER 7

I The etching is close to a drawing in the Dijon Museum, see J.Gantner, 'Rembrandt und das Abendmahl des Leonardo', *Festschrift Friedrich Gerke, Baden-Baden*, 1962, pp.179-185, fig.3, but this drawing is not generally accepted as by Rubens's hand.

II The copy after repainting conforms to the layout of the table in the original but the variation is likely, nevertheless, to have been the copyist's invention rather than a caprice of the draughtsman, whose drawing was made for a practical end.

III The British Museum has a complete set of working proofs for the print.

IV Repr. Heydenreich (Leonardo) pp.102-3.

Index